THEMES IN AMERICAN PAINTING

ELEMENTS OF MATERIA MEDICA

ALSO BY ROBERT HENKES

American Women Painters of the 1930s and 1940s:
The Lives and Work of Ten Artists
(McFarland, 1991)

The Art of Black American Women:
Works of Twenty-Four Artists of the Twentieth Century
(McFarland, 1993)

•

Orientation to Drawing and Painting (1965)

Notes on Art Education (1969)

Eight American Women Painters (1977)

Insights in Art and Education (1979)

The Crucifixion in American Painting (1980)

Three Hundred Lessons in Art (1981)

American Art Activity Book (1983)

Sport in Art (1986)

Art Projects Around the Calendar (1991)

New Visions in Drawing and Painting (1992)

•

Open Your Eyes to Art (filmstrip, 1981)

20th Century American Painting (filmstrip, 1983)

Hispanic Art (filmstrip, 1984)

THEMES IN AMERICAN PAINTING

A REFERENCE WORK TO
COMMON STYLES AND GENRES

by
ROBERT HENKES

McFarland & Company, Inc., Publishers
Jefferson, North Carolina, and London

British Library Cataloguing-in-Publication data are available

Library of Congress Cataloguing-in-Publication Data

Henkes, Robert.
 Themes in American painting : a reference work to common styles
and genres / by Robert Henkes.
 p. cm.
 Includes bibliographical references and index.
 ISBN 0-89950-734-4 (lib. bdg. : 50# and 70# alk. paper) ∞
 1. Painting, American—Themes, motives. I. Title.
ND205.H42 1993
759.13—dc20 92-53599
 CIP

Manufactured in the United States of America

McFarland & Company, Inc., Publishers
 Box 611, Jefferson, North Carolina 28640

Dedicated to my friends —
Gundor, Greg, Todd and Ron.

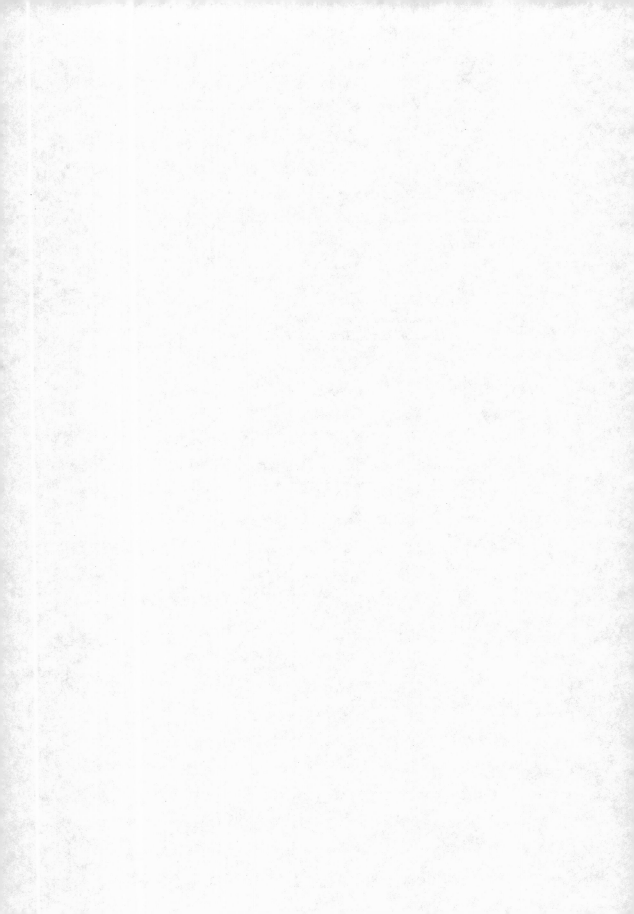

• C O N T E N T S •

Between pages 148 and 149 are 8 pages
(A–H) containing 11 color images

• INTRODUCTION •

This book represents an attempt to record in artistic fashion the major topics or concerns of the American artist. The themes selected for discussion include Mother and Child, Modes of Transportation, the City, Clowns, Sports, the Crucifixion, Interiors, Natural Disasters, Wars and Aftermath, Social Protest and Injustices, Still Life, Self-Portraits, and Music. Attempts have been made to include a wide variety of schools of art: Naturalism, Realism, Cubism, Abstract, Abstract Expressionism, Photorealism, Op and Pop.

There is an unintentional overlap of artists among chapters. Ben Shahn, for example, may be discussed in reference to several themes; Abraham Rattner may excel in paintings of sports, the crucifixion, politics and mother and child and thus appear in the corresponding chapters. There are other themes of artistic interest, but I have selected in my estimation themes which are timely, ever-present and representative of the elements of art.

The paintings here reproduced cover several decades, from the early Mary Cassatt mother and child themes to the Photorealistic works of Janet Fish. They are intended to present a varied display of compositional, intellectual and emotional paintings regardless of the theme being portrayed. The still life, often considered a dead subject matter, was selected because of the freedom it affords for experimentation as evident in the works of abstractionist Stuart Davis and photo-realist Audrey Flack.

The themes examined herein by no means exhaust the artists' resources. Themes are as numerous as the artists themselves. Each theme is popular and broad enough to support a book-length manuscript, so this book is not the last word. Several famous masterpieces must be omitted from between its covers because of unknown owners and whereabouts. The selection was diligently made in order to ensure a just and even representation of America's finest paintings.

MOTHER AND CHILD

In dealing with this theme, I have deliberately excluded the original mother and child theme associated with the birth of Christ. Instead I discuss a quite different theme which, though centuries old, was introduced onto the American scene in a notable sense by artist Mary Cassatt, who became noted as the Degas of the American family. Her several mother and child themes were eloquently styled and identified with the maternal instinct in ideal circumstances. Her painting titled *Mother and Child* evokes a mixture of charm and a sense of freedom, a release from the tension of worldly concerns, a total freedom to devote exclusively to one another the love and affection of a mother-child relationship.

The intimacy of a mother and child dialog is reflected in fleeting episodes of endearment—a gentle touch, a caring glance—which Cassatt made famous. *The Bath, In the Garden,* and *After the Bath* also shun traditionally posed compositions, but transform familiar, common-place events into magical moments. Cassatt's mother and child scenes are not ideally portrayed as some critics would

seem to believe, but are noteworthy examples of a popular theme executed in an acceptable mode and transformed into lasting memories.

One does not ignore the works of Mary Cassatt, such as *Mother and Child*. Rather, one is drawn into her work, not as a participant but as a spectator who wishes to be a participant. It is this close relationship between artist and viewer that Cassatt creates in her work. And her subjective approaches leave little to contemplate outside of the featured roleplayers. The environments harboring Cassatt's subjects are familiar to all classes of society, though each might interpret them differently.

In those works already mentioned, Cassatt applies an impressionistic technique to the background, while the significant anatomical elements of her primary subjects are in sharp contrast as the soft, smooth fleshtones compete with the textural habitat. There is a dreamlike quality, a stillness so quiet and so peaceful that one senses the deep affection in the unspoken word, the gentle smile and the innocent look of dependence.

Above: Mary Cassatt. *In the Garden* (1893). Pastel, 23⅝ × 28¾ in. The Baltimore Museum of Art, the Cone Collection, formed by Dr. Claribel Cone and Miss Etta Cone. *Opposite:* Mary Cassatt. *The Bath* (1891/92). Oil on canvas, 26 × 39½ in. The Art Institute of Chicago, Robert A. Waller Fund, 1910.2. Photograph ©1990 the Art Institute of Chicago. All rights reserved.

Cassatt's portrayals were of the upper class of a different world from that of an artist such as Gladys Rockmore Davis. The charm and sophistication of a Mary Cassatt is not the image one witnesses in Gladys Rockmore Davis's version of the mother and child theme titled *The Kiss*, or *Endearment*. In it one sees a mother embracing her child in a desperate clutch as if a miracle has come to pass. The mother's firm but gentle grasp is one of maternal need. The symbolic hand images relate the appropriate strengths and innocence of both persons of the pair. The helpless child is lovingly cradled as the viewer is treated to an intimate event. Although roughly textured in a strong and deliberate surface treatment, *The Kiss* is charming and timeless in its beckoning to life.

The Kiss stems from the ravages of World War II; thus the moment it depicts transpires under the worst possible economic and social conditions. The dramatic circumstances surrounding the event contribute to its powerful discharge of emotion. The viewer, in turn, responds with deep affection and compassion for the mother and child.

The expression of the theme of a mother and her child is generally a total commitment. Artist Mabel Dwight, however, offers an unusual version of not a single relationship but several in her painting *Children's Clinic*. The melodramatic display of emotions portrayed in this work is common in medical clinics and readily understood and accepted among the nation's motherhood. Missing in the real world, though, is the artist's satirical touch, the special hallmark of the master of American satire, Mabel Dwight.

The viewer is cautioned to observe *Children's Clinic* with a certain casual attitude. Mothers recognize the scene and identify with its varying degree of anxiety, frustration and perhaps even anger that is leveled not at the doctors or their own children, but at society's system of caring for the sick. Each of the six obvious mother and child connections, were they isolated and enlarged, would be ideal compositions.

The several dialogs are compositionally united by a unique overlapping of figures. In spite of an objective arrangement of figures, a definite intimate relationship is sustained among the roleplayers, and the tightly knit composition avoids the usual loss of compositional unity. The children's clinic is routine for the medical staff but exasperating for the mothers.

Dwight endeavors to lighten life's burdens with sardonic interpretations of bits of reality. The viewer whose maternal instincts lack those witnessed in Dwight's masterpiece may snicker at the proceedings, but for the experienced mothers the ordeal is never forgotten. Dwight's smack at life's events of both consequential and inconsequential magnitude leaves the viewer with the need to experience more of her approach to life. Dwight scans the entire picture of life, and the happening depicted in her *Children's Clinic,* although devastatingly crucial at the moment, for its participants, is but a fleeting incident of life's total experience.

A bit reminiscent of Gladys Rockmore Davis's *The Kiss* is Philip Evergood's masterpiece titled *Mother and Child*. Heavily textured pigment accompanied by appropriately placed contour lines

Opposite: **Gladys Rockmore Davis. *The Kiss (Endearment)* (1948). Oil on canvas. McBride Galleries, 1010 Water Street, Port Townsend, Wash. 98368.**

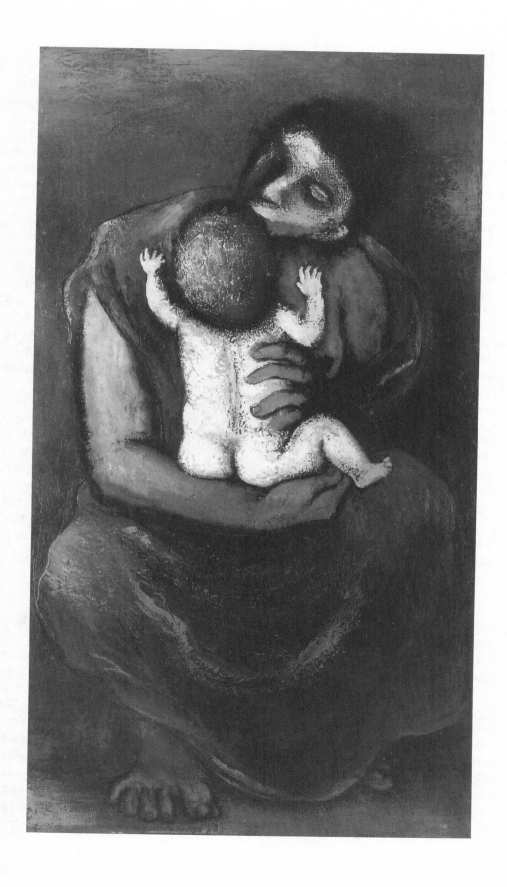

makes *Mother and Child* a tender, intimate dialog between mother and child, a visual exchange of affection registered in the eyes of each subject. The union of love and mutual dependence is evidenced in the blend of subject matter and background and mirrored in the dual optical commentary.

A sense of isolation permeates the canvas. Mother and child seem anchored into a tightly knit habitat as Evergood has removed all obstacles and possible interruptions. The background consists of land and sky which seem to swarm over the intimate couple, forcing the viewer to readily acknowledge their presence. The mother's rather buxom form enriches the joyful reunion. The naked trees which barely inhabit the environment suggest a nostalgic event, and childhood memories seem remote in their incidental inclusion.

Both Gladys Rockmore Davis and Philip Evergood fortify the significance of subject matter by muting the background. In doing so they prevent the background from contacting their primary images, and the environment surrounding the mother and child duality blends with the subjects so that foreground and background become one. This totally subjective approach creates a direct communication between the viewer and the artist's subject. In the case of Davis's image, the contact is made between viewer and mother; in Evergood's portrayal, the viewer shares the response with both mother and child. This difference elicits degrees of emotional response from the viewer. In the case of Evergood's portrayal, the viewer is drawn into direct confrontation with both mother and child, whereas Gladys Rockmore Davis invites the viewer to console the mother.

However, in a drawing also titled *Mother and Child,* Evergood sets down an in-tuitive response with a background totally free of interruption. The beauty of line is witnessed in the delicately applied contours which define both the child and the mother. The insertion of appropriate gesture lines suggests the emotional joy of security and love.

The drawing is a contemplative piece which is uncommonly direct in its style and avoids the danger of color dominating the theme. The focus on facial features prompts the viewer to ignore the hint of sorrow reflected in the painting and to contemplate the gazes of the roleplayers. It also highlights the tender concern for this sacred union. The bony structure of both figures is typical of Evergood's elongated style of portraying human anatomy.

In severe contrast to Evergood's provocative imagery is Milton Avery's version titled *Mother and Child,* executed in 1944. Avery's flatly arranged pattern of pastel colors is ambiguous in its definition. In fact, the viewer relies upon the title to decipher the images. The abstract shapes, although softly edged and pronounced in gentle colors, leave the viewer questioning the technical procedure. However, the artist never alters a current technique to satisfy a particular idea.

Avery's complete disregard for the recessive aspect of nature, anatomical foreshortening and visual perspective coincides with his belief that all visual images should be executed upon a frontal plane. The three-dimensional nature of things is totally ignored in *Mother and Child.* The intimate couple becomes a universal symbol, an unidentifiable image. Any visual intercourse between viewer and the artistic image occurs through the use of soft, lyrical color to evoke subtle emotion. Avery's simplification of form and luminous color harmonies initiated a new

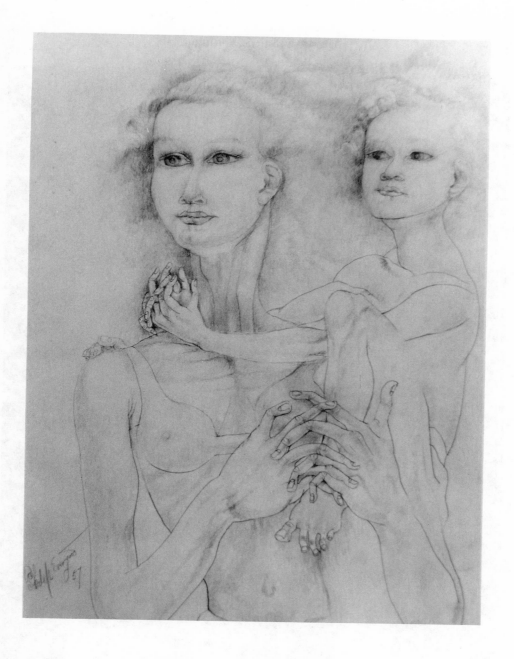

Philip Evergood. *Mother and Child* (1957). Pencil drawing, 18 × 23⅞ in. Terry Dintenfass Gallery, New York City. Photo by Walter Rosenblum.

approach to color in American art. In *Mother and Child,* Avery's subtlety of pastel colors creates an innocent relationship, a purity of form which corresponds with the theme at hand.

No objective barriers or distracting de-tail confronts the viewer. Avery's simple palette records a simple idea within a simple environment. His complete disregard for facial features and anatomical details can puzzle the viewer; Avery prefers that the viewer accept the universal image

Ben Shahn. *Miners' Wives* **(1948). Egg tempera on board, 36 × 48 in. Philadelphia Museum of Art, given by Wright S. Ludington.**

from a purely subjective color scheme. He was able to abstract the mood of an event or situation with the application of color.

Avery abstracted an idea instead of extracting an idea from an abstract form. Avery's subject matter is definite in its contours. Each shape of color defines a particular segment of the subject's makeup. Beyond this initial identity, the viewer relies upon the tones of color to set the emotion. Avery's paintings are peaceful expressions of a commonplace world. *Mother and Child* is no exception.

Artist Ben Shahn employed his unique style to document major events of the American scene for decades. His remarkable sensitivity for the human condition was never more obvious than in his masterpiece titled *Miners' Wives*. In it he portrays a mother cradling her child while awaiting news of a mining tragedy. During the Great Depression coal mines were prosperous because coal was the sole heating material for the homes of America. Shahn was noted for recording artistically those events of historical significance that affected America and its inhabitants.

Although titled *Miners' Wives,* the painting might well have been named *Mother and Child,* since it is that couple that is the focal point of the painting. One of three compositions residing within a single painting, the mother and child are positioned slightly off center to allow the viewer first to scan the entire composition and its spatial effects, and then to relate the cradled couple to the background.

Shahn's individual linear technique of defining masses of color is witnessed in the deliberate distortion of facial features and bodily segments of the human figures. His method of distortion is universally accepted as an instinctive response to the emotional states of others.

Shahn's use of space to create psychological effects is evident in *Miners' Wives.* The distance existing between the human figures coincides with the waiting period, the anxiety created by the unknown. There is an urgency, yet in response to previous tragedies, there exists a patient form of resignation to whatever ensues. Meanwhile, the mother and child wait in fear that their lives will be altered by the loss of a loved one.

Working in an entirely different avenue of expression is Dorothea Tanning's Surrealistic version of the mother and child theme called *Maternity* (1947). Portrayed in a state of uncertainty is a beautiful young mother attired in white who stares into infinity while caressing a young child. Both mother and child wear similar white bonnets anchored with similar blue flowers, signifying one flesh. This magnificent female is anchored to a matting spread across a desertlike flooring which extends beyond reality. Dark clouds move across the horizon in billowing tiers.

The Surrealist relies on a dream world of contradictions free of social conventions. Despite differing schools of thought about this style, the Surrealist adapts a natural event to an unreal environment.

Since Surrealism deals with both what is real and that which is not real — known as imagination, fantasy or dreams — the Surrealist is free to engage without limitations in any form of expression essential to a personal need. And being of a deeply personal nature, the Surrealist's symbolism is not always the root of a painting's surreal aspects. For example, other than the obvious symbolism of finiteness and infinity that they carry, open doors may also fulfill compositional needs.

The mother and child theme has been utilized frequently as a segment of a painting, as witnessed in Shahn's *Miners' Wives.*

Abraham Rattner. *Mother and Child* (1938). Oil on canvas, 28¾ × 39⅜ in. Collection, the Museum of Modern Art, New York, given anonymously.

Another approach used by the American artist is the dual theme as seen in Philip Evergood's drawing *Two Mothers,* in which both mothers cradle their children tenderly, forming a circular composition. The closely knit design sharply contrasts with Shahn's spatial composition. An urgency fills *Two Mothers.* The four figures vie for love and affection as if struggling for ownership. Their fidgety, nervous hands, gnarled and elongated, converge to complete a confusing assem-

blage of anatomical parts and are coupled with a quartet of inquisitive eyes. The viewer is tempted to leave the scene.

Evergood's prolific production allowed for expediency which occasionally resulted in lesser efforts which were nonetheless of sufficient stature to survive and warrant study. *Two Mothers* is one of these, a hurried sketch, instinctively expressed and therefore not without a cumbersome aspect of execution. The subject matter warrants further scrutiny and perhaps even a painting, but none exists.

Timely events frequently bring into art subconscious concerns such as the need for racial integration and opportunity. *Two Mothers,* whether it intends to make a racial statement or not, is a portrayal of a racially integrated couple. Racial injustices had occurred long before Evergood painted *Two Mothers,* and instinctively — perhaps deliberately in order to express sympathy with the integration movement — the artist has portrayed a formerly unacceptable union. In doing so Evergood satisfies a dual commitment — to himself and to the black culture. He does more than record tension between the two races: he avoids the tension by treating the problem of race relations by assuming that there is no problem. The union dispels any previous difficulty.

Philip Guston, noted for his psychological studies of the human condition, reveals in the 1930 *Mother and Child* his De Chirico and Picasso influences. Painted at the early age of 17, his *Mother and Child* offers a powerful image of this popular theme. Mother and child are ponderous in stature, shrinking the surrounding buildings in comparison. In spite of her masculine appearance, the mother tastefully caresses the young child after a welcomed bath. There is a stillness which hints at the unreal world, a giant female form looming above the architectural environment. The child, having left the bath, climbs to the mother's bosom.

Buildings display open windows, creating a sense of infinity and a mood of the unknown. Other paintings of the same year display a similar De Chirico influence. The receding and advancing linear directionals also add to the surreal atmosphere. The choice of subject matter to monopolize this eerie background is peculiar. Why a mother and child theme as the positive image? Guston gives no hint. Of course, one may suggest that the theme is ideal in terms of a contrast of circular and angular compositions.

Guston's *Mother and Child* is not the usually adorable and charming couple generally confronting the viewer. The powerful and masterful maternal image is indeed a comfortable and secure haven for an innocent child, but Guston's intent may well be simply to adapt a popular theme to an unreal environment. The psychological significance attached to the mother and child theme, as evidenced by the immensity of the couple, heightens the excitement of a commonplace activity.

Artist Abraham Rattner, whose daily prayers guided his life through periods of frustration and despair and whose works deal with the trials and death of such Biblical greats as Christ, Job, Abraham and Moses, presents to the viewer a delightful switch to the theme of birth in his *Mother and Child.*

Instead of the usually angular, jutting contours and shapes, a 1940 version by Rattner exhibits a frolicking composition of love and affection. A semi-abstract design shows a gleeful mother lying on her back with legs kicking in jubilant fashion while the young child is affectionately bounced from bosom to arms' reach.

Unlike most artists who refuse a technical change to meet particular ideas, Rattner underwent an obvious change. His portrayal is unique, his technique ideal. Had he clung to a consistent style regardless of the idea of a particular painting, this work would have depicted a despairing couple, one perhaps living in fear of tomorrow. Rattner has used the interpenetration theory of overlapping in space. The recessive nature of things is captured by the altering of color tones as form recedes in the background. Foreground and background merge as the mother and child imagery is duplicated as shadows in the distance. The gestures of the mother and child coincide with Rattner's state of mind. One could say his daily prayers were answered, or that this change of pace was essential to his well-being.

The remarkable freedom displayed in *Mother and Child* is so unlike Rattner's usual style that one is tempted to reject the painting as one of his own. It is as if he were released from bondage in order to reveal bits of tenderness that remained hidden beneath tiers of frustration, agony and despair.

Rattner reached for greatness, yearning for great themes to result from the touch of his brush. The daily occurrence of birth, although precious in and of itself because, according to Rattner, it represented a soul into heaven, was a joyous occasion for mother and child and cause for celebration by the artist. Although Rattner's paintings in general demand profound reflection and extensive study, *Mother and Child* is a joy readily accessible to all.

One is reminded of the great French painter Georges Rouault as one participates in the dual communication of Nahum Tschachasov's *Mother and Child*. The drooping head suggestive of sadness is a remnant of the early Christian portrayal of Christ and the Madonna. One wonders how the mother and child theme would have developed if the Christian adaptation had not occurred. It was, of course, a definite influence on those portrayals that followed.

The viewer is forced to participate in Tschachasov's personal interpretation of an age-old theme. The muted background, void of visual interruptions, aids the viewer response by focusing dramatically upon the union of mother and child. The tender moment of embrace is reinforced by the contemplative bow of heads and the closed eyes of the participants. The rugged texture adds another dimension. The textural application of pigment creates a dramatic appearance which is coupled with smooth fleshtones. The facial features of both images are so closely united as to form a singularity, a oneness that sustains an eternal and profound relationship, an inseparable devoutness between mother and child.

The Soyer brothers were famous for figurative painting. Moses Soyer's *Mother and Child,* executed in 1965, appears Expressionistic in style, although the idea is conceived realistically. In other words, the basic recording is objectively natural in its adaptation to the canvas. Brushwork, however, appears rather slushy, as if the drawing were recorded in realistic style with pigment added in a roughshod manner.

Or Soyer may have done the reverse, painting his idea directly upon the canvas as intuitive impulses dictated his every move. There is a Kokoschka nervousness evident in the Soyer brushstrokes. A contemplative mood fills the scene as the mother proffers her breast to nourish her child. This is a personal and lovely event which Soyer conveys to the viewer without

extraneous trappings. The environment is muted so that full response is given to the endearing pair.

Raphael Soyer, the most famous of the Soyer brothers, also portrayed the mother and child relationship. Instead of setting it as the focal point of attraction, he places the couple in a subordinate role in the circumstances of their environment. Although considered a mere segment of the whole, the couple caught in a transportation delay demands first-rate accommodations. The habitat surrounding the mother and child is akin to that in which crowds of several kinds might gather Paintings like Soyer's *R.R. Station Waiting Room* were executed during the Great Depression when mothers and their children endured with forced patience circumstances of unparalleled frustration — bread lines, immigration centers, bus and train depots and flophouses. The mother and child element became a symbol for recording historical events of the Great Depression, droughts, floods and wars.

Bundled in wintry clothes, the child creates an invisible dialog with the dejected woman to the left. Soyer has turned the child's head to beckon the viewer onto the scene. The viewer now joins the would-be passengers as the train arrives outside of the picture plane.

Nude Mother and Child subjectively portrays an intimate relationship between mother and child, or at least it so appears. Soyer's models were not happy people so it was not difficult to portray the imagery Soyer sought. Quiet, pensive, forlorn individuals fill Soyer's canvases. People off the street, so to speak, were welcomed as models for Soyer's paintings. *Nude Mother and Child,* a preparatory sketch, is quickly but assuredly executed and fulfills its purpose. The sketch never was used as the basis for a painting. The child and the

mother share a physical attachment and presumably a maternal bond, and the viewer is left to observe the event without participating in it, much as in *R.R. Station Waiting Room.*

Will Barnet presents an image similar to that of Milton Avery titled *Mother and Child.* He called it a modern version of the theme. In a sense, Barnet's portrayal is a contradiction. Three-dimensional figures are presented as flat surfaces, contrasted with realistic facial features. Barnet believed in individualism which one can see in the way mother and child are isolated on each one's terms rather than united on the way which seems to prevail in other expressions of this theme. Barnet recognized individual differences, an independence on the part of each role-player to survive as isolated aspects of figurative nature, yet be united as a composite form through artistic expression.

The individual personalities are revealed not through juxtaposition of form but rather through facial gestures. The sternness of the mother's countenance is revealed in the contours of her facial features; the child's innocence is reflected in its probing glance and sweetly formed mouth. Both mother and child invite the viewer to participate, to acknowledge the individual need of each for acceptance. But Barnet's characters seem isolated to the point of utter aloneness.

In a compositional sense, the two images seem to float in space even though anchored to a sofa. Evenly distributed textural patterns in a triangular design foster variety in an otherwise flat surface. In spite of deliberate isolationism, the mother and child blend into one, separated only by the smooth fleshtones and detailed facial features. *Mother and Child* is a charming picture, one of constraint and yet daring innovation.

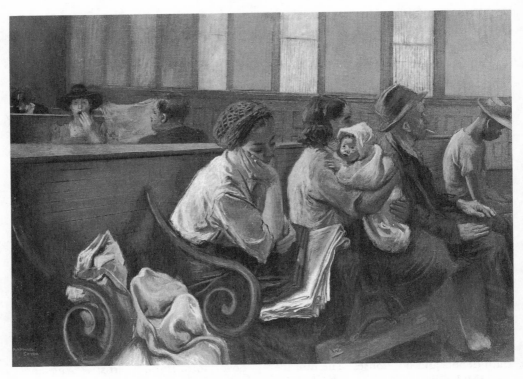

Raphael Soyer. *R.R. Station Waiting Room (Waiting Room)* (1938). Oil on canvas. The Corcoran Gallery of Art. Museum purchase, William A. Clark Fund.

Abstract Expressionism is noted for its instinctive response to an idea, leaving in its wake highly suggestive and often grotesque renditions of the idea. Willem de-Kooning has illustrated perfectly his version of mother and child.

To understand Willem de Kooning's *Woman and Child,* a 1967 painting, one needs to understand the basis and process of Abstract Expressionism. The idea, which is seldom preconceived, emerges from a series of instinctively applied brushstrokes resulting in highly abstract formations. Both mother and child are difficult to distinguish in the chaos of apparent smears and blotches. But the Abstract Expressionist knows what he is about. What appears as reckless abandonment of human faculties is rather a series of thoughts carefully constructed before

the paint is released onto canvas. The movement of paint is thus dictated by artistic impulses dependent upon the movement the artist is compelled to take.

In *Woman and Child,* the woman is located to the left of the canvas and the child to the right. There is no foreground or background but only a single frontal plane. In fact, the roleplayers are hardly discernible. Color and technique blend into unidentifiable images. The entire painting screams with excitement. What appears to be a chaotic distribution of color is rather an ongoing process of creation, expungement and recreation. It is a nonstop excursion into a realm that is unknown in the sense that the ensuing result is seldom predictable. If an idea should exist prior to the execution of such

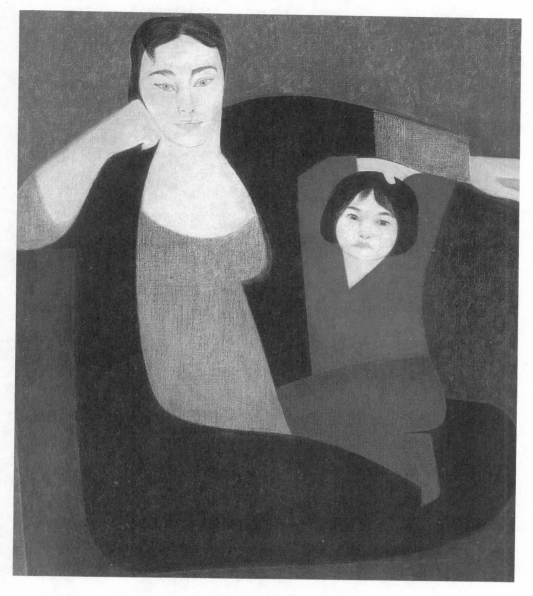

Will Barnet. *Mother and Child* (1961). Oil on canvas. Courtesy of the artist.

a work as *Woman and Child*, it may lose its identity as the painting unfolds. This change is significant because the Abstract Expressionist is free to shift in midstream to directions heretofore unheard of.

Woman and Child lacks—indeed, defies—the beauty of a Degas or Renoir painting on the same theme. Beauty was

not de Kooning's concern. Rather, he dealt with the inner need to develop on the run, so to speak, a totally unified composition of color, shape, line and space—to be in complete control of the creative process in the truest sense of the phrase.

If a predetermined idea was sidelined and a new idea introduced as the painting

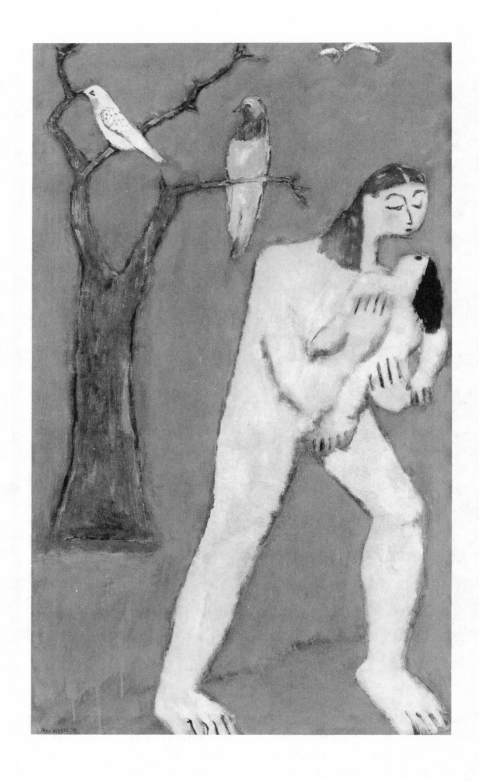

Max Weber. *Fleeing Mother and Child* (1913). Oil on canvas, 35 × 51 in. New Jersey State Museum Collection, Gift of the Friends of the New Jersey State Museum and museum purchase, FA 1974.41.

developed, so be it. Often, such a new idea results in a stronger painting. *Woman and Child,* although disappointing to the traditionalist, introduces a sense of discovery and excitement to the adventurous.

To satisfy the traditionalist, one need only look to the artist Gari Melchers, who established himself as a mainstay of the American art scene in the early 20th century. His painting *Madonna* is a depiction of the Christian birth which utilizes a contemporary environment and enlists the Impressionistic style of color. *Madonna* differs from Melchers's other mother and child themes by the presence of a third party. The figurative triangle overcomes the flowery environment, and the visual dialog activates intimate circumstances within the expression itself. It avoids the commercial poses usually attributed to the academic portrayals of the late 19th and early 20th centuries.

The *Artist's Wife and Child,* executed in 1932, is a typical presentation by Moses Soyer, who relied upon family for stimuli. Like his brothers, Raphael and Isaac, Moses used relatives as subjects because their human qualities were more familiar than those of strangers. Both mother and child display a pensive attitude although posed in commonplace attire and circumstances.

There is a particular excitement in the application of pigment. Coloration is a human quality of which Soyer seems especially aware. His familiarity with street people, the homeless, immigrants and the aged, and the infusion of figures representing such states of the human condition into his subjects, has made Moses Soyer a significant part of the American art scene.

Max Weber's *Fleeing Mother and Child* (1913) is a remarkable portrayal of a reaction to fear not unlike a child's subconscious distortion of bodily features in response to form and degree of pain. However, unlike the child's, Weber's deliberate distortion is created to warn the viewer of an agonizing experience. Several references could be made to religious overtones of Weber's *Fleeing Mother and Child.* The naked tree recalls the Christian image of the Crucifixion. Weber's dramatic portrayal is reminiscent of the Christian flight into Egypt.

Fleeing Mother and Child is realistic in its emotional impact and Surrealistic in its spiritual suggestions. The simplicity of the muted background permits a full appreciation of the theme at hand. In a sense, Weber is devoted to his theme and spurs the viewer to a contemplative effort to receive his message.

Mother and child relationships are generally depicted in joyous surroundings, as by Renoir or Cassatt. Weber, however, has preferred to portray the hardships that mark a life of extreme responsibility. Weber's *Fleeing Mother and Child* is a direct and honest testament to the recognition of motherhood. The spatial atmosphere suggests freedom of movement. Unlike his tightly knit compositions, Weber's mother and child depiction suggests the need for ample space into which one may retreat.

The purpose of Weber's flight remains hidden. All art is speculative, and regardless of apparent intent on the part of the artist, it remains for the viewer to accept or reject. *Fleeing Mother and Child* presents this opportunity.

Bedouin Mother, an early 20th century painting by John Singer Sargent, an American citizen who spent his life in Europe, reveals a definite influence of the early religious paintings of the virgin birth of Christ. The mother and child hover

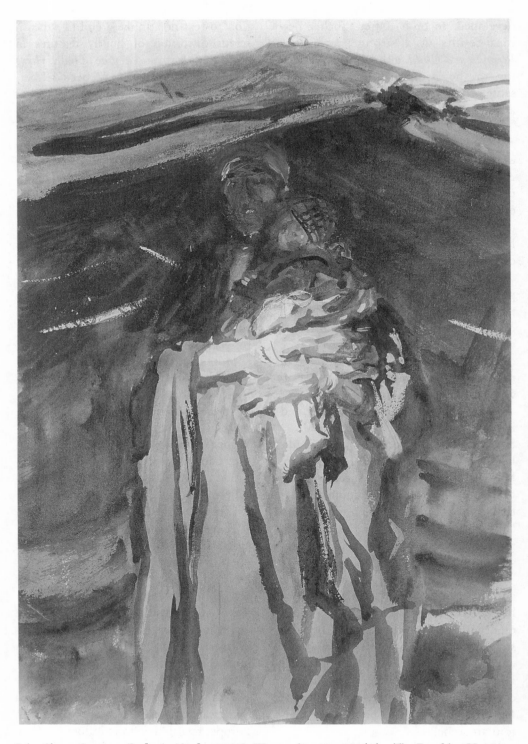

John Singer Sargent. *Bedouin Mother* (1905). Watercolor, 12 × 18 ¹/₁₆ in. The Brooklyn Museum, purchased by special subscription, 09.812.

under the desert tent, with only the Virgin's arms grasping the child's lower body glistening in the bright sunlight. The mother's and child's faces are rendered in shadowy splendor as the mother looks out upon the open spaces.

Rendered in a fluid watercolor technique, Sargent's dramatic imagery reveals the mother strong in physical stature but tender in her cradling of the child. The application of wet and dry brush techniques sustains a dramatic effect. There is an instinctive quality to *Bedouin Mother,* but authoritative brushstrokes identify Sargent's mastery of the medium.

The darkened habitat of the desert tent leaves the figures in a shadowy atmosphere while the mother figure looms large in the foreground. Although the mother figure is not identified, there exists a strong maternal revelation as witnessed in the protective posture and the urgent cradling of the child. Although the word "child" is not part of the title of the work, there is a oneness in the mutual dependence of the two characters.

Bedouin Mother is a small painting, measuring only 17 by 12 inches, but its dramatic appeal is nonetheless effective in evoking a strong maternal instinct and innocent child response. There is an element of timely reporting in *Bedouin Mother,* a need to record an intimate yet historical incident quickly before the imagery vanishes.

Artists have approached the mother and child theme through two significant viewpoints, depicting the pair either as a singular unit expressed with or without circumstantial environments or as a couple subordinate to others in some group activity.

In Maxim Kopf's portrayal, the viewer is shown the circumstances surrounding the mother and child. The poverty-ridden community explains the shredded clothing worn by the subjects. The viewer is confronted with a stalwart mother cradling a small child in her lap.

Surrounding buildings mirror and reinforce the upright posture of the intimate couple, set against a darkened sky. The guiding star barely visible in the distance reminds one of the Christian birth. Kopf's textural application of pigment adds to the dramatic effect of the event. Kopf sustains a balance between the notion of the Christian birth and a contemporary setting.

The painting, *The Star,* was motivated by the artist's return to war-torn Europe. This explains the disorder of things expressed in his painting and the chaotic future that is predicted. Kopf firmly believed that the essential elements of the human condition—birth, life and death—were essential ingredients of the painted expression as well. *The Star* exemplifies this notion with the image of the birth and the environment suggesting both life and the inevitable death.

In John Blowers's painting titled *Hope* (1983) one witnesses the mother and child during a wintry spell huddled about a makeshift fire for warmth. Their poverty is obvious. Shabbily dressed and wrapped in blankets, the two together with the father desperately attempt to survive.

In the distance, the artist paradoxically includes an amply lit home, suggesting a well-heated haven. The nighttime environment casts shadows of doubt and fear as an eeriness envelopes the painting.

The mother and child are a segment of the whole, sharing the spotlight with the father and the home in the distance. Blowers's painting is a depiction of the rural homeless. Aside from its environ-

ment, it coincides in theme and mood to Maxim Kopf's *The Star*.

Another John Blowers painting, *Mother and Child* (1983), includes the father figure in a setting uncommon for this theme. The situation seems hopeless as Blowers portrays a pathetic view of contemporary homelessness. Wintry conditions envelope the scene, and the small fire seems inadequate to ward off the icy atmosphere.

Although the work is objectively calculated and composed, the application of paint is intuitive in creating an eerie mood. Blowers has surrounded the figurative images with snow-covered slopes and planes that claim the family as victims of cruel circumstances. Potential aid is pictured in a distant homestead so that the image of the poverty-stricken couple seems remote in its plea for warmth and shelter.

Blowers has included no snowy slopes to the left of the father figure, thus widening the focus on the motherly image. Facial features are frozen as if fate has already struck the actors in the scene. And yet, in spite of the seemingly hopeless situation, Blowers allows for a slight ray of hope to emerge.

The mother and child theme becomes a springboard for a cause. The fate of homelessness remains a current social tragedy, and Blowers's rendition proclaims a desperate need for economic assistance. Blowers has used a popular theme to fulfill a need other than that of artistic satisfaction. Contemplation of the scene is partially and temporarily sidelined because of the abrupt use of color. Particular areas are treated in an intuitive manner while others demand a more tranquil style. Blowers has focused on the mother and child imagery by dramatizing the areas surrounding it.

Blowers's *Mother and Child* is an example of a preconceived composition with a semi–Expressionistic application of paint. It is a difficult manner of painting because rigid limitations set up beforehand disallow the movement of established objects. This seemingly confused approach is due to a change in temperament after the original theme was composed and recorded. The brisk brushstrokes in the case of Blowers's *Mother and Child* add to the tragic circumstances and moody environment.

Perhaps one should not include Paul Cadmus's riotous *Coney Island* (1935) in the list of mother and child themes. However, this painting, somewhat similar in composition to Mabel Dwight's *Childrens' Clinic,* involves a mother and child relationship subordinate to a group and presented as buffoonishly as the group. One may hate Cadmus's interpretation of fun at the beach, laugh at his gawky characters or recoil at the ugliness of his depiction of humanity, but regardless of one's reaction to his style, one cannot avoid its existence. Within this human wasteland are a mother and child whose intellectual, physical and spiritual future looks as barren as that of their immediate neighbors.

The variety of physical misfits is a delight to behold. Cadmus is a master of the human anatomy, and in *Coney Island* he has pressed imagination to its peak. The mob depicted in this 1935 work is characteristic of the Depression decade, when people had to opt for free entertainment. Other indications of the time period include the opened Cracker Jacks box, the Hitler headline, the style of the swimsuits and the box camera.

The mother and child, discovered in the lower left corner of the painting, both lick lollipops while the father pinches his

John Blowers. *Mother and Child* (1983). Tempera on paper. Courtesy of the artist.

child's naked bottom. The scene may well be real, but one recoils at the sight, not in pity or sympathy but in disgust. Cadmus became famous for the recording of such unusual events.

If the mother and child image were enlarged and isolated from the total scene, its impact would be greater. Placing it in a different environment would create a new meaning and also raise questions as to a suitable environment. The beach is the ideal locale. In fact,

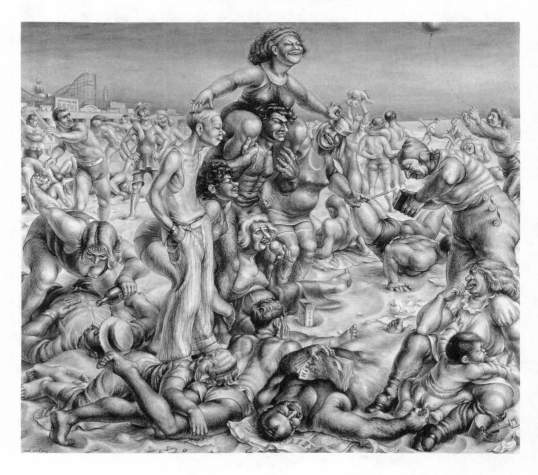

Paul Cadmus. *Coney Island* (1935). Oil on canvas, 36¼ × 32¼ in. Los Angeles County Museum of Art, gift of Peter A. Paanakker.

however, the mother and child image needs no environment. Were it placed against a muted background, its singularity would suggest another, surreal world.

One is reminded of Ivan Albright's beautifully ugly renditions of elderly flesh rippling with bumps and bulges, images of the deterioration of the flesh. In Cadmus's work, one envisions a sordid aspect of life, an existence the viewer would wish to avoid, but which nonetheless is a reality for souls perhaps even unaware of their status in life. There is no question that

were Cadmus's mother and child segment treated as a lone expression isolated from the whole, the theme would raise even more eyebrows than does the painting in its actual form.

Several mother and child dualities occur in artist Honore Sharrer's painting titled, *Workers and Paintings,* but two are distinct in appearance and location. The most obvious is the pregnant mother holding her first-born. Conceived as individuals among a crowd, the mother and child form a universal family of workers. Sharrer's strong and aggressive motivation

to depict individual personalities and simultaneously incorporate them into a panorama of the working class has made him a celebrated member of the American art scene.

His paintings are in a sense a tribute to the worker's never-ending confrontation with hard labor practices. Life is exemplified in the image of the pregnant mother who guarantees another generation of workers. In spite of the artist's devotion to the working class, there exists within the workers themselves a sense of resignation; they are a dissatisfied membership whose patience is sustained by sheer perseverance. The immediate background is a factory building with monotonous window frames darkened by layoffs and inactivity. The stern facial expression of the mother suggests the standard of living experienced by the working class. The preservation of life, regardless of its quality, is maintained unto death, which is suggested by the carefully placed white cross squeezed into the corner cemetery lot. Motherhood, according to Sharrer, is an important function of the proud working assemblage.

The traditional composition is once again witnessed in Ben Benn's painting *Mother and Child*. Painted in 1915, it reveals an Oriental mother holding her child astride an animal. The turn-of-the-century atmosphere is reflected in the stone pavement, the outdoor bannister, the factory-like tenement buildings and the tree seemingly growing out from the concrete pavement.

The pattern of the monotonous window frames is repeated in the attire worn by the mother. Considered by some critics as a folk tale illustration, Benn's *Mother and Child* confronts the viewer head-on. There is an inkling of a primitive style and an Oriental influence which defines the

mother's characteristics. There appears a lack of three-dimensional modeling of facial features. Contour lines identifying physical traits of both mother and child. The painting treats three-dimensional objects by means of linear applications. Although flatly painted, buildings appear in recession thanks to varied tones of a single color. The mother and child greet the viewer on friendly terms. There is no message, no protest, no confrontation, just a friendly call for companionship.

The mother and child theme has proved popular throughout the American art scene, but its greatest significance has been considered in terms of its emotional and spiritual contributions to America. Such scenes as the agony of Ben Shahn's *Miners' Wives,* the satire of Mabel Dwight's *Childrens' Clinic,* or the comedy of Cadmus's *Coney Island* define the role of mother more vividly than the traditional portrayal. Gladys Rockmore Davis's *The Kiss* provides an example of an emotionally charged relationship between mother and child.

Although this theme will remain popular as an artistic stimulus, its integration into the fiber of American tragic painting will depend upon the intensity of the artist's intent.

No discussion on the mother and child would be complete without a reference to the works of Elizabeth Nourse, whose hundreds of drawings and paintings on this theme reflect similarities to the works of Mary Cassatt. The number and variety of her works force this writer to comment on only a few of her intimate portrayals of the mother and child image. Two such paintings are titled *Consolation* and *Meditation.*

In *Consolation,* Nourse reveals an intimate dialog between mother and child. The child is embraced by the mother,

Elizabeth Nourse. *Meditation* (1902). Oil on canvas, 26½ × 27½ in. University of Nebraska–Lincoln, Sheldon Memorial Art Gallery, bequest of Mr. and Mrs. F. M. Hall, 1928.H-59.

whose delicate kiss meets the child's forehead and whose arms assure tenderness and affection in keeping with the painting's title. The dual event is commonplace and is perhaps a daily affair occurring in any household but Nourse's delicate heading of composition makes the painting a compassionate view of a universal image.

Consolation is one of hundreds of var-iations of this theme painted by Elizabeth Nourse. There is a stillness, a dual unspoken dialog between two loves, a spiritual atmosphere unlike that of the early Renaissance period. The circular composition is set against a vertically planned environment. It is muted to allow for full exposure of the mother/child image.

A similar composition titled *Meditation,* however, presents a bit more

Mary Hatch. *Princess* (1989). Oil on canvas, 36 × 40 in. Courtesy of the artist.

freedom; the images of the mother and child are separated so that a greater space exists between the two subjects. Therefore the visual space is activated by the viewer as anticipation becomes more intense. The tender moment between mother and child can never be duplicated.

Even though the mother/child theme is a daily and universal occurrence readily identified with by the viewer, it is the ar- tistic touch that springs the image out of reality, so to speak, and into a magical world. Even though the physical exper- ience itself is precious, the artist has been granted the power to add a bit of spiri- tuality. The title suggests a religious at- tachment between mother and child and thus enhances the tenderness that pre- vails.

A similar appeal occurs in the work of

Mary Hatch. *Good Little Girls* (1988). Oil on canvas, 17 × 23 in. Courtesy of the artist.

Isabel Bishop's painting *Waiting*. This 1938 depiction records a mother waiting for an unknown companion or vehicle. Bishop has muted the background with a compositional blend to strengthen the mother/child image. The child, a young boy, lies asleep, drooped over the lap of the waiting mother. The viewer is treated to a commonplace incident which occurs in waiting stations of hospitals, depots and hotel lobbies. The complete exhaustion of the child spells relief for the mother, whose patience has worn thin in her anxious waiting.

The environment in which the child/ mother image is established is blurred, while detailed and definitive features are recorded in the faces of the two roleplayers. Hands and feet are also featured in Bishop's circular composition. Statuesque in figurative form, the mother maintains a proud countenance in spite of the circumstances.

The mother and child theme has generally been regarded as an intimate nonverbal dialog between the two roleplayers. Bishop's portrayal is no exception.

Artist Mary Hatch introduces two examples of the mother and child theme. Her painting titled *Princess* invokes a surreal image in the person of mother. Aside from its odd trance-like portrayal of the mother and the torturous chair awaiting

the presence of someone, the intricate pattern of darks and lights created by a sunlit sky performs a unique compositional task. The stillness is eerie, and the unpredictability of the scene creates a mysterious anticipation of the unknown.

Equally poetic, but a bit more accessible, is Hatch's *Good Little Girls,* a painting readily related to personal childhood memories. One is drawn to the unusual composition, which deliberately severs the mother's head from the composition. One can only anticipate the mother's facial expression as she clutches her breast in horror at the antics of the child. Executed in a simple vertical panel, the painting focuses upon the facial expression of the child and the anxious gesture of the mother's hands.

The strength of Eve Whitaker's *Guatemala: Woman and Child* (1988; see color insert, A) lies in her deliberate distortion of the figures. The element of pain is usually associated with the exaggeration of physical features. Whitaker purposely symbolizes the pain of childbirth and the ensuing development of the mother's offspring. It is not unlike Picasso's early works with distorted figures enlarged beyond reality to convey a psychological point.

Another notable work on this theme was executed by Todd Zimmerman and titled *Mother and Child.*

Bibliography

Baur, J. H. *Revolution and Tradition in Modern American Art.* Cambridge: Harvard University Press, 1951.

Brown, Milton. *American Painting: From the Armory Show to the Depression.* Princeton, N.J.: Princeton University Press, 1955.

Cheney, Sheldon. *The Story of Modern Art.* New York: Viking, 1941.

Eliot, Alexander. *Three Hundred Years of American Painting.* New York: Time, 1957.

Flexner, J. T. *A Short History of American Painting.* Boston: Houghton-Mifflin, 1950.

Goodwich, Lloyd. *American Watercolor and Winslow Homer.* Minneapolis: Walker Art Center, 1945.

Henkes, Robert. *Eight American Women Painters.* New York: Gordon Press, 1977.

Hunter, Sam. *Modern American Painting and Sculpture.* New York: Dell, 1959.

Janis, Sidney. *Abstract & Surrealist Art in America.* New York: Reynal & Hitchcock, 1944.

Koots, S. M. *New Frontiers in American Painting.* New York: Hastings House, 1943.

Larkin, O. W. *Art and Life in America.* New York: Holt, Rinehart & Winston, 1949.

Leepa, Allen. *Abraham Rattner.* New York: Abrams & Sons, 1963.

Medford, R. C. *American Painting.* Philadelphia: F. C. Davis Company, 1941.

Mellquist, J. *The Emergence of an American Art.* New York: Charles Scribner's Sons, 1942.

Pearson, Ralph. *Experiencing American Pictures.* New York: Harper & Row, 1943.

Pousette-Dart, Nathaniel. *American Painting Today.* New York: Hastings House, 1956.

Ritchie, A. C. *Abstract Painting and Sculpture in America.* New York: The Museum of Modern Art, 1951.

Schinneller, James. *Art/Search & Self-Discovery.* Scranton, Pa.: International Textbook Company, 1965.

Wight, F. S. *Milestones of American Painting in Our Century.* Boston: Chanticleer Press, Inc., 1949.

Zigrosser, Carl. *The Artist in America.* New York: Alfred Knopf, 1942.

MODES OF
TRANSPORTATION

The theme of modes of transportation is often an integral segment of an artist's output. It is not the vehicle itself but the passengers within the vehicle that excite the artist and subsequently the viewer. The artist who focuses upon the inhabitants rather than the habitat creates life itself rather than the environment in which the occupants reside. A prime example is Gregorio Prestopino's painting titled *Trolley Car*. Aside from its unusual composition and the essential environment, the distorted images of the passengers, who are victims compartmentalized into indiviudal slots of life, are committed to secrecy and isolation. Prestopino's deliberately segregated trolley car patrons are nonetheless tenants of the same residence, so to speak, and yet, governed by the conductor of the transportation unit, and find it impossible to alter their individual situations.

Prestopino's juxtaposition of window frames, each of which encloses a particular lifestyle, adds to the deliberate distortion of life which incidentally defines

reality more than the undisturbed existence of life. Prestopino places the lives of ten individuals under the control of a single being charged with transporting them to unknown destinations. It is the unknown ingredient which lies hidden in the hearts of the riders with which the artist intrigues the viewer.

The unknown quality is also seen in Colleen Browning's painting titled *The OkMeWeTeam Car* (1967). The unusual title seems at odds with the presence of the mysterious inmates in the train car. The menacing messages adorning the outside of the car act as a barricade to a diminishing freedom. The unhappy passengers on the train gaze into an unknown future. Life seems as an endless nightmare which is intensified by the limited space within which to function. The compositional treatment of the environment divides the canvas into dissimilar rectangles. The three upper compartments housing the occupants of the mysterious train are filled with icy stares.

There are no divisions of race, creed,

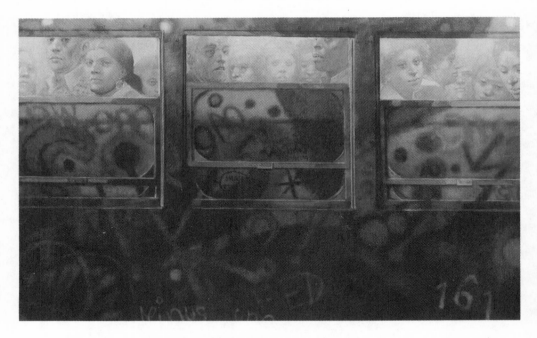

Colleen Browning. *The OkMeWeTeam Car* (1967). **Oil on canvas. Courtesy of the artist.**

nationality or age. The human race is being transported to destinations unknown. The inhabitants of a world of greed, hostility and violence seem resigned to a future of futility.

The personality of the artist is seldom communicated on canvas. Personal insights remain the artist's property. Yet the need to record and express are essential for survival. Browning's passengers have ceased to exist in spirit. They have been trapped, either by their own doing or by the flow of society's ills. Spirituality has been drained from their bodies, leaving a mere shell of existence. Hope has long passed; there remains only a resignation to whatever the future has in store. And yet the ride continues.

Unlike the apprehension, anxiety and despair registered on Browning's faces and the inevitable futility of existence, a different approach characterizes a treatment by Raphael Soyer. One of several depictions of riding the El, Soyer's *Pas-sengers* draws the viewer into the car's compartment. Soyer's occupants seem resigned to society's injustices. The mother and child, rigidly posed, reflect the tone of daily activity, an essential ride to nowhere. The mother's stare into space reflects a resignation to an uneventful future. Her folded hands resting upon the daily newspaper and the child's forlorn look dispel any thoughts of contentment. The older woman seated to their left presents a look of indifference and boredom.

Soyer has allowed space to ease the agony of monotony. Space tends to mellow the situation and individualize the circumstances surrounding the riders' dilemma. The entire painting is muted. The rectangular shapes dominating the background contrast to the circular bodily movements of the occupants, and to a degree subdue the atmosphere of the El tour.

Another view of El transportation is

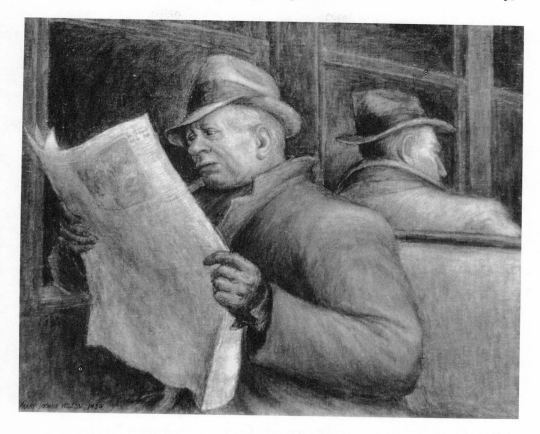

Mary Loomis Wilson. *Men on the Subway* (1936). Oil on canvas. Courtesy of D. Wigmore Fine Art, Inc., New York, N.Y.

seen in *Men on the Subway* by Mary Loomis Wilson. One can only speculate as to the cause of the apprehension, disgust or fear registered on the face of the principal subject. His steely eyes glued upon an item in the local newspaper hold the viewer in speculation. Since the painting is dated 1936, one might assume that the rider is seeking employment. His hands tightly gripping the newspaper suggest tension not easily diminished.

The second figure, a back view, acts as a deterrant to full appreciation of the major figure or as a pivoting device to redirect the viewer to the original focal point.

The *Trolley Crowd* by Albert Gold differs considerably from Prestopino's similarly titled *Trolley Car*. Instead of locking his passengers into place, Gold jams his riders into standing positions. Social contacts are deliberate as a complex overlapping of figures dominates the canvas. The background is muted except for hints of the environment. The riders represent a single family, yet each is individually personified.

Compared to the Prestopino group, Gold's trolley crowd is a happy lot. *Trolley Crowd* was painted during good times preceding the war effort. Gold's presentation is a typical rendition of a trolley car of the year 1940. Gold's figures are a bit illustrative but nonetheless fitting for the occasion.

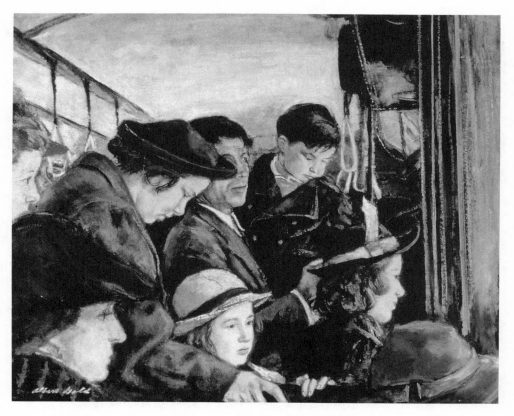

Albert Gold. *Trolley Crowd* **(1940). Oil on canvas. Courtesy of D. Wigmore Fine Art, Inc., New York, N.Y.**

Another important transportation mode was the automobile, popularly known as the horseless carriage. The painting of 1907 by John Sloan titled *Brass* displays a wealthy automobile owner driven by chauffeur. Sloan reveals the elegance of this miraculous vehicle in its brass headlights, bumpers and fenders.

Hidden in shadow, the onlookers are awestruck at the sight of this phenomenal machine. Sloan has more than recorded the event; he makes a social statement about the smug and snooty riders who haughtily ignore the downtrodden and the unfortunate. Yet Sloan is excited about his city, its lights, the hustle and bustle of its citizens.

Compositionally, Sloan positions his focal point to permit the discreet presence of the underdogs, the onlookers. Visual movement to the left is offset by a space allowed between the vehicle's front end and the edge of the canvas. This space acts as a rest stop for the viewer to acknowledge the other aspect of the painting, the subordinate element which is essential to the storyline. Without the envious onlookers, Sloan's painting would be a mere recording of an event instead of the additional political statement.

The period of the Great Depression seemed to beckon artists to respond to stimuli related to travel. In metropolitan cities, it was the El, or more accurately its transient riders, that attracted the artist.

This attraction is evident in Reginald Marsh's diverse use of the human form in *Subway Station.* His rendering of architectural settings groups his figures into several distinct compositions within the whole. Simple gestures such as purse fiddling, newspaper reading, parcel toting and mirror gazing abound. Each figure suggests a personal tale. Facial expressions relate personal drama and determined responses to their destinies.

Closely related to *Subway Station* is Marsh's painting titled *Why Not Use the "L"?* Provocative and profound, Marsh's work blends objective essentials with symbolism to advance a sympathetic and heart rending display of compassion. In this similarly architecturally staged scene, Marsh fits into three cubicles (similar to the more obvious shelters found in George Tooker's *The Subway*) three humans distraught and individually dismayed. Except for the difference in spatial conceptualization, it parallels the loneliness attributed to Edward Hopper. While Hopper's loneliness is derived from the lack of objects within space, Marsh's concept of loneliness is manifested in the postures and facial expressions of the figures.

In *Third Avenue El,* riders seem preoccupied, unaware of their environment and concerned only with future destinations. Eyes stare into space as if frightened by uncertainty, though perhaps not as surely as in George Tooker's *The Subway.*

Without obvious segregation, Marsh isolates his victims of society with partial architectural divisions of space as a compositional need, but more important, he differentiates among personal psychological references. With the characters removed from his subway scenes, one witnesses an exquisite example of interior design. Marsh's positioning of figures into the set

design determines the degree of unity. Although his works maintain visual unity, mental and spiritual isolation continues to exist. Humans remain uncommunicative, antisocial. Marsh seems to switch from the fun-loving, frolicking spirit of the crowds of his beaches and amusement parks to the desperation of the souls on the subway. His alternation of crowd scenes and images of individual crisis seems a necessity, as if the artist's moods dictated his themes.

Similar actions occur in *Bus Passengers,* a moving painting by Raphael Soyer. The bus riders are absorbed with their own thoughts as their gazes focus on emptiness. Soyer disrupts this mood with a face peering out the bus window. The passengers are boxed into partial cubicles, hands folded, resigned to waiting for the next stop—where nothing of value will occur. Even the windows offer no psychological escape. The surroundings of the slums permeate the riders' lives.

George Tooker's *The Subway,* mentioned above, surveys the icy stares and hapless bodies of caged-in city dwellers. Tooker implies the impossibility of the urban resident's surviving in a real sense. Cubicles dominate Tooker's work, forming a monotony of escape-proof enclosures. He is masterful in curtailing hope for his creatures. The bare structure lined with heavy concrete blocks and iron gates and staircases psychologically oppresses the men and women, making their every turn a dead end. Those who continue to move about the subway complex will find nowhere to go. The stairs lead up and down, but this imprisoning continues in the same pattern. Human faces shriek despair as their bodies seemingly crawl between the lowered ceiling and the rising floor.

The artist's eerie effects impose on this

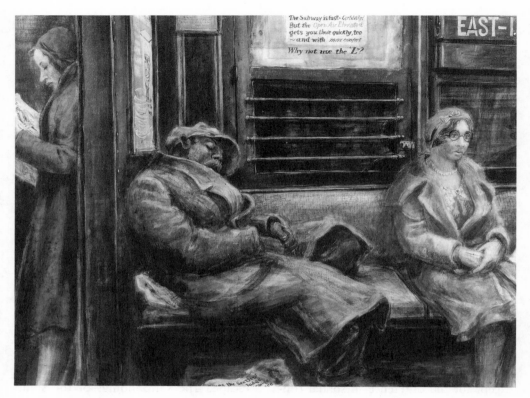

Reginald Marsh. *Why Not Use the "L"?* **(1930). Egg tempera on canvas, 48 × 36 in. Collection of the Whitney Museum of American Art. Purchase. 31.293.**

everyday scene an unnatural quality like a nightmarish form of Surrealism. It differs considerably from Bishop's *Subway,* which reflects the constant movement of people, and from Sloan's merry painting.

Elaborate in composition, *The Subway* portrays a calculated confusion, a sterile entrance to nowhere. Unlike the usual big city subway with its grafitti, litter and bustling movement, Tooker's scene is articulated precisely and functions at a snail's pace. Awesome terror fills the subjects' faces. Each passenger, fearful of the others, seems prepared to elude the others' presence, but there is no escape. Each resides within an individual environment. Tooker purposely avoids a social drama or mass culture commentary by

portraying distinctly individual personalities. Furthermore, he avoids psychological penetration in order to intensify the isolation by its silence and to universalize the drama.

Artists have considered modes of transportation from both the inside and the outside environments. Prestopino, for example, considers both environments in his painting *Trolley Car.* The viewer contends with the outer environment, from which the passengers are excluded, and primary attention is devoted to the vehicle of transportation rather than to the occupants.

Several artists, including Reginald Marsh, have painted the glamor of ship arrivals and train stops. Marsh's *The Queen Elizabeth Sails,* executed in 1948,

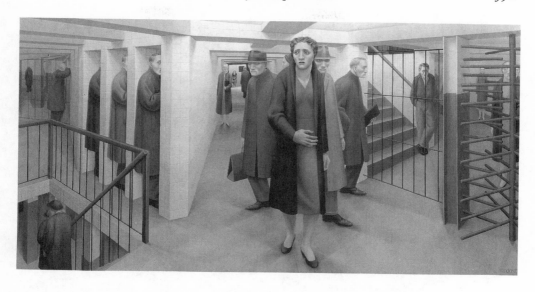

George Tooker. *The Subway* (1950). Egg tempera on composition board, 36⅛ × 18⅛ in. Collection of the Whitney Museum of American Art. Purchase, with funds from the Juliana Force Purchase Award. 50.23.

displays a horizontal tier of composition. The viewer joins the spectators in witnessing the luxurious liner being escorted out to sea. Spectators line the pier as the massive vessel sets sail. Marsh has squeezed the mammoth boat onto a small working surface. The *Queen Elizabeth* is the celebrity, and it is the miraculous feat of naval engineering that is being admired. The tugboats lined up like toys alongside the gigantic ship illustrate the gala occasion.

Eleven years earlier, in 1937, Marsh captured on canvas the power and the energy of the steamship *Normandie* in a painting called *Tugs Warping the Normandie into the Docks,* or simply *The Normandie.* In this work, too, Marsh focuses upon the comparison of the lowly tugboats guiding the huge ship into port, again excluding the human element. Perhaps the avoidance of the human portrayals acted as an artistic reprieve, a rest from the artist's obsession with the flesh that he encountered in the flophouses, burlesque joints, bars and beaches he frequented. The *Normandie* painting is a powerful work incorporating the majestic with the lowly.

There is a great pride in the face of the *Normandie*. The clouds of smoke billowing from its stacks join the disruptive yet cooperative waves of emotion in the waters surrounding the massive tourist ship. The horizontal structure of the ship is countered with the vertical smokestacks of both the *Normandie* and its accompanying guide boats.

These two paintings of the *Queen Elizabeth* and the *Normandie* became segments of a mural for the rotunda of the Custom House in New York City.

Marsh was also noted for his paintings of locomotives. He attempted to include the human element in these works, not within the inner environment but rather outside the subject itself. In *Locomotive — Jersey City* (1934), Marsh developed a powerful horizontal plane with the attachment of two locomotives on a stretch

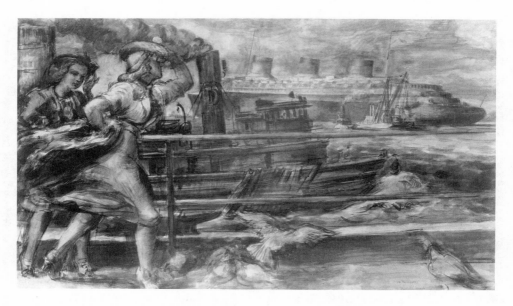

Reginald Marsh. *The Normandie (Tugs Warping the Normandie into the Docks)* (1937). Water-color on paper, 50 × 30 in. Courtesy of the Butler Institute of American Art, Youngstown, Ohio.

of rail broken vertically by poles, water towers and smokestacks. The row of steaming engines seem ready to compete in a furious race to the finish. The engineers in each locomotive, a locomotive attendant and a stranger leaving the scene in the lower left of the painting are the only humans Marsh includes in this work.

Because of the strict objectivity and diminutive size of the human figures, one is forced to observe their presence and, in so doing, recognize their significance. The emotional tension, however, rather than emanating from bodily gestures and facial expressions, grows out of the energy and pride of the locomotive.

Painted in a style similar to that of Milton Avery is Lyonel Feininger's *Locomotive with the Big Wheel*. Utilizing the baseline theory, the old-fashioned steam engine rides atop a rectangular shape defined as grassland. The engineer located in the outer area of the image stands proudly in black tophat between the engine and the coal car.

Although three-dimensional in structure, the locomotive and its companions are flatly painted like a paper cutout. There is an equal distribution of linear and spatial elements forming a visual unity. Colors are soft and feminine. Nothing about Feininger's work is fierce or overpowering. Rather, *Locomotive with the Big Wheel* is a childlike image of fantasy, a nearly surreal portrayal of a popular mode of transportation.

In another Feininger locomotive painting, *Small Blue Locomotive*, the human element is enlarged and distorted as if in competition with the scale of the locomotive. Texture is added to an essentially flat pattern of geometric shapes. Linear images succumb to solid shapes of surreal color. A blue engine puffing orange smoke and hoisted on red wheels strongly suggests that the color choice is unrelated to the images portrayed.

There is a slight hint of Impressionism, a cautious employment of textural design. Although similar in composition

and color scheme to Avery's whimsical palette, Feininger's images overlap in space rather than float in infinity. The baseline is again significant to the visual world Feininger has portrayed but the hints of other schools of thought elude definitive identification of a particular style. Feininger's locomotive is decorative rather than the emotional outlet for reporting and recording an emotional event that one finds in the works of Marsh and Soyer. Color as a visual perspective is ignored in favor of the overlapping of planes as they recede and advance in space.

One of Feininger's more intriguing works, *Velocipedists,* portrays bicycling in a highly decorative fashion. Feininger eliminates the baseline in favor of the frontal plane, and instead of the Cubist influence which dominates Feininger's earlier work, flat planes of color in contrast to the linear decoration of the spoked wheels dominate the theme. Again, Feininger's extreme bodily distortions and exaggerated wheeled images place his paintings within the realm of the surreal.

The elongated figures are remnants of the Cubist influence. In addition, one is reminded of the Toulouse-Lautrec posters of the Moulin Rouge theme. The floating images of a Chagall are also reflected in *Velocipedists.* The small heads attached to enlarged bodies are reminiscent of the childlike images in reverse. However, carefully delineated facial features, although difficult to notice, manage to operate within the outlines of the shrunken heads. Feininger's painting suggests a pleasurable means of transportation akin to a Sunday afternoon diversion.

Tragedies occur among travelers. Plane crashes, train wrecks and auto accidents are daily occurrences. The artist's concern for passengers motivates Philip Evergood's painting titled *Railroad Bridge Collapse.* Evergood has recorded the cause of the train tragedy and the effects of the accident upon its victims.

He incorporates several compositions within the whole. Eye glances and bodily movements have created visual dialogs which individually represent personal experiences but, when accompanied with figurative overlapping, create a total union.

The train acts as a springboard for the recording of different emotional states and as an environment for the release of emotions. Seldom is it the mode of transportation itself that produces the results depicted by the artist; if, for example, the emotional states of despair and frustration are to be expressed in a painting, the artist may choose to position the victims of these emotional states in an environment that is not necessarily the cause for such conditions.

Several American artists have used steamships and ferry boats in paintings. Even though a cruise is a recreational tour rather than an essential element of one's daily transportation needs, artists have often recorded and exploited the event. It was fashionable in the late 19th century to engage in leisurely cultural cruises to the Mediterranean. A century later, the Caribbean became the favorite spot for pleasure cruises. It is not, however, the theme of 20th century painters.

Julius Stewart portrays the leisurely pace of people on a cruise in his painting titled *On the Yacht* Namouna, *Venice* (1890). It is not a natural scene; that is, the painting appears contrived to suit compositional needs. It is an event of relaxation, but the viewer may consider it one of boredom. It was customary at the time of this work's execution to highlight the rich and to exploit their personalities.

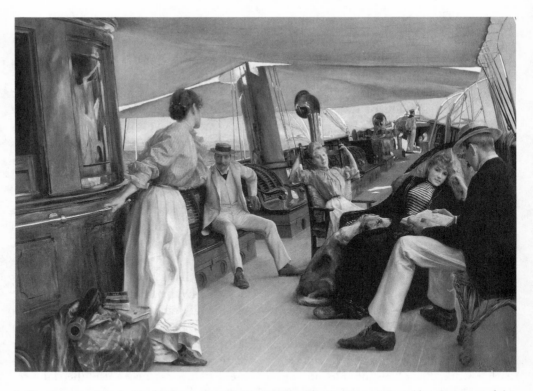

Julius Stewart. *On the Yacht* Namouna, *Venice* (1890). Oil on canvas, 77 × 56 in. Courtesy of the Wadsworth Atheneum, Hartford. The Ella Gallup Sumner and Mary Catlin Sumner Collection.

The painting features a traditionally academic portrayal. Its highly detailed composition involves a pleasing visual perspective. The recessive angle of the boat allows the viewer to enjoy the subdued atmosphere of the cruise. The passengers seemed resigned to nothingness, a sort of limbo in which all earthly problems are forgotten. A complete abandon, a total loss of responsibility or an escape from reality appears to occupy their minds. There is a delicate handling of figures as they recede gracefully along the contours of the sailing ship. Elegant attire is an essential element of Stewart's theme. The woman in the foreground clings to a brass rail as she glances toward a male companion who also grasps tightly a safety catch.

Almost identical in appearance, but with a different motivation, is Henry Bacon's painting *First Sight of Land*, in which European immigrants sight America for the first time. Dated 1877, thirteen years earlier than Stewart's cruise, it exhibits a close-up view of a single passenger who looks out to sea.

Bacon intercepts the gaze of his major figure by inserting near the ocean rail a couple who also look for a distant shore. As his major image Bacon focuses on a statuesque, elegantly dressed woman who has interrupted her leisurely reading in answer to the call of land.

Charles Burchfield's painting titled *Safety Valve*, executed in 1921, reveals a steam engine resting alongside a row of tenement buildings. Steam pours from the stack and spreads heavenward. The artist's fluid watercolor style casts a gloomy

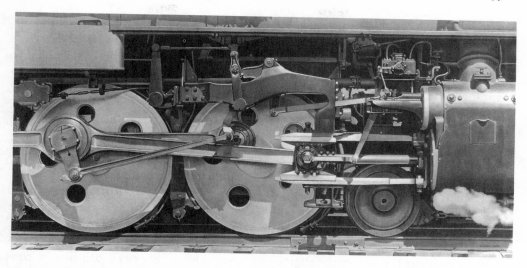

Charles Sheeler. *Rolling Power* (1939). Oil on canvas, 30 × 15 in. Courtesy of the Smith College Museum of Art. Purchase, Drayton Hillyer Fund.

gloomy mist over the environment. A quiet scene indeed, with overtones of mystery.

There exists in the painting a surreal sense of emptiness, yet a fullness ready to pounce upon the unfortunate one who might interrupt the quietude.

Burchfield evokes a sense of magic with a childlike yet sophisticated application of color and a deliberately whimsical approach.

Safety Valve instills an eerie sense of belonging, a yen for freedom, yet a need for security. It is a painting focusing not so much on a pleasurable excursion, but rather on a source of hardship for those who must toil to meet the demands of the day. The scene is one of sunlit airiness interrupted by clouds of steam and smoke.

As a mode of transportation, the steam engine has served as stimulus for the American artist for decades. Marsh, Benton, Soyer and Curry are among a few who have captured the power and speed of the locomotive and its effects upon its passengers.

Other artists such as Charles Sheeler

have chosen to exploit the theme in a pure semi-abstract form. Sheeler's work is immaculately honed in an ultra-pure style. For example, *Rolling Power,* a painting executed in 1939, shows a mighty locomotive brought to a standstill. A photorealistic vision of the Depression era, *Rolling Power* depicts a machine that propels a multitude of passengers to thousands of destinations. The human condition remains absent from the painting. Sheeler's purity of form and surface sterility could be considered the forerunner of the Photorealist movement, yet the intricate steel structure is reminiscent of the cool calculation of a Flemish painter. The closeness of its view makes reality appear abstract, yet the painting's factual rendition is more true to its visionary form than to the object itself.

In portraying another mode of transportation, namely the airplane, Sheeler suggested potential energy in quiet fashion. The painting *Yankee Clipper,* executed in the same year as *Rolling Power,* invites the viewer to explore its hidden mysteries. The facts of the painting be-

come apparent through intellectual study. A visual recording is more than a proportionately correct expression.

One considers the stillness that fills the painting. The plane's propeller remains mysteriously quiet, its three blades splitting the canvas into segments which constitute the composition. A cleanliness similar to that of the locomotive surface dominates the outward sheen, avoiding all elements of energetic toil. The vast sky area which amplifies the stillness introduces an eeriness suggestive of the unreal.

One anticipates the start of the engine, the swing of the propeller and the lift upward. The geometric shapes, were they not attached together to form an object of mechanical wizardry, would perform in an abstract fashion. The initial focal point, the point of visual departure and simultaneously the cause of liftoff is the propeller gear which resides in the circular fuselage. As its blades pierce and divide the peaceful sky they unify the composition. One wonders who resides inside this immaculate creature of the skies. Two windows are visible, but no passengers are in view, suggesting a stationary position before takeoff or after landing.

In another of Sheeler's works, gigantic sails stretch upward in a slanting, swooping movement to dominate the entire canvas. Again, Sheeler ignores the human element. Although boats and sails indicate strong forward movements, there is a notable lack of human operators. Triangular shapes curve, overlap and interpenetrate in a slashing interplay of geometric shapes. Lacking the cleanliness of *Yankee Clipper* and *Rolling Power,* the painting is titled *Yachts and Yachting* and was executed in 1922. By this time Sheeler had already hinted at the polish and shine method that would promote the sterilization of the painted imagery. This painting differs considerably from Sheeler's later works, whose subjects are stilled in anchored positions; *Yachts and Yachting* movement becomes the essential element of the image.

It also differs considerably from Edward Hopper's depiction of a pleasurable sailing cruise titled *The Lee Shore,* which incorporates a human pilot. There is a definite swiftness that defines the activity, whether by serving as a communicative link to a destination or by satisfying a human desire. Other differences relate to composition. Sheeler's painting is controlled by the swirling sails of the yacht which leave little room for an airy atmosphere while Hopper's boats move freely in the middle tier of three horizontal planes: land, sea and sky.

Three boats sail the ocean at varying distances from the viewer's location. The three horizontal planes are joined into a single unit by the spiralling masts of the three boats. Appropriate textures characterize the three distinct tiers. Sunlight engulfs the landscape as highlights converge upon the masculine sails. Even the shimmering heavens echo the radiant atmosphere.

A second painting by Hopper titled *The Martha McKean of Wellfleet* shows a vacationing couple nearing an isle of seagulls. The birds seem unimpressed with the strangers' invasion, in keeping with Hopper's typical imagery. Peace, resignation, indifference, quietude, loneliness and calmness describe the Hopper experience. Whether one should classify Hopper's cruises as paintings of transportation is questionable, but one must remember that transportation is simply the act of moving through a distance to reach a destination, whether for pleasure or for business.

Charles Sheeler. *Yankee Clipper* (1939). Oil on canvas, 28 × 24 in. Courtesy of the Museum of Art, Rhode Island School of Design, Jesse Metcalf and Mary B. Jackson Funds. 41.006.

In *The Lee Shore* Hopper arranges his three boats in a triangular pattern, thus creating a three-dimensional spatial effect. In *The Martha McKean of Wellfleet,* however, eyes move to the left. The boat, its sails and its passengers face the left. Even the twelve seagulls stand in rigid order, facing the left as if pledging allegiance to something outside the picture plane.

Although modes of transportation are invented to satisfy society's need to convey people to distant destinations, a Hopper painting accomplishes the same effect by assumption. Hopper's famous painting *Dawn in Pennsylvania* abolishes all humans, not by destruction but by avoidance. An empty, desolate train depot exists as dawn attempts to sustain the loneliness created by the night before. Hopper was a master, and in *Dawn at Pennsylvania* he was able to transport the human element to its appropriate destination without any evidence of the human presence.

In his painting titled *Compartment C, Car 283,* Hopper does provide the viewer with the human presence, again disposing of all extraneous subjects in order to express the loneliness of a single passenger. The interior scene, which is a trademark of Hopper's imagery, is a masterpiece of quietude well suited to the unspeaking and unveiled soul residing in the lone car of *Compartment C, Car 283.* Hopper escorts the viewer inside to an intimate view of an unassuming individual who seemingly prefers to remain aloof.

In spite of the dominance of the occupant of the enclosed rectangular environment, color and the lack of objective details become as isolated as the primary subject itself. Is the essential stimulus the solitary female form or the emptiness which prevails and which identifies the message? Were the human element removed, there would remain the ghostly vision of the occupant. The viewer senses the human presence whether it is visible or not. Even if it were not so, Hopper's insertion of such individuals seldom alters the loneliness that becomes the message of his work.

Vertical and horizontal planes alike contribute to the development of the painting's lonesome world. One is intimately involved with the train's passenger because her subjectivity is current and because the viewer has no objective imagery to share with the rider.

An earlier painting, one of Hopper's 1908 series, relies upon the mode of transportation for stimuli in depicting a train from the exterior. Viewing *Railroad Train* one again must wonder about the train's occupants, whose destinations remain unknown and personalities hidden to the viewer.

Hopper sustains activity within the non-objective horizontal planes of the painting, which are disturbed only by varying textural coloring. Hopper succeeds where others would fail in treating vast monotonous expanses.

Several etchings by Hopper illustrate other early approaches to the transportation theme. Such etchings as *Night on the El Train* and *The Locomotive* include the human figure but not in Hopper's usual isolationist manner.

Edward Hopper's fame stemmed from his paintings of vast desolate landscapes, empty rooms, isolated lighthouses, hotels and motels occupied by single personalities and locomotives of the past. He became the master of isolation and loneliness. Yet in a captivating portrayal of seagoing enthusiasts, *Ground Swell* (1939), Hopper portrays a motionless sailboat occupied by five sailing fans in a sea of roving waves. A potentially dramatic event is stilled by the quiet touch of Hopper's brush. The sunlit sky, appropriately vested with lightly moving clouds, matches the delightfully rolling waves. And the positioning of the stalled sailboat allows for the vast expense of the sea to display the immensity and the solitude of the scene.

There exists in *Ground Swell* a sense of the eternal. The unbroken horizon is not unlike the Surrealist's handling of the infinite. Recession of sea and sky are visually realistic, though Hopper has applied the theory of optical illusion. From a literal viewpoint, the action remains stagnant. There exists, as in most of Hopper's portrayals, a sense of the present, no anticipation of the future and no recollection of the past.

Ground Swell is a delightfully quiet, pleasant work to witness. It reinforces Hopper's zest for the lonely, contemplative life which the majority of his characters relish, and it reflects the spirit of religious thought. The extensive, uninterrupted ocean and sky are typical of Hopper's textural treatment of vast, seemingly empty areas.

Hopper was a master composer. *Ground Swell,* with its unusual positioning of the sailboat and its occupants to the far right of the composition, would normally suffer problems of balance, but Hopper's sophisticated use of color and his knowledge of textural surfaces create a visual unity.

Even the speed of a locomotive did not

Edward Hopper. *Ground Swell* (1939). Oil on canvas. In the collection of the Corcoran Gallery of Art. Museum purchase, William A. Clark Fund.

excite Edward Hopper, as revealed in his painting titled *Locomotive, D & RG (Santa Fe, New Mexico)*. The locomotive is quiet, still and stagnant. In spite of its immobility, Hopper enables it to reflect the memories of past events. Rail transportation was popular during the forties, and the artist's brisk technique suggests the preservation of the locomotive's memorable journeys. Strongly sunlit skies produce sharp highlights and shadows reflected on the locomotive's engine.

The painting is evenly divided into foreground and background, and the locomotive forms a third plane which is anchored onto the lower segment of the composition and extends into the upper section.

Hopper's obsession with emptiness is evident in the sky, which is blank except for billowy clouds, and in the foreground, which is treated with clumps of color. Even though all areas appear calculated and executed by plan, the painting is intuitively pierced with strokes of color. But perhaps the most notable feature is the stillness, the serenity, the romantic nostalgia that Hopper has attached to the locomotive.

Hopper's watercolor technique is less sophisticated than that used for his landscapes and seascapes. *Locomotive, D & RG*, is roughly textured, ancient in its appearance and unlike the shimmering steel of Sheeler's sterile portrayals. Nonetheless, *Locomotive, D & RG* defines the ever-present quietude of a Hopper masterpiece. Although accomplished at painting watercolors, Hopper frequently considered them preparatory works for his more

permanent oils, which may explain the seemingly unfinished character of *Locomotive, D & RG.*

Another of Hopper's train paintings is *Chair Car* (1965). Aside from the normal architectural composition, this work introduces a human visual dialog and in so doing creates a rectangular pattern of hidden secrets and mysterious personalities.

Hopper's circular human forms create both an unspoken dialog and a mysterious relationship to the unadorned environment, serving variously to offset, enhance or contrast the rectangular door and windows. The viewer is invited into the scene by the visual perspective of the chair car. The seated passengers are conveniently swirled into appropriate attitudes.

Chair Car reflects a typical train car of 1965, a comfortable, relaxing conveyance created for peace and quietude. Hopper in his trademark style avoids the confusion of a crowded passenger car, but there are nonetheless mysterious glances, destinies to follow and unpredictable personalities. The four occupants, whose destinations remain unknown, show indications of uncertainty as each reflects the need to communicate, yet communication remains anticipated rather than actual.

A flood of sunlight forming rectangular highlights leads the viewer directly to a closed door, a blank wall which automatically directs the viewer back to a female form in the foreground which becomes a natural focal point to which other elements are subordinate. No matter at what length and in what depth one studies *Chair Car,* one is left in puzzlement. The painting presents an inside look at passengers whose lives remain secret. The mode of transportation still functions as an essential link connecting its passengers to career, pleasure and life.

Reginald Marsh painted several images of transportation, and in those that include the human element one is treated to provocative circumstances and situations, with the transportational environment serving as a background for serious contemplation. When the human presence becomes subordinate to the whole, however, one is forced to marvel at the vehicle itself. In the case of *Lehigh Valley Locomotive,* a tall telephone pole splits the canvas into two equal parts. The unusual composition is puzzling because it merely slows down the viewing process. At best, it records the scene and relates little to the esthetic experience. One may identify with the activity of the locomotive engineer, but any artistic influence is forfeited. Perhaps Marsh intended the scene itself as an introduction to a broader experience since the locomotive image had become a favorite means of expression for him. One can only speculate at the human emotions contained within the locomotive itself.

One will find only pleasure in Childe Hassam's watercolor rendition titled *On the Boat Deck,* an 1885 version of the exotic cruise. More popular today because of a lower relative cost, the cruise was once available only to the rich. *On the Boat Deck* illustrates the awesome design of vast cruise ship. The viewer observes the magnificent view from directly on deck.

Hassam's fluid movement of color reveals an openness which suggests a calm and relaxing atmosphere. The few passengers, although of little compositional significance, add the human element. The viewer does become a passenger, however, thanks to Hassam's architectural arrangement. The boat's deck lies open as an invitation to participate, and is rendered

Top: Edward Hopper. *Locomotive, D & RG (Santa Fe, New Mexico)* (1925). Watercolor on paper, 19⅝ × 13½ in. Courtesy of the Metropolitan Museum of Art, Hugo Kastor Fund, 57.76. All rights reserved. *Bottom:* Mary Hatch. *A Silent Journey* (1988). Oil on canvas, 22 × 24 in. Courtesy of the artist.

with a fluidity unlike the style of Hassam's Impressionistic oils. The ship's vastness and spaciousness are reflected in the comparative size of the human figures.

A major contrast with the ship's elegance is the clouds of smoke, which evaporate in the ocean air but continue to challenge the vertical ship's decks and cabins. A secondary contrast is the technical difference in the treatments of the solidly built ship's deck and the billowy smoke clouds spewing from the ship's stacks.

The mode of transportation becomes a young girl's pastime in Robert Vickrey's painting titled *Landing Circle*. Although eluding the tag of Photorealism, *Landing Circle*'s textural surfaces contrast with the several lightweight toy airplanes that dot the landing surface.

Vickrey establishes a direct line of activated space between the landing circle and the source of the takeoff, namely the young blonde girl. Even though Vickrey includes her in the painting, the human form participates outside the vehicle of transportation. In fact, the human element becomes the focal point along with the landing circle.

There can be no separation of the two elements since within the painted expression one relies upon the other for its existence. Remove the image of the girl and the motivation for the activity is lost. Remove the landing circle and the purpose of the activity is lost. The toy airplanes outside the landing circle become excess baggage, demanding no consideration except as points of subordinate attention.

Vickrey uses the theme of the transportation image for the satisfaction and fulfillment of childhood dreams. His paintings utilize the boat, bicycle, roller skate, skateboard, automobile and airplane as subject matter. An essential mode of transportation under the imaginative guidance of a visionary artist becomes a magical game of "landing in the circle." *Landing Circle* is a charming rendition of a commonplace subject matter.

Even though the automobile is the most popular mode of transportation, it can still produce an air of mystery. In Mary Hatch's *A Silent Journey,* the viewer witnesses a moment of hesitation or inquiry as each figure stares into space. There is a sense of resignation. Hatch's work always creates a sense of uncertainty, a concern for the future and a definite concern for her characters. Even the half-pictured animal perched atop the automobile creates a mystery.

Hatch establishes frameworks into which the human form is positioned. Geometric shapes do not compete with the human realism of the two occupants. The open vehicle presents an invitation to inquire about the circumstances that surround the mysterious couple.

An earlier form of conveyance is the subject of John Marchand's 1906 painting *Stagecoach,* which depicts a scene in mountainous Western terrain where a stagecoach is being led by a mounted guard with rifle. The viewer is drawn into the painting as the rifleman heads directly toward the viewer. The stagecoach, meanwhile, is positioned on a dangerously mountainous ridge in the distance.

The stagecoach itself is downplayed, and no passengers are visible. Only the driver and those riding shotgun are pictured. In this respect the painting differs from the works already discussed in which the riders become the focal point. Marchand's paint application is as rugged as the scene itself.

Other noteworthy transportation paintings include Todd Zimmerman's treatment of the theme.

Most of the paintings discussed in this chapter deal not so much with the vehicles they depict as with the effects of those vehicles upon the human condition and the environment.

As years passed, certain modes of transportation became obsolete, and no longer essential means of travel but pleasurable diversions. Artists, in turn, explored the contemporary machines used for tourism and daily commutes from home to work. Buses and trains traveled the land, planes soared overhead, fewer boats crossed the oceans and automobiles jammed the roadways.

Regardless of current modes of transportation, the artist concentrated on those activities which involved the human personality. Artists of the city painted the El, the subway, the trolley car or bus—all of which are still popular aspects of the artist's imagery because they apply to individuals of differing circumstances and emotional states. The congested morning rush or a group of late night revelers, opposite in their compositional challenges, attest to the artist's interpretation. There is seldom a need to apologize for the artist's choice of subject.

Bibliography

Albers, Josef. *Interaction of Color.* New Haven, Conn.: Yale University Press, 1975.

Arthur, John. *Realism-Photorealism.* Tulsa: Philbrook Art Center, 1980.

Barker, Virgil. *From Realism to Reality in Recent American Painting.* Lincoln: University of Nebraska Press, 1959.

Bevlin, Marjorie. *Design Through Discovery.* New York: Holt, Rinehart & Winston, 1984.

Canaday, John. *What Is Art: An Introduction to Painting, Sculpture and Architecture.* New York: Knopf, 1980.

Chase, Linda. *Photorealism.* New York: Eminent Publications, 1975.

Ellinger, R. *Color, Structure and Design.* New York: Van Nostrand Reinhold, 1980.

Feldman, Edmund. *Varieties of Visual Experience.* Englewood Cliffs, N.J.: Prentice-Hall, 1981.

Fleming, William. *Arts and Ideas.* New York: Holt, Rinehart & Winston, 1980.

Goldstein, Nathan. *Painting: Visual and Technical Fundamentals.* Englewood Cliffs, N.J.: Prentice-Hall, 1979.

Hartt, Frederick. *Art: A History of Painting, Sculpture and Architecture.* Englewood Cliffs, N.J.: Prentice-Hall, 1976.

Honour, Hugh and John Fleming. *The Visual Arts: A History.* Englewood Cliffs, N.J.: Prentice-Hall, 1983.

Janson, H. W. *History of Art.* New York: Harry N. Abrams, 1977.

Johnson, Ellen. *American Artists on Art.* New York: Harper & Row, 1983.

Jones, Lois. *Research Methods and Resources: A Guide to Finding Art Information.* Dubuque, Iowa: Kendall/Hunt, 1983.

Lucie-Smith, Edward. *Cultural Calendar of the 20th Century.* New York: Phaidon, 1979.

Piper, David. *Random House Library of Painting and Sculpture.* New York: Random House, 1981.

Rich, Daniel Cotton. *The New American Realism.* Worcester: Worcester Art Museum, 1963.

Richardson, John, Floyd Coleman and Michael Smith. *Basic Design: Systems, Elements, Applications.* Englewood Cliffs, N.J.: Prentice-Hall, 1984.

Sandler, Irving. *The Triumph of American Painting: A History of Abstract Expressionism.* New York: Harper & Row, 1970.

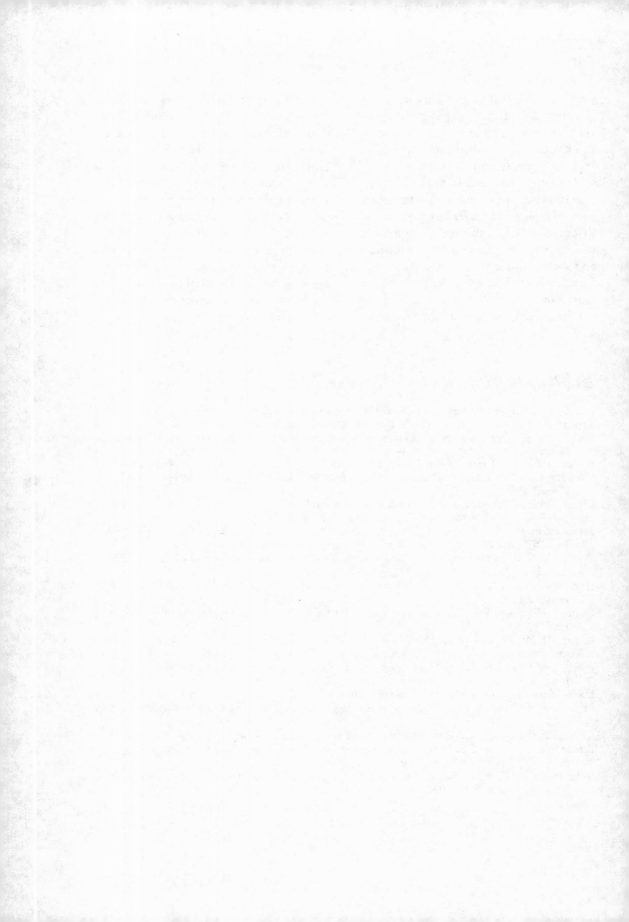

THE CLOWN

The clown, an image of artistic endeavor almost forgotten today, was the core of entertainment in the Middle Ages. Aside from the clown's incorporation into circus acts, its usage seems restricted to the arena of religious debate. The clown has filled a continuously changing role in society, seeming to defy life itself. It has triumphed over life, perhaps due to the dual role of the clown as Christ and Christ as clown. Christ and the clown have much in common. The quality of having been abused by fate can be witnessed in the torn shreds of Christ's clothing as well as in the tattered dress of the modern circus clown. Christ has further been made clownish by the unholy behavior of some of those who claim to adore Him. Such a mockery is also seen by audiences in performances conducted in view of an onstage clown.

The clown is a controversial entity who represents numerous things in life, in many ways resembling the individual as acutely as society at large. He is diversely viewed as an object of affection, ridicule, distaste, sorrow, pity and laughter. He is an actor whose performances sway an audience from trust to mistrust, from sorrow to laughter, from pride to humility. He apes our very notions of life, our failures, our successes, our tragedies and even our deaths. The clown is all that is in his audience. But to what degree and in what manner is he a person? Does the person die after the makeup is applied, or does his life only begin? Who is more real, the clown or the person hiding beneath the symbolic extension of life?

Even though the American clown developed from the early Greek, Roman, French and English traditions, its usage today is newly created. Types of clowns exhibited during medieval times reflected different moods and spiritual misgivings, as do their modern counterparts. The world is full of clowns, but the real clown is an artist giving symbolic meaning to human behavior in relation to rational norms. The audience identifies with the clown's antics, but more important, it identifies with behavior that the audience seems not to recognize as characteristic of itself. The clown's ability to appeal to a subconscious sixth sense in the members of his audience signifies artistic success for

the clown. The question as to the extent and nature of the artist's individual personality demands an answer. The clown performs in a manner which the audience refuses to accept as part of its own behavior, preferring to reject the unpleasant truth. Is the clown a riddle? An audience responds with laughter, but the clown is more than a laugh instigator. He is sophistication. A clown is a clown until a breakthrough occurs beyond the superficial gimmickry needed to perform his act; now the clown is an artist who stimulates the intellect.

The fact of the matter is that superficiality belongs to the essence of the clown, but is not the whole of the essence. Laughter often reveals surprising depths of awareness and emotion. The clown's deep knowledge of human behavior is as much a part of his art as are his superficiality and triviality.

Clowns present variations of a single form. One recognizes a clown instinctively regardless of appearance, dress and actions. Even if he does absolutely nothing, he commands attention.

Over the centuries and into 20th century America, the clown has commanded an enduring importance. The spectator assumes a role well in advance of the performance. Even the uninitiated will respond — if not sincerely, then superficially — because such reaction is expected. The sophisticated clown is seldom surrounded by a vast audience, just as many an artist is appreciated by a few rather than by a multitude of fans. It is this transcendence beyond the merely human that makes the clown or the artist great. A multitude of fans grows as the sophistication of the art develops.

The clown and his audience belong to each other and absorb each another. The relationship is strangely short-lived, yet this ephemeral quality reappears and the mutuality continues. The clown, an essential part of the normal world that he mocks as if from outside, is still foreign enough to disappear and be forgotten — but not for long, for when he returns the mutuality returns, and the bond that earlier existed becomes almost indissoluble in spite of the ridiculous appearance of the clown. What appears to be a casual and superficial translation of intellect and emotion is in reality a recurrence of mutual understanding between an artist and his audience. Brief performances lead to permanence, for during the disappearing phases of activity (that is, the moments that the clown disappears from stage) mental images linger until the clown returns once again. The clown has an uncanny talent for transmitting the future in ridiculous fashion, establishing over a series of performances a bond that touches the minds of a sophisticated audience with a superb emotional depth.

The clown's threats to his viewers relate little to the purpose of his acts, but they reinforce the mutuality of the relationship between the clown and the audience. The audience generally approaches the clown as a symbol of relaxation or a means of finding personal satisfaction through entertainment without the effort of mutual participation. If one analyzes the clown in terms of the meaning or interpretation of the act with all of its diverse ramifications; the clown's physical gestures, facial makeup and unusual dress; and the effects of the performance on its viewers, one has adopted an academic approach that seems at odds with the way the audience perceives the clown. If, however, this interpretive approach is used to clarify and deepen the artistic act of the clown, then the method coincides with that of the clown.

As one studies the formal and academic relations among the distinctively different clown types among various cultures, one notes images and fantasies that would otherwise go unnoticed. Following the recognition of types is their interpretation. A single performance by a single type emerges only as a description, and the audience experiences a minute aspect of the extreme diversity of the clown's art, an art which embraces folly, laughter, tragedy, joy, frustration and sorrow. Identification with a single emotion touches only a single aspect of the audience's lives. The truest understanding and appreciation recognizes the clowning experience as a means of expression that broadens the scope of human behavior.

Even though the clown aspires to the role of artist in his performance, the artist utilizes the clown image as a symbol to deepen, clarify, spiritualize, emotionalize and intellectualize the human position in the universe. The artist's use of the clown ranges from the purely academic statement to the description of life through the eyes, mind and heart of the clown and to the spiritualization of life itself. The painted portraits of famous clowns are artistic interpretations of these clowns as artists—a difficult accomplishment indeed. Perhaps only an artist can understand the artist. Some of the most moving expressions of life are those which uncover the scars of tragedies and remove the masks of deceit, for once they are removed, human frailties become a part of the audience.

The clown and artist have identical roles. Entertainment is essentially ephemeral, but without it the audience would excuse itself from the scene, and the clown's opportunity to record historical and cultural events in an interpretative art form would never materialize.

Aside from the interpretation of clown types, the artist's symbolic approach may involve social commentary. The clown image evokes the totality of life from birth to death and eventual resurrection. This life cycle coincides with the audience's so that the audience's experiences are those of the clown. The clown is an elusive identity that cannot be defined. He is an abstract being. Only his performance can be indentified, and even it verges on the abstract because of the wide ranging individual interpretations.

In the art of painting, the clown is portrayed as a sympathetic being grotesquely masked, as a greedy, befogged fool lusting for wealth that he is unable to attain, as a symbol of man's dual personality as perceived by himself and by an antipathetic audience, or even as a Christlike figure. The clown has become, and perhaps will always remain, an integral part of the social scene. And it is not unlikely that the clown's image will forever threaten the artist's complacency. It will be a challenge to future generations to accept or reject the clown as a source of inspiration or contentment.

Artist Aaron Bohrod, who became famous in the 1930s with his much publicized satirical painting titled *Chicago Landscape* developed a unique style characterized by exquisite detail. Provoked by social ills and unjust causes, Bohrod's social commentaries remain constant in a world of artistic change. A scrupulous observer and masterful recorder of life, Bohrod rendered splendid criticisms of the annoying and unjust behavior of the social elite. Astute in his selections Bohrod portrayed the clown with extremely sensitivity to problems relating to the dual role of comedy and tragedy. Often his expressions delve deeply into the surreal, but more significantly he

buffoons audience participation with intense awareness of the clown's performance and characteristics. His ability to bring forth that which is hidden or unknown suggests an eternal order in which the clown finds himself. Photographic in appearance, Bohrod's sensitive paintings invigorate reality with bits of tenderness and agony so as to make his clowns seem the most humble of all creatures.

Bohrod revels in the minute and inconspicuous ingredients which evoke the most primitive sensations of human emotion. His painting *Dozen Clowns* reflects a surreal connection to the outside world. Rather than use physical forms to express the standard human appearances, the artist exploits the characteristics of the masks which when applied to the human form communicate the personality of each of the dozen clowns.

In a painting titled *Wall Nuts,* Bohrod engages in his own act of clowning, not only in the title but in the reinforcement of walnuts shaping the composition into one of buffoonery. The placement and textured detail of the walnuts exhibit the artist's delicate technique. The clowns, integrated into the scheme of the painting, suggest Bohrod's distinctive concern for the clown's welfare. Bohrod eliminates all seriousness from the clown's expression, focusing solely on the fool aspect. Reactions of the audience — in this case, the single viewer — cease at a given point of the clown's performance. Bohrod seems unable to discard the comical completely even in his most serious works, perhaps because comedy is the trademark of the clowning act and thus demands prominent position on the agenda.

His rather consistent use of the skull reflects the medieval disregard for the clown's life, the belief that a fool is less than human and thus unworthy of life itself. The symbolic skull further emphasizes the birth/death duet, the idea that what is real is truly unreal and vice versa. Bohrod's Surrealistic bent adds interest to the visual impact of his work, which is not grotesque or ugly as is typical of artists utilizing the skull theme. Indeed his paintings are exquisitely beautiful — not in the purpose they serve but in the content itself.

Bohrod's earliest clown works reveal a style similar to his famous Chicago painting. He paints life as is, yet those unacquainted with his work feel that factual distortion identifies his expression. His painting *Little Circus,* typical of his early work, suggests the clown as a part of a whole. Objectively portrayed, the painting elicits the viewer's concern with all its elements. The clown, important as he may be, must share the spotlight, though his positioning elevates his significance above that of the other figures. Bohrod's objective style gives way to subjectivity, merging his subjects into a single unit.

His ability to combine elements into a mainstream is never more evident than in his painting *Great and Small Comics.* Even the title classifies greatness and mediocrity in various artists' attempts to answer their calling. *Great and Small Comics* is a historical panorama of clown personalities dating from the Middle Ages to the current comic strip *Peanuts.* Moreover, in spite of its detailed objectivity, the painting comes off as a personal subjective statement unrealized by any of Bohrod's predecessors. Each portrait in the painting receives complete concentration and a serious tone that isolates as well as integrates. Isolation of the greats such as Kelly, Jacobs and Savo occupies major portions of the canvas, while Skelton, Marx, W. C. Fields, Chaplin and others con-

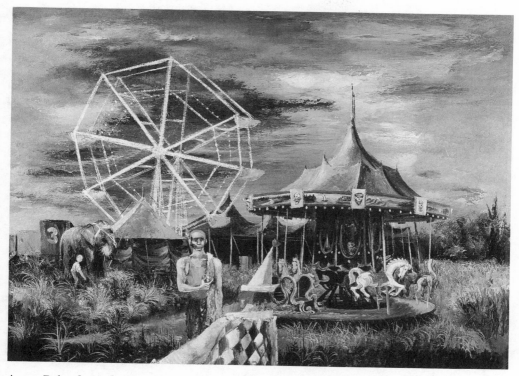

Aaron Bohrod. *Little Circus* (ca. 1946). Oil on gesso panel, 32 × 24 in. Courtesy of the artist.

sidered lesser clowns, or perhaps not clowns at all, are given a small degree of recognition. Not only are the portrayals exact representations of their subjects, but characteristics of each comic are apparent.

In the painting *Triad,* Bohrod incorporates once again the opposing passions of comedy and tragedy, and again the symbolic masks act as substitutes for the real emotions. The inclusion of a child clown illustrates the artist's concern for the everlasting life cycle branding the clown a permanent phenomenon.

Symbolically aging the circus by using weatherbeaten barnwood as a backdrop for his painting *Prologue,* Bohrod infuses symbols of the coming circus. The clown's face, tattered into bits of gaiety, carries nostalgia and a slightly pestilent fly perched on the nose of the entertainer.

Satire interwoven with symbolic commentary illustrates the artist's compositional strengthens, which are bolstered by juxtaposition and interpenetration of physical objects. The wagon wheel, symbolic of the circus train, doubles as a roulette wheel anchoring the number 3, which in turn signifies the date of the performance. Bohrod's composition reveals an inner order which goes unnoticed except under careful study.

A similar panoramic montage delights the eye in *Circus.* A master of minute but complete compositions of the most simple forms, Bohrod set his symbolic images roaming about the canvas restlessly in anticipation of the coming event. A carefully striped peanut bag exquisitely contoured in varying angular shapes lets loose a barrage of freshly roasted peanuts which rain over images of prancing horses and the

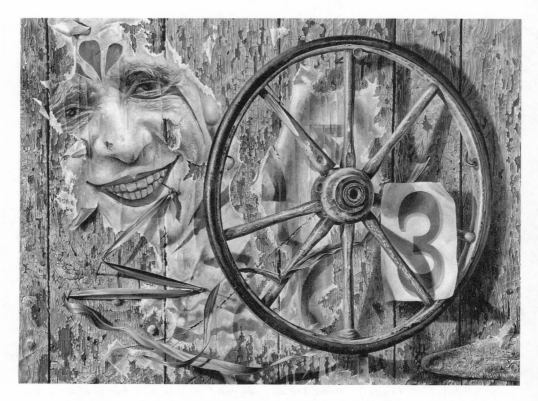

Aaron Bohrod. *Prologue* (1960). Oil on gesso panel, 24 × 18 in. Courtesy of the artist.

inevitable clown. Kernels of corn, fully popped, grace the canvas in appropriate spots to delight the onlooker. Bohrod's attention to suggesting causes of actions is relentless.

Bohrod's preoccupation with the life/ death theme is especially apparent in one series of paintings. *Laugh, Clown* reveals a grotesque mask fitted to a decayed skull, suggesting the "show must go on" theory. The fictive viewer responds only to the humorous element of a clown's performance. The title of the painting relates the theme and fully illustrates the mockery of a clown's singleminded pursuit of laughter. Even the mask is nearing death.

Bohrod frequently includes self-portraits as persons witnessing the ongoing events. In *Yorick,* Bohrod becomes integrated as

an aging clown overseeing his own masterpiece. He describes himself as a crotchety old man who enjoys the employment of symbols known only to himself. Does self-involvement suggest personal clownlike attributes? Is the artist associated with the fool as Rattner proposes in his religiously oriented works, or as Romano has stipulated in that even the greatest beings are made fools of. Romano remains outside his paintings, but Bohrod delights in including himself, thus eliciting responses from an even greater audience. Bohrod seemingly acts the role not only by identifying himself as a clown within his own work but by commanding an audience with his presence just as a clown would do onstage or in the center ring. Bohrod performs in a limited way, opening wide the gate to various interpretations. The

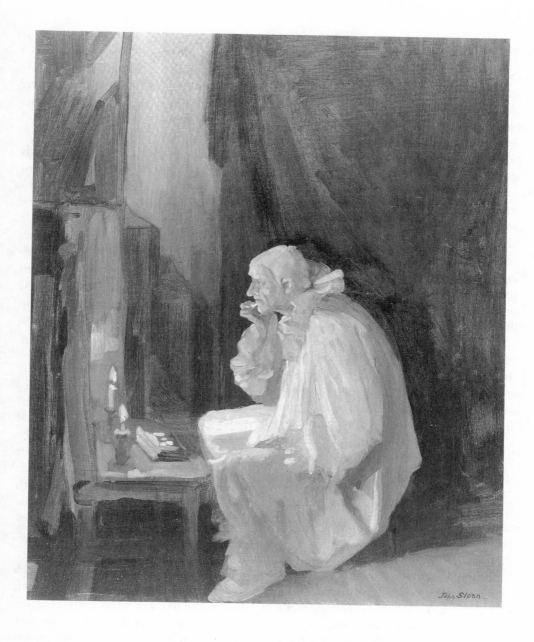

John Sloan. *Clown Making Up* (1909). Oil on canvas, 32 × 36 in. Courtesy of the Phillips Collection, Washington, D.C.

viewer of Bohrod's performance is an outsider looking in, so to speak, while the viewer of the physical act of clowning is already in.

Aside from his own "performance" Bohrod delights in developing everything in sight in his paintings. His own signature bears a preoccupation never displayed by other renowned artists. If not directly hinged to an idea on the canvas, his signature at least projects a composition of abstract angular shapes which ultimately settle into a name.

In *Clown Quartette,* Bohrod exercises

the entire repertoire of age-old Surrealism. The quartet of doll-like creatures come from the Middle Ages. As if a symbolic burst of ancient rituals would draw the artist away from the contemporary, he amusingly attaches a bent spike to the old barnwood beam.

Bohrod titles another work *Laugh* to reflect the painting's content and incorporates a feather as a tickling device. In his game playing, Bohrod loves to test his wit. His love for life and joy in painting coupled with his profound insights and unique sensitivity, make his world of clowns an extraordinary experience for those who witness his work.

There is not much one can do to alter the condition of the circus clown without changing his ideology. The circus atmosphere must always be a part of his expression, and artistic realization either embraces or rejects the substance which makes for realistic portrayals. The artist manipulates the objective and subjective approaches to his theme, balancing both throughout the creative process. Veering acutely from one or the other indicates a personal insight, or lack of it, into artistic purposes.

James Bama's clown is a direct statement about humanity in the form of a person in clown makeup. Bama's self-portraiture lacks an artistic commitment generally associated with depictions of emotional reactions. John Sloan's *Clown Making Up,* on the other hand, deals with an emotional reaction to conditions prevailing before a performance. Like the clown, the painter fuses intellect with an emotional charge to create art.

The paintings *Little Circus* by Aaron Bohrod and *Circus Clowns* by Edmund Brucker present a study of compositional contrasts. Both identify with the clowns as focal points, but Bohrod's clown image directs his audience from the clown to surrounding activities, while Brucker steers his audience from the outlying segments of the canvas to the clown image front and center.

The clown in each painting commands immediate attention, but for different reasons. Because the clown in each painting shares the viewer's attention with other elements of the painting, it forms a unit worthy of a subjective response. Even upon sustained study, each painting adheres to the subjective content manifested in the atmospheric elements of the work. The seeming contradictions contained in these works are the trademark of artists whose personal insights into the theme being expressed avoid the strictly objective and the highly personal form of the abstract. The apparent struggle for definition coincides with a similar tug-of-war within the emotional and intellectual makeup of the clown. This is why the clown and artist are so unique in their relationship. Objectively, both must communicate with the audience, yet both are subjectively tied to the personal style as well as the personal insights necessary for the production of any artistic performance.

Lily Harmon, in her painting *Clown and Monkey,* fuses the clown image with that of the monkey, thus furthering the medieval ridicule of the clown. One now questions the focal point of entertainment. Is it the clown or the monkey who provokes laughter—or is it that the teaming of the two lowers the clown's humanity to that of a monkey? The sorrow in the clown's expression is mirrored in the monkey's face, posing a unique portrait of teamwork. The fusion of objects is enhanced through suggestive application of paint and contour lines in rendering those elements significant to the idea.

Young Clown, a painting by Richard Wagner, shows a clown performer checking his makeup in a mirror. The scene's subjectivity is somewhat diminished by brushstrokes that cause the eye to react emotionally. A conflict of movement and stability exists which enables the viewer to experience a duality typical of the clown's image of sorrow and laughter. Movement seems to stem from the need to be active after an arduous feat of concentration. Wagner expresses activity within a non-mobile subject. Blurry paint application extends the effects of emotion. Even the background area sustains this excitement through manipulation of brushwork. The clown of the circus is nearly ready to perform.

Thickly applied pigment forms the inner structure of Oscar Van Young's painting titled *Harlequin & Columbine.* Unlike Wagner, Van Young demonstrates the clown's struggle to survive. His technique of idea-background consumption obliterates daily concerns. Idea and environment become one. Line accents sustain the clown figures to prevent their complete disappearance. Basic clown trademarks are partially erased to emphasize the subjective response of the artist to his idea of the clown's temperament as he sits in contemplation of his difficult performance. One wonders whether the performance is over or not yet begun. The sparseness of surface occupation and the seemingly facile paint application seem to render a simple statement, yet that very simplicity beckons one to further study as intellectual response follows the initial emotional impact.

Artist John Tayral's *Nocturnal Conversation Piece* illustrates a similarly somber exchange of thought. The viewer is drawn quietly to clown figures at the left of the painting. Compositionally, Tayral's work abounds with excitement, yet its numerous objects are quieted by the illusion of emptiness. The circus is silent. Reflections of peace reign as the two clowns communicate in silence.

Edmund Brucker's *Circus Clowns* is contrary to Tayral's piece both in its compositional objectivity and in its theme. Brucker prefers to exhibit the joviality of the circus performers. Smiles encircle the canvas and objects are placed precisely in overlapping positions.

Margo Hoff's painting *Clown* takes an unusual approach to a theme. The insignificant area of space devoted to the central figure becomes the most important element of the painting. The vast area of darkness surrounding the light spot appropriately positioned illustrates the unusual subjectivity of Hoff's portrayal.

According to Hoff, "the original title was *Entrance of the Clown* and represents a view looking into the arena of the Medrano Circus in Paris. The clown was a dot of color at the bottom of the painting, not really a clown. Because of catalogue space, the title was shortened to *Clown.*"

The placement of the dot of color becomes a symbol of success or failure, Hoff's spotting of the clown creates a subjective mood in spite of the obvious objectivity of the unseen audience. The distance between the clown and the viewer would normally introduce several objective interruptions were the clown not surrounded by darkness.

Hoff's long-range view of the clown is artistically designed. A view from Hoff's angle of vision would disappoint any enthusiastic circus fan. What should be an intimate communication between clown and spectator is obviously impossible at such a distance. But Hoff eliminates the spread by making one segment dependent on the other. The clown and his

Margo Hoff. *The Clown* (1956). Oil on canvas, 30 × 40 in. Collection of the Whitney Museum of American Art. Gift of Mr. and Mrs. Allan D. Emil. 56.24.

surroundings are a single unit. Not only is an intimate relationship established, but the viewer is enabled to enjoy not the clown's performance as an art form but rather the artist's approach to a popular theme.

Clown is a daringly exciting approach to a popular theme. It may be considered an example of several schools of thought. Because of its unusual viewpoint, speculation suggests the abstract, the surreal and the real. Frequently the real appears abstract due to the angle from which the subject is viewed, a definite possibility in Margo Hoff's *Clown*.

Artist Jack Wolsky's use of the clown in *Holocaust* shows a definite link to the atrocities of the Holocaust. The short, stubby clown positioned amid sprawling archaic structures invites an audience to participate in the celebration, a celebration of victory over evil. Hitler is transformed from the monarch of Nazi Germany to the clown of the century.

Wolsky initiated a series of panels depicting Adolf Hitler in the image of the clown. The clown becomes the victor. The gestures of the German Gestapo and the Nazi faithful are ridiculed and abused, and it is the clown and the accompanying antics that Wolsky uses to build a montage of events.

Weird creatures creep and fly about what appears to be an Egyptian environment as the clown becomes the spokesman of the world. A huge gargoyle occupies the right of the montage while the costumed clown makes gestures of invitation. Textural surfaces line the palacial background. In spite of isolated bits of differing habitats, a unified composition is the result of Wolsky's manipulation.

In the final analysis it seems that Hitler becomes the clown — not the joyous, funny clown of children's dreams, but the clown

of ridicule who was spat upon for the good of humanity. Wolsky's *Holocaust* is a complex composition open to speculative inquiry. The artist's personal approach has frequently misled the viewer, yet the painting is an intriguing display of opposites which, even if not understood, at least will afford the viewer an intellectual challenge.

The Clown Doll Window by Edward Walker (see color insert, E) is more an exhibit of clown differences than an emotional or intellectual approach to the psychological constitution of clown imagery. The popularity of clowns coincides with the devotion frequently granted to performing clowns, and to devote an entire window to the clown image is not merely unusual but indeed questionable in terms of purpose.

The doll image becomes a symbol of the clown. It serves to illustrate differing personalities of clowns and also serves as a friend for young children whose favorite clowns were always out of reach. Thus the doll clown becomes a source of inspiration second in legitimacy only to an actual performance personally attended.

The Clown Doll Window is calculated to display rather than inspire. It is arranged in a balanced manner in terms of utilizing background space; that is, the surroundings remain negative in order to avoid congestion. Walker diligently arranges a pattern of visually different clown images to create a pleasant treat for the spectator. Colors are distributed informally but blend into a unified composition.

The clown images in *The Clown Doll Window* are puppets or marionettes which offer an entirely different performance idiom from that of the performing circus clown. One is reminded of a hobbyist, a doll collector whose favorite avocation is clowning. The frontal display uses

Jack Wolsky. *Holocaust* (1952). Collage and tempera on paper. Courtesy of the artist.

negative space to accentuate the positive. As doll images are added to the working surface, negative space diminishes. Eventually the positive aspects of the doll images dominate the scene. Although each clown image is individually rendered, it is the accumulation of dolls that makes the total picture.

Artist Glenda Green, with her *Unknown Factor,* reveals an approach unlike that of most artists who have painted clowns. Her cavorting clownlike figures express her belief that clowning creates activity and relies more on physical action than on a mental or intellectual exchange between the clown and his audience. Green's clowns have more to do with the burlesque than with the more sophisticated musings of the other clowns under consideration here.

Mario, one of Walt Kuhn's several famous clown paintings, beckons to its au-

dience not with frivolity and laughter but with the absence of such ingredients, a deliberate display of emptiness. The blackness surrounding the famous clown propels the image forcibly toward the viewer, sparking an emotional response. Kuhn forsakes the usual composition of clown trickery and presents the image starkly for all to view.

Edward Hopper's *Soir Bleu* is set in a social atmosphere, with the clown depicted in isolation during a break. Noted as the painter of American boredom, Hopper utilizes both the natural (human beings) and the man-made (buildings, streets, bars and restaurants). He relishes the lonely and the pathetic, with sympathy and a deep understanding for souls that desperately plead for acceptance. Hopper specifically reveals the shallowness and hopelessness in a life lacking spiritual purpose and the clown seems

Edward Hopper. *Soir Bleu* (1914). Oil on canvas, 72 × 36 in. Collection of the Whitney Museum of American Art. Josephine N. Hopper Bequest. 70.1208.

a prime example of this loneliness. Hopper was a master in the expression of loneliness within a crowd, despair in reach of hope and isolation amid social activity.

Allan Davidson's *Anyone for Billards (The Hustler),* projects the hustler (clown) minus the tools of his trade. His only identification is the cuestick. With his props removed he becomes a clown of all seasons. His stance suggests his approach to the task at hand, and this technique delights the viewer. The very lack of props brings their presence to the mind of the viewer, who immediately thinks of the missing items. Were they to be shown, their presence would demolish the theme of intrigue. One wonders about the clown's future movements, his attack upon his audience.

The hustler stops short of his spectators awaiting a cue to his performance. A similar figure (the same one?) appears in Davidson's *Fence Sitter,* executed in 1960. Sorrow prevails, and the loneliness and quietude earmarking Davidson's work

permeate every inch of his canvas. One is drawn humbly to the saddened face of the bum of skid row, the clown of pity. Why has Davidson's clown forsaken life? Is it because the clown has become the universally accepted symbol of sorrow? Seldom do artists betray themselves, but the clown image—seemingly destined toward laughter and joy—often takes the form of sad bums or traveling hobos.

The pitiful creature described as the clown has absorbed the attention of Umberto Romano (*The Beggar,* 1953) and Philip Evergood (*The New Lazarus,* 1927–1954). Is it because the artist himself identifies with the clown? As one gazes at the body of Romano's clown hunched into a slender vertical panel, his bony hands groping for acceptance, one is reminded of the agony of Christ on the cross.

The circus clown symbolically reflects the tragedies of the world. He is caught in the grips of savagery and disdain. Images of the clown's world reach beyond the masquerade of joy and laughter, for in Romano's world of anger and resentment

there is only sorrow. Romano uses the centuries-old theme as a bridge between the evils of the earth and the hope rising from salvation. Once tragedy is recognized, the inevitable solution through peaceful techniques will eventually erase the clown's sorrow and the universal evils from the earth. Is the clown to be looked upon as a cross to be borne, a form of crucifixion from which to advance to a more peaceful life? Or is one to sing the words of laughter as the clown would seemingly advocate?

Philip Evergood's painting claims everyman to be a clown. According to Evergood, however, the clown is a fool. The businessman fools only himself; the czar fails as he is shot down; the priest gives in to temptation; the politician cheats his constituents. Only the clown is a clown. The rest are fools.

No painting more intimately portrays a pensively concentrated effort toward the preparation for performance than Robert Vickrey's *Clown*. The gesture of donning gloves finds the clown lost in thought. The simplicity of gesture, composition and technique offers a unique question of interpretation. Is the subject a circus clown? Vickrey's clown is truly one of all seasons.

Emil Kosa's *Clown* is a similarly intimate inquiry into the psychological makeup of the clown. It could well be autobiographical. The serious, almost sinister stature of the clown personality abandons the long established image of love and laughter. *Clown* is a release of the anxiety that frequently accompanies the antics which identify the clown with his audience. Fame as a clown comes from one's dedication to one's calling. Clowning is a performing art, and because it elicits laughter, and occasionally ridicule, it is less often regarded as a serious profession.

Kosa's *Clown* is profoundly subjective. In spite of surrounding apparatus which defines the environment, the painting communicates a personal relationship between the artist and his subject. The clown's facial makeup does little to distract the viewer from the provocative viewpoint. Kosa brings the background and foreground onto a single frontal plane by placing red circular shapes on the clown's face, on his outrageously oversized tie, and in the immediate surroundings.

The grease paint fails to remove the facial wrinkles created by decades of toiling performances. Kosa's refusal to diminish signs of aging suggests that clowning, like most performing arts, has its toll—but "the show must go on."

Kosa's distribution of color is visually exciting, and in spite of the age of the clown, the artist's incorporation of color to enliven the subject is nonetheless expected. *Clown* concentrates on the portrait of the clown image, and hidden fears, doubts and insecurities are left to the viewer to uncover. The painting suggests a sense of mystery, an intrigue which is not fully exploited by Kosa, but which challenges the viewer to seriously consider the artist's undiscovered gems of wisdom. This has to do with individual emotional reactions to the painting itself.

All professions demand rest periods. In *The Clarinetist,* artist Emil Kosa provides a relaxing moment for the clown whose yearning to create music is momentarily satisfied. Kosa's speciality is the clown portrait showing the human outlook enhanced through the medium of clowning. Kosa does not manipulate. His respect for the canvas and its eventual image lies not in compositional devices of visual stimuli, but rather in the personality drawn out of a simple statement. The

Allan Davidson. *Anyone for Billiards (The Hustler)* **(1957). Oil on canvas. Courtesy of Mrs. Allan Davidson.**

clown is what he is: a clown. Each of Kosa's clowns is portrayed specifically as a clown, rather than merely a person. Each clown's characteristics are enlarged, defined, detailed and developed into a personality of a singular character like no other existing clown. Human traits are assumed before the clown is identified. In *The Clarinetist* Kosa blends personality with musical atmosphere. The emotional impact of the abstract sounds springs the clown out of depression, or soothes his soul, with an ethereal touch.

Kosa's ability to relate dual abstract

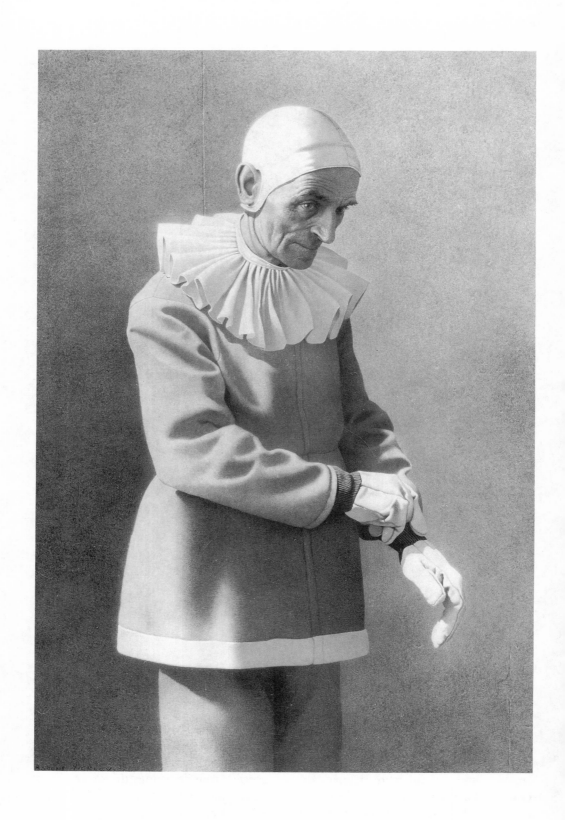

Robert Vickrey. *Clown* (1967). Egg tempera. Courtesy of the artist.

states within a given painting rests with the honesty and integrity of his subjects. His works are not happenstance; they are inner identifications with professionals practicing their art in the most personal manner available. Kosa's approach is not unlike that of Walt Kuhn, differing only in the emphasis. Kuhn prefers to focus on the integrity and physical prowess of the human being, whereas Kosa assumes these traits and extends his approach to the individuality of the clown.

In *The Clarinetist,* one's focus rests on the distance between the clown's eyes and hands. The clown as musician is wrapped in ecstasy. Another world is encountered as the business of clowning diminishes into a surreal world of emotional dreams, a calming release of tension and anxiety that resembles a form of psychiatric treatment.

Kosa utilizes the entire canvas, maintaining the clown atmosphere throughout. The colorful shirt, shiny gold clarinet, partial makeup and sailor cap assist in one's full appreciation of the scene. The area surrounding the clarinetist blends both the circus and the musical feelings and sets the mood of the piece being played. One senses a mystic quality, an escape from reality, with the entrance of some soothing melodic rhythm hidden within the movements of the clown's fingers.

Emil Kosa is a painter of moods. His painting titled *Clown with a Yellow Cane* (see color insert, B) exhibits a nostalgic dream of lovely ladies. Shimmering facial features providing a backdrop and an emotional dimension peek at the clown's performance. A full view of the clown helps to maintain Kosa's technique of intimate treatments of his subjects. A companion piece is *Debbie* (see color insert, B), the female counterpart. A whimsical

figure, with floppy big shoes which seem essential to sustaining her vertical posture, gleams with theatrical excitement. The colorful café type tablecloth shrouding her lower torso contrasts with her red and white polka dot blouse to set the stage for her performance. The cool, icy background contrasts with the rich, lush reds of the clown's costume.

Kosa's thematic portraits grow out of personal experience. His patriotic work *Red, White and Blue* reflects American freedom. The color scheme absorbs the canvas. Amid the array of Independence Day paraphernalia, Kosa sustains a dramatic appeal, a pensive plea for recognition, in the person of a troubled clown. His worrisome face reflects the atrocities of war. The tension of the tightened head with its deeply disturbed eyes, quizzical mouth and wrinkled brow is lessened by the open neckline. Kosa's ability to impose upon a traditional theme an image of anguish marks him as a master artist capable of blending sorrow with joy in a single work.

No lonelier spot exists than that within the circus tent emptied of its theatrical attractions. With glitter, laughter and drama gone, a vast emptiness prevails. The artist John Teyral studies this nothingness in *Circus Tents.* There is no excitement and no anticipation of it. Teyral has created a compositional masterpiece of realistic geometric shapes. The usually dull canvas circus tents are enlivened by intricate variations of shapes and tones. Supporting ropes running in various diagonal directions break the tent's surface into an exciting abstract pattern.

As if this intricate "breaking of space" were not enough, Teyral psychologically and physically inserts the human element into the picture. The viewer is overwhelmed by loneliness before spotting

Emil Kosa. *Clown* (1973). Oil on canvas. Courtesy of Mrs. Emil Kosa.

the young performer, who only heightens the lonely atmosphere. Additional objects serve to adjust the viewer's vision and sustain compositional unity.

Loneliness may reside within the human form as well as within ugly circus tents. Lily Harmon's painting titled *Clown with Dog* explores this aspect of the human condition. Propped against a colorful circus-like backdrop, the clown stares into space as his faithful dog seems destined to the same fate. Harmon blends the foreground and background into a single unit. Dark accenting lines scattered throughout the painting point up the significant areas of focus.

Walt Kuhn, famous for his direct, realistic portrayals of circus performers, splits his energies between clowns and acrobats. Lining up his figures like a rogue's gallery, Kuhn displays an amazing tenacity to his own rules of painting. Discipline oozes from his figures as they prepare for their dramatic performances. Whatever purpose Kuhn's subjects serve, they are eternally poised in integrity, honesty and true manhood. The simplicity of the composition shows the master touch and renders the painting all the more complex. The subjects' compound interaction with a simple arrangement is a disciplined treatment often ignored by Kuhn's contemporaries. Because of this self-discipline, Walt Kuhn has produced a lasting tribute to the circus clown and other such performers.

Circus clowns are in their glory as artist Victor A'Gostina reveals the whimsical motions of clowns at play. Each clown is designed to suit both the needs of an individual character and those necessary for the performance. Gestures are made fresh through a rapid but well-planned application of pigment. The scene appears to be a rollicking time, yet facial features, masked under heavily applied makeup, contain under close scrutiny a sadness associated with circus clowns.

The dressing room is an integral part of the circus clown's habitat. Preparation for performance enlightens as much as the performance itself. Frank Kleinholz, a master at activating the commonplace, offers in *Clown and Wig* a dramatic interpretation of makeup preparation. The seemingly simple task of fitting a wig becomes a provocative exercise that determines the future performance, the individual personality. Faced with such a serious decision, the clown naturally balks with indecision. Is this to be the final performance? Is this the initial entrance into the circus kingdom? Kleinholz's clown asks of himself, "Will I bring joy and laughter to those who need it more than I?" A simple idea, but with profound implications.

Similar in concept is Ivan Davidson's *Clown with Wig*. The act has not yet begun. Hesitation marks the eyes of the performer. The clown, seemingly unable to decide his future, gazes into space as he readies himself for makeup.

Clarence Carter, like many Depression artists, found the entertainment field a ready subject matter. His painting titled *Clowns Making Up* (see color insert, B), executed in 1934, shows the routine task of preparing for a performance. As if to relieve the monotony or tension, Carter splits open the tent covering allowing an infusion of fresh air into the dressing room. Offstage the clowns appear sad and almost unwilling to make others laugh.

Philip Hampton presents an unusual approach to the clown theme with his painting titled *Environment and Happiness*. It presents the harlequin as the central figure, one which the artist states "is

a signal of folly, buffoonery and frivolity . . . these being for the most part signals of happiness." He indicates with good reason that the role of the clown stems from folly, though the clown may also be seen as promoting a state of merriment as an escape from temporal problems. The painting is a panorama of the pleasures of urban life which again coincide with the clown's makeup, a mask disguising reality. Hampton's becomes a surreal picture of life within the clown's realm of performance.

In contrast is Carl Heldt's painting simply titled *Fred* (1968). The artist states "Just as art is the reflection of society, so is the clown. Clowns seek to enhance understanding in the same way art tries, unhampered by the barrier of language. That is why it is so appropriate that the two be linked together." If art is a reflection of society, then Heldt's painting reveals a side of society marked by loneliness and abandonment of life. *Fred* is indeed a vision of life at a standstill, a mood of profound thought or sheer laziness. Heldt leaves no doubt that his clown feels a deep sense of concern for his performance and for those he must serve.

The artist becomes a different being during the creative act just as the clown differs during his performance as a clown and his life offstage. The similarity of roles makes the artistic portrayal of the clown image an essential ingredient of the creative act. The type of clown camouflage selected by the artist varies according to the artist's emotional reaction to the idea being expressed.

The artist's choice of the clown image as a stimulus for his expression seems thoroughly natural, as does the fact that the image differs considerably among individual artists' interpretations in accordance with varying instinctive responses.

The paradox is that the clown is more himself as a clown, and likewise the artist as an artist. The major difference is simply that one is ever changing, and the other is cemented into a permanent surface which is preserved through centuries. The role of each remains the same over time.

No other beings are more open to ridicule and misunderstanding, yet both are popularized by the masses and glorified by the few who carry forth the knowledge of history in its relationship to the artistic act. One may disguise oneself in humility and be eulogized as a saint, or replace humility with pride and arrogance and be considered a success. Both clown and artist have utilized this fact of life.

Hans Moller, a highly diversified artist whose works entered the abstract shortly after the Depression, utilized the clown image well. One of his first exercises on this theme was painted in 1940 and is titled *Clown Family*. The first in a string of clown paintings covering the decade of the forties, it relies on the toylike image of a marionette show. Positioned within a stagelike atmosphere are a father/mother/child group costumed after the fashion of ice cream cones. Confined to geometric shapes that appear in repeated patterns, an abstract design emerges. Each image representing a human form is masked.

In a later painting, *Marionettes* (1941), facial masks are altered, bodies are fattened and the entire image reverts from the vertical to the horizontal plane. Decorative dress similar to that witnessed in *Clown Family* now becomes refined and subdued. Instead, body forms are well defined. Although remaining abstract, bodily features are evident and resemble those of marionettes. Strings are added to identify the marionette performance, and chairs arranged in the background reinforce the theme.

Carl Heldt. *Fred* (1968). Oil on canvas. Courtesy of the artist.

Hans Moller. *Clown Family* (1940). Oil on canvas. Courtesy of the artist.

Moller's theatrical devices continued through his next painting, titled *Two Dancers*. Showing the influence of the early works of Paul Klee and Joan Miró, Moller blends the two techniques with his own in provoking the last of a series solidly establishing him as an early American master in the abstract school. He again employs the boxlike composition for the theatrical atmosphere, but in place of empty chairs he seats spectators in the front row directly before the performance. The two loosely painted dancers agitate the surface as wavering stick figures balanced in geometric shapes. Although the subjects of the painting are boxed in, so to speak, Moller eliminates the pent-up feeling by continuing the tones of color from within the box to the outside limits.

These abstract works are mood paintings. Throughout his career, Moller has painted instinctively rather than by deliberate objective rendering of an event. He seldom realizes beforehand the final outcome of his work. This method is common among artists, but with Moller not only the composition but moreover the ideas may change in midstream. The movement of the brush will determine the idea to follow. Instinctive painting is difficult because it calls for continuous altering of the painting in the absence of a set formula, goal or technique. The current mood of the artist determines the character of line which delineates the subject.

The looseness in Moller's work is caused by his own feelings of freedom and individuality. Moller seldom begins with an idea because ideas act as dictatorships; an idea is applied only after the painting is complete or after the initial doodling suggests one. Even then the idea, once suggested, may change several times before the completion of the work. *Two Dancers* started with a drawing, a doodle of hard and soft lines. The idea of two persons dancing emerged, and as Moller drew and his imagination loosened with the wavering coils of his lines, it seemed logical to develop several solid shapes to correspond with the spiralled lines.

A believer in spontaneous expression, Moller would have felt confined to literal portrayal had he started with the notion of painting dancers. Having established his idea, Moller then deliberately concentrated on line and color to convey an exhilaration conducive to dancing. With bodily features avoided, lines flow in unbroken curves in a continuous whirling action.

The use of the Christ image in clown paintings puzzles those who consider Christ to be the most holy of men. The historical role of the clown parallels Christ's humbleness and the low position in which he placed himself. The clowns of old (or the fools, as they were known in the king's court) served royalty. They were pitiful creatures believed to have no mind or soul, animalistic in action but human in appearance. Because love and mercy were not qualities of a territorial king, such characteristics were considered foolish. The Crucifixion of Christ was considered the lowest form of execution. His treatment as an outcast has prompted artists throughout the centuries to relate this classic example of injustice against the innocent, and some see the clown's treatment as similar. Lesser examples that have occurred ever since also present the unfortunate, the downtrodden and the underdog as fools.

Yet the greatest "fool" of all has conquered the world and proved the eternal triumph of good over evil. The message of the Crucifixion is indeed a victory for the

Hans Moller. *Two Dancers* (1942). Gouache. Courtesy of the artist.

clown over his audience—or is it? *The New Lazarus* (illustrated in Chapter Six) seems to indicate otherwise. This work by the great American master Philip Evergood combines illustrations of the Crucifixion, racial turmoil, war and the clownish phantasmagoria of modern society on one large canvas. A trio of clowns, positioned at a distance in Evergood's masterpiece, exhibits the "see no evil, hear no evil, speak no evil" mindset. The clown, human as he is, remains stagnant in his role of counteracting the evils of society. As the clowns play dumb to the evils of

the Crucifixion of entire societies, man is immersed in aimlessly destructive activities, unable to cope and powerless to rebel. What the clowns refuse to acknowledge is the core of the turmoil, the rejection of Christ's message delivered centuries ago. Christ is ignored as nations clash with one another in greedy pursuits of power.

Umberto Romano once stated that "the clown and Christ are similar in nature caused by differing audiences"; that is, the similarity relies upon the tendency for different audiences to react differently to images of each. The clown purposely causes the audience to laugh, and this is according to God's plan—but it is against God's plan that an audience should react to Christ with laughter. The audience becomes Romano's chief concern as he depicts Christ in the most ridiculous of clown outfits.

In Romano's *Christ in Costume* the conceptual difference between Christ and clown lies in the fact that the clown dresses himself as a performer while Christ is costumed by the nature of man's evil. One might conceive Romano as a culprit for his portrayal of Christ as a clown unless one recognized the intent of the artist. *Christ in Costume* exhibits the sins of man caused by a severe disregard for the purpose of the Crucifixion. As an earthly human, Christ forfeits divinity to relate to the human condition. It is for this reason that Romano feels comfortable in using Christ on the human level. It is not unusual to disguise the highest form of life in the degrading form of the lowest. Romano was a master at pointing fingers, painting physical structure and tearing it to shreds with emotional forces.

The Christ/clown motif occurs in works by artists who prefer to isolate a single Christ clown image on the canvas. *Christ*

Among the Clowns by Jonah Kinigstein opens wide for critical analysis a reflection of humility of the highest order portraying Christ relegated to the lowest company. The painting calls to mind the Biblical statement, "He who exalts himself, shall be humbled, and he who humbles himself, shall be exalted."

Christ as man, and man as clown coexist in a humble relationship. The ridicule, mockery and blasphemy evident during the passion of Christ coincide with similar emotional states of the clown's life. Can it be that the artist sees the two as one? Is he paying tribute to the divinity of the clown, the elevation of the human soul to the highest of all achievement? Is the clown's earthly life, in other words, worthy of the kingdom of heaven? The results of human brutality reflected in the distorted and gnarled body of Christ are also evidenced in the bodies of the clowns, reinforcing the similarities of the two figures. Eternal life is the reward of suffering. Is the clown consoled by this fact? Why is the theme of the Crucifixion portrayed in a circus atmosphere? Never is the joy of Christ's birth expressed with greater joy and love than that of the clown. Artists like Jonah Kinigstein relish the dramatic notion that the clown is destined to sorrow and tragedy. Like Christ as a man, the clown is doomed to ridicule and disappointment.

It seems strange that one should title a self-portrait *Clowns and Kings,* as Abraham Rattner has done. In this 1946 work, he relates his life in terms of fools on the lowest and highest levels. The clowns in his painting are the grotesque, greedy, befogged fools who lust for wealth that they are unable to achieve, lacking the sense to recognize wealth as worthless, which Rattner believes it to be. Religious beliefs are imbued with a personal

Jonah Kinigstein. *Christ Among the Clowns* (1962). Oil on fiberboard, 48 × 72 in. Courtesy of the National Museum of American Art, Smithsonian Institution, gift of S.C. Johnson & Son, Inc.

philosophy in Rattner's work. Denominations are ignored, but a general acknowledgment of moral values is exemplified. It is difficult to distinguish the clown from the king. Facial expressions are portrayed for pathetic effect. One sees in Rattner's clowns and kings a definitive statement of reality, but a cry as well for a reorganization of human society to forcibly retire greed and corruption in favor of moral and humane consideration for all of mankind. In Rattner's painting Christ becomes a clown, and the clown becomes Christ. Rattner, who believes firmly in the scriptural phrases pertaining to humility, makes little distinction between the two.

Philip Evergood portrays Christ as a symbol of hope, and the Crucifixion as the seeming destruction of all hope of salvation. His clowns present images of complete despair for the future. The clown often lurks in the shadows as if having replaced the evils of society.

The Christ/clown relationship is a symbol of the outcast, a pathetic figure representing man's poor efforts to make himself into that which he is not. The mask is a device to disguise one's true feelings. Christ did not mask himself as the clown does, but the artist suggests that society ignores Christ's message as if he were but a masked clown. The treatment of Christ differs little from the abuse granted the clown.

The most renowned of the American religious painters see little difference between the clown act and the act of Christ; the difference lies in the intent. The clown performs as a clown and Christ was treated as if he were a clown. The Resurrection cleared the way toward understanding and accepting Christ as the savior of the Christian world. The clown saves the human race from boredom, anxiety and depression, but on a human level,

whereas the artist projects Christ as a clown to reveal his intense suffering as a human being in order to relay the divine aspect of his character.

Artists including Romano, Rattner, Nagler, Blume, Franck, Carter and others have portrayed Christ as human flesh embodying clownish features in order to project the human frailty. Just as Christ was ridiculed, disbelieved and distrusted, the artist in his role suffers from the same disrespect. No wonder the two make such beautiful images for thought and expression.

In reference to his painting titled *Crucifixion,* artist Joseph Deaderick states that "Christ performs as a leading figure, a tumbler projected from the springboard by other members of this human troupe. At zenith, Christ momentarily becomes transfixed on the Now suggestion of the Cross, later suggestion of light (perhaps from the circus, perhaps from the spirit). Upon descent, He will surmount and defy death who gambles with the clown, our humor, folly and tragedy." In this work Roman soldiers in clown costumes and facial makeup roll dice as they sneer and spit upon Christ, who, shaped as an acrobat in tights, welcomes the atrocities bestowed upon Him. The clowns' skeletal makeup suggests that Christ is the clown and they merely bystanders.

The Christ/clown duality serves to deepen the maddening wrongness of the scene as both clown and Christ are laughable images tortured to the joy of others. Yet the clown survives as the laughter builds, and Christ's justice will be found in the Resurrection. The clown role in Deaderick's painting commands a significance equal to that of Christ in that a confrontation is ever-present.

A state of humility often found in works of art is advanced most profoundly

in the duality of clown and Christ. The humility of Christ is transferred to the clown as an intermediary, since the divine in order to communicate in a human sense needs a human receiver and a human sender.

The technique of the clown is the unusual style essential to performance success. Benny Andrews's portrayal of Christ crucified established a comic/tragic duality. The tragedy of the event is heightened by the compositional technique, but to an unaccepting viewer or disbeliever, the composition might well suggest comedy.

Fred Nagler's devotion to Biblical interpretation ranks him high among America's religious painters. His work *Men Are Divided Even Among Thieves* is a mixture of laughter and atonement. Interspersed amid the crowd surrounding the Crucifixion are clowns, whose antics parallel the religious attitude of the times.

Several artists prefer the enlarged portrait style of painting. Often it becomes a painting of a dream, bringing inner satisfaction through the clown image. Frank Taira's *Pensive Clown* becomes a self-portrait. The artist's deliberate enlargement and the subtlety of the background area force the viewer to acknowledge his image.

In contrast is Jacques Zucker's *Clown,* painted so as to invite the viewer to look beyond the limits of the portrait. The basic form of the misty-eyed clown is thrust upon the viewer, but muted slightly to spread suggestive ideas about the clown.

Unlike Zucker's *Clown,* Morris Berd's symbolic *Clown's Head* reflects power and greed, a sort of envy that reaches beyond the real world. Berd's clown's eyes are opened wide to a world out of his grasp. Similar to the figures in Rattner's *Clowns*

and Kings, Berd's clown anxiously awaits the moment of kingship.

The full face portrait is a plea for acceptance as an artist/clown, a direct visual communication as well as a simultaneous expression of clown/artist activity. Background areas are generally subdued or practically eliminated by the enlargement of the subject to focus the viewer's complete concentration. This subjective approach prevents secondary elements from interfering with or interrupting the direct communication between the artist and his subject. If substantial background areas exist, they must not draw attention away from the primary subject.

A dual portrait of Fritz Blumenthal simply titled *The Clowns* reveals a brotherly act of compassion. The remorse and despair of one clown is the delight of the other. Sharing his experience is the clown's escape hatch, although neither admits to the other's assistance. The space between the two becomes an active compositional element; though seemingly implying separation, in reality it forms a union between two opposing forces. The sorrow exhibited upon one face is contrasted with joy upon the other. Background areas suitably blend the two figures into wedlock. The bursting sun, symbolic of hope, adds to the philosophical statement.

Anthony Cardosa, noted for his portraiture of famous circus clowns, demonstrates the basis for his fame with paintings of such performers as Emmett Kelly. Kelly was a satirist, and Cardosa's intimate knowledge of his methods and personality enabled him to relate his life in a distinctive manner in this detailed study. Cardosa's subject displays the look of frustation and profound sensitivity to the most commonplace that characterized his performance. This same sensitivity appears

Jacques Zucker. *Clown* (1959). Oil on paper, 16 × 24 in. Courtesy of Mrs. Jacques Zucker.

in other works of Cardosa, namely *Young Performer* and *Harlequin. Young Performer* depicts a simple, beautiful young woman modeled in exquisitely chiseled features deposited in front of clown performers.

Walt Kuhn devoted his energies to the upper torso, diminishing the relative importance of the head. Kuhn's ability to penetrate the viewer's vision through the clown image does not, however, make the head subordinate. The eyes of *Young*

Morris Berd. *Clown's Head* (1949). Oil on canvas. Courtesy of the artist.

Clown evoke sympathy and concern. The very smallness of the head is a technical device to cause its own psychological reaction.

The purpose of the portrait image, other than the immediate effect upon the observer, is to eliminate objects which interfere with the subjective or personal reaction to the idea. The artist prefers that the viewer enter the image and closely examine the details of the enlarged view. Kuhn's work allows this to happen.

Walt Kuhn was noted as the circus artist. Others such as Bohrod, Davidson and Moller spent only segments of their lives in the clown arena. Techniques seldom varied, but one artist, Jack Hammond, made versatility the trademark of his technique. Images of sorrow prevail throughout his work, although they are developed in different styles of painting. Hammond's clowns, seemingly exhausted, present postures of old age and despair. One painting, *Survivor,* relates in abstract geometric form the clown's body in contrast to the poetically ethereal head. The body is positioned so that it is partially obscured by the strong emphasis on his armorlike dress, suggesting a highly personal reaction to the notion of survival.

A similar juxtaposition marks *Encore,* a clown painting difficult to recognize as such and technically different from *Survivor,* but consuming similar space. Controlled scribbling excites the viewer as Hammond carefully but instinctively

applies circular streaks of color defining the clown image.

Different in both technical and compositional approach is the painting *Waiting,* whose title defines only the action of the clown. The viewer remains uninformed of the purpose of the wait. The deliberate placement of the clown on the left of the canvas brings out a lonely quality further developed by the clown's secretive countenance. Perhaps he is awaiting his turn to perform, listening for his cue. The purpose of the wait is of less significance than the quietude of the scene.

Despite the intense excitement reflected in his works, Hammond allows some of his canvases to reflect a mood of solitude, even despair. Even in the case of *Graffiti,* he balances ferocity with secret solemnity. In a psychological sense, Hammond projects three notions, each of which could survive individually. One may ignore the background and reflect on the clown, whose figure silently and singularly displays the complexity with which Hammond invests a single element. Ignoring the clown instead, one focuses on the ferocious tiger, another subject complete in itself and sufficient to sustain an entire idea. The union of the two, however, projects a provocative dilemma, the use of the circus poster as a symbol of attack or an idea contrary to the role of the clown. In spite of personal and occupational problems, the clown fulfills the role of entertainer. In addition, he occupies a position of special importance, being separated from the background to satisfy a compositional need. Hammond uses the circus poster as a device to correlate the tragedies that exist within the human experience and the nonchalant manner in which such events are dealt with.

A similar venture lacking the three-dimensional distance revealed in *Graffiti* is the painting titled *Circus,* a work that draws into a single expression both the clown and the circus poster. It becomes a montage. The clown and the circus poster become one as Hammond blends the clown's tragic appearance with symbolic images of the background poster. The weatherbeaten look of the poster coincides with the worn-out appearance of the clown's clothing. A perfect balance, Hammond's world of clowns differs considerably from the works of other American artists as well as foreign masters. Usually different themes call for different techniques. The tragedy of clown life tends to be vividly expressed, as one might depict a bouquet of flowers. But Hammond's approach matches technique to idea so well that it seems several painters could be responsible for his output. Technical similarities among his works are due to the overlap between paintings, which results from a natural flow of the physical, emotional and mental energies. It takes a second work to absorb the remains of the first. Hammond draws his technique from the idea, not the reverse. If an appropriate technique does not suggest itself, he prefers to disband his idea. Within his search, Hammond may through experimentation or instinctive responses alter his composition rather than his technique.

Hammond sets the stage for complete abstraction by first using natural symbols in the overlap process to maintain realism, then simultaneously suggesting Abstractionism. In his painting *Realist,* Hammond veers completely from realism by using geometric shapes in place of realistic items. However, he retains some identification to his idea (clown) through the manipulation of those shapes to correspond to the realistic image of the clown.

Hammond first sketches the clown image to consume space within the canvas's working surface. Once he has determined the space to be used and the shape of that space, he forms geometric shapes as closely as possible to the sketched clown image. Thus the outline of the clown is maintained although it becomes semi-abstract in appearance.

Hammond remains within the realm of recognizable art rather than veering into the arena of op and non-objective art. In so doing, he deepens and enriches his notions of the clown and his environment.

Historians have claimed that in a religious sense, clowns similar to those painted by Kinigstein were tormented throughout their lives by that doubt and fear that Christ experienced for a moment on the cross when he questioned whether even he might be forsaken by God.

Bibliography

Baur, John. *Philip Evergood*. New York: Harry N. Abrams, 1971.

Birdella, Stewart, and Dennis Baker. *Clowns Must Die*. New York: Inspirational, 1988.

Boll, Heinrich. *Clown*. New York: McGraw-Hill, 1971.

Cole, Joanna. *Clown-Arounds*. New York: Parents Publications, 1981.

DePaola, Tomie. *Clown of God*. New York: Harcourt Brace Jovanovich, 1978.

Disher, Maurice. *Clowns and Pantomimes*. New York: Ayer, 1968.

Fowlie, Wallace. *Clowns and Angels*. New York: Cooper Square, 1973.

Gerdts, William. *American Impressionism*. New York: Abbeville Press, 1984.

Goodrich, Lloyd. *Edward Hopper*. New York: Harry N. Abrams, 1971.

————. *Raphael Soyer*. New York: Harry N. Abrams, 1972.

Hensley, Lorraine. *Clowns, Clowns, Clowns*. New York: Daisy Books, 1988.

Litherland, Janet. *Clown Ministry Book*. New York: Meriwether, 1982.

Manning, Paul. *Clown*. New York: Macmillan, 1988.

Neumeyer, Sarah. *Enjoying Modern Art*. New York: New American Library, 1957.

Nouwen, Henri. *Clowning in Rome*. New York: Doubleday, 1979.

Schrader, Janet. *Clowning Around*. New York: CKE, 1988.

Sobol, Harriet. *Clowns*. New York: Putnam & Sons, 1982.

Soby, James. *Ben Shahn*. New York: George Braziller, 1968.

Thaler, Michael. *Clowns' Smiles*. New York: Harper & Row, 1986.

Walton, Rick, and Ann Walton. *Clowning Around: Jokes About the Circus*. New York: Lerner, 1989.

West, Morris. *Clowns of God*. New York: St. Martin's Press, 1990.

THE CITY

The city, unlike the other themes discussed in this book, is an artifact rather than a human activity. It is a basic and ever-present stimulus for the American artist and has challenged all schools of thought, all styles of painting and all political and religious beliefs.

Artists born in the slums of the metropolis, on the farmlands of the Midwest, in the coastal cities and in the mountains of the Northwest have all painted their origins. Perhaps it is unfair to exclude such masterful city artists as Isabel Bishop, the Soyer brothers, Paul Cadmus and Reginald Marsh who have depicted the city through its inhabitants, but to expose the viewer to the countless artists who have dealt with the theme of the city via its occupants would be to echo a narrow range of sentiments to the point of monotony.

Each city artist applies a personal interpretation to a scene of metropolitan life that is seen daily but generally ignored. No city has been exploited by these artists more than New York. Its skyscrapers, bridges and waterfronts have been painted in various styles and compositions.

The towering skyscrapers of Max Weber's *The City* vibrate with energy and excitement. The tension created by receding and advancing brushstrokes unites with soft interpenetrating clouds of color. This early technique of Weber is anxious and impulsive. The buildings themselves form a solid structural environment, and the gaily lit sky visible between the buildings reinforces the hustle and bustle of city life.

In order to include bridge structures, which are integral to large cities, Weber positions bridge spans above the skyscrapers. Their presence has more to do with the art product than with visual exactitude. The cloudlike feature also assists in the development of the composition by diminishing the vertical mass of the skyscrapers.

A total freedom from visual perspective marks Philip Guston's painting titled *The Painter's City,* in which Guston reached the peak of a style that resembles children's doodles. In this 1957 work intellect and emotion coincide. Slowly Guston's works changed from the literal figures of his childhood to distorted forms drawn from emotional responses. Despite the

claims of criticism, Abstract Expressionism demands an idea on the part of the artist, a notion of a sort that feeds or humbles the ego, and one to which emotional forces are applied. The notion itself can be abstract so long it establishes a point of departure.

Such is true of *The Painter's City*, a painting suggestive of the rapid pace of denizens of a metropolitan city. Darker colors dominate the lower portion of the canvas, and lighter colors correspond to the lightness of the sky overhead. Jagged vertical rectangular shapes suggest spiraling buildings residing between the earth's surface and the heavens above. Figures are also suggested, identifying the hustle and bustle of a metropolis.

To scan the work of Ralph Fasanella and form an opinion is akin to picking a racehorse after a single lap around the track. Fasanella's *New York City* is a fascinating panorama of daily chores, urgencies and pleasures. Each square inch of canvas is jammed with activity, carefully refined to add up to a totality heretofore unknown to the American art scene.

Proclaimed as an American primitive, Fasanella disregards visual perspective, proper proportions and color propriety. Instead, buildings and figures are stripped of their three-dimensional structure, color is applied according to personal choice and figures' natural proportions are ignored in order to accommodate numbers rather than satisfy visual perspective. Metropolitan characters are treated like neighborhood heroes. Vacant buildings and lots are nonexistent; no space is left void of activity.

Fasanella rejoices in life and is fascinated by the human condition and its countless variations. Each minute detail is not a suggestion but a declaration. Each living creature and each moving vehicle

and each standing building is diligently worked into the grand scheme of things. Fasanella's city becomes a retreat to prosperity, yet sadness and joy live together and celebration coincides with tragedy. Fasanella is dedicated to exploring the numerous facets of urban life, and the emotional states of his subjects coincide with the status quo, leaving the viewer to acknowledge and perhaps accept Fasanella's precepts.

One is reminded of such early American primitives as Horace Pippen, John Kane and Joseph Pickett, and perhaps most recently Grandma Moses. Fasanella's *New York City* suggests not so much an emotional experience as a pleasurable trip through a city through the vision of an American patriot.

Artists across the United States have painted the city in different ways, but in spite of the diversity of approaches, the artist never alters a style to suit the theme. The technique of John Marin, Charles Sheeler, Millard Sheets, Benton, Wood and O'Keeffe vary considerably, but each matches the individual personality of the artist.

Lyonel Feininger is no exception. His 1948 painting titled *Cityscape* typifies his original style; indeed it was motivated not by the theme itself but by his well established style. Feininger's instinctive approach of wet-on-wet enables a fluid response to a stationary stimulus to occur. Dark and light pigments are applied to a moderately wet working surface, allowing the color to spread beyond the normal confines of the building sites. While the paint remains damp, additional color is added to enrich the scene.

Once the underlying color prescribed for the city's structures is well established, carefully calculated contours are worked into the surface to define the outline of

each building. The contours, seemingly carefree in application, develop a suggestive identification and create a bustling atmosphere generally associated with city life.

Highly subjective, *Cityscape* has few details. One experiences a scant sense of belonging, a feeling of glimpsing a city in transition. Feininger's painting is a generalized impression of a city and is somewhat reminiscent of John Marin's swiftly executed watercolors of New York's skyline, although Feininger's structures are architecturally rectangular compared to the circular forms of Marin's skyscrapers.

Even though the linear elements seem randomly positioned, their placements are final. The linear application does more than define the outer and inner structures, which pierce and extend into the atmosphere for no apparent reason other than to justify the compositional scheme. Additions are made not to satisfy the literal presence, but rather to develop the composition. A theme or stimulus is merely a springboard for action. A departure from the original scene suggests much about the style of the artist. In Feininger's case, the abstract approach and its maintenance motivate the creative process. Not only does Feininger overlap his buildings, but the theory of interpenetration is fully applied. Feininger's *Cityscape* introduces an exciting contrast to the immaculate images of Charles Sheeler.

Sheeler's numerous depictions of buildings include cityscapes of various compositions. Among his more famous are *Skyline, Windows* and *New York #2.* If a simple word could define Sheeler's cityscapes, it would be the "interpenetration." Frank Lloyd Wright's architectural credo is applied in Sheeler's *New York #2,* tall, slender, rectangular shapes extend skyward, overlapping and interpenetrat-

ing to form a semi-abstract appearance. To further expand and emphasize the abstract nature of the painting, Sheeler allows the sky to advance and recede, and the buildings' shadows add another dimension to the architectural masterpiece.

The structures are manipulated considerably for the sake of composition. Window frames become balancing items for design considerations rather than integral parts of buildings. Important shapes are echoed throughout the painting. Baselines are forgotten since the mammoth structures seem to exist without a base and journey upward with no end in sight.

Viewing *Windows* (1951) is akin to taking an endless elevator ride. Sheeler positions color and shape in an argumentative manner defying the visual rules of the recessive theory of color. Although the overlapping of shapes would suggest recession, color contradicts the notion that light advances and dark recedes. This adjustment of shape and color loosens the strictures of reality for the sake of compositional unity.

A city is judged and statistically evaluated by several criteria—population, employment, school systems, crime rate, show fare, culture, sporting events and even sounds, according to Carolyn Ploughman's painting titled *City Sounds.*

The liveliness of a city is determined by the movement of people. Sloan, Cadmus, Marsh, Soyer and Bishop were excellent exponents of the people's city. Coastal cities are described as being noted for imports and exports. Crime cities are depicted with violent events. In spite of the above notions, in expressing a city in painterly terms, the artist frequently adheres to the reliable skyscraper theme, or a panoramic view from above eye level— the John Marin version.

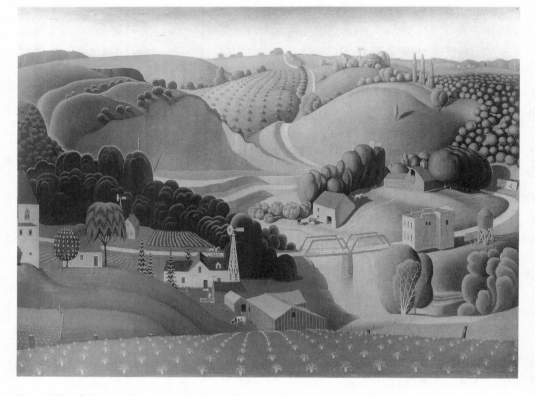

Grant Wood. *Stone City, Iowa* (1930). Oil on wood panel, 40 × 30¼ in. Collection, Joslyn Art Museum, Omaha, Nebraska, gift of the Art Institute of Omaha. 1930.35.

There are also images of quietude, such as Grant Wood's *Stone City, Iowa,* or the inner sufferings of the city as witnessed in Reginald Marsh's *Smoke Hounds* and *Bread Lines.* The city is a haven for the homeless; its streets and alleys are shelters for the unwanted, the bums, drunks and addicts. Cities are many things to many people—a hero one day, a fool the next. Its followers love a winner, hate a loser. Cities are proud, or they merely exist.

Gordon's *City Pedestrians* incorporates both the inanimate and the human aspects of the city in a view of a single segment of city life. Gordon portrays an ongoing trek of pedestrians who enact a commonplace event. One approaches the scene as a daily observer in a routine manner and is drawn into the scene. *City*

Pedestrians is readily acceptable and understood.

Although realistic in a visual sense, the painting excludes emotion, perhaps because Gordon's intent is to record rather than express any emotional reactions to his idea. Gordon provides an attractive view of a city fruit market which suggests the elements of Op and Pop art, but he avoids the temptation and instead includes the human reality.

His placement of human figures serves two psychological purposes. The viewer is forced to acknowledge the action of the human couple and thus focus visual attention on the central portion of the painting. The back of a third figure forces the viewer to backtrack and re-enter the painting. This spatial examination by the

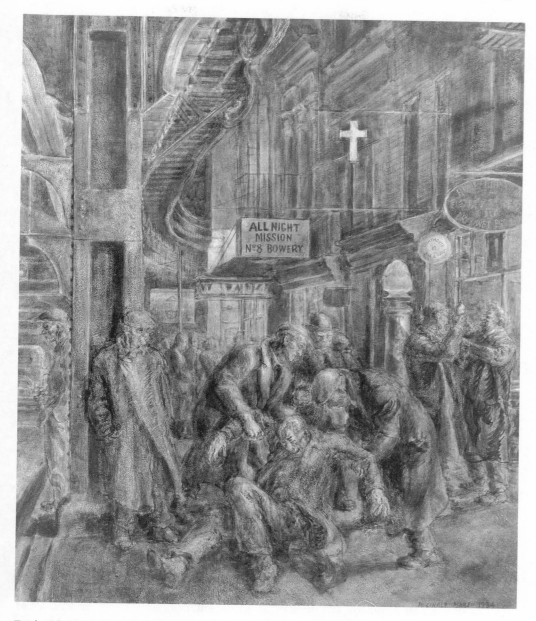

Reginald Marsh. *Smoke Hounds* **(1934). Oil on canvas. In the Collection of the Corcoran Gallery of Art, gift of Felicia Meyer Marsh. 58.26.**

viewer prompts recognition of details previously ignored.

Gordon seldom strays from his photographic recording. Instead of adjusting forms upon the canvas, Gordon prefers to adjust his physical position in relation to the cityscape until the scene presenting itself becomes compositionally satisfactory. Details are seldom added beyond what appears in the original setting. *City Pedestrians* is a slice of life, unlike Cadmus's *Coney Island* or Marsh's *Smoke*

Harvey Gordon. *City Pedestrians* (1976). Oil on canvas. Courtesy of the artist.

Hounds, but it still represents a segment of society frequently ignored by the artist who prefers the seamy side of life or the violence projected by the criminal element of society. *City Pedestrians* is a recording of stability in a society which needs to witness more of the positive aspects of life.

Reginald Marsh viewed the city from all angles and from all distances. His mural-like cityscapes set the stage for future exploration. The shoreline of skyscrapers beckons the viewer to move in closer. The artist guides the viewer inward from the outskirts of the city to the brawling streets, harbors and beaches, to the city's occupants and finally to the heart and soul of humanity. Marsh utilized shop windows, signs, slogans as symbolic means of ad-

dressing his viewers, making the environment as essential as its occupants.

His work titled *Tattoo and Haircut* is a case in point. The title serves to identify the scene, in which drunks, crooks, cripples, derelicts and other societal outcasts occupy a corner stand under the El and next to a mission house—a hangout for the creeps. Marsh delighted in a diversity of personalities and events and places of participation. He claimed that his attitude toward these derelicts was objective and impersonal, lacking in emotion and anguish, yet comparisons made between Marsh's photographs of the transients and the ensuing drawings and paintings indicate strong emotional responses.

Although Marsh painted the city from every viewpoint—its outskirts, its shorelines

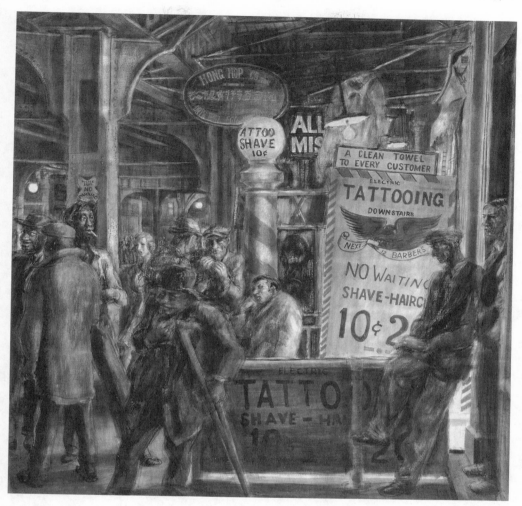

Reginald Marsh. *Tattoo and Haircut* (1932). Egg tempera on masonite, 118.2 × 121.6 cm. (46½ × 47⅞ in.). Courtesy of the Art Institute of Chicago, gift of Mr. and Mrs. Earle Ludgin, 1947.39. Photograph ©1990 the Art Institute of Chicago. All rights reserved.

and harbors, the inner city of buildings, railroads and boats — his success lies not in the gaiety of the carnival and burlesque but in his compassion for the helpless and hopeless humans generally ignored by the vast multitude of artists.

Although the metropolitan skyline, the railroads and the architectural designs were of worth, it was the human inhabitants within these structures that made Reginald Marsh the giant he was.

He recorded human conditions in the most squalid and decayed state, offering little hope for the underprivileged, the downtrodden and the crippled. Perhaps his acknowledgement of their plight is all that is needed from the artist; the rest is up to society. *Tattoo and Haircut* is a masterpiece of the inner city, which describes the urban landscape far more vividly than the traditional skyline.

The word "cityscape" typically refers to

Harvey Gordon. *Cityscape* (1978). Oil on canvas. Courtesy of the artist.

a skyline viewed from an ocean shoreline, but in his painting *Cityscape,* Harvey Gordon illustrates visual perspective from atop a tall building. The viewer finds a view of a major downtown thoroughfare sandwiched between rows of buildings. The unusual angle from which Gordon approaches his subject suggests that several perspectives were rejected before the final choice was made.

In most renditions of the city theme, some portion of a metropolis is ignored because of the vast area of the view. Small country towns, however, may be viewed and recorded as total communities as in Grant Wood's *Stone City, Iowa.* The tall foreground structure is designed with a balanced row of windows, yet to avoid the monotony of similar rectangular shapes, Gordon injects slight differences into each.

Furthermore, details flourish along rooftops. Because the painting is totally objective, the viewer is forced to acknowledge the smallest detail as a significant element of the whole. Dots of color symbolizing the human factor of the city adorn the thoroughfare.

Gordon reveals the insignificance of the human being by making his buildings loom large and tall. The human factor is nonetheless acknowledged as part of the material structure of the city. To avoid a traditional city view, Gordon has thrust the inner structure of a building into the foreground, thus eschewing a stereotypical vanishing point and developing a spatial relationship between foreground and background environments.

To paint a city is a challenge because of its vast diversity. The artist must select, witness, adhere to certain standards of morality and decency, and appeal. Certain buildings become frequent stimuli for artistic expression — the Sears building in Chicago, the U.N. building in New York and Fisherman's Wharf in San Francisco, for example.

Edward Hopper, the chronicler of boredom and solitude, ignores the skylines and skyscrapers, the hustle and bustle of a Marsh concept, in favor of depicting the hours in which the city becomes a haven for loneliness. Hopper never uses the image of the American city as an environment for human activity. Instead, he focuses on the urban makeup, the materials upon which the city itself relies for its existence. The structure itself has a life of its own, reflecting sunlit deserts of emptiness and shadows of loneliness. The human element is present only to remind the viewer that the city is a lonely station in life.

The towering buildings of Hopper's painting *The City* present a sharp psychological contrast to the antlike creatures who roam the urban landscape. A further study of a psychological nature is the endless rows and tiers of window frames which exude an aura of emptiness.

Hopper's refusal to engage in the skyline craze results in his usual intimate reflections on the human condition in scenes void of the human presence. Although his works are objective in architectural composition, subjectivity is strongly suggested in the deliberate exclusion of the human element.

Hopper's *The City,* a rooftop view, is a masterful union of horizontal and vertical planes. One is treated to a downward view instead of the customary view looking skyward. Hopper avoids the monotony of identical windows by inserting adjacent windowless building sides. This equal distribution of solid concrete sidings and windowed buildings promotes a compatibility of architectural forces. In a way *The City* is merely a segment of a city, with the

totality existing well outside the picture plane.

Completely opposite Hopper's lonely cityscape is Dong Kingman's rendition called *Angel Square*. A single corner reveals the excitement of an entire metropolis. Avoiding human participation, Kingman indulges in highly decorative billboards. The obvious windows of Hopper's *The City* are not to be found in Kingman's version; instead murals, construction and billboards all add to the excitement (or confusion).

Kingman's work is a nonstop trip through a tourist's treasure chest. The city is an oversized billboard that changes according to box office receipts. It is a showplace whose variety of tourist highlights engages Kingman in the thrill of an everlasting parade of uniquely urban activities.

Kingman, not unlike Hopper, diminishes the prominence of the human element, but for different reasons. Hopper's intent is loneliness; Kingman's is excitement. Kingman prefers to reveal the glamor of the city by covering buildings with tiers of monotonous windows. The latest renovation or coming attraction becomes the stimulus. Kingman's *Angel Square*, a definite reflection of New York City's Times Square, is a morality statement, a subtle reminder of the insidious underlying causes of a breakdown in spiritual aspirations and practices.

Peter Blume has been acclaimed by critics as a Naturalist, Realist, Abstractionist and Surrealist. His famous painting *The Eternal City* combines several schools of thought. Rome, considered by historical and Biblical sources as the eternal city, seems to identify with Blume's concept.

Benito Mussolini, the Fascist ruler of Italy in World War II, springs like an accordion from the Roman catacombs. His image, created from papier-mâché and attached to a paper accordion form, is painted green, and with a leer of greed and anger, his facial image oversees the events of the Roman environment.

The human presence is indeed prevalent, notably consisting of the persons partitioned in the catacombs, the formations of Roman soldiers and the rebellious crowds of onlookers. The individual human element is also featured in the personalities of Christ visible through the encased window and in the crippled old woman begging for alms. Blume's mastery of detail is a sheer delight to witness. Visual perspective is also masterfully treated.

The power and greed of the Fascist regime is contained in the single image of Mussolini leering while the world disintegrates around him. The sheer beauty of detail shows in the crumpled marble statues, in the brilliant red bricks of the darkened building, in the sharply drawn creatures exiting from the catacombs and in the Roman buildings rising before the distant mountains.

The Eternal City is another example of the freedom essential to the artist's creative nature. Blume's approach parallels that of Philip Guston, whose painting *The Painter's City* is conceived in terms of the individual concept attributed to the creative process and artistic freedom.

With a limited palette and structural design, Richard Florsheim produced a magnificent rendition of the city at night. In *Night City*, a gala affair confronts the viewer as lights explode throughout the city in the manner of a Fourth of July celebration. Dark rectangular shapes dominating the canvas are countered by fiery forms of undulating color. *Night City* is a remarkable emotional response to the

Peter Blume. *The Eternal City* (1934–37). Oil on composition board, 47⅞ × 34 in. Collection, the Museum of Modern Art, New York. Mr. Simon Guggenheim Fund.

excitement of a city whose attractions remain without identification. Its apparent instinctive application of paint is really quite carefully calculated. The fiery reds and yellows forming an eerie atmosphere suggest the metropolitan nightlife. Of course, the magnificence of the scene is but a slice of life, a small piece of a city night that extends beyond the limits of the canvas.

The variety of linear extensions piercing the fiery skies is the only obvious definition of visual perspective. In fact, the foreground appears as tiers of dark blocks piled upon one another. The human element is missing, but one may assume that human activity is well under way amid Florsheim's *Night City*.

The Photorealist school of painting has rallied the American artist to urban por-

trayals, particularly to busy street corners and store windows. The stimulus is further motivated by the theory of interpenetration. In Richard Estes's painting *Central Savings,* a calculated duplication of inner and outer structures exhibits an immaculate rendering of pigment. To avoid sterility of process and product, Estes compounds his composition, capitalizing on mirrored reflections and shadows, each of which augments the other. Details became important factors of the whole. Even the repetition of similar objects avoids monotony because of the variety of items.

Central Savings invites several interpretations since it verges on superrealism. It hints at optical illusion and is devoted to a clean appearance. To insert even a hint of litter would change the photorealist

Richard Estes. *Central Savings* (1975). Oil on canvas, 48 × 36 in. Courtesy of the Nelson-Atkins Museum of Art, Kansas City, Missouri (gift of the Friends of Art). F75-13.

image to one of realism. Estes's *Central Savings* avoids virtually all references to the human presence. It is strictly documentary in content, avoiding emotional commentary. Since the human element is removed from the scene, human communication is obviously absent.

Diligent attention to detail identifies the nature of *Central Savings*. It represents a resurrection of Charles Sheeler's technique, which produces paintings of shimmering reflections and sharp shadows and which proved the forerunner of the Photorealist movement. Objects recede and advance in accordance with the diminishment and enlargement of structural objects rather than with the intensity of color.

Richard Estes's *Central Savings* is a superb study of the inner city—not the poverty-ridden section but that harboring the upper level crest of society. It represents a small segment of a larger panoramic scene.

In Wayne Thiebaud's study of the city and its patterns of streets and byways, buildings spiral skyward, expressways form circular jungles and traffic is polarized. In a painting titled *Day City (Bright City)* Thiebaud arranges on a steep hill a single row of automobiles, somewhat oddly parked uphill, not downhill, for purposes of composition.

Huge rectangular shapes occupy a double baseline. Thiebaud details the distant buildings with rows of windows, while those structures in the forefront escape without so much as a dent. What would

Mary Hatch. *Illusive Destinations* (1983). Oil on canvas, 40 × 36 in. Courtesy of the artist.

normally be detailed has no detail, and that which might be expected to appear as a blanket of nothingness is showered with detail. This disregard for visual perspective and proper proportions is artistic freedom.

Thiebaud acquaints himself with a particular location, develops a composition, eliminates details, adds incidentals and color to suit a personal taste. The result is a charming, sophisticated, immaculate portrayal of a city at daybreak. Thiebaud alters original cityscapes to meet compositional needs; the architectural scene becomes abstract, a step out of reality.

Thiebaud's several cityscapes also include *Night City,* an unusual display of architecture and automotive transportation. *Night City* is Surrealist in the sense that streets become buildings as visual perspective is removed. Remarkable features include the upward thoroughfares piercing the skies where vehicles move through what should be windows. Vertical planes remain vertical, but visual horizontal planes turn vertical.

Night City is reminiscent of the child's painting commonly referred to as an X-ray picture; that is, it reveals more than what could be seen in a single view of a situation. Thiebaud in *Night City* merges a front view and a top view on a single canvas. This deliberate distortion of the visual landscape imposes a surreal aspect on the scene. Streets are viewed as from above while the upright structures are visually correct as if seen from ground level. The rectangular shapes of visible objects adds to the compatibility of Thiebaud's choice of action.

Edward Hopper. *Nighthawks* (1942). Oil on canvas, 144 × 76.2 cm. (56 ¹¹/₁₆ × 30 in.). Courtesy of the Art Institute of Chicago, Friends of American Art Collection, 1942.51. Photograph ©1990 the Art Institute of Chicago.

Thiebaud's distribution of opposing forces such as the elements of action and inactivity exercises artistic freedom. The reconfiguration of nature to suit personal and social needs has always been an option for the artist. Thiebaud's stimulus is the city and its surroundings, its entrances and exits. At times he choses to record without distortion. Other times, as in *Night City,* distortion occurs, not by the exaggeration of a single object or series of objects but rather by the composition of objects expressed in visually correct terms.

Yet it is Thiebaud's combination of events which ranks *Night City* as a springboard to Surrealism. It could even be considered abstract in spite of its contents being visually correct. What appears abstract is often merely an unusual approach to a commonplace stimulus. Thiebaud's objects are painted just as they look, but their positioning gives one pause. The central rectangular shape which contrasts with adjoining shapes resembles an elevator shaft, with pulleys intersected by horizontal planes symbolic of floor levels.

Horizontal planes are featured subordinately within the major vertical pattern. Thiebaud sets the tactile in combat with the visual, playing off the emotional sense of moving upward (as on the hills) against the visual sense of the vertical stance of buildings. The sensation of ascent competes with the stationary position of the vertical structures.

Compared to Florsheim's *Night City,* Thiebaud's is a calm, peaceful rendition of a great metropolis. It utilizes a precise outer contour with a seemingly suggestive interior. Thiebaud introduces a personal approach to a universal theme. The human element is not totally ignored, since activity reigns within the countless lit windows and the moving vehicles, but the human role in the scene becomes a mystery. Automobile headlights activate the street areas while corresponding to the

brightly lit windows of other rectangular shapes. The city is the ideal springboard for artistic freedom with or without the human element.

The city is a rest stop, a destination or a departure point. In Mary Hatch's intriguing portrayal titled *Illusive Destinations,* one is introduced to an assemblage of human personalities beset by uncertainties. Some seem to await the arrival of circumstances which may alter their lives, and others accept their routine cycle of activities.

Hatch's use of shadows in the lower portion of the painting is a compositional aid to the whole. Hatch's exquisite use of the doorway and the window frame suggests personal fantasies and dreams to which only the occupants of the painting are alert. Hatch's figures move about as city folks do, but they are concerned only with themselves. *Illusive Destinations* is a glimpse of city life with an added bit of mystery and poetic charm.

The city is also a hangout. Edward Hopper's *The City,* discussed earlier, is overshadowed by his famous *Nighthawks,* an expression of loneliness. Hopper's *Nighthawks* reflects not the bustling hooligan crowds of Reginald Marsh, but the empty lives of those seeking a spiritual purpose. Hopper depicts a city scene which reflects a common bond among all of humanity.

Other artists who have made notable studies of the city through differing approaches include George Bellows, Ernest Fiene, Charles Demuth and Adolf Dehn.

Bibliography

Barker, Virgil. *From Realism to Reality in Recent American Painting.* Lincoln: University of Nebraska, 1959.

Baur, John. *New Art in America.* New York: New York Graphic Society, 1957.

Blesh, Rudi. *Modern Art USA: Men, Rebellion, Conquest: 1900–1956.* New York: Alfred Knopf, 1956.

Friedman, Bernard. *School of New York; Some Younger Artists.* New York: Grove Press, 1959.

Geldzahler, Henry. *American Painting in the 20th Century.* New York: Metropolitan Museum of Art, 1965.

Geneuer, Emily. *Best of Art.* Garden City, N.Y.: Doubleday, 1948.

Gerdts, William. *American Impressionism.* New York: Abbeville Press, 1984.

Goodrich, Lloyd. *Edward Hopper.* New York: Harry N. Abrams, 1971.

_____. *Raphael Soyer.* New York: Harry N. Abrams, 1972.

Larkin, Oliver. *Art and Life in America.* New York: Holt, Rinehart & Winston, 1960.

Mendelowitz, Daniel. *A History of American Art.* New York: Holt, Rinehart & Winston, 1960.

Motherwell, Robert. *Modern Artists in America.* New York: Wittenburg, 1952.

Rose, Barbara. *American Art Since 1900; A Critical History.* New York: Praeger, 1967.

_____. *Readings in American Art Since 1900.* New York: Praeger, 1968.

Schapiro, Meyer. *Rebellion in Art; America in Crisis.* New York: Alfred Knopf, 1952.

Shahn, Baranada. *Ben Shahn.* New York: Harry N. Abrams, 1970.

Smith, Bradley. *The U.S.A.: A History in Art.* New York: Thomas Crowell, 1975.

Soby, James. *Ben Shahn.* New York: George Braziller, 1968.

Wilmerding, John. *Genius of American Painting.* New York: William Morrow, 1973.

SPORTS

The theme of sports is ideal for artistic expression and affords the artist a choice of several activities. Aside from the American national pastime of baseball, football ranks high in spectator participation as well as artistic experience. As early as 1890 the great Western artist Frederick Remington painted *Touchdown, Yale vs. Princeton, Thanksgiving Day, Nov. 27, 1890, Yale 32, Princeton 0*. Its unusual compositions and perspective draw the viewer onto the field. Astonished spectators glare at the Yale back scoring with his arms wrapped tightly around the ball as the Princeton player crashes with him to the ground. The face of the victor beams with satisfaction, while that of the vanquished shows the frustration of defeat. Remington's elfin figures are nimble and agile.

The painting is divided into three diagonal planes. Remington features the players in the lower section. The anxious crowd lining the playing field occupies the middle section of the painting, and the sky fills the third area.

At the time games rules ignored the sidelines, which were marked by wooden posts looped and strung with heavy rope, so in Remington's painting it is difficult to distinguish players from spectators.

In his rare sporting scenes Remington assumed a style similar to that of his famous Western paintings. In both, his concern was to depict wide vistas. The same open skies that graced the Western prairies rise above the football field.

The eyes of everyone in the painting focus on the play occurring in the lower left corner of the canvas, except for a single player who stares at the viewer. The players and teams are unidentifiable since names, numbers and letters are absent from the uniforms. Only the title of the painting indicates which team is scoring.

In his painting *More Than a Game*, artist Bruce Brown attempts to objectivize his feelings in order to express their innumerable facets and subtleties. Because the sport of football, especially if it is part of one's life, calls forth personal memories of failure and success, abstract tendencies creep into the work. Brown combines the abstract elements with a personal imagery and symbolism to depict nuances beyond the explicit statement.

Bruce Brown. *More Than a Game* **(1972). Oil on canvas. Courtesy of the artist.**

Brown juggles symbols of fear, courage, frustration and victory associated with football and war and formulates an objective view of emotional reaction to both football and war. One is obviously of greater consequence, but both football and war expose similar traits of humanity.

The sport of football becomes a remembrance of greater events, loftier purposes and lasting rewards. *More Than a*

Game exists on two vertical planes, each maintaining its own life. The two are isolated yet superimposed, with a compatibility that relies on a unique fusion of ideological similarities. The recession and advancement of the two planes coexist in spite of the contrariness of compositional function.

Elaine de Kooning has chosen to generalize her painting *Scrimmage*. Rather than specify that the sport portrayed is football, she suggests the general theme of physical contact. Human forms enmesh and overlap in apparent confusion. As de Kooning explains, the struggle exemplifies rather than identifies the sport. Her concern is for the unification of form, which does indeed exist in a highly emotional way. The artist's intuitive response to an idea is typical of the Abstract Expressionist movement of the 1950s.

Indeed, the beauty of any sport is its form and the technique or style in which that form is expressed. Although basic rules exist for both sports and art, the results inevitably rely upon individual performances. Such artists as Rauschenberg, Landau, Benton and Arman differ considerably in their methods of painting the theme of football, yet each method is valid.

The beauty of art rests in its versatility within a given theme. Football, if robbed of the variety of play patterns and individual performances, would disintegrate into boredom and failure.

Elaine de Kooning seems concerned with the emotional display of human anatomy in confrontation. In an intuitve painting such as *Scrimmage,* the intellect gives way to instinct. As an Abstract Expressionist, deKooning presents her total self. Her visual, physical, mental and spiritual (emotional) faculties all seem to overflow onto the canvas. From this initial point frenzy and control seem to combat each other as the artist attempts to pour out as quickly as possible all that is in her. During this intuitive process, mind and spirit never separate. Intuition ends when the spirit tires or the mind falters.

Abstract Expressionism relies on the exact moment of execution, the point at which the intellect and emotions agree. De Kooning's painting, for example, concerns itself with emotional reaction rather than intellectual research and definition.

In the 1960s, Pop artist Robert Rauschenberg introduced a collage concept. He believed in injecting the whole of life into a given moment. Everyday objects splash and bounce about the canvas, resulting in an unlikely union. Significantly positioned, football plays a major role in Rauschenberg's *Echo*. In this provocative juxtaposition of disparate images, football thrusts itself into the forefront. Intertwined with torn, cut, segmented photos, keys attached to a beaded ring and daubs of paint function as positive and negative spaces. Engrossed at one time with Abstract Expressionism, Rauschenberg in *Echo* propels the adventure into the third dimension. Cold, provocative and detached elements clash, but with the passage of time mellow and nestle into place as the whole becomes complete. Drawing and painting are kept to a minimum as collected images are attached to the canvas.

Two-dimensional relief sculpture found a hero in Armand Arman, whose Plexiglas, resin and football helmet assemblage represents the Pop movements of the 1970s. Arranged in an all-over pattern, his work *Untitled* echoes the strains of the earlier banal subjects of Warhol, Johns and Rauschenberg. It graduates from the earlier Pop Expressionism into an Op version of repetition. Like a series of X-ray photos, the inner

Elaine de Kooning. *Scrimmage* (1953). Oil on canvas, 36 × 25 in. Courtesy of Albright-Knox Art Gallery, Buffalo, New York. Gift of Mr. and Mrs. David K. Anderson to the Martha Jackson Collection, 1974.

helmets suggest the brains of 24 football players, each unique unto itself but collectively forming a monotony representative of that attributed to the sport. Lacking brute force and physical contact, *Untitled* remains a tribute, if not to the sport itself, then definitely to the art movement of the sixties and seventies known as Pop.

Noseguards, resembling gas masks, connect the sport's violence with that of war-torn nations in combat. The linear qualities of the assemblage unite the complexities within each helmet as well as connect each to the whole. Negative space adds to the uniformity, assisting in the definition of the picture. Arman is noted for unusual displays calling into play several schools of thought. Seeking his purpose is well worth the effort.

Artist Murray Stern uses the drama of football to accent a far greater event—a historical happening. Since spontaneity and discovery are essential aspects of his work, his paintings never suffer from tiredness of theme or image. His attraction to the sport was motivated by its violence, and his search for a moral message haunted him. Rather than dramatize the sport of football, Stern transfers its violent aspect to the world at large. Reflecting the artist's concern with civil rights, these football paintings lead to an idea other than the game itself. Rather than a struggle with positive and negative spaces, Stern's work becomes a mental and emotional fight for freedom, a battle against the evils of a hostile society, suggestive even of the concentration camps of Nazi Germany.

Unlike such artists as Spruance and Benton, whose works glorify the sport, Stern demythologizes it, not as an act of protest but more as a stimulus. He finds in the sport of football an outlet for vengeful retrospection, a use of an American tradition for more serious aims.

Regardless of the ideas he expresses, the artist functions within a chosen style. The Realist movement of the thirties and forties, the Abstract Expressionist school of the fifties, the Op and Pop movements of the sixties and the Photorealist concept of the seventies all left room for individual identities, yet individual ideas adhered to the currently practiced techniques.

In the thirties the works of such artists as John Stuart Curry, Thomas Hart Benton, Fletcher Martin and Benton Spruance resembled each other. Similar to Spruance's lithograph *Short Gain* is his dramatic, ethereal display of darks and lights titled *The Driving Tackle*. Clothed in mysterious eclecticism, players vie in a simple runner-tackle play. Although traditional in concept, Spruance's rendering surrounds figures of mystic poetry with a ghostlike shroud of graded luminosity. The driving tackle is evident, but he is overwhelmed by a predictable play executed in light and shadow. Only a hint of facial expressions glimmers through the haze. Players seem to emerge from nowhere as if cached within but forging forward to fulfill their destiny.

Football, never considered a gentleman's sport, has won artists' enthusiasm for several reasons. The exhilaration of physical contact resembles a similar explosive power in the creative process. The many facets of the sport parallel the diversity of the creative act itself. Its numerous movements and gestures, both emotional and physical, allow for freedom of rendering. But perhaps the most valid reason for consideration is the sport's connection with provocative events of history. Artists render the sport with personal insights and make the sport of football a cultural achievement.

The sport of boxing existed long before its introduction in America. As an Olympic sport it was known in 688 BC; as we know it today, however, boxing began in England a hundred years before America claimed its first major title bout. In portraying a boxing match or any other historical event, the artist depicts happenings that stimulate emotional reactions. Sometimes the artist reacts to the crowd witnessing the event rather than to the event itself. In most portrayals of boxing, however, the artist identifies with the boxer. In order to fully comprehend the role of the boxer, the artist reacts to and then re-enacts the boxing match.

Sometimes the artist assumes the point of view of a spectator in the crowd reacting to the fallen victim, as in George Bellows's paintings *Stag at Sharkeys* and *Dempsey and Firpo*. Bellows's ability to depict several intimate situations within a major event established him as a giant of American realism and an important recorder of sporting events. In these two paintings the viewer is deposited in the midst of a throng of dedicated fight fans. Bellows's attention to facial expressions typifies the era preceding the Great Depression. America thrived on the robust, and Bellows responds to the emotion of the crowd. *Stag at Sharkeys* exemplifies the unity of idea and technique. The fighter's flesh is depicted with sweeping brushstrokes that parallel the brute force of the event itself. Bellows, who obviously relished the excitement of the fight, experimented with several media, including lithography, before settling on painting,

which proved the ideal medium for his robust and instinctive personality. Lithographs constituted his entire artistic output for several years until painting was found to meet his stringent demands. Only four of his several hundred paintings dealt with the sport of boxing, but they were sufficient to establish his early popularity and his eventual worldwide fame.

As early as 1835, an editorial blasted the sport of boxing, tagging it a detestable practice that threatened to poison the American landscape. In 1860, George A. Hayes's painting *Bare Knuckles* was the first to eulogize the sport of prizefighting. Primitive in nature, *Bare Knuckles* lacked the raw intimacy of a Martin, the ferocity of a Romano or Bellows. Yet it served to historically record in visual form the bare-knuckle fighting technique. The execution of Hayes's work does little to excite the viewer, but it reflects the charm, naïveté, directness and honesty of the primitive school of art.

There are critics who prefer to exclude from criticism the entire gamut of primitive art because they claim it ignores anatomical realism. Movements in art generally demand the mastery of artistic principles such as basic proportions and perspective of nature, to neither of which did primitivism adhere.

Thirty-eight years after George A. Hayes's famous primitive painting, Thomas Eakins presented two paintings executed in 1898, *Taking the Count* and *Salutat*. The refinement for which Eakins was noted made for perfect anatomical rendering but consequently lessened the anticipation of action and movement. In *Taking the Count* a feeling of photographic realism pervades the canvas. The preliminary study for the painting relied more on emotion than does the painting itself.

The background audience, complete with theater posters hanging from the upper tier, coincides with that of *Between Rounds*. Eakins's obsession with anatomical perfection overshadows any potential action. Perhaps because Eakins worked from photographic studies, his boxing scenes lacked the dynamics and interaction perfected by his successor, George Bellows. In the same year, however, Eakins produced *Salutat,* a painting of stillness with a glimmer of movement in which a portraitlike depiction of a group of well-wishers generates more excitement than the main attraction. Eakins's three major fight pictures lack action, suggesting instead the anticipation of action. Each represents a different stage of a fight. Each reflects a rest period, a break from the anticipated action, to allow for model positioning.

Even though he studied the photography of motion, Eakins was unable to incorporate it into his work, partly because of his philosophy regarding anatomy. His creed of recording anatomical detail with scientific accuracy hindered emotional expression. Eakins's world was portraiture without action, always on the verge of movement. He was a revolutionist breaking ground and allowing others to take advantage of the openings.

James Montgomery Flagg was a noted illustrator whose works were prominent during the 1930s and 1940s. Several Flagg lithographs were acclaimed as artistic successes. His lithograph *The Dempsey-Willard Fight* is one of those illustrations. A typical academic portrayal, its artistic content emerges as spectators are drawn into the scene. Not only is the viewer outside the canvas an integral part of the response, but the distance between the two opponents and the surrounding audience causes a dramatic tension similar

to that in Bellows's *Dempsey and Firpo* masterpiece. Jack Dempsey had become a favorite subject of sports artists before and during the Depression, having held the world heavyweight boxing crown from 1919 to 1926.

The viewer responds to the audience at ringside. The audience, in turn, reacts to the fighters in the ring. This counterpoint between action inside and outside the ring creates a point of central interest. Even though ring ropes act as a sustaining compositional technique, they also serve as a guide to facial expressions of the audience.

Interpretations of the philosophy of boxing differ among individual artists. Fletcher Martin's identification with the sport was closely tied to his own experience. Men in motion motivated Martin to the sporting scene. Split-second decisions determine victory or defeat after hours of mental and physical anguish in pursuit of a single goal. Win or loss was not Martin's interest; rather, he was concerned with the end of a physical act. Martin approached defeat as the end of a contest. Death in the ring was not a tragedy but, according to the artist, merely a stopping point for the painting.

In his 1949 painting titled *Glory,* which exhibits the winning fighter in a jubilant dance pirouetting in midair, Martin draws the spectator to the battered opponent's corner, allowing a full view of the activity between rounds. Martin's subscription to the final result prevails in his 1962 painting *The Corner.* One senses a pause, a complete absence of physical activity even though further action is inevitable. Yet Martin enables the viewer to enjoy the end of the battle, and with it a peace, a fulfillment of purpose.

Fletcher Martin's life of hardship and near starvation enabled him to under-stand the odds and thus to project his artistic ability into the win-loss columns of the sporting world.

An artist who gained momentum during the Great Depression and was recognized before his death as the greatest American exponent of religious feeling was Abraham Rattner, who revealed in a single year a unique exhibit of astounding paintings on the theme of boxing. Noted for his tightly knit, geometrically charged bits of vibrant colors fused with black outlines reminiscent of the works of the great French painter Georges Rouault, Rattner introduced a technique of spontaneous paint application that mimicked the action of the event. Physical power is released through the spirit, resulting in the even greater power of love and compassion.

Rattner refused to identify his combatants. Painting quickly, he forfeited logic in favor of an impulsive application of pigment. Distortion prevails, not by Rattner's deliberate choice but as a violent reaction to a violent sport.

A series of thirty watercolors becomes a blow-by-blow account of a fight. Staggering lefts, jolting rights, uppercuts, clinches and body punches make up the vicious physical attacks of fighter against fighter. Brawn and muscle greet the viewer as clenched fists attack and counterattack. Rattner edges his subjects with heavy black lines. His is an intuitive response to a fleeting moment, painted as if by instinct in order to record without hesitation.

Rattner uses the most direct means to convey his emotional reactions to what he sees as a fiendish sport. He combines contour and gesture lines with dramatic washes out of a savagery stemming from compassion. His devastating response to the sport of boxing is not unlike Stern's

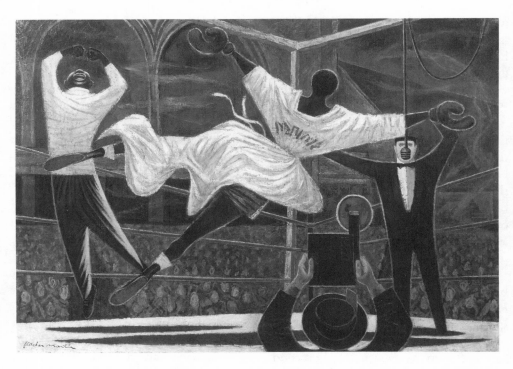

Fletcher Martin. *Glory* **(1949). Oil on canvas, 48 × 34 in. Courtesy of Wichita State University Endowment Association Art Collection.**

illustrations of football; both artists stress the brutality of the sport they depict.

Robert Riggs, a prolific artist of the Depression era, thrived on the sporting scene. His portrayals of boxing outnumbered those of all others. As tenaciously as a newspaper reporter, Riggs faithfully followed the fights of such famous pugilists as Max Baer, Primo Carnera, Tony Zale, Joe Louis and Max Schmeling. Typical of the works he produced is a lithograph titled *Boxer*. Draped in towel and robe, the fighter awaits the bell ringside, fists crossed, body tensed, eyes fixed on his opponent as he contemplates the seconds ticking away. Even the mute pose generates a wave of excitement as Riggs suggests in a single portrait a lifetime of glory and frustration.

Almost identical to Bellows's *Dempsey and Firpo* is Riggs's version of the Joe Louis–Max Schmeling bout. In *The Brown Bomber,* Riggs shows Louis, world heavyweight champion from 1937 to 1949, avenging his defeat two years prior at the hands of the German pugilist. All eyes are focused on Schmeling, each heart pounding as the world awaits the final count.

Anxious seconds tick away as ringside watchers nervously anticipate victory. Riggs presents an intimate bit of unfolding drama that follows an intense barrage of punches delivered by the champion. Louis defeated Schmeling in a struggle that transcended the sport itself, perhaps the greatest athletic contest of the Depression era.

Riggs utilized the compositional technique favored by Bellows, sectioning his work into three major horizontal planes, each of which contains a separate com-

position. The center plane, however, becomes the focal point as Schmeling lies victim to Louis's powerful attack. Robert Riggs has portrayed a proud moment for America, which needed a morale boost while still surviving the effects of the Great Depression.

Also representative is Riggs's painting of the Baer-Carnera fight, which focuses on the spontaneous crowd reaction to the angry Baer, able contender for the heavyweight crown, and the shocked Carnera, the Italian import. Reporters and spectators, moved by the surprised victim's sprawling body grasping for the ropes, show a shock of bewilderment as Riggs's ability to evoke emotion registers throughout.

The victor (Baer) hovers over his fallen prey prepared to deal out further punishment. This dramatic scene encapsulating the heat of the match reigns as a tribute to the artist as well as a highlight to this boxing era.

Jacob Landau's woodcut *Boxing* presents a highly dramatic version of a pugilistic encounter. Surrounded by frenzied spectators, the fighters exchange punches in grueling fashion. An extreme distortion of the fighters has little to do with the idea of boxing but coincides with Landau's style.

With figures positioned on a single plane, Landau ignores perspective and pushes the entire image into the forefront. Each spectator becomes a psychological study of emotions.

The dominant black masses that occupy crucial areas demand immediate attention but are lost with further study of Landau's linework. In most art works, one easily traces the development of an idea, but with Landau's intermingling of line and space it becomes impossible to discover a start or a finish. The viewer individually determines the point of departure.

In Landau's provocative woodcut, one joins the crowd by playing the role of referee or of a sideliner drawn into the fray. Searching through agonizing bits of his linear network, one is reminded of the German Expressionists and of the grotesque figures of the Nazi regime. The violence of the sport parallels the violence of society.

The work invites an abundance of interpretations, but one is tempted to compare Landau's work with that of Murray Stern, whose bony creatures more resemble the victims of the Holocaust than participants in the sport of football.

Landau's work has a distinctly disturbing element about it. Whatever his subject, jagged and swirling lines form distorted images that set the viewer on edge. Landau spreads this exaggeration throughout *Boxing*, X-raying his subjects to display their muscle and bone structure and using his accurate linework to advantage.

In an unusual composition, *Wolcott vs. Charles,* Harvey Kidder spotlights the referee as a symbol of judgment and as a design factor splitting the canvas into two ideologically different segments. Centrally located, the referee commands immediate attention and retains it by gazing on the fallen victim. Kidder transforms a two-dimensional surface into a three-dimensional spatial theater, with performances occurring on either side of the referee. Preoccupied with the decision, the viewer loses sight of the victor. Kidder's emphasis on the prey illustrates a then-current trend of highlighting the underdog.

Never influenced by artistic and social changes, Kidder preferred to alter the idea itself within the academic approach.

He relied on a compositional format change. Angling his vision to the unusual enabled ideas to widen, deepen and even reverse meaning. Artists have experimented with art movements, fought media fads and tried mainstream ventures. Some have succeeded; others have failed. Kidder simply shifted his compositional emphasis, maintaining his style and opening wide the door to viewer participation.

Harvey Kidder's painting *Wolcott vs. Charles* could well be a prerequisite to the study of Surrealism. Its theatrical atmosphere and layout lend themselves to the infinite extension of objects into space. Its stars, Joe Wolcott and Ezzard Charles, were both contenders for the heavyweight title relinquished by Joe Louis.

It is not always the sport of boxing itself that excites the artist; often it is instead the shrieking audience that summons the artist to action. The dual presence of fighters and spectators presents a natural contrast of concepts, and the artist's decision to accept or reject one concept determines the compositional approach. The constant maneuvering for position within a confined space sets up a compositional challenge.

Boxing is a brutal sport in the ring, and it becomes no less brutal when translated onto canvas. Abraham Rattner emphasized the violence in hopes of bringing about the abolition of boxing. George Bellows and others ignored the brutal consequences in favor of the raw power of the sport. And still others have used their canvases primarily to record sporting history.

The individual sport is the most difficult of all. Only experience, concentration and total commitment enable the athlete to succeed. Dedication and desire direct the energies, channel the pain and propel the future. The athlete must go it alone. Such is the plight of the athlete in any individual sport, be it running, swimming, gymnastics or even golf.

As has often been stated, the artist paints the times. Such is the case with William Palmer's painting *The Defeat of Bobby Jones*. Palmer began his artistic rise in the 1930s, when Jones's career was ending. It was as if Jones stamped Palmer's credentials for success. Jones's defeat by unknown amateur Johnny Goodman did little to lessen his fame, yet Palmer's pensive rendition of the loss indicates anxious moments for several spectators surrounding the eighteenth green. Groups of onlookers encircle Jones, clad in his famous white knickers, as he casually studies the situation. In the absence of facial expressions, the general mood is one of calm resignation, an emotional stillness.

Palmer achieves a measure of charm in a subject that might easily be burdened with detail. One's eye is made to roam the landscape of a still and hushed crowd rather than to focus solely on the event itself. The contours of the bunkers, greens and fairways form a rhythmic pattern of circular shapes. Crowds of spectators carefully line and surround the fatal eighteenth green.

The focal point of the painting necessarily lies in the distance between the caddy and his master, for it is within this distance that the defeat of Bobby Jones will occur.

Using the foreground/background theory of interest in his painting *Indian Summer,* Palmer locates a casual group of golfers at the tee and then gracefully shifts attention to a twosome on a green to the right. This peaceful painting depicts the charm and poetry of a summer afternoon's social outing in a landscape replete with foliage. The restless sky

counterbalances the mood of the nonchalant golf patrons awaiting the signal to tee off.

One of the earliest paintings of the sport of golf was executed in 1922 by the early American Impressionist Childe Hassam. The painting, titled *The Dune Hazard,* depicts what resembles an open mine rather than a golf course. The human figures seem anchored to the environment as if made of the same material as the dunes. The golfers seem stymied by the hazard, the odds of winning seemingly not justifying the effort. The rough terrain, marked by lofty dunes of sand and variations of land contours, sets out for the golfer a most unpleasant task.

Paul Cadmus, noted for his satirical musings about American life, scores again with his 1936 work *Aspects of Suburban Life: Golf,* in which he demonstrates his ability to record the inner motivation of the rich. He portrays the sport of golf as a social necessity for the elite. Gregarious but self-centered creatures of the business world compete in a seemingly relaxing pastime that is actually an egoistic indulgence. Cadmus makes a sharp distinction between the fine attire of the suburban golfers and the worn-out shoes and trousers of the caddies.

Art works of the Depression era relied heavily on studio models, which perhaps accounts for their tightly knit compositions. As in William Palmer's *Indian Summer,* the objective positioning of figures sometimes eludes the viewer because of casual painting techniques. The psychological meanderings of Cadmus, however, are expressed with masterful draftsmanship and calculating composition. His work is sheer joy to witness.

Paul Cadmus and William Palmer both entered the art scene during the Great Depression. Their styles and design patterns are similar as evidenced in their works *Aspects of Suburban Life: Golf* and *Indian Summer.* Both works have a casual tone and atmosphere. Cadmus's satire emerges as the sole difference. In retrospect, one sees that Cadmus's oeuvre is peppered with images of protest. His superb anatomical figures, reminiscent of those of Reginald Marsh, underlie his several portrayals of controversial events of his lifetime. His tactics, often deliberately offensive, are his trademark; one must expect sardonic reaction to his work.

The sport of golf as a suburban diversion is paralleled by a similar approach to *Aspects of Suburban Life: Polo.* Cadmus's wit is at once bitter and charming in his presentation. William Palmer casually portrays similar scenes, but with no malice of forethought. His *Indian Summer* simply depicts a friendly foursome. The shift from competitive golf *(The Defeat of Bobby Jones)* to a friendly style of play marks no shift in technique but merely shows less objectivity. In both works the human presence is significant but is guided by a compositional use of nature.

Golf, once reserved for the idle rich, has now produced a following of dedicated fans. A sport of the loner, it motivated artists as early as Childe Hassam and more recently has immortalized such players as Jones, Snead, Hogan, Palmer, Nicklaus, and Trevino in the sensitive hands of such artists as Landau, Cadmus and Palmer.

Jacob Landau produces a provocative display of swirling lines in a 1960 woodcut, *Golf.* Spectators view a golfer's tee shot with various emotions in an anxious moment before the single vicious swing of the golfer. Although interpenetration makes abstract this swirling mass of humanity, the superimposed golfer

looms large above the gallery. The technique parallels the inner excitement preceding the swing. Lines swoop from the upper left of the drawing to the lower right, suggesting the speed of the stroke. Landau forsakes anatomical perfection for compositional unity.

Landau differs considerably from the other artists mentioned in this chapter. For him, golf is a contemplative sport controlled by the intellect. There is no violence. Yet violence resides in Landau's slashing knife stroke technique, which contributes to a style akin to that of the German Expressionists. The work succeeds because of his depiction of the crowd reaction, which adds a second plane of interest beyond the golfer. Landau articulates the need for compositional unity, which takes priority over the viewer's need. The theme of golf has little to do with Landau's abstract, dynamic style. Rather than alter technique, he prefers to broaden his scope.

Tennis was introduced to America in 1875, and the first national championship was held at Newport, Rhode Island, six years later. George Bellows, the first major American artist to record the sport, preferred the spectators as subjects for his work rather than the event itself. For Bellows, tennis lacked the fierce combat of boxing. Proper spectators clad in lacy tea outfits and carrying parasols, attending the match to seek prestige, were more interesting.

Bellows's burlesque portrayal of the game emphasizes the elegance and pretense of the spectators. The audience seems to be on a Sunday afternoon outing, and the players, garbed in leisure slacks, move about the court like dancers out of *Swan Lake*.

Whether at Newport, the boxing arena or the athletic club, however, Bellows concentrates on the moment of play. He paints the Newport scene as though from lifelong familiarity. His vigorous brushstrokes communicate the gaiety of the crowd in attendance. *Tennis at Newport,* a 1919 work, is a memorable painting, not only for its color but for the intensity of the action of both the audience and the players. The entire painting is stroked with bold segments of color that form a rhythmic pattern throughout.

Tennis at Newport is in extreme contrast to Fairfield Porter's *The Tennis Game,* painted in 1970. There is little regard for the movement of pigment; the chief goal is to set forth an emotional response to an idea. Porter uses a predetermined positioning of players in a doubles match and, in an apparently spontaneous application of paint to the figures and the background, presents a semi–Impressionistic mood. A close study of the work suggests a method not unlike that of the French Impressionists. Rapid, confident brushstrokes fill out the prearranged forms, activating the space between the subjects and the background.

Less concerned than Porter with background utilization is Miguel Covarrubias, whose painting of Helen Wills, a former American singles champion and Wimbledon crown wearer, portrays a dramatic match with an unseen opponent. Covarrubias employs a highly distorted technique engaging physical disarrangement for the sake of displaying Wills's determination. Compositionally, the net pattern is carefully echoed in the racket, which extends the outstretched arm of the player. The net also acts as a barrier to victory, as well as a stabilizing parallel to the diagonals of the figure. The cocked-arm image is repeated in the stylized eye and sun-shaded tennis cap, holding the viewer's attention within the picture plane.

Helen Wills, painted in the fifties shortly after World War II, is a bit of war nostalgia. Its drama results from facial distortion, daring compositional techniques and simplicity of color application.

In his series of portraits of tennis stars, James Paul Brown utilizes the intuitive process in the second of two steps he follows in creating a painting. Brown first draws onto the canvas a definitive figure and completely paints the canvas in subdued tones of related colors. The second process is the application of related colors to activate large painted areas, highlights and shadows. Figures are defined and colors muted, both within the figure and throughout the surrounding area. Colors float lazily about the canvas and suit the contours of the figures. Highlights and shadows appear more natural in Brown's tennis paintings than in his track series. His choice and application of color suggest a less intense reaction to the sport of tennis; in fact, the paintings seem more objective than intuitive. Because Brown thrives on the intermixture of color, it is difficult to distinguish between the primary and secondary ideas or between background and foreground. In the case of *Tennis No. I* the idea and background survive because of appropriately positioned accents that separate the two.

Artist John Cernak avoids secondary notions in his strong painting *Tennis.* Anchored in the Photorealist school of painting, Cernak projects the viewer into the role of opposing player rather than that of spectator. The viewer watches from one side of the net, waiting intently for the ball's return. The real art of the painting lies in the player's position, the enlargement of the view and the unique moment of action being recorded. It owes a debt to the Pop movement in its photographic verisimilitude. The manner in

which Cernak's tennis player charges directly at the viewer recalls Roy Moyer's *Horses and Jockeys.*

In the sport of tennis, distance is placed between the two opponents. Consequently, less activity enriches the canvas. The objective approach allows the presence of space, as in the works of Bellows and Porter. Tennis is a gentleman's sport indeed, yet a sport of stamina, speed, finesse and determination. The racket, which for the artist identifies the sport, becomes a weapon.

America's national pastime became an organized sport in the year 1845. Historians are undecided about the identity of its founder, though Abner Doubleday has often been mentioned. As early as 1875 the American painter Thomas Eakins produced the first major work on the theme. Titled, *Baseball Players Practicing,* it represents Eakins in a typically academic mode. Although he never lived to know it, Eakins's painting set the pattern for similar compositions to follow.

The viewer is drawn to look beyond the painting for the anticipated action. The central figure, the batter, awaits the pitch, which will originate outside the picture plane. A few spectators are splashed into the upper deck of the grandstand, while the two ballplayers occupy the middle plane. The lower section leads the viewer's eye to the central figures.

The watercolor background seems quickly applied but exhibits adequate rendering. The wrinkles of uniforms are closely wrapped about well posed bodies. Eakins's painting quietly generates an excitement introduced first by the aggressive watercolor wash and second by the anticipation of the batter as he awaits the pitch.

The Depression and the outbreak of World War II thrust artists into the sports

arena. Baseball maintained its popularity in spite of political and military turmoil. Night baseball also had its beginning. Such artists as Morris Kantor, Byron Thomas, Fletcher Martin and Ferdinand Warren painted to reflect the times.

It was Ferdinand Warren who combined a panoramic view of America's national pastime with the ethereal, haunting quality of night baseball. Warren prepared for his masterful drama by attending games in Ebbets Field in Brooklyn. In *Night Ball Game* Warren, noted for his nocturnal cityscapes, transforms the baseball stadium into a metropolis, a city of roaring fans who will be content only with a Dodger victory. The entire theatrical performance glows with eerie clouds hovering over the stadium as if preparing for an attack.

One hundred years after Eakins's *Baseball Players Practicing,* Harvey Dinnerstein put a painting into action. Titled *The Wide Swing,* the painting focuses on three figures. The batter's vigorous swing leaves unanswered the question of where the ball is. Is it in the catcher's mitt, or has it left the ballpark? The answer remains tantalizing outside the picture plane as Dinnerstein both excites the viewer and presents an aura of mystery. Carefully positioned figures on a horizontal plane directing full attention to the left of the canvas are offset by the negative spatial areas surrounding them.

In 1982 Lance Richbourg duplicated Dinnerstein's compositional scheme but reversed the batter's stance in *Campanella.* Richbourg delivers a similar message and the identical question, but suggests an overflow crowd of spectators. He leads the viewer's eye more directly out of the picture plane and relies on the background of figures to hold attention. The viewer is forced to settle on the energized space between the batter and the catcher. Also executed in the traditional style of realism, Richbourg's work generates excitement by suggesting the unknown.

Similar to the Eakins/Dinnerstein connection is the Eakins/Richbourg relationship. Although complete with backstop, details and suggestive spectator background, Richbourg's *McGraw Watching Travis Jackson,* closely resembles Eakins's *Baseball Players Practicing,* executed a hundred years earlier. Attention is drawn to the three major figures, but the eventual transfer of attention relies upon action yet to occur. Richbourg's work is a masterpiece of geometric shapes of dark and light carefully positioned in an objective portrayal. The viewer awaits the pitch, and Richbourg introduces McGraw as a fellow viewer within the painting. A pair of shelters shield three individual compositions. The backstop encloses the batter and catcher, and the permanent home plate screening isolates McGraw and simultaneously protects the grandstand spectators.

The use of line is the oldest and most direct means of communication in the visual arts. Ben Shahn uses it to good effect in *The National Pastime,* a drawing of psychological significance. The tactual experience bursts out full force as the batter's greatly distorted arms reveal the pressure of the moment. Segments of the human figure appear disjointed to emphasize the psychological and physical exertion of the arm and leg movement. Baseball cleats are exaggerated, dramatizing the scene as the catcher awaits the ball that never arrives. Drama is heightened by the overlap of figures, the ribbed chest protectors and the boldly striped baseball stockings.

The viewer's attention is directed to a

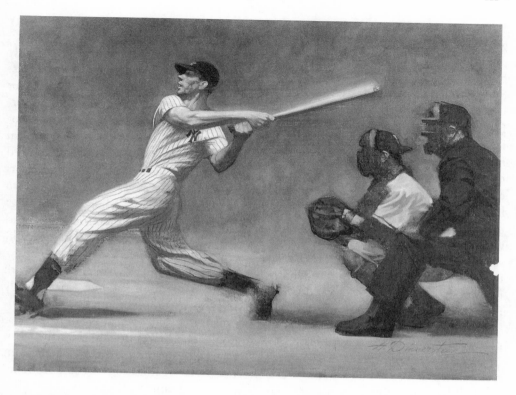

Harvey Dinnerstein. *The Wide Swing* **(1975). Oil on canvas. Courtesy of the Butler Institute of American Art.**

Ben Shahn trademark: the penetrating eyes, which seem occupied with a single concern—the destination of the baseball. Shahn's nervously contoured lines overlap into abstraction, which introduces an uncertainty of approach. The combination of lines of contour and movement on wet and dry surfaces in union with varying wash tones creates accidental, sometimes irreversible marks which add to the apparent confusion. However, the artist's realization that instinct is not infallible allows Shahn to create an exciting, quickly executed, emotional vision of a moment in the game.

Shahn's style seldom changes with a shift of subject matter. Although he was noted for satirical social and personal commentary, a sophisticated irony seems to pervade his entire output. The ironic

title of *The National Pastime* suggests that American society might more effectively budget its time. Nevertheless, Shahn's very choice to treat baseball as part of his enormous body of work on significant social events indicates the importance of the sport.

It is difficult to isolate the primary subjects from surrounding debris in Bruce Brown's *Mahaffety Shuts Out Cincinnati*. Pitcher and batter seem undisturbed by the seemingly chaotic surroundings of a dumplike environment. Removing the refuse would destroy the painting's unity. The painting takes on a highly suggestive approach to the sport of baseball. Three easily recognized entities are Mahaffety, the batter and the scoreboard. The remaining objects are questionable.

The beauty of Abstract Expressionist works is the possibility of diverse interpretations. Brown's painting gives a clue but no solutions. Other than the obvious duel between pitcher and batter, the subject of the work puzzles the viewer. Has Brown used the game of baseball for loftier purposes? Is his portrayal an experiment with techniques and materials? Has he set out purposely to confuse his audience? Perhaps none of these questions is answerable. In the Expressionist's domain, inner organization is never obvious, and it is only with careful, extended study that one can appreciate Bruce Brown's art. As in the works of other artists who depict the pitcher/batter duality, the viewer wonders where the ball is.

America's national pastime has been portrayed by one of the most diverse lists of artists to have tackled any sport in history. Represented in all schools of art, baseball has encouraged styles from Naturalism to Op to Pop. Recorded in permanent splendor are the portraits and actions of such renowned personalities as Babe Ruth, Lou Gehrig, Joe DiMaggio, Sandy Koufax, Reggie Jackson and Pete Rose. Artists have added to the sport personal insights, both emotional and intellectual, which even the sport of baseball unknowingly forfeited in the course of time.

In the realm of American sports, wrestling holds a prominent place because it stems from the combative nature of man. Through the years wrestling has served the training needs of soldiers, the physical education of America's youth and the egotism of the braggart. The sport of wrestling in America has changed little since the turn of the century. In Thomas Eakins's painting *The Wrestlers,* painted in 1899, the wrestling poses resemble current practice. The wrestlers form basic positions as one attempts to gain victory while the other struggles for freedom.

Eakins's introduction of the partially nude body caused a furor in art circles. Yet today his fame has risen in spite of, or perhaps because of, his semi-nude portrayals. His purposeful evasion of emotion typifies his concern for anatomical perfection. In a sense Eakins experienced art scientifically, and unlike his successors he avoided the one ingredient that led to the famous Ashcan school of painting: emotion. In all likelihood Eakins would deny the absence of emotion in his work, insisting that it injects itself subconsciously. Perhaps the degree to which Eakins's work lacks an emotional punch, particularly when focused on potentially strong emotional situations, depends on the perception of the viewer. In addition, the eye is not always the ultimate judge of emotion; the inner organization of the work relies upon a sustained prior study.

Because wrestling requires two opposing forces, tension varies in accordance with the distance placed between them. Tension heightens as the two opponents approach each other and increase the possibility of physical contact. Once contact is made, the opposing forces become one unit, and all tension now resides in the positive image of the unified wrestlers.

Contrasting with Eakins's placid portrayal is George B. Luks's *The Wrestlers.* Bulging muscles mark the efforts of both wrestlers as they vie for mastery. Swirling masses of sinewy flesh are set in opposition as a rare composition of foreshortening and positioning of lights and darks heightens the drama of combat. The personal display of physical contact enacts Luks's preference for an intimate visual intercourse between artist and subject. Lured into the Ashcan school and likened to Eakins and Bellows, Luks painted the

gutsy, raw, true American scene. Beauty he considered a byproduct of life. The raw, rough characters Luks portrayed in his works are not incapable of evoking compassion. *The Wrestlers,* though brutal in appearance, reveals an inner sensitivity understood only by the wrestler and the artist himself.

The Photorealist movement was in full swing during the seventies, and Rita Hill Torlen's painting titled *Four Wrestlers* is typical of the large scale works the movement produced. Carefully positioned in a Surrealistic environment of simple dark and light planes, the figures disobey the recession theory. An oval arrangement superimposed on a triangular backdrop is elaborately detailed, and the positioning of the wrestlers is emphasized by sharp contrasts. The wrestler tossed from the ring moves the viewer psychologically beyond the picture plane. Yet Torlen manipulates vertical, diagonal and horizontal planes into a gripping confluence of self-punishment and grueling torture.

The conspicuous absence of an audience in Torlen's painting is a Surrealistic element, and the omission of facial expression reminds one of George Tooker's robot-minded mass of humanity. But the size of Torlen's canvas, which measures seven by ten feet, would seem to contradict a Surrealistic intent and link the work to the Pop and the more recent Photorealist movements. The purpose of large canvases is emotional—a Surreal idea would be served just as well on a smaller scale. The dark background suggests infinity of space, a nonexistent environment, a vacuum that beckons its victim. The surface plane on which the wrestlers are anchored floats in space and projects a feeling of security for the wrestlers as long as they remain on the surface. Torlen transforms a common-

place theme of the wrestling game into an image of a survival sport transcending earthly mortality. Regardless of intent, Surrealistic implications prevail.

Closeup views of nature have resembled Surrealism because of their unique recordings. What is seldom seen is likely to appear unreal until it becomes customary to see it more often. Torlen presents a detailed study of four humans in a manner unfamiliar to the critical viewer.

Closely related to the sport of boxing, the body-twisting, muscle-bulging exhibition of fleshy combat that is wrestling draws a spectator crowd of fanatics that often makes a more interesting subject than the match itself. Less popular today than in its heyday during the Great Depression, wrestling serves the artist in its constantly changing compositional overlap of figures.

In any sport, personal experience enables the artist to grasp the emotional and mental strain essential to the essence of the sport. In individual sports such as track and field, the athlete is a loner. Artists acknowledge the loneliness of the athlete by depicting in a personal manner their reactions to the event.

Art and sport seem similar in a unique way. The athlete trains for years to prepare for a given moment in time, while the artist spends an extensive period of time in preparation for recording a split second of action. But the act of running, jumping, tossing or vaulting is temporary, while the result of recording the event—the work of art—is permanent.

The track and field athlete affords the artist a versatile range of artistic stimuli, as is shown in Max Weber's superb painting *Athletic Contest,* executed in 1916. As a result of the influence of Europeans (Braque, Gris, Léger) bits of realism emerge throughout. The painting itself is

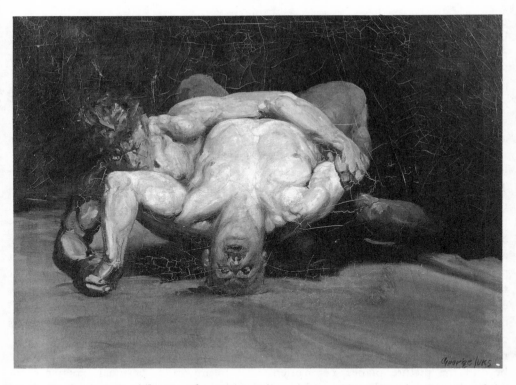

George Benjamin Luks. *The Wrestlers* (1905). Oil on canvas, 66¼ × 48¼ in. Courtesy of the Museum of Fine Arts, Boston, the Hayden Collection.

a duel of the opposing forces of energy and rest. Forms overlap in a continous battle for supremacy. The photographic rendering of movement is evident in the pole vault, the hurdles and the running events. Numbers and letters are scattered throughout, symbolizing competitors' identifications. Human heads, segmented to project an image of intuitive response, fulfill the emotional and intellectual levels needed for the abstract elements. *Athletic Contest* is a panorama of the diversity of the sporting world.

A singularity of subject matter is encountered in *The Hurdler,* a painting by Conrad Marca-Relli. The abstract nature of the work stems from the artist's emotional and intuitive response to the action. Since the painting is completely void of visual realism, the viewer becomes

the hurdler in space, running and jumping in a rhythmic pattern. Bodily motions overlap each other and those of the composition as the composition flows from left to right. It is difficult to identify the hurdlers. Instead, geometric shapes of varying colors overlap and interpenetrate or simply lie adjacent to one another. The fierce combat is characterized by the proximity of shapes and sharp contrasts.

Extreme distortion coincides with self-determination in Jacob Lawrence's amazing depiction of a relay race. As the runners near the tape, each seems in state of anguish. Realism is ignored in favor of compositional unity as the five runners contend on a three-lane track. Flat patterns of color prevail in contrast as linear accents are used to guide the viewer smoothly through the painting. Accuracy

is rejected in favor of physical distortion. The human condition is suggested in the intense physical agony of the athletes. Lawrence uses the running form as a springboard to artistic achievement.

In Lawrence's masterpiece, *Study for the Munich Olympic Games Poster,* each background segment is interrupted compositionally by a positive factor of the idea. Although laid out by plan and diligently executed, the work is suffused with intense emotionality. Distortion characterizes the drawing, and the application of color merely maintains the high degree of exaggeration. The colors and shapes of the batons of the five runners are duplicated in the upper surface of the painting. The lines dividing the track lanes serve to slow the viewer's eye movement, allowing freedom to enjoy the runners crossing the finish. Lawrence's style differs considerably from Conrad Marca-Relli's technique of distortion in that Lawrence's somewhat similar idea relies on visual reception, while Marca-Relli's approach depends entirely upon an emotional response.

Unlike the interpretation by Lawrence, which shows a front view of the finish, James-Paul Brown presents a rear view of a similar scene. The two also differ in the artists' philosophical and psychological perspectives. Where Lawrence reflects on the highly emotional effects of a grueling race, Brown exhibits a pleasant reaction — emotional, perhaps, but with a jab of exuberance.

Pastel colors are flatly applied except for the obvious highlights and shadows, which seem splattered onto appropriate surfaces. Brown abandons realism as shadows become contrary elements. Much of Brown's splashy technique when isolated into smaller subordinate compositions appears disorganized, although on a larger scale unification becomes evident.

The sport of running becomes a joyful experience. Carefully distilled colors overlap, blend, emerge, submerge, advance and recede. Brown bounces colors onto canvas in a deliberately Impressionistic style with an intuitive awareness unlike that of any of his contemporaries.

In most of his works, Brown focuses on a single performer (an exception is *The Race,* in which four runners compete for laurels). His painting *The Hurdler* draws the viewer closely upon the performer, exercising Brown's Impressionistic style in full force. The viewer experiences the turmoil of an agonizing race. Expressed in abstract form, *The Hurdler* emerges into full view as the distance between the painting and the viewer widens. Muscles, represented by quick jabs of the brush, bulge and float in exhilarating gestures.

Although Brown's *Hurdler* is an abstract representation, its results are more objective than Marca-Relli's painting of the same title. Both rely on abstract qualities, but Brown's initial charge is objective, and the resulting images take on an appearance of applied intuition. One is struck by Brown's preoccupation with the intuitive process that emerges from an objective origin. Marca-Relli's meticulous composition demands extensive study in search of an inner order that defies the viewer.

The sport of track suggests various reactions on the part of the spectator as well as diverse interpretations by the artist. Like any sport, it has a scientific aspect and physical, emotional, spiritual and intellectual manifestations, and so grants to the artist a great freedom of personal reaction. Not only does the artist have the choice of individual interpretation, but he is free to select his mode of presentation.

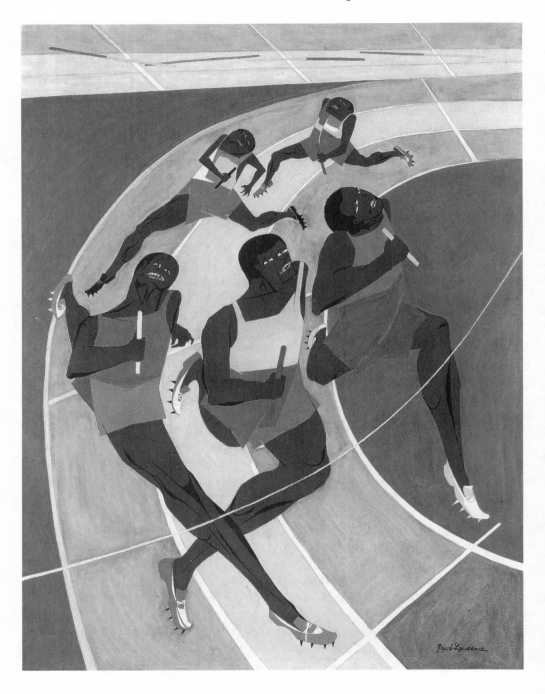

Jacob Lawrence. *Study for the Munich Olympic Games Poster* (1972). Gouache, 27 × 35½ in. Courtesy of the Seattle Art Museum, purchased with funds from PONCHO. 79.31.

A strange paradox exists in Suzanne O. Weber's painting *Runners*. The long-distance runner is a loner, and consequently Weber's marathoners are individualists. Each exemplifies a different physical, intellectual, spiritual and emotional makeup, yet Weber insists that individual runners be identified only by number. The runners resemble robots moving by rote. Arms swing in unison, forming a rhythmic pattern of shadows and highlights. An eerie atmosphere permeates the crowd of runners as they methodically move across the pavement, which acts as both foreground and background. Baseline theory evaporates as runners occupy the surface to which they are anchored.

Weber's crowd of runners emerged from a single runner. One by one the group developed until each individual merged into a whole. One views the individual runner not as a single entity but as an integral part of the whole. In order to sustain this anonymity, Weber treats her subjects collectively; hence the lack of individual emotions. The emotional charge of this work comes from the artist's own involvement.

Emotion in the physical, humanistic sense is abolished. Individuals do not react feelingly to their sport; nor does the spectator. One views Weber's work emotionally as a complete work in which the intellect, spirit and physical being function simultaneously. Compositionally, the vertical structure of the runners is complemented by the negative horizontals of shadows and white parking lanes. The numbers identifying the runners tend to unify the composition and break the monotonous tone of the group. In a sense, a bit of Surrealism hangs over the work. One is reminded of George Tooker's icy humans, whose robotlike features

stand the viewer still. Except for the strong sunlight brightening up the destiny of Weber's runners, they too would fall into a state of anonymity. *Runners* is objective in nature but subjective in appearance. As one studies individual runners, the similarities force the viewer to abandon the objective approach in favor of a holistic appraisal.

Weber's method of painting is preconceived, prearranged and deliberate in its application from start to finish. Results are visualized in advance so that the idea forms at the drawing stage. Weber strictly adheres to her plan, as do others utilizing the Photorealist approach. Yet she adds a note of eeriness, a loneliness that is not evident in the drawing. Although the drawing of *Runners* is a complete composition, within each runner is a shifting atmosphere of darks and lights that become cemented in place when color is added.

Unlike other artists who delight in the agony of the finish, Weber prefers to consider a cluster at the start or midway through the race. Emphasizing the group identity by avoiding individual facial expression, she numbers her competitors, but only as a technique of compositional unity, not for identification. Number 18, in spite of room to run, manages to go unnoticed as an individual and fuses into the pack.

Unlike Suzanne O. Weber, who eschews individual identification, Mary Hatch lessens the number of runners and identifies spectators as eyewitnesses. Each figure has its own personality. Hatch's run is not a race for victory but a social commentary on the running craze. Obsession, indifference, dedication and fantasy participates in the work titled *Different Paces*. Lacking are agonized leers, distorted muscles, anguished faces and despairing

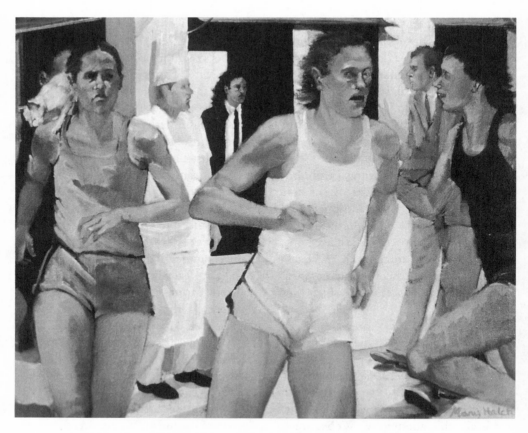

Mary Hatch. *Different Paces* (1983). Oil on canvas. Courtesy of the artist.

bodies. Hatch's lack of artistic emotionalism is the result of an intellectual and carefully conceived plan of composing her subjects. Positioned between the three runners are solid structural units acting as background for the observers. The artist's technique is academic but hints at George Tooker's robotistic rendering of human figures. Hatch's runners move but, momentarily frozen in space, lean toward a Surreal image, maintaining a pace unlike any seen in the works of other artists.

Anchored to a horizontal plane are the vertically oriented onlookers, mired in their selfish outlook and tolerant only of their own identity. Hatch uses the sport of running as a springboard for intellectual inquiry and compositional exploration.

None of the artists discussed uses the sport of track and field as a rebellious symbol for social change. Lawrence hints at it, but his dramatic display is far less violent and traumatic than Murray Stern's protest against the sport of football.

Several determinations are made in the production of art in relation to the nature of sport. The artist may record visually what he sees, react emotionally to what he sees or alter the course of life because of what he sees. He may decide to experiment with what he sees or feels, or he may record symbolically that which is seen. Finally, the artist is determined to use the sport of track as a motif for some manner of change. It is essential that the artist go beyond the mere recording of a sport and,

if possible, use ideas to alter the lives of others.

One of the few sporting events actually created in the United States is the game of basketball. In 1891 Dr. James A. Naismith, a Canadian clergyman, combined several elements of different sporting events to form what would mushroom into one of the greatest spectator sports in America. Such All-Americans as Bill Russell, Oscar Robertson, Bob Cousy have been portrayed in paintings by such artists as Stanley Martineau, Robert Handville and Russell Hoban. Artists have avoided painting with the kind of simple recording that is typical for depictions of such sports as football, boxing, wrestling and hockey, perhaps because of the less violent nature of basketball.

Marsha Feigin's etching *Basketball* illustrates the player/spectator theory, drawing the viewer into the rebounding act. The back view of the player eliminates extraneous material and concentrates on what is about to happen, whether it be rebound or a basket. Feigin's Photorealist approach is technically flawless. The vertical posture of the figure, overlapped by the strong diagonal backboard, forms a geometric arrangement of highlights and shadows. The blank background contrasts with the positive force of the play. Feigin's work portrays a single act that evokes a strong subjective response. The artist has departed from the reality of the sport in favor of compositional unity. This artistic privilege establishes the use of the sport as stimulus to the art form regardless of purpose.

A closeup view of Mark McMahon's drawing *Basketball* is revealed in *Basketball No. 2,* in which the complexity of combat takes an artistic twist. Reality gives way to free-flowing figures executed by impulse without regard for accurate visual recording. Abstract qualities prevail as the artist divorces the visual from the emotional. The players' bodies are blocked out by the method of intense concentration that accompanies the contour/gesture technique of visually recording moving objects. Each figure, separately drawn, functions independently of the other figures, but McMahon manages to integrate the individual drawings into a whole.

Sporting events in America were especially popular during the Great Depression, and the American artist promoted them further with works commissioned by the WPA. Since horseracing had always been a popular spectator sport, it became an ideal subject for such artists as Vaughn Flannery, whose *Horses Arriving at the Start, Fair Hills, Maryland* portrays a moment of contemplation as horses and jockeys prepare for the start. Seemingly relaxed or preoccupied, jockeys maneuver toward the starting gate. The simple overlapping of horses, creating advancing and receding divisions of space, adds to the mute excitement. Each jockey shifts in posture as he quietly but nervously checks essentials. Horses' numbers correspond in linear fashion with stripes of the jockeys' clothing. Technical devices are employed when needed but not to the point of interrupting the composition.

Flannery interestingly guides the viewer's attention into the distance, then suddenly shifts attention to the extreme right of the canvas. Strong temptations to let one's gaze wander out of the picture are thwarted as the artist successfully moves the viewer back to the center of the canvas through color and overlap.

In Roy Moyer's painting *Horses and Jockeys,* the viewer has nowhere to go. The forward thrust of the subject totally

occupies the canvas, eliminating spectator space. Faceless jockeys further strip the painting of temporal and spatial elements. The artist purposely avoids the typical racetrack characters and festive atmosphere of colorful flags, banners and silks, preferring the darkened mood of a cool palette. Yet in spite of the limited palette and other restrictions, or perhaps because of them, an intense emotional impact is made. Perhaps the scene's simplicity creates its own emotion. A limited palette frequently inspires a higher intellectual and stronger emotional expression.

Moyer's highly personal statement borders on Surrealism, with grotesque masks that resemble weird gas masks. The subordinate background allows no freedom for the viewer, who is forced to dodge the oncoming horses or be trampled by their hooves.

Fay Moore's *Steeplechase Start* glows with anticipation as relaxed jockeys approach the start. The pastel medium brings the drawing a fresh look. Etched lines accentuate the contours of both horses and riders as they proudly move ahead. Overlapping shapes cover the canvas eliminating negative space. Moore's knowledge of horse racing and horses is evident in her anatomical workmanship.

In contrast is Vaughn Flannery's 1932 painting *The Maryland Hunt*. Horse and rider gird for the start as the flagman waves the participants into action. The rear view establishes the goal in the distance and acts as a horizontal ploy sustaining the central plane of the painting. Each contestant is eager to win as horses stampede to the lead. In any moving situation, the technical style determines the action, or at least the appearance of action. Moore expresses intuitive responses solidly anchored in anatomical perfection. The technical activation of paint propels movement whether or not it exists within the idea.

In similar fashion, Flannery's *The Maryland Hunt* moves the viewer into the distance. The positioning of the horses and riders in the foreground marks the start. The viewer quickly spots the destination ahead. Bits of slashing brushstrokes suggest an emotional response. The immediate foreground will eventually lose its excitement as the horses draw away from the viewer. The objective approach limits the emotional response since attention is shared by several participants.

The visual expression of an event depends upon the artist's ability to record faithfully or to employ distortion in order to deepen, broaden or change the painting. In *Florida Downs,* Sandor Bodo sends the viewer into the race. The onrushing horses loom large as they approach the finish. Bodo's technique is academic, but honest in its purpose. No secondary motives clutter the view as the artist realistically extends the race to suit the viewer's anxious anticipation. Bodo is careful to subordinate his background, yet he allows it to establish the proper setting. Each horse and jockey is given individual attention. The background and foreground sustain the action on the track and yet provide a realistic, objective environment. Bodo's is a masterful rendition of the sport of kings.

Similar in concept, composition and technique is Kristopher Copeland's *Horse Race.* Dirt flies in the jockey's faces as horses fiercely gallop to the finish. Copeland integrates the viewer with the action, realistically surmounting the technical problem of maintaining immediate action throughout a painting that depicts separate activities. The painting of galloping horses, complete in itself, and the

scattering of dirt as an aftermath are unified into a single act upon canvas.

Copeland lets a part of the lead horse's head protrude beyond the canvas yet maintains compositional control by the positioning of other figures. The closeness of the subjects subordinates the race audience in importance to the viewer.

The ghostly appearance of Moyer's *Horses and Jockeys* recurs in Marsha Feigin's etching *Rider.* Both horse and rider wear protective gear that obscures their natural appearance. Feigin shifts the visual recording to an artistic level, using both the horse's mask and a frontal view. This unusual presentation balances between the real and the Surreal. Graded tones resting between the extremes of black and white radiate an eerie, magical quality. Whenever painting is so perfectly rendered as to cause an effect the opposite of its intent, a new art form has been created.

The sporting event of polo is subject to several interpretations. The artist weighs the advantages of portraying the buildup to the match, the event itself and the decision and determines which best parallels his own philosophy, ability and interest.

George Bellows gained fame for staging emotional atmospheres, and polo supported paintings of unusual tension. The sport is a compromise between the tameness of tennis and the ferocity of boxing. The skill of horsemanship on the finest thoroughbreds excited Bellows, who, although thwarted by preconceived notions, was quick to recognize the dual courage of horse and player. "Nerve tucked under their vest pockets" was how Bellows described the riders in these dramatic clashes, as shown in his polo drawings of 1921.

Horse and player unite in dual perfor-

mance as mallets swing high to send the ball skimming along the turf. Horses manipulated in quick starts, thundering gallops and screeching halts prey on the nerves of the riders. Bellows utilizes the open spaces of the outdoors to contrast with the bulk overlapping of horse and rider. His focus on the central action is complemented by isolated groups on either side of the canvas.

In his painting *Polo at Lakewood* , Bellows matches a stormy sky to a potentially explosive polo match. Seven horses with riders converge at a single point in an effort to strike the ball with the mallet.

Polo demands terrific concentration on a single object. The artistic attempt to focus without destroying the path to the focal point forces the artist to solve the problem individually. The polo ball dictates the action of the painting.

Polo Spill, an etching by the perpetual antagonist Paul Cadmus, reflects the social aspect of the sport. All of the elements of composition focus on the spill, which leaves the viewer uncertain of the effects of the accident. The socialites react with disdain and horrified amusement while the victim pleads for assistance. Even the sky erupts with pain as clouds hover over the scene. Sunshine, symbolic of hope, pours down upon the tragedy, which is purposely made insignificant in size and location.

Cadmus seldom pictures single events without introducing an element of social protest. The polo match becomes the cause of the painting rather than the effect. The exquisite detail that is part of the Cadmus trademark is clearly evident.

Although the polo match is subordinate to the social commentary in Cadmus's work, the opposite is true in Bellows's rendition of the same situation. In *Polo at Lakewood* a cluster of fashionable

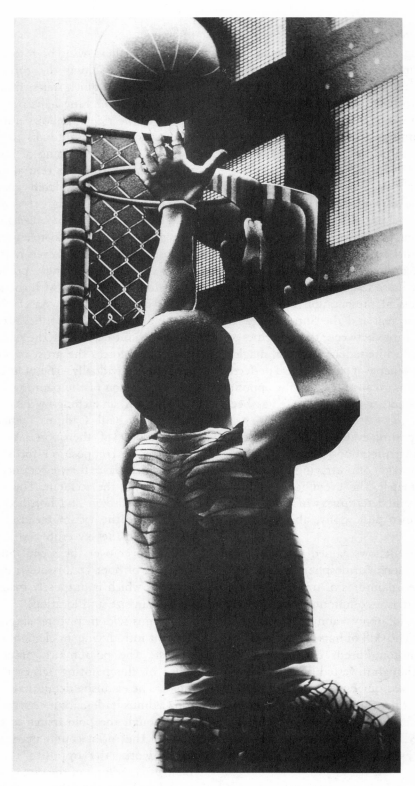

Marsha Feigin. *Basketball* (1979). Etching. Courtesy of the artist.

spectators, made even more splendid by the silk-hatted carriage driver, is kept at a respectful distance so as not to distract from the focus of dramatic action. Not only do the horses and riders plunge into action, but the viewer of the painting is forced into the skirmish.

Reminiscent of medieval combat is Roderick Mead's etching *Polo,* in which the ball rests quietly amid grassy shadows as three armor-clad riders charge into it. Highlights of pure whites adjacent to solid blacks intermixed with textural patterns dramatize the match. Severe anatomical distortion accents the movement of both horse and rider as mallets swing in reckless abandon. The ball is the focal point of action in a triangular composition set against a middle ground of grey. The beauty of this etching lies in the balance, an arrangement of completeness. Applied design seems to embellish rather than accentuate the basic idea. *Polo* was executed in 1950, shortly after World War II, when the sport of polo was still popular in the East.

Hockey was born in England and was played in Canada as early as 1876. Still recognized as Canada's national pastime, it was introduced to American audiences in 1920. One of the leading international artists of the sport is Ken Danby, whose now famous painting *At the Crease* is a masterpiece in tempera incorporating several schools of thought. An initial glance reveals a Surrealistic image of mystery and wonder. The human form, hidden beneath hockey paraphernalia, seems immortal. One is unaware of the strong fundamental composition.

Completely opposite in approach and style is Frizt Bultman's collage painting *Face-Off.* Working in tones of grey, Bultman maneuvers geometric shapes in space in symbolic fashion. Varying squares of grey tones dot the painting surface, suggesting positions held at face-off. There is no action, no human success or failure, no crowds, no flashing skates, no excitement. Drama is generated by the positive and negative aspects of a low-keyed palette as an abstraction represents the reality of life. The design itself symbolizes the action. Bultman succeeds in presenting a highly sophisticated statement, an intellectual manipulation of idea and technique. Geometric shapes advance and recede in space according to adjacent and surrounding environments.

Similar to Danby's *At the Crease* in eerie appearance is Isadore Seltzer's *Hockey Player.* One questions whether there is a human hidden behind the ghostly face mask. The human element is completely obliterated by an ironlike mask with strange protrusions. Cumbersome protective gear covers the goalie's legs as a mitt clings awkwardly to a paddle in lieu of a hockey stick. Deliberately positioned streaks of color emerging from the goalie's feet combine with the ghostly appearance of the hockey player to form an invitation to violence. The goalie, as the protector of his team's goal, is forever in a state of tension, either preparing for an attack, actively engaged in preventing a score or recovering from an onslaught. Seltzer uses the painting not only to promote the sport of hockey but to render the incidental meanderings of the medium into a psychological portrayal.

In Marsha Feigen's etching *Hockey,* opposing players overlap to form a compact unit of energy that is soon to split into single entities. The anticipation of combat assists the psychological movement of the composition, while the merging of the two forces sustains its stability. Within this mass resides a sensitivity

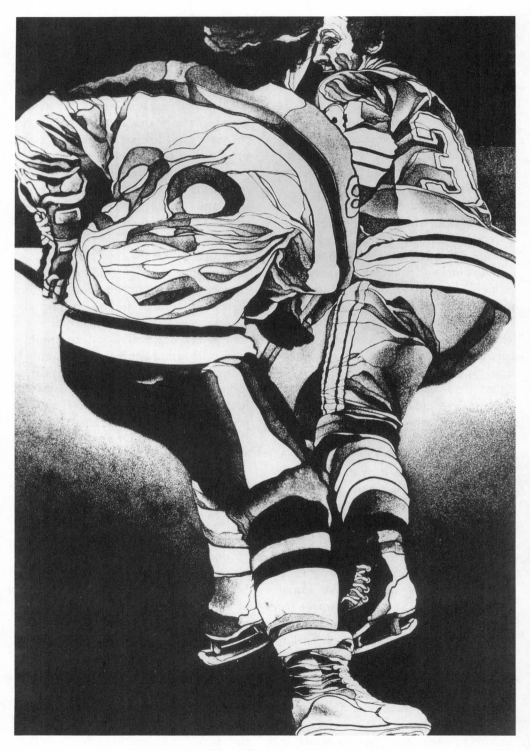

Marsha Feigin. *Hockey* **(1978). Etching. Courtesy of the artist.**

toward human movement as contour lines define bodily action.

Competitive speed skating in America began well before the turn of the twentieth century, yet its popularity has remained low because of European domination of the sport. Ken Bartholomew, Del Lamb and Vic Ronchetti dominated the American scene in the late thirties and early forties, but it was not until Eric Heiden monopolized the event in the 1980 Olympics that America forged ahead in world domination.

Artist Ray Caram's *Speed Skating* (1979) is an overlapping of speeding figures, thus creating an eerie atmosphere. His speed skater is posed with one arm tucked behind his back as the other arm swings in turning the curve. The essentially blue palette transforms a typically cold sport into an icy panoramic display of championship form. The free-flowing watercolor technique adheres to Caram's philosophy. The wet-on-wet style of painting enables Caram to gracefully move his figures to appropriate positions. The easy stride of one skater overlapping a tensed, determined figure rounding the curve indicates the ease and speed of the racing skater.

Alex Colville's painting *Skater* superbly illustrates features of both the Photorealist and the Surrealistic schools of thought. Unlike others whose charging front views capture viewer attention, Colville's reversal of form cements the spectator's vision in space and suggests a trek toward infinity. The unusual composition relies on extreme foreshortening of the upper and lower torso as a diagonal positioning of the racing skate suggests a speed skater at full speed. Colville excites a vast area of the lower environment with clean blade incisions, forming an abstract pattern in the icy performing platform.

The female skater, draped in cashmere and fur, waltzes in a typically relaxed fashion into a world of uncertainty. Surrealistic in concept and Photorealist in technique, Colville's work reflects an illusion of reality. The silhouetted lower torso suggests an optical illusion in an otherwise poetic setting.

The sport of skiing, still dominated by the European nations, has had its moments in America. Like speed skating, skiing reached a peak of recognition during the Depression and, though its reputation declined severely afterward, it regained some of its popularity during the 1980s. Artist Ray Caram succeeded in recording the sport in a recent series of paintings.

Byron Thomas's painting *Suicide Six,* a unique combination of Photorealism and Surrealism, is a masterpiece of objectivity, yet with a personal touch reminiscent of early Flemish painting. Its porcelain surface creates an eerie backdrop for weird creatures maneuvering down a monstrous mountain. A stormy sky shrouds the skiers on the vast snow-clad landscape as delicately naked trees dot appropriate locations throughout the painting. In spite of the deliberate placement of the figures, a casual atmosphere prevails as the skiers thrive on the adventurous slopes.

William Palmer, noted for his casual, quiet, unassuming portrayals of life, further exercises his unique talent with his unusual interpretation of the sport of skiing. His work titled *Snow Ridge, Turin* is laden with excitement. Although somewhat concealed by the scores of skis at rest, avid skiers jam the slopes. A shroud of mystery hangs over vast dunelike slopes on which skiers appear as tiny creatures faced with insurmountable obstacles. Palmer splits his painting into three areas.

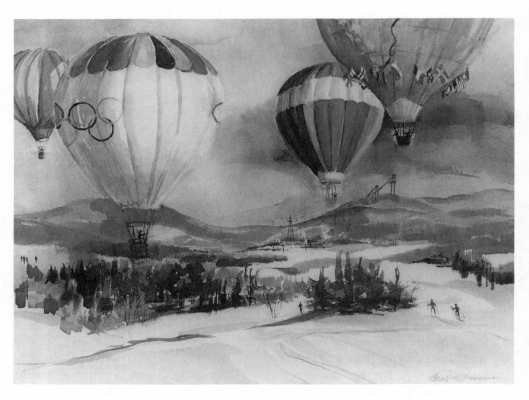

Cecile Johnson. *Skiers and Balloons* (1980). Watercolor, 30 × 20 in. Courtesy of the artist.

Although the sky acts as one area, its objective emptiness serves as a subjective statement, setting the stage for emotional circumstances. The middle ground pictures vast slopes challenging seemingly insignificant skiers, while the foreground anchors dozens of upturned skis, symbolic of the rest that follows action. The skis in turn unite the two lower sections of the work and are symbolically repeated in the area nearest the sky in the form of trees. The medium of suma ink on paper creates beautifully rendered effects of light and shadow.

In contrast to William Palmer's contemplative sky, Cecile Johnson's *Skiers and Balloons* practically removes the sky from evidence by filling the major part of it with hot-air balloons. The artist forces the viewer to acknowledge the balloons, erasing any notion of a meditative atmosphere. Instead, Johnson seems to promote a sky-land competition, a race between man on land and man in the air. The artist's reflective yet intuitive brushstrokes activate the work throughout, leaving no portion of the canvas void of activity. Even where a negative area exists, its adjacent counterpart offsets it.

The paintings selected for discussion in this chapter represent a highly selective sampling of works on this popular theme. Several worthy artists are not represented, but the paintings included should be sufficient to indicate the theme's significance.

Bibliography

Alexander, David. *A Sound of Horses.* Indianapolis: Bobbs-Merrill, 1966.
Barick, Bill. *Laughing in the Hills.* New York: Viking, 1980.
Berry, William. *Great North American Ski Book.* New York: Scribner, 1982.
Bradley, David. *Expert Skiing.* New York: Grosset & Dunlop, 1960.
Bush, Jim. *Inside Track.* Chicago: Regnery, 1974.
Call, Frances. *Practical Book of Bicycling.* New York: Dutton, 1981.
Casson, Ray. *Encyclopedia of Wrestling.* New York: Barnes, 1972.
Chisam, Scott. *Inside Track for Women.* Chicago: Contemporary Books, 1978.
Costanza, Betty. *Women's Track and Field.* New York: Arlington House, 1978.
Cutino, Peter. *Polo.* New York: World, 1976.
Disston, Harry. *Beginning Polo.* New York: Barnes, 1973.
Dobereiner, Peter. *World of Golf.* New York: Atheneum, 1981.
Dorsey, Frances and Wendy Williams. *Creative Ice Skating.* Chicago: Contemporary Books, 1980.
Douglas, Robert. *The Making of a Champion.* Ithaca, N.Y.: Cornell University Press, 1972.
Dryden, Kenneth. *Face-Off at the Summit.* New York: Little, Brown & Company, 1973.
Fischler, Stan. *Everybody's Hockey Book.* New York: Scribner, 1983.
Halberstam, David. *The Breaks of the Game.* New York: Knopf, 1981.
Henkes, Robert. *Sport in Art.* Englewood Cliffs, N.J.: Prentice-Hall, 1986.
Killy, Jean-Claude. *Situation Skiing.* Garden City, New York: Doubleday, 1978.
Livingston, Bernard. *Their Turf.* New York: Arbor House, 1973.
Marshall, Jeff. *Bicycle's Bible for Riders.* Garden City, N.Y.: Doubleday, 1981.
Pearson, Billy. *Never Look Back.* New York: Simon & Schuster, 1958.
Petkevich, John. *Skaters Handbook.* New York: Scribner, 1984.
Rosen, Charles. *Players and Pretenders.* New York: Holt, Rinehart & Winston, 1981.
Smith, Robert. *Baseball.* New York: Simon & Schuster, 1970.
Stamm, Laura. *Power Skating.* New York: Sterling, 1982.
Stephenson, Richard. *Ice Skater's Bible.* New York: Doubleday, 1982.

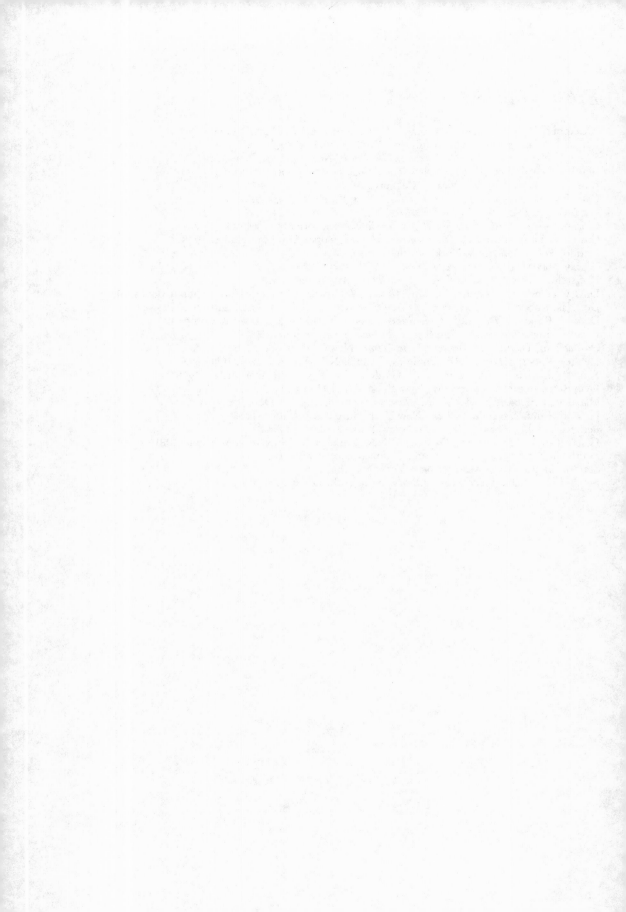

THE CRUCIFIXION

The enduring theme of the Crucifixion has been prominent in the minds of American artists during and after World War II. In fact several artists have devoted their lives and careers to the life of Christ through their painting as a direct result of World War II. William Congdon, Fred Nagler, Umberto Romano, Louis Freund, Xavier Gonzalez are a few whose careers focused on religious themes. Others turned to religious painting late in life, including Edward Boccio, Jon Corbino, Hans Moller and Peter Blume.

In a contemporary vein, the thoughts of Xavier Gonzalez coincide with the 15th century great Mathias Grünewald. He maintained in an indifference toward heaven and hell; it was the fear of Christ, the Son of God, that caused his unwavering faith in spite of universal despair caused by sin, suffering and doubt. Gonzalez transcended temptation and acquired a divinity of spirit which he never relinquished.

The crown of thorns so symbolic in much of the contemporary work is evident in the works of Hans Moller as his single motif in depicting the Crucifixion.

Clarence Carter and Georgia O'Keeffe, among others, avoided painting the suffering Christ by totally ignoring the figure and exhibiting a bare or decorative cross. Reasons for this choice could include a refusal to acknowledge the intense suffering of a human being regardless of the purpose of the suffering, or a lack of faith in the story of the Crucifixion. The most contemporary reason, however, is the matter of artistic style.

The contemporary American religious painter typically makes a sincere effort to be true to Christian principles in order to convey the message of the holy gospel. Religious art has long been divorced from the church, but only now is the American painter free to pursue personal reactions to the Crucifixion. By the same token, the very fact that the church does not support religious art endangers the artist's financial survival. The church does not acknowledge the ability of the artistic process to promote spiritual awakening in human beings and rejects the notion that artistic expression is a significant extension of God's plan.

American artists have consequently

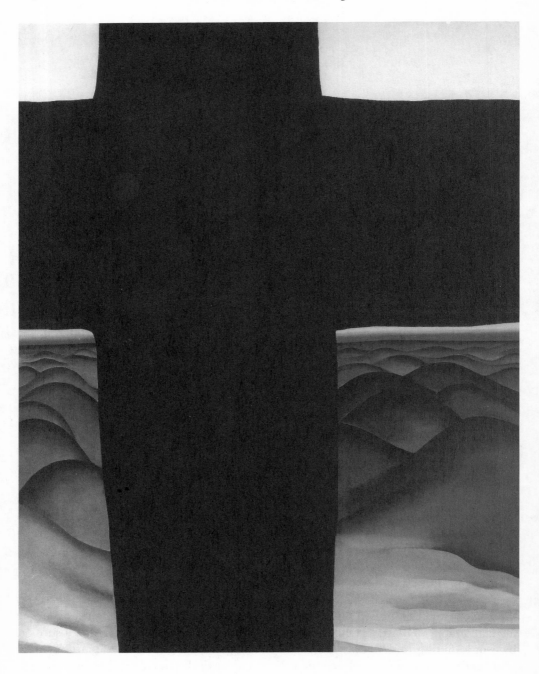

Georgia O'Keeffe. *Black Cross, New Mexico* (1929). Oil on canvas, 77.2 × 99 cm. (30⅜ × 39 in.). Collection, Art Institute of Chicago. Art Institute Purchase Fund, 1943.95. Photograph ©1990 the Art Institute of Chicago. All rights reserved.

ignored the church in terms of artistic expression and treated religious themes according to personal preference. Peter Blume, for example, utilizes silver votive offerings as symbols which are attached to a burlap loincloth like decorative ornaments on a Christmas tree. Included are the dice rolled by the Roman soldiers for Christ's garb, two horsemen with the lances which pierced the side of the victim, the skull symbolizing the dead that preceded the Crucifixion, a crudely built ladder, a claw hammer and three spikes, a crowing cock and a kneeling figure. In the midst of all this apparatus is the figure of the crucified Christ.

Franklin Watkins also places Christ on a secondary level. Though allotted a central location, Christ shares the canvas with two other personalities. In addition, three Easter lilies line the base of the canvas, three nails are strewn below the cross and a large urn, a hammer and a fig branch lie beneath the feet of the crucified Christ. A partially built altar sets behind the cross upon which lie a chalice and the Bible.

The American artist seems obligated to express the Crucifixion theme for reasons other than religious. Robert Indiana, for example, draws a parallel between the crucified Christ and the slaying of Martin Luther King, Jr. The murder of King represents one being following Christ to the cross. The sociological emphasis of Indiana's painting coincides with that of other American artists.

Umberto Romano, in his painting titled *Ecce Homo* (which is further discussed and illustrated in Chapter 10), presents a robust Christ in a manner that an audience cannot fail to recognize as the savior of the world. Romano has consistently drawn upon the message of the Crucifixion to alert society to tragedy caused by the abandonment of religious tenets as a solution to social difficulties.

The philosophical statement of scorn has never been so forcibly evident as in Nathan Rabin's *Crucifixion.* Rabin utilizes banal and commercial objects to project society's ignorance of Christ's message. Mixed with symbols of the Crucifixion are images of the game of tennis. Rabin seduces society, injecting the burlesque into a deadly serious event and thereby causing man to look into his own soul and cringe at the seemingly complete disregard for the Christian message.

Similar in nature but of a more profound sensitivity is Valfred Thelin's montage/collage painting titled *Then 'Til Now,* in which tragedy overlaps with joy. Instead of Christ's figure on the cross solely occupying the canvas, several individuals and events appear simultaneously: Moses smashing the Ten Commandments, a mother and child, a crucified Christ accompanied by a sobbing woman, praying hands and tombstones. The result is a montage of the Old and the New testaments.

Famous for his social commentary, Henry Koerner in *Crucifixion* presents a drastic change in content, style and composition. His switch from a complex design to simplicity demands of the viewer an immediate response. Christ is absent from Koerner's earlier works, in which man, destined to solve his own problems, falls into the hands of greedy capitalistic monarchs. Koerner in this painting abandons his usual meticulous rendering of color. Beneath his loose, Expressionistic style is a basic anatomical knowledge of the human figure. His Christ hangs tormented, still associated with materialism through the device of the wired structure. Koerner believes that verbalizing his work is a poor method of understanding, and

that the viewer reaps a greater reward through the proper attitude and a suitable background of knowledge.

Joseph Deaderick makes it clear that the Resurrection follows the Crucifixion, and he identifies the tragedy of death with the familiar image of the carnival.

The thought of the Crucifixion for John Blowers was an emotional experience. Unlike many artists, Blowers leaves Christ's physical features unidentified in order to universalize the theme. And the image of Christ is not alone; Blowers portrays the Crucifixion scene as a trinity of figures. It seems at times that the two thieves occupying adjacent crosses merit equal attention because Christ is not considered a divine being by the audience. Most artists, however, consider the significance of central positioning a major factor in a composition.

In reaction to the notion of such extreme physical torture, Blowers paints intuitively. *Crucifixion* (1982) was initiated and completed within a brief period of time in order to set down strong spiritual feelings at their height. This approach relates firmly to the Abstract Expressionist movement. The diagonally employed brushstrokes project the ascending Christ heavenward as if the premonition of rebirth were already known. Blowers therefore celebrates with his work both Good Friday and Ascension Thursday.

Blowers's palette is limited to tones of blue. The background environment is shattered with brisk brushstrokes that emphasize the drama of the event. The consistency of the application of paint creates a compatibility of the three images and their environment. It is this oneness of composition in which the distinction between foreground and background is virtually eliminated. The single frontal plane features similarly applied brush-strokes which totally eliminate the recessive process. All images, including accompanying habitat, are brought forward to provide the viewer a total fulfillment of the emotional experience of the artist as well as of the victims portrayed.

Contemporary American painters have fulfilled the possibilities brought by a freedom from rigorous adherence from church authority. Most artists associated with this theme do approach it from deeply religious convictions, but their freedom from church rule has allowed them to adhere to the message of the Crucifixion without sacrificing artistic principle.

Considered one of America's most dynamic painters of religious themes is Abraham Rattner. Torturous, agonizing swirls of paint accent the terrible segmented body of Christ that appears in Rattner's numerous treatments of this theme. His Crucifixion paintings demand intensive study even though emotions erupt well in advance of intellectual comprehension. An apparent rampaging of color slowly emerges as a technique revealing profound concern for the notion of man crucified. Rattner knows the significance of the Crucifixion in relation to human problems, and his use of the strongest image in the history of mankind forces the viewer into a state of self-examination. Rattner's *Crucifixion* is controversial. One may not embrace his image, but one cannot avoid it.

Fred Nagler, a traditionalist, has painted numerous works on this theme by incorporating the subjective approach of enlarging the central theme while presenting objectively several details surrounding the core of the painting.

One of the early forerunners of religious art in America was Albert Bloch, whose 1911 work was titled *Procession of*

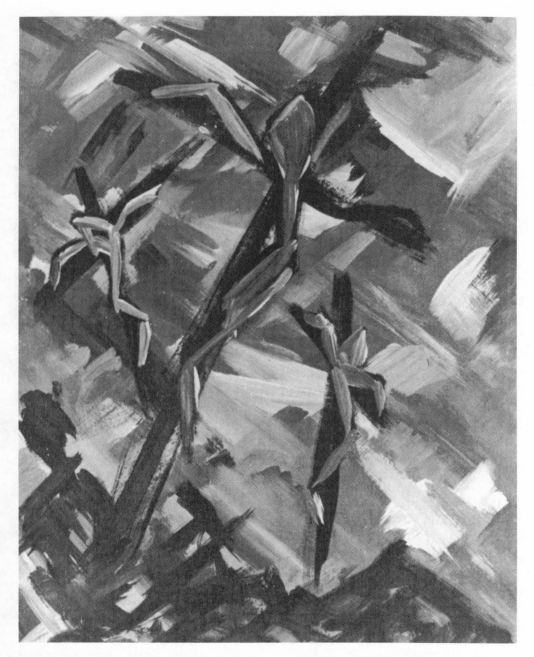

John Blowers. *Crucifixion* (1982). Tempera on paper. Courtesy of the artist, John Blowers, Richland, Michigan.

the Cross. The scene is constructed of blocky terrain in thick brushstrokes of color. Drama is heightened by the compelling procession of mourners who accompany Christ on His long journey to Calvary. Mary and Joseph shelter themselves from the impending tragedy while shielding their sorrow from Christ. There is an extreme simplicity of form in a symbolic gesture of humility. A seedling tree splits the canvas to reflect the new life soon to occur.

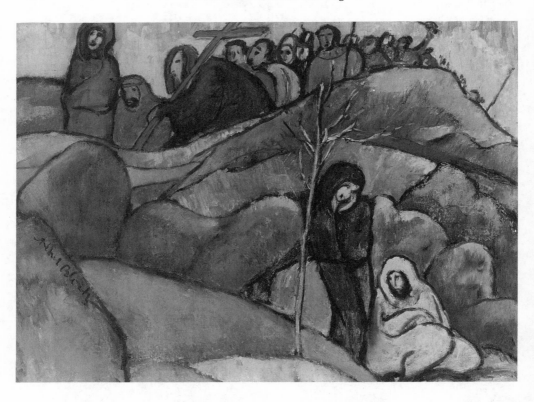

Albert Bloch. *Procession of the Cross (Composition Study)* (1911). Oil on canvas, 30³⁄₈ × 25⁵⁄₈ in. Courtesy of the National Museum of American Art, Smithsonian Institution. Museum purchase, 1982.74A.

The Great Depression became a motivational force in the production of religious paintings, particularly those portraying the Crucifixion. A case in point is Franklin Watkins's 1931 work titled *The Crucifixion.* The excitement of the Crucifixion becomes evident in the emotional manipulation of paint. The grotesque events leading to the Crucifixion form a climactic and chaotic expression of repentence in which the evil-doers react insanely to an event beyond their control. Those who love Christ are outnumbered in the scene by those who are in the process of committing the crime. The unbelievably distorted body of the crucified victim takes on a Surreal appearance as the frenzied audience continues its relentless attack upon humanity in the person of Christ.

With the advent of World War II artists once again turned to spiritual themes. In Rico Lebrun's painting of 1948 titled *Wood of the Holy Cross,* the vertical panel mirrors the symbolic twisting and turning of the victim's body into a distorted, anguished chunk of humanity. Lebrun avoids painting Christ's pain but reflects instead the symbolic image of Christ within the wooden cross itself. Christ has succumbed to the evils of man, but He will resurrect to forgive their sins. The tension of receding and advancing colors creates a strong three-dimensional effect. Spike marks in the wood symbolize the spikes driven through Christ's hands and

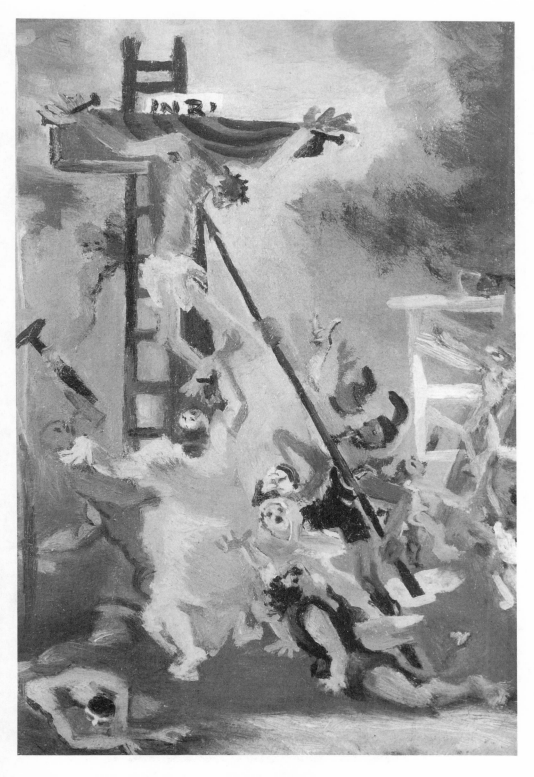

Franklin Watkins. *The Crucifixion* (1931). Oil on canvas, 7 × 10 in. Collection of the Whitney Museum of American Art, New York. Purchase, 31.373.

Rico Lebrun. *Wood of the Holy Cross* (1948). Oil on casein on canvas, 30 × 80 in. Collection of the Whitney Museum of American Art, New York. Purchase, 53.10.

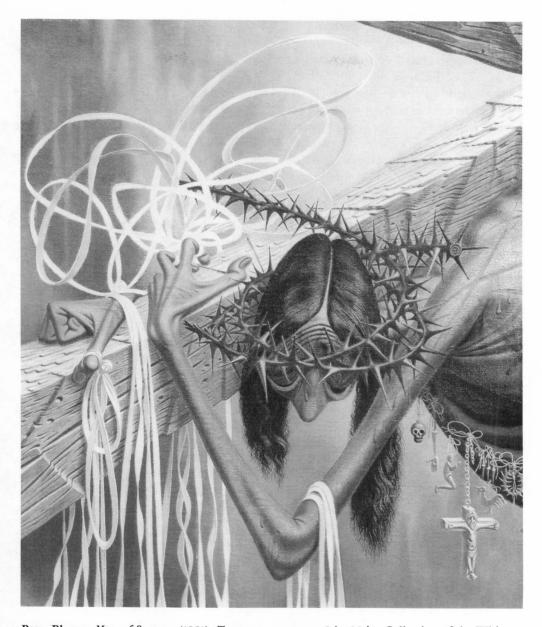

Peter Blume. *Man of Sorrows* (1951). Tempera on canvas, 24 × 28 in. Collection of the Whitney Museum of American Art, New York. Purchase, 51.5.

feet. The shredded message spiked into the upper area of the wooden cross reflects the free spirit of the artist.

Other intensely strong paintings were inspired by the Second World War. In 1951 Peter Blume created a masterpiece titled

Man of Sorrows which recalls the great masterpiece of Mathias Grünewald. Excruciating pain is registered in the extreme distortion of the body. Hands and arms are stretched like rubber bands in sharp contrast to the unyielding mass of

the cross. Articulately designed thorns which pierce the outrageously exaggerated head resemble the barbed wire that encircled the Berlin Wall. Drops of the victim's blood adhere to the sweaty body, and a small crucifix is attached to Christ's garment. Although the painting is objectively portrayed, its extreme distortion creates such a dramatic response that one views *Man of Sorrows* from a purely emotional perspective.

Less distorted but equally dramatic is Seigfried Reinhardt's 1953 *Crucifixion.* Overlapping and interpenetrating elements combine to form an intricate design indicating agony and sorrow. The culmination of torturous events is evident in the excruciating agony of Christ.

The victim's body, abstracted into muscular bits of flesh and bone, shows strength and determination to survive. Rinehardt merges foreground and background and forfeits the formality of a balanced design in favor of a direct focus upon the desperately pleading clenched hand of the victim. Diagonal, vertical and horizontal planes overlap and intersect to form a dramatically enticing invitation to participate. Reinhardt's strong abstract pattern incorporates a lifetime of emotions: hate and love, hope and despair, good and evil.

Philip Evergood's philosophy of life is summed up in his painting titled *The New Lazarus.* Begun in the year 1927, it was finally finished in the year 1954. Directly influenced by the grotesque Mathias Grünewald altarpiece, it shows Christ tortured beyond recognition. It reveals the folly of earthly delights and the uncertainty of temporal pleasures. The desertion of spiritual guidance is revealed in the spiritual desolation, the mockery of justice and the disintegration of the flesh. Greed, vanity and gluttony become sins

of humanity and Evergood reveals the insanity of adhering to such earthly pleasures.

The New Lazarus is a plea for life's reorganization. It represents the hopelessness of life without the guidance of a supreme being and suggests that a new kind of life is essential for the survival of humanity. Evergood has spread throughout his painting blooming flowers poking through the earth's surface. *The New Lazarus* is a panoramic view of life from birth to death with a hopeful view toward a rebirth with a more compassionate outlook on the purpose of life on earth.

The agony of the Crucifixion and its sorrowful effects on the saddened mother are excruciatingly rendered in William Pachner's 1954 painting titled *Avignon Pieta* (see color insert, D). Pachner's escape from Hitler's Germany during World War II did not erase from his memory the atrocities of the Holocaust. Those painful years of torture and executions are now reflected in Pachner's versions of the Crucifixion.

Pachner's original realistic approach gave way to the profoundly emotional style of Abstract Expressionism. Instinctively responding to the agony of the cross, Pachner reveals a deep devotion to a disciplined faith. The relationship between the slaughter of the Jews throughout Europe by the German military and the crucifixion of an innocent man in the person of Christ has been a common theme.

The deliberately distorted body, mutilated beyond physical recognition and garnished with blood stains, demands that the artist maintain emotional control of a medium while experiencing the emotional trauma of recreating the tumultous event of Good Friday. Even in depicting the violent death of a human being, Pachner manages to maintain a semblance

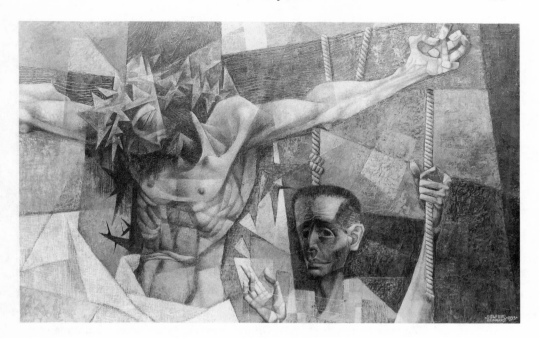

Siegfried Reinhardt. *Crucifixion* (1953). Oil on composition board, 45½ × 28 in. Collection of the Whitney Museum of American Art, New York. Gift of William Benton, 55.2.

of dignity by utilizing a palette of compatible colors and by building a strong structural base so that the composition achieves a strength suitable for the theme being expressed.

Avignon Pieta is a pleasant painting in spite of the extreme distortion of the physical body color. Pachner suggests that spirit has conquered flesh. The Resurrection is soon to follow, and consequently the notion of the risen Christ is suggested by viewing *Avignon Pieta*. *Avignon Pieta* is a contemporary masterpiece long to be remembered for its emotional control of a violently uncontrollable event.

Crucifixion by Liza Shapiro is a highly subjective painting of a theme which intimately affected the artist. The Expressionistic style reflects the anguish suffered by a single human being. Highly suggestive in its application of paint, the painting reveals only by location the iden-

tity of the victims and the mourners. Since two crucifixions are evident, the artist has not defined the identity of either. A third victim is missing, leaving the viewer to assume a personal interpretation. The activated space between the two crosses is partially dealt with by the presence of the mourners. These figures are defined in dark colors but unidentified in all other facets. It is interesting to note the absence of literal activity in the central park of the canvas. The area might serve a psychological purpose as a rest area, but instead it inherits an aura of anticipation. Visual attention to this area is short-lived because of the anxiety created by the two crucified figures on the left and right of the canvas.

Abstract Expressionism maintained its strength during the sixties but lost a number of advocates as the Pop and Op movements entered the art world. The

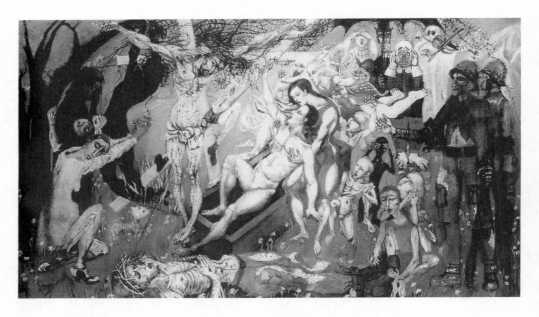

Philip Evergood. *The New Lazarus* (1927–54). Oil on plywood, 83¼ × 48 in. Collection of the Whitney Museum of American Art, New York. Gift of Joseph H. Hirschhorn, 54.60.

turbulent times directly motivated artistic achievement. Social unrest, Vietnam protests, political assassinations, Vatican II, riots, the Kent State killings and racial strife split the nation. Artists became angry, devastated and frustrated, and their cause became a cry for the underdog as vulgarity both in content and execution dominated the art scene. Amid this sea of confusion and uncertainty artists created works seething with hate and anger. Christ again fell victim. The artist turned to the turmoil of the Crucifixion and identified current tragedies with Christ's assassination. In direct reference is Jeanne Miles's 1965 painting titled *Homage to John F. Kennedy*.

Diametrically opposed forces traverse the canvas in overlapping cruciforms. Stark, bold crosses interweave as Miles successfully forms an intricate display of a trinity of events. Several emotional traits expose the birth, death and rebirth in abstract form. Strong vertical thornlike

planes split the canvas. Both darkness and dawn seem to break open the maze of crosses occupying center stage. Two free-floating shapes reminiscent of the star of Bethlehem hang in a lustrous firmament. A staff topped with a circular cross resembles the lead of an Easter procession.

A technically intricate and intellectually provocative work, *Pieta*, executed in 1965 by David Huntley, carries forward the Abstract Expressionist movement of the late forties. This intuitive response to the theme reveals an intimate painterly quality drawn from the artist's personal faith in Christ. Drawn images of the crucified Christ and his followers precede lush brushstrokes applied instinctively to meet spurts of anxiety. Figures are demolished and reinserted or modified according to inner spiritual promptings. Huntley's traditional composition maintains its original position but succumbs to the mood of the moment.

A similar Abstract Expressionist style

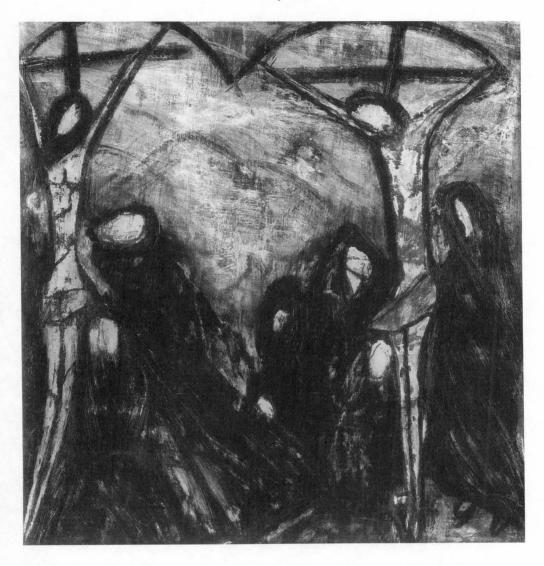

Liza Shapiro. *Crucifixion* (1958). Oil, gouache, watercolor, wax and ink on cardboard, 27 × 30 in. Collection of the Whitney Museum of American Art, New York. Gift of Dr. Mortimer F. Shapiro, 60.38.

appears in Morris Broderson's *Crucifixion II* of 1960. The interpenetration theory is aptly applied as figures overlap and intertwine, bringing the background forward and pushing the foreground back. According to Broderson, imperfection is the key to a successful painting, and that distortion becomes the emotional force behind the idea. Divine creation can never be duplicated and since it is already perfect, attempts to mimic it would result in sterility. *Crucifixion* is a blend of the Crucifixion, the Pieta and the descent from the cross. The combination drawing/painting is dominated by the deliberate distortion characteristic of Broderson's approach.

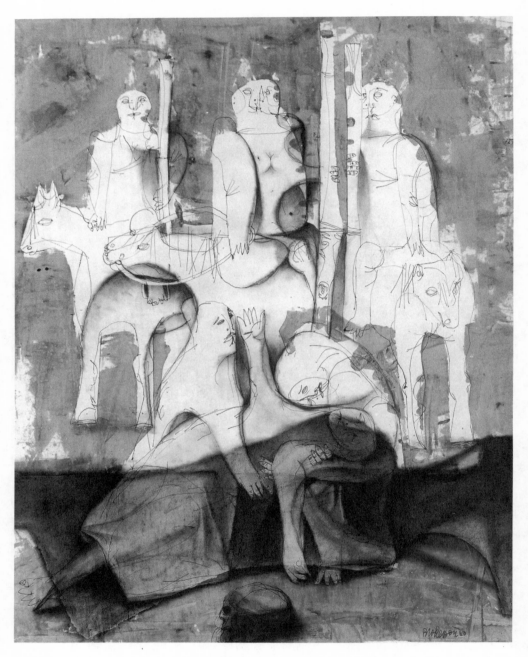

Morris Broderson. *Crucifixion II* (1960). Textile paint, chalk, charcoal and ink on paper, 28 × 36 in. Collection of the Whitney Museum of American Art, New York. Purchase, 60.45.

Clarence Carter, in his Crucifixion painting titled *The Ninth Hour,* painted in 1967, retains a bit of his earlier Regionalist style of the thirties but injects an element of Surrealism. Eluding the agony of the cross, Carter exhibits the darkness of the event. Stark, bold crosses dominate the canvas in a monumental surge of rectangular shapes. A glowing sky, threatening spears and darkened sun set the stage for the tragedy that is to follow. Carter is a master at anticipation. The viewer waits

agonizingly for the event to occur. The painting is cold, objective and calculating, yet eerie in its simplicity of concept and execution. Carter's concept is as simple and direct as his painting.

Expressionism reaches a great height in George Dworzan's *Crucifixion* (1967), a painting which blurs with anxiety and despair (see color insert, F). Christ's body becomes a smear of flesh strewn about the canvas as a symbolic gesture drawn from the gesture or action painting typical of the Abstract Expressionist movement. Human flesh seems to hang in globs as a dreamlike appearance reflects the Surreal image of a real event. The crossbar of the cross is barely visible against the darkened sky. *Crucifixion* is a provocative, intuitive painting of a monumental event.

A certain looseness appears in Abraham Rattner's work titled *Crucifixion,* as if to suggest a bit of mellowness. Executed in 1964, the painting lacks the sharp angular distortions characterizing Rattner's earlier works. Brushstrokes are allowed to move beyond the artist's dictates as if by memory or by a supernatural demand. Colors run, drip, bleed and blend to form meanings, yet are blocked as if to alter concepts. This looseness seems to have freed Rattner to exploit the evils of society, and to fully cast upon the victim the burden of man's sins. His combination of line and shape, never clearly defined, stamps his work with unlimited emotions not unlike Christ's quest to fulfill God's will.

Hans Burkhardt's savage 1965 display of Christ's remains, *Grey Christ,* somehow sustains a completeness contrary to the artist's proposed concept. In a formal traditional layout, Burkhardt has strewn segments of Christ's body in disarray only to fit them piece by piece onto the cross, still segmentized beyond recognition.

The head and hands, although grotesque in appearance, maintain a semblance of distorted reality compared to the lower torso, which is mangled beyond repair. Background blends in technique with the figure on the cross to amplify an excruciating experience.

Despite social turmoil and unrest, Loren MacIver strengthened her personal faith while others ventured into alien territory. MacIver's *Bretagne* eliminates the anguish of the event by shrouding the Christ figure in the joy of Easter. Flooded with flowerlike images, the artist's overall pattern barely reveals the subject matter. Unusual for MacIver is the Impressionistic style she employs in this work, and though she maintains a poetic mystery, she manages a simplicity bordering on Primitivism.

The turbulent composition of Gustav Rehberger's classical spiritualism combines the objective complexity of the Renaissance with the subjective emotionalism of Abstract Expressionism. Several compositions occupy the canvas. Of the three crucifixions, that of Christ is the focal point, flanked by the two thieves. Sharp, angular darks and lights move in stormy fashion as figures sob in anguish beneath the crucified Christ, and Roman soldier readies to pierce His side. Although objectively conceived, Rehberger's *Crucifixion* reeks with the drama in a movingly tragic episode. Rehberger's painting has little to do with the times in which it was painted; rather it is the artist's simple testimony of his everpresent preoccupation with a religious outlook.

Neither did times affect the concepts of artist Hal Lotterman. With Pop and Op dominating the art world, Lotterman continued in his Expressionistic niche with *Crucifixion,* a spiritual example of sacred art and an expression of the duality of art

and spirit. Alert to the pitfalls of objectivity, Lotterman utilizes the image of the crucified Christ as his mind visualizes the tragedy. His application of emotion avoids the detachment of the two forces of art and spirit which so often occurs in contemporary works. Cruciform images blend into the background area to cement the all-encompassing importance of the event.

In a somewhat realistic vein, Henry Koerner shifts his earlier psychological studies of the human race from an audience within the picture plane to the viewer outside the picture plane. No longer are subjects within his painting the observers of the event. Society at large becomes the slayers of the victimized Christ. In his painting titled *Christ and the Mountain,* Koerner exploits the mountainside. His technique and composition veer from Surrealism to realism, but his concept sustains symbolic notions. Koerner casts the guilt on today's society, not merely the Roman centurians of old.

The duality of Pieta and Crucifixion remarkably coincides with the Nativity. The sorrow of Mary over the death of Christ complements her joy in giving birth to the baby Jesus. Fulfilling the prediction of death and resurrection, the mother bears the agony of the cross and shares in compositional unity the figure of Christ. Artist Manuel Ayaso, in vibrant Expressionistic style, prompts the viewer to react.

Ayaso, like many of his contemporaries, accuses contemporary society. Unlike others, he does not hold the institutional church up for blame unless as a result of the leniency propagated by Vatican II. Ayaso's statement stems more from a profound faith than from historical circumstances. His dramatic display of the victim, whose anguish is shared by the faithful in the person of the grieving mother, adheres closely to the reaction of such spiritualists as Congdon, Lotterman and Golub.

In Rollin Pickford's version, the background's spatial effects, although negative in appearance, act in a positive fashion. The vast emptiness is appropriate to make significant the figure of Christ through the device of diminishing size, coupled with the sheer elongation of Christ's body. Pickford's *Crucifixion* beckons the viewer to share the guilt.

The assassination of civil rights leader Martin Luther King Jr. directly influences Robert Indiana's unusual painting titled, *Stavrosis.* A series of ten superimposed crosses lines the working surface as if suggesting a multiple massacre. Inscribed across the upper portion of the painting are the following words: "Thursday, April 4, 1968, Martin Luther King was shot and killed tonight in Memphis, Tenn. The snake still prevails. The red stain spreads, and the crosses for the gentle man in endless rows are waiting." The painting is a quickly instinctive response to a dastardly act: fluid, honest and direct. The dynamic scrawl of words actually acts as a compositional device to balance the weight of the crosses.

Jack Laycox believes that the Crucifixion is the event of all seasons, that its need is forever crucial. His staccato technique has crosses emerging without context of time or space. Nowhere is the significance of the Crucifixion nonexistent. Laycox approaches his theme urgently, yet its presence is eternal. Christ, however, is absent; only the cross symbol relates the omnipotent love that Laycox deems essential for a spiritual reconstruction of America's future.

Laycox describes his painting *Return to the Mountain* as a symbolic interpretation

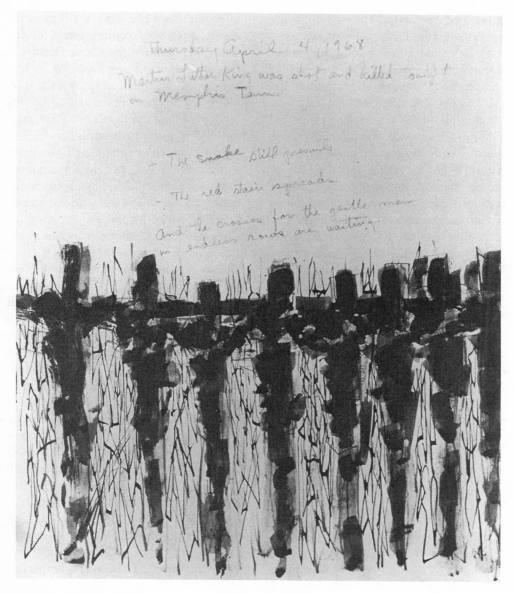

Robert Indiana. *Stavrosis* (1958). Watercolor and ink wash. Courtesy of the artist.

of the significance that the life and death of Christ hold for the past, present and future generations of mankind. All the social events of the sixties, the upheavals, riots, slavery, human injustices, political assassinations and protests, explode in a single figurative image of an urban crucifixion.

Seymour Tubis exploits the turmoil of the sixties in his painting titled *Crucifixion of the Bridge*. Christ prevails as a slaughtered figure hung on the shank hooks of a tanning dryer. Tubis claims that he painted the *Crucifixion on the Bridge* because he was attempting to sum up the limitless ways in which human

beings are crucified by the city and those who inhabit it. He believes that such a response could never have come about without his own participation, involvement and reaction; therefore he considers the painting not only a philosophical statement but a symbolic self-portrait as well.

With a few words Elizabeth Korn has described her approach to painting *Crucifixion* (1963) by stating that though the image of Christ is evident, the agony of the Crucifixion is not in the subject matter but in the technical application and arrangement of paint. These words define the Abstract Expressionist philosophy. The process of dying becomes the process of painting as the two acts become one. The agony that Christ endured is transferred to the artist during painting. Korn refutes boundaries. Positive and negative elements complement each other as knife and brushstroke slash across the canvas. Although cruciforms become the images, literal identification is impossible. Korn paints the image of the Crucifixion not the Crucifixion itself.

Mitiam Beerman takes an all-over view of American tragedy and symbolically crucifies peoples of the earth in a painting closely related to the Abstract Expressionist movement of the fifties, *Crucifixion* (1961). Christ is left unidentified. Beerman's is the intimate response of a concerned artist for the plight of mankind. Each victim of an unjust crime becomes personally placed on the cross. Objectivity is lost in a sea of love and compassion, a seemingly reckless discharge of paint defining intuitively the suffering of the world's population.

Frederick Franck's odd approach to viewer involvement is a product of the Pop movement. His insertion of mirrors into his canvases for personal identification with Christ represents a profound

faith in eternal life. Franck advances the theory of personal commitment, allowing the viewer to elude the Christ identity or become personally involved. As in life, the degree of human communication relies solely on those potentially involved. Franck relies on the viewer's curiosity as an initial step toward commitment—not to his work, which in and of itself survives as a masterful piece, but to Christianity. Details are removed to limit focus to the figure of Christ. The act of identification becomes an admission of sin, eventual atonement and finally the need for reorganization of one's soul.

Franck claims that the artist, whether he wants to or not, preaches a sermon while realizing his own visions and his own dreams. When a mirror is implanted within the surface of the canvas, the beholder sees his own face, his relation to Christ. The viewer too is crucified constantly, and thus the presence of Christ in the inner core of man is here affirmed.

William Christopher's direct, realistic image of the crucified Christ dwells upon the realization of death and the aftermath of the Resurrection. Christopher lays bare the image of Christ, forcing witnesses to accept the guilt for His death. The artist allows us to view in length our sins, to acknowledge our guilt and to respond in a Christian manner. Christopher avoids the art trends of the sixties and employs a personal style.

Although Renee Radell's *Pieta* seems to indicate the contrary, the artist's own philosophy questions the effectiveness of Christianity and holds that the number of believers is diminishing. *Pieta* is a compassionate work which seems to ignore the artist's personal feelings regarding the future of religious faith. In the face of worldwide tragedy, faith, according to *Pieta*, remains the single recourse.

Nicholas Sperakis's version of the Crucifixion titled *The Second and Unknown Crucifixion* dramatically excoriates supernatural interpretation of the Crucifixion. The clergy of old, represented by monastic attire and supported by crucifixes, are seen forcing victims of an unjust society to partake of Christ's blood as a source of salvation and eternal life. The grotesque nature of the priests suggest the hypocrisy, indifference and disbelief of the institutional church itself.

A monstrous creature seemingly hanging in space is George Dworzan's image of Christ on the cross. There seems a contradictory notion of anchor and ascent. Dworzan superimposes Christ and the cross while creating the illusion of ascension, as if Christ's rebirth has already been put into action even during his death. The figure of Christ, distorted beyond reality, only slightly resembles a human form.

Joseph Jeswald uses the protest movements of the sixties to suggest faith in spite of despair. A simple but activated cruciform represents the shadow of death as American society strums a guitar in melodic strains as Martin Luther King's motto rings through an atmosphere of hate and bigotry. Jeswald's painting is a restful piece, a resignation (if only momentary) to the turmoil, with hope of a resurrection to a better America.

There coexisted in the sixties a relinquishing and a reaffirmation of faith. Angelo John Grado declines to confront Christianity directly in his *Crucifixion*. Faces are left unidentified. Hands prevail, posed in gestures of compassion. The base of the cross is anchored by an unidentified weeping figure. Grado's composition is a classical rendition recalling the formality of the early European masters.

The Pop forms of collage and montage were in high gear during the sixties. Newspaper clippings, photos and headlines of social unrest, wars and protests were ready-made implements of expression. In his painting titled *Then 'Til Now*, Valfred Thelin pictures a contemporary concept of the creation of Christianity. A collection of clippings and headlines from magazines and newspapers gives a contemporary image to a historic happening, allowing one to relate thoughts of the Old and New testaments to existing surroundings.

The blending of Op and Pop was perfected in the works of Alton Tobey. Constructed in isolation but composed into a single unit are the four canvases that make up Tobey's *Crucifixion* (1967). One senses upon viewing his work the cosmic atmosphere and man's minute but significant relationship to it. Tobey's work is an exquisite example of a style which encompasses all subject matter. He unites the physicist's concepts of space with the artist's concern for spiritual and moral application.

Werner Groshans generalizes the Crucifixion beyond the realm of Christianity. His painting titled *Southern Landscape*, executed during the peak of racial unrest, integrates the human element of this supernatural event.

Morris Broderson believes that the perfection of nature in artistic terms is impossible since its creation is of a divine character. Any attempt to improve on nature is futile, and artistic perfection stems from the distortion of nature to suit a divine cause. Broderson perfects the use of line and shape in a dramatic display, *Crucifixion* (1960). Shapes displace space as contour, and gesture lines define the shapes as positive factors, establishing simultaneously the negativism of secondary shapes.

In 1966 Willem de Kooning created a series of Crucifixion paintings in which the cross is the major motif. Yet the cross remains invisible as the figures carry the aspect of cruciforms. De Kooning's fame had already emerged, and his switch to the male form suggesting the religiosity of the Crucifixion had little to do with the social turmoil of the time.

Christ Among the Clowns by Jonah Kinigstein (illustrated in Chapter Three) is a true example of Abstract Expressionism. Christ is posed in a crucified position as clown images lurk about His body. The deeply distorted figure is scarred with deep wounds and spattered with blood. The Christ/clown combination is not unusual. Other artists using the theme and who have already been discussed are Evergood, Romano and Deaderick.

Kinigstein's portrayal depicts a pathetic Christ made to suffer by the evils of mankind. The background environment is completely obliterated by the presence of the crucified Christ and His clown companions.

Even more frightening than the Kinigstein portrayal is Bob Thompson's ghoulish depiction titled *Descent from the Cross*. Demonic angels hover over the deceased victim like vultures over a dead carcass. Even the sorrowful Marys appear under Satan's spell. Hope is removed with no sign of the Resurrection.

Space does not permit discussion of several other artists who have contributed significant works on the theme of the Crucifixion. Their efforts, like those of the artists discussed in this chapter, have been influential in setting the tone for paintings on this subject.

Bibliography

Adams, Thomas. *Crucifix: A Message on Christ's Suffering.* New York: Reiner, 1977.

Bowden, John. *Crucifixion: In the Ancient World and the Folly of the Message of the Cross.* Minneapolis: Augsburg, 1977.

Genauer, Emily. *Best of Art.* Garden City, N.Y.: Doubleday, 1948.

Goodrich, Lloyd. *American Art of Our Century.* New York: Praeger, 1961.

Henkes, Robert. *The Crucifixion in American Painting.* New York: Gordon, 1980.

_____. *Reflections on the Crucifixion.* Unpublished.

Hess, Thomas. *Abstract Painting: Background and American Phase.* New York: Viking, 1951.

Hunter, Sam. *American Art Since 1945.* New York: Harry N. Abrams, 1966.

Khan, Ismith. *Crucifixion.* New York: Three Continents, 1987.

Kirstein, Lincoln. *Paul Cadmus.* New York: An Imago Imprint, 1984.

Kootz, Samuel. *New Frontiers in American Painting.* New York: Hastings House, 1943.

Larkin, Oliver. *Art and Life in America.* New York: Holt, Rinehart & Winston, 1960.

Leepa, Allen. *Abraham Rattner.* New York: Harry N. Abrams, 1967.

Maas, Robin. *Crucified Love.* Nashville: Abingdon, 1989.

Mendelowitz, Daniel. *A History of American Art.* New York: Holt, Rinehart & Winston, 1960.

Moltmann, Jurgen. *Crucified God.* New York: Harper and Row, 1974.

Moore, Sebastian. *Crucified Jesus Is No Stranger.* New York: Harper & Row, 1977.

Reep, Edward. *A Combat Artist in World War II.* Louisville: University of Kentucky Press, 1987.

Romano, Umberto. *Great Men.* New York: Dial, 1980.

Schmeckebier, Laurence. *John Steuart Curry's Pageant of America.* New York: American Artists Group, 1943.

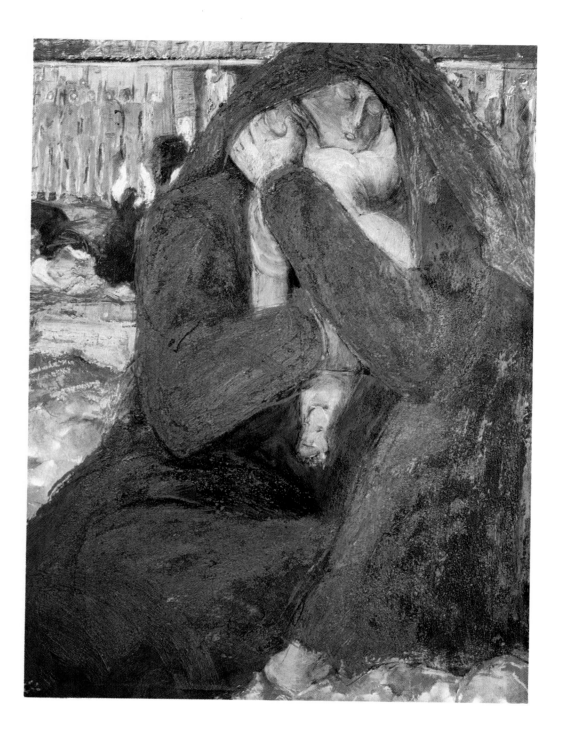

A. Eve Whitaker. *Guatemala: Woman and Child* (1988). Oil on canvas. Courtesy of the artist.

C. Robert Henkes. *Crucifixion* (1987). Oil on canvas. Courtesy of the artist.

D. William Pachner. *Avignon Pieta* (1954). Oil on canvas. Courtesy of the artist.

E. Edward Walker. *The Clown Doll Window* (1967). Watercolor on paper. Courtesy of the artist.

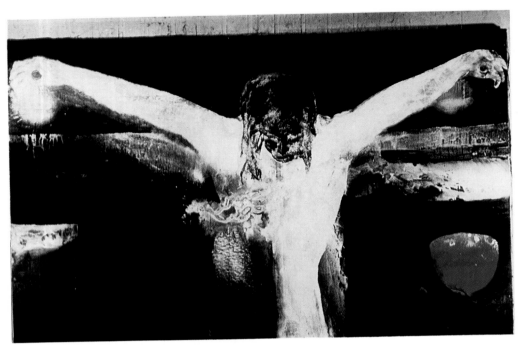

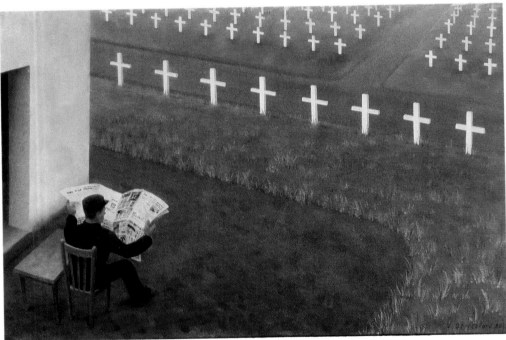

F. *Top:* George Dworzan. *Crucifixion* (1967). Oil on canvas. Courtesy of the artist. *Bottom:* Virginia Berresford. *Final Edition* (1937). Oil on canvas. Courtesy of D. Wigmore Fine Art, Inc., New York, N.Y.

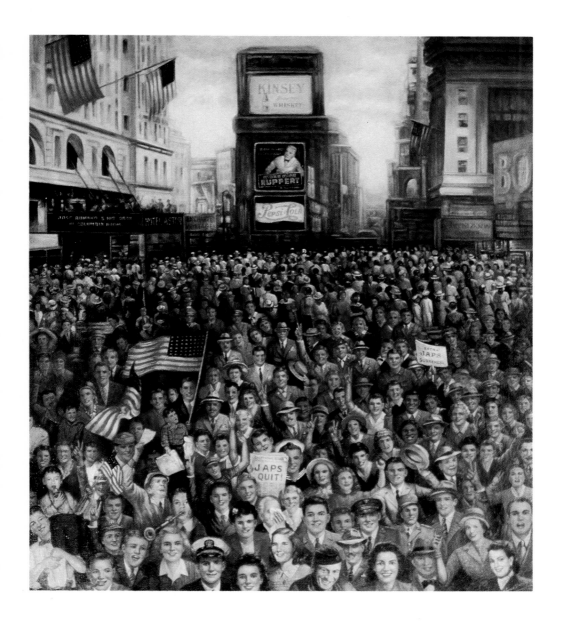

G. Edward Dancig. *V–J Day: Crowds Cheering at Times Square* (1947). Oil on canvas, 45¼ × 40 in. Courtesy of D. Wigmore Fine Art, Inc., New York, N.Y.

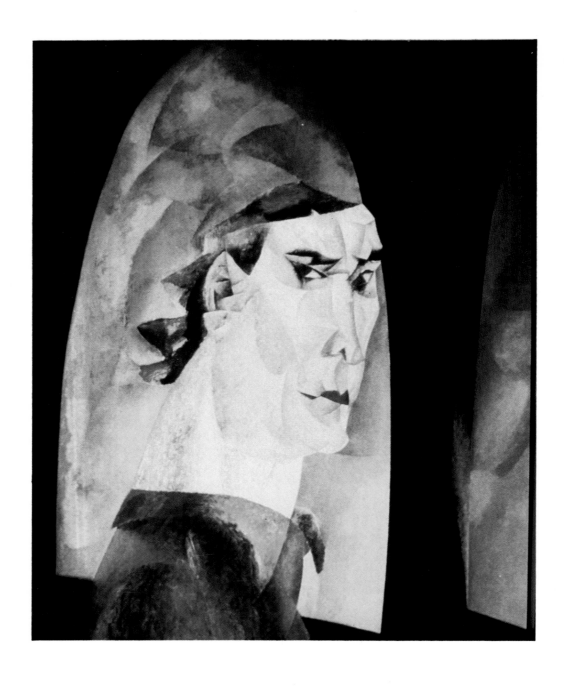

H. Lyonel Feininger. *Self-Portrait* (1915). Oil on Canvas. Courtesy of the Sarah Campbell Blaffer Foundation, Houston, Texas.

INTERIORS

The theme of interiors is generally conceived and executed as a last resort, so to speak, a theme that is always available when all others are exhausted. A particular charm is nonetheless associated with the interior atmosphere. Interiors relate to studios, cities, hotel rooms, churches and even the human soul.

Discussed in this chapter are paintings considered interiors by their artists. A particular artist who has excelled in interior atmospheres is Hobson Pittman. His *Studio Interior* has a poetic charm, a hauntingly beautiful sense of emotion that captivates the viewer. *Studio Interior* seems redolent with a perfumic quality. Sunlight pours into the interior and rebounds off the interior objects, creating a sense of spiritual presence. Even though empty of furniture, *Studio Interior* glows with energy and delightful splendor.

There is a loneliness, not the stark and hopeless loneliness of a Hopper interior but a sense of contemplation, a spiritual communication with a higher being. One identifies with a Hobson interior because one feels at ease with the artistic rendering of the most commonplace. The empty walls and barren floor become energized with a fluidity of color that vanquishes staleness and inactivity. Pittman claims that the stimulus for *Studio Interior* was the attic scene from *La Boheme*, but it is the artist's technique in rendering of color that results in the masterpiece known as *Studio Interior*.

The vertical appearance of the interior is counteracted by a faint horizontal line symbolizing a clothesline draped with aromatic brushstrokes of color. It is a simple but subtle technique of diminishing the vertical force while unifying the whole. *Studio Interior* is appropriately titled since it deals with the artist's tools and trade. It is the artist who has instilled an artistic habitat with an artistic atmosphere.

In *Interior,* Abraham Rattner is concerned with recording interior thoughts, which are the real subject rather than such insignificant objects as flowers, fruit and a newspaper that appear in the painting. In his semi–Abstract style, Rattner blends together with lush, rich color commonplace objects which take on significant identities related to the issues of the world's

news. The use of inanimate objects to convey a spiritual message is a trademark of Rattner's long and prolific career. It is not enough to surround oneself with nature's beauty and the latest news and assume that the world will cure its own ills.

Rattner's interior is the interior of a human soul, depicting its innermost spiritual cravings and their eventual fulfillment. To shield oneself against social injustice by embracing trivial objects is not the answer. *Interior* is a religious painting, an expression of compassion and hope for the future.

Similar to Rattner's compassionate *Interior* is Moses Soyer's *Sad Interior*. The major difference is in the visual statement. Soyer's subjective application of color and the distorted human forms leave little room for an interior. There are no walls, ceiling or floor, only a condensed area of space which engulfs the two homeless creatures. One lies in full sleep; the other wrestles with the darkness. The interior that Moses Soyer displays is a reflection of the real world because his subjects are people of the streets, bars and flophouses.

As in Rattner's philosophy, spiritual commitment is long gone from Soyer's subjects. *Sad Interior* is not only a place but moreover a human dilemma. The sad interior is a human interior—the inner soul of man which is hidden and sheltered to be reckoned with only when recognized that spiritual happiness arrives in eternal life. Soyer was a humanist, and his concern is indeed felt in *Sad Interior*.

The articulate, deliberate and immaculate display of the commonplace is again witnessed in a roomful of household objects in Charles Sheeler's *Interior*. A precise, deliberate positioning of a few objects upon a geometrically shaped table

makes for a Surreal setting. The semiabstract appearance is clothed in subtle reflections of sunlight and sinister but quiet shadows. There is a deadly stillness about *Interior*, a mood of mystery and anticipation. A slight interpenetration of forms is created by overlapping shadows, some of which are arbitrarily conceived and executed for the sake of compositional unity. The deliberate exclusion of the human form forces the viewer to acknowledge a precisionist point of view of a simple still life.

The treatment of space is a difficult matter since both negative and positive space must be considered simultaneously. Sheeler's clean surfaces, untouched by dirt, dust, cobwebs, cracks or scoff marks, lean toward the unreal. Sterility becomes a trademark for Sheeler. Recessive perspective is challenged as objects appear on a frontal plane, and shadows and reflections collide to activate vast empty areas. Walls are intersected only by faint shadows which do little to disturb the peacefulness of the interior. Geometric shapes, devoid of textural surfaces, form monumental structures strongly resembling buildings.

A discussion of Rattner's *Interior* earlier involved the spiritual inner promptings of man. In Rattner's *Studio Interior*, a similar religious fervor emerges. Rattner was emotionally unable to divorce his spiritual needs from his artistic work. In *Studio Interior*, Rattner deliberately or subconsciously injects into the central scheme of things a crucifixion image surrounded by instinctively applied shapes representing canvases which also mirror the stained glass windows of the ancient cathedrals.

Rattner was noted for his search for Oneness, an idea illustrated in *Studio Interior* in which artistry and the spirit

become one. *Studio Interior* resembles an artist's studio as well as a church studio, and a Oneness results from the fusion of those two items essential to Rattner's existence. Rattner expresses his religious beliefs and the means of sustaining those spiritual tenets — his art. *Studio Interior* reflects this Oneness in an Abstract Expressionist style. The emotional discharge of color and shape reveals a consistently unified arrangement. One is drawn into the studio interior by the sheer power of Rattner's emotions. As does John Marin in his exuberant views of the city, Rattner displays a unique command of his subject coupled with a real freedom.

The titles of paintings are at times deceiving. There are especially vague titles such as *Interior*. One expects to see the presence of the essentials that make up a room, but sometimes the title of a painting has little to do with its contents. In Edward Hopper's painting titled *Interior,* one is puzzled by the presence of a female figure leisurely engaged in reading a book. Hopper uses her female form to communicate the emotional state of loneliness, transferring the loneliness of the artist to the subject of the painting.

Hopper was noted for the presence of a single character in an essentially stripped environment. Loneliness may be caused by boredom, and Hopper's subjects tolerate life individually, refusing to share their sorrow, frustration or despair with others. Hopper adds to the dilemma by diminishing objective interruptions to the environment, causing the victim to dwell in her own misery. In the case of *Interior,* the female form awaits her destination. Suitcases to the left and right of her person suggest her presence is temporary.

One senses that a companion is essential to complete the picture. However, such an addition would defeat the artist's

intent. To add a second figure to *Interior* would be to sacrifice the viewer's participation. The dialog between the viewer and the subject of the painting would be transferred to the two figures in the painting. The viewer would truly become an outsider, a spectator. The beauty and charm of viewing a work of art is to become obsessed with the subject matter as in a good play or movie. It is as if the female form in *Interior* is waiting for the viewer to enter the painting. One senses this compassion for Hopper's characters, a need to become involved. That is the secret to Hopper's paintings.

Church Interior by artist Samuel Halpert explores the gigantic structure of a medieval cathedral. Gothic pillars tower like hugh mushrooms and shelter stained glass windows too distant to permit identification of their colorful images. Halpert visually describes the simply designed structure and its complex decor, amidst which rests an isolated figure, a human being standing guard over the massive architectural masterpiece.

Halpert's painting reveals the colossal tribute paid to the divine order. The compositional strength lies in the vertical structures shielding the contrasting complexities of the stained glass. The introduction of the human element transforms a view of an architectural design into a hauntingly contemplative rendition of a common experience among the Christian faithful. Its inclusion also nullifies any monotony introduced by the series of vertical pillars. Each of the three elements — floor, windows, pillars — contains individual monotony, and the combination of the three offsets the obvious monotony of a single element. Halpert has successfully utilized an architectural stimulus to inspire a meditative effort. The painting also illustrates humility

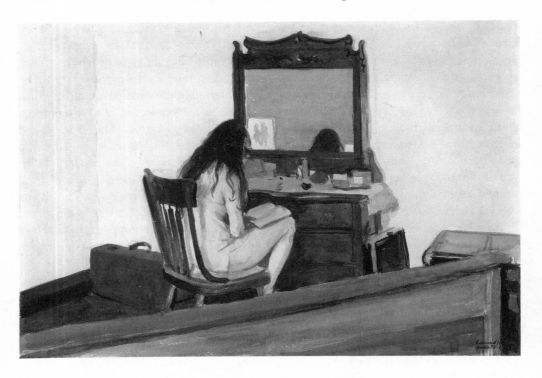

Edward Hopper. *Interior (Model Reading)* (1925). Watercolor over pencil on ivory wove paper (19⅞ × 13⅞ in.). Courtesy of the Art Institute of Chicago. Gift of Mr. and Mrs. Lewis L. Coburn in memory of Olivia Shaler Swan, 1933.487. Photograph ©1990 the Art Institute of Chicago. All rights reserved.

by suggesting a lonely sinner seeking spiritual guidance within a gigantic structure representing the omnipotent being.

Church Interior by Ralph Fasanella is a mixture of beliefs, emotions and contrary thoughts. One is startled by the fiery reds and yellows, so contrary to the cool, quiet, contemplative atmosphere of prayer. The artist seems to be shoving the colors of hell at the viewer, or perhaps the colors are symbolic of the Crucifixion. One is not led but shocked into the holy sanctuary. The blood-red carpet leads the parishioner directly to the equally blood-red altar. A yellow crucifix inflames the frontal plane of the altar, and a second crucifix is lodged above the tabernacle. A circular halo surrounds the cross.

The entire altarpiece is shrouded in red

while perched above and adjacent are shimmering stained glass windows. There are no human figures, only colorful abstract geometric shapes held together with contrasting black borders.

Instead of a receptive arena of meditation and prayer, one is introduced to a loud, brash climate. In spite of Fasanella's pure color palette, his pigment application in *Church Interior* is intense and unreal, and its primitive nature tends to hoist the fiery altar atop the red carpet, which, rather than receding into the background as visual perspective would dictate, forms an architectural structure which also lends itself to the world of fantasy.

Fasanella deliberately omits the congregation from *Church Interior*. The

communion rail remains barren, and one wonders why the artist has omitted the human element when other paintings abound with human flesh. There are other errant ways about Fasanella's church interior. Stained glass windows typically symbolize Biblical characters and events. Other than the altar complete with tabernacle and the communion rail for the reception of the Holy Eucharist, Fasanella's *Church Interior* lacks authenticity, but its expressive primitivism overcomes an inadequacy of calculation in visual perspective and proportion.

Primitive art is exhilarating because of its honest, direct and unassuming character. At times sophisticated and charming, Horace Pippin's *Victorian Interior* reveals the magical world of the child, whose humility and integrity prevail without question. Furthermore, *Victorian Interior* displays the expected elements of an interior.

A baseline is established as the floor meets the back wall. Even though the baseline is not a compositional need, it presents the childlike approach used by Pippin. Because of the blend of front and top views within a single expression, the primitive nature of *Victorian Interior* becomes obvious. Decorative laced doilies grace the furniture as Pippin delivers a picture of carefully conceived and executed details.

All objects stand front and center, but the tables are tipped forward slightly to acknowledge the full top view of each table. Urns and vases are seen in front view. No overlapping of objects occurs other than the vertical posture of the furniture, which joins together the two horizontal planes. Each object is a delightful expression of the Victorian age executed in a twentieth century primitive fashion. Decorative carpeting echoes the decor of the furniture and picture frames. Pippin has created a simple, direct frontal display of a typical Victorian room.

An artist may choose to portray not the inside of a building but the interior of a city. According to Charles Sheeler, the interior of a city is a neighborhood, or a portion of a city steeped in ethnic or industrial flavor. Sheeler's example is titled *City Interior*. A Detroit suburb, a product of the Ford Motor Company plant, is indeed an interior of a vast factory complex. Even the skywalk highlights a single worker silhouetted against a narrow slit of sky as the only sign of an outer environment.

The complex composition encompassing tubes, pipes, stairs, tracks, windows and the inside workings of an automobile manufacturer is a total and unified accomplishment executed in a highly immaculate fashion. The intricate positioning of darks and lights created by the sunlit geometric shapes makes *City Interior* an objective panoramic view of an interior of an outer environment.

Similar to Moses Soyer's notion in *Sad Interior* is Arthur Carles's work titled *Interior with Woman at Piano*, which is also reminiscent of the magical charm of a Hobson Pittman interior. A fluid, instinctive rendering of color identifies a single room interior occupied by two female figures, one resting on a sofa in a distant corner and the other situated at a piano. Nostalgia permeates the scene. The figures remain unidentified as a subjective sense of unity prevails. Interior emptiness is offset by nuances of color dripping from walls and ceiling. Color drapes the female forms as well, suggesting a continuity from one area of the painting to another. There is a suggestion of separation between the two figures, but application of common colors binds them together in a single scene.

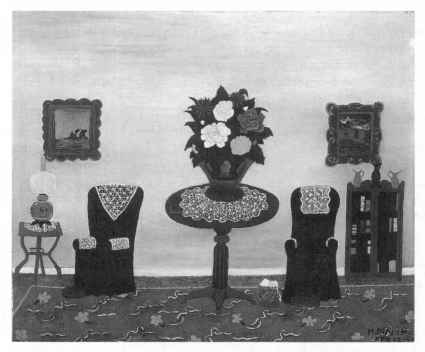

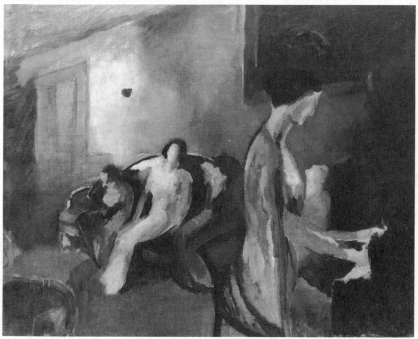

Top: Horace Pippin. *Victorian Interior* (1958). Oil on canvas, 30 × 25¼ in. Courtesy of the Metropolitan Museum of Art, Arthur H. Hearn Fund, 58.26. *Bottom:* Arthur Carles. *Interior with Woman at Piano* (1912–13). Oil on canvas, 39 × 32 in. Courtesy of the Baltimore Museum of Art. Museum purchase, BMA 1963.5.

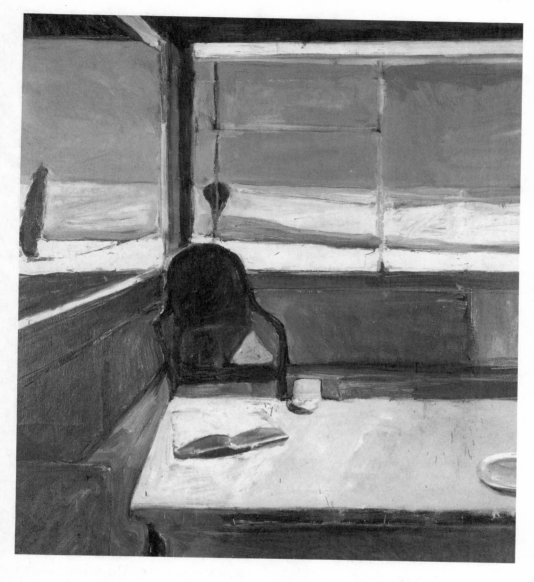

Richard Diebenkorn. *Interior with Book* (1959). Oil on canvas, 64 × 70 in. Courtesy of the Nelson-Atkins Museum of Art, Kansas City, Missouri (gift of the Friends of Art), F63-15.

Artist Richard Diebenkorn painted a series of interior scenes of a semi-abstract nature. *Interior with Book* reveals the interpenetration theory as a blend of horizontal and vertical planes with appropriately selected and positioned objects becomes a union of the natural landscape and essential materialism. Paint is applied in layers, with vast areas of apparent emptiness smothered in layers of cohesive color thickly applied with a palette knife.

The book referred to in the title is a mere prop occupying a corner of a table on which also sit a single cup and dish.

Richard Diebenkorn. *Interior with View of the Ocean* (1957). Oil on canvas, 57¼ × 49½ in. Courtesy of the Phillips Collection, Washington, D.C.

Each of the horizontal shapes in the painting contains a single object that enlivens an otherwise inactive area.

Interior with Flowers maintains a similar standard, though the paint application is a bit looser. The title again refers to an object that seems a mere afterthought. The flowers are set near the edge of a circular table and act to unify the horizontal planes, counterbalancing those areas which lie outside the focal point but within the painting itself.

Interior with View of the Ocean focuses more on the interior than the ocean. The ocean view, which consists of more sky than sea, resembles a blue tinted movie screen featuring nuances of a single color. The lower portion of the painting incorporates a Matisse-like tabletop split into geometric shapes in contrast to the simply devised wall space. The painted surface holds layer upon layer, with each color retaining its original application. Diebenkorn's views are personal yet convey a universal message.

A final painting by Richard Diebenkorn, titled *Interior with View of Buildings,* again incorporates the interpenetration theory, bringing the outside in and pushing the inside out. Diebenkorn defies visual perspective. Lightness is transferred to the background (outside) and

Richard Diebenkorn. *Interior with View of Buildings* (1962). Oil on canvas, 67 × 84 in. Courtesy of the Cincinnati Art Museum, the Edwin and Virginia Irwin Memorial. 1964.68.

darkness resides in the foreground (inside).

There are hundreds of interior paintings labeled with personal titles, painted by such notables as Van Gogh, Wyeth, Vickrey, Doris Lee and Jacob Lawrence. It is the combination of subject matter and the title itself (interior) which identifies the theme.

Harvey Gordon brings into focus a single item as part of a total interior in a portrayal considered subjective because of

Harvey Gordon. *Interior with Chairs* (1989). Oil on canvas. Courtesy of the artist.

the subject's nearness to the observer. Because of the careful calculation of details involved in the scene, however, the label of objectivity seems more appropriate. The title, *Interior with Chairs,* is a bit misleading since the only semblance of a chair is a fragment in the lower portion of the painting. The background environment of window shutters is a common but effective backdrop for the delicate flowers and shimmering crystal.

Gordon's realistic technique is a product of his painstaking attempts at uncovering or discovering a suitable composition after the fashion of a professional photographer who by focusing on a commonplace theme from an unusual angle

Mary Hatch. *Empty Rooms* (1984). Oil on canvas, 36 × 28 in. Courtesy of the artist.

or under unusual climatic conditions is rewarded with a masterful image.

Photographic in appearance, *Interior with Chairs* strongly reflects the Photo-realist viewpoint. Although Gordon's technique is Impressionistic in process, the theory of Impressionism does not apply. Curiously enough, the title neglects the major portion of the interior and focuses on a small segment of the whole. A vase of flowers actually dominates the scene.

Gordon is concerned not with the emotional element of the painting, but rather with the ideal positioning of his subject, hoping for an unusual emotional effect from the process. Gordon is a naturalist even though he deals with material items unlike Audubon or the landscape artists of the Hudson school. Gordon's subjects

are those items encountered daily but ignored because of their utilitarian functions. His obsession with the effects of light creates fascinating illuminations and shadows affecting sinister notions of the Surrealist world.

Harvey Gordon is a perfectionist, as are all artists. But his brand of perfectionism lies in the appropriate site for execution of his work and then the execution itself. *Interior with Chairs* demonstrates his technique at its best.

In Mary Hatch's mysterious portrayal titled *Empty Rooms,* human beings occupy the interior but lack communication. There is an attitude of isolation among the interior tenants without the barriers of total exclusion that one finds in a George Tooker subway or waiting room. Hatch prefers to portray the human

condition while creating an emptiness that exists despite the presence of humans. There is always a mystique inherent in Hatch's work. *Empty Rooms* is an excellent example.

Bibliography

Anderson, Donald. *Elements of Design*. New York: Holt, Rinehart & Winston, 1961.

Bates, Kenneth. *Basic Design*. Cleveland: World, 1960.

Beam, Philip. *The Language of Art*. Garden City, N.Y.: Doubleday, 1958.

Cairns, Huntington and John Walker. *A Pageant of Painting*. New York: Macmillan, 1966.

Canaday, John. *Mainstreams of Modern Art*. New York: Holt, Rinehart & Winston, 1966.

Capers, Roberta and Jerrold Maddox. *Images and Imagination*. New York: The Ronald Press, 1965.

Cary, Joyce. *Art and Reality*. Garden City, N.Y.: Doubleday, 1958.

Edman, Irwin. *Arts and the Man*. New York: New American Library of World Literature, 1951.

Emerson, Sybil. *Design: A Creative Approach*. Scranton, Pa.: International Textbook, 1953.

Faulkner, Ziegfeld. *Art Today*. New York: Holt, Rinehart & Winston, 1963.

Fleming, William. *Arts and Ideas*. New York: Holt, Rinehart & Winston, 1968.

Fry, Roger. *Vision and Design*. New York: Meridian, 1956.

Goodrich, Lloyd. *Edward Hopper*. New York: Harry N. Abrams, 1965.

Hauser, Arnold. *The Social History of Art*. New York: Alfred Knopf, 1957.

Janson, Horst. *Key Monuments of the History of Art*. New York: Harry N. Abrams, 1959.

Knobler, Nathan. *The Visual Dialogue*. New York: Holt, Rinehart & Winston, 1967.

Kuh, Katharine. *The Artist's Voice*. New York: Harper and Row, 1961.

Rodwell, Jenny. *Painting Interiors*. New York: Watson-Guptill, 1989.

Shahn, Ben. *The Shape of Content*. New York: Vintage, 1960.

Weller, Allen. *Contemporary American Painting and Sculpture*. Urbana, Ill.: University of Illinois Press, 1963.

Wolchonok, Louis. *Design for Artists and Craftsmen*. New York: Dover, 1953.

NATURAL DISASTERS

The natural disaster and its effects upon the human condition have excited the American artist for decades. Storms, floods, dust storms, tornadoes and other such phenomena have all served as stimuli. Also known as "acts of God," these disasters of nature are actions of the outside environment, uncontrollable by man. The dust storms of the thirties beckoned the Regionalist painter to record the devastating events, as Alexandre Hogue did in his famous painting titled *Avalanche by Wind.* Recognized as the artist of the American dust bowl, Hogue painted a bittersweet masterpiece in *Avalanche by Wind,* a beautiful painting in spite of its dramatic contents. His unique style and palette soften the scene.

The wind continues to blow as a train approaches the impending danger. Although the setting, including the wind and sand, appears stationary, one senses an event unfolding. As the distant train approaches the partially covered railroad tracks, tension pervades the intervening space. Hogue records the action while anticipating the effects upon the oncoming train and its passengers.

In *Avalanche by Wind,* devastating effects to the animal and human kingdoms are not immediately recorded and realized. Long-range effects are anticipated in the loss of pastureland for animal survival and eventual human consumption, communication disruption as sands and wind dislocate telephone lines and the interruption of transportation.

Hogue's meticulous application of pigment is beautiful in and of itself. *Avalanche by Wind* includes not only the giant forces of the train and the storm but also the minute, a seemingly remote detail which determines the psychological course of the painting in the person of a flagman cautioning the locomotive engineer of the impending peril.

To emotionalize the omnipotent presence of the outer environment, Hogue expresses a remarkable similarity between the windblown sand and the wind itself. Sand clouds form a rhythmic pattern dominating the otherwise beautifully cloudless skies. Hogue leads the viewer into the painting and walks the viewer along the tracks to the flagman where he awaits the decision of the engineer.

Alexandre Hogue. *Drouth Stricken Area* (1934). Oil on canvas, 42¼ × 30 in. Courtesy of the Dallas Museum of Art. Dallas Art Association purchase, 1945.6.

Another of Hogue's 1934 drought paintings is *Drouth Stricken Area,* which depicts oceans of sand receding into infinity. The Southwestern farmland is inundated by sand dunes that obliterate all signs of grasslands and grain fields. Hogue positions two starving animals so as to invite the viewer to reflect with pity on the unpictured humans who reside in the homestead surrounded by sand. Lights and darks swirl throughout the landscape to form highlights and shadows on the sunlit dunes.

The dust storm has ceased leaving in evidence the full effects of this natural catastrophe. The windmill stands in total silence. Although composed of two horizontal planes, *Drouth Stricken Area* is unified by the extension of the windmill into the upper plane. Adding to the

emptiness of the sky area are four birds circling the area as if awaiting the death of the starving animals. Corral fences encircling the farmhouse and the adjacent buildings are replaced by mountains of sand forming natural banks of protection.

The stillness of the aftermath is eerie in effect. The devastating results of the natural disaster are visually evident in the far-reaching hardships which are inevitable in the days ahead.

Alexandre Hogue's entire artistic output has been devoted to disasters brought by ecological mismanagement. The very ingredients that sustain life are the same forces that destroy it. If the balance of life's survival forces is disrupted, disastrous results occur. Hogue, in his famous painting *Crucified Land,* notifies America of the devastation caused by droughts and

Alexandre Hogue. *Crucified Land* (1939). Oil on canvas, 60 × 42 in. Courtesy of the Thomas Gilcrease Institute of American History and Art, Tulsa, Oklahoma.

floods and cements his conviction by erecting a scarecrow in the form of a crucifix. This strong statement accompanying an already devastated land is typical of Hogue's work during the Great Depression.

Several sketches preceded the final painting. A deliberate, stylized distortion of the land imparts a Surrealistic appearance, for it is unreal to experience the forces of reality when they too exceed the balance of nature. Indeed, the symbol of death raised high above the furrowed farmland is a prime example of the farmer's neglect of the land in stubbornly clinging to notions of crop raising that defy natural law.

In spite of the obvious devastation, there exists beauty in Hogue's portrayal, for the artist is aware that beauty may stem from ugliness depending on the focus one wishes to exploit. Hogue lays before the American farmer and the American government the evils of nature abused in order to make known the consequences.

The beauty that Hogue subscribes to is a meticulous style of painting and a palette which preserves the artist's freedom of expression. Clouds have dispersed. Sunlight invades the scene, and the overworked tractor and plow sit motionless at the edge of the rain-soaked fields.

Natural disasters emerge and disrupt nature in varied forms. Alexandre Hogue found it necessary to focus on droughts and floods, demonstrating that when the balance of nature is set askew, scenes like that of *Crucified Land* result.

Far from deifying the plow as Grant Wood's *Fall Plowing* is described as doing, Hogue's *Erosion No. 2 — Mother Earth*

Alexandre Hogue. *Erosion No. 2—Mother Earth Laid Bare* (1938). Oil on canvas, 56 × 44 in. Courtesy of the Philbrook Museum of Art, Tulsa, Oklahoma.

Laid Bare defines the plow as a satanic tool that ravages the soils of the earth.

A nude female form shapes the drought-stricken land of the Southwestern farm-land, the cropless land spoiled by neglect and filled with ruts and grooves. As an ecologist, Alexandre Hogue blames the farmer for greedy use of the land. The land is never respected as a divine gift essential to man's survival, but rather is used greedily to support a lifestyle beyond anyone's need.

Hogue's depiction shows the result of that greed, whose consequences span several years. Verging on Surrealism, *Mother Earth Laid Bare* introduces several symbolic images. A naked tree to the far right reflects the barrenness of the earth's surface and recalls the memory of the crucifix

posted astride the barren land in *The Crucified Land*.

The plow, as mentioned earlier, represents a diabolical tool which, instead of serving as a savior of the land, has torn and shredded farmland throughout the Southwest. The farm buildings are empty with rotting timbers, the families having long ago vacated the premises. The torn barbed wire fence illustrates the escape of cattle seeking greener pastures for survival. The specks of green grass squeezed between dunes of sand act as reminders of more prosperous years, and the small puddle of water is a reminder of improper methods of channeling rainfall to the farmer's advantage.

The sandy nude female form dominating the scene is secondary to the soil

erosion that exposes it. Hogue has made an indelible mark in the annals of American art history through this single theme.

Other artists have recorded the dust storms which were prevalent during the Depression in the Midwest and Southwest. One in particular was John Steuart Curry, who executed many drawings and paintings on the theme. Curry actually became famous, however, as the recorder of the tornado. He made famous several storm and tornado scenes which led to equal recognition of his flood scenes. Perhaps his most popular painting is *Tornado,* a painting of a twister which occurred in Kansas during the early part of the Depression. Several sketches were created, altered and recreated for the final composition.

Tornado reveals a family of five plus two animals dashing for the cellar of their farmhouse as the devastating tornado appears in the distance raging on a destructive course. Animals in the path of the tornado react in frenzied activity, hoping to gallop to freedom. The farmer and his family, positioned as the central characters, have similar fears as they rush toward the open cellar entryway.

Curry carefully shifts head movements toward the oncoming tornado, thus creating an intensified space relationship between the family and the tornado's path of destruction. He fills the painting with a state of anxiety, a crucial excitement rather than an actual event occurring. It is the excitement of the impending tragedy rather than the tragedy itself or the aftershock with which Curry excites the viewer, exploiting the agony of the unknown and a plea for safety.

Tornado incorporates the usual trappings which identify the family and its farming culture; their objective rendering lets them assume a nonchalant presence

more as a compositional necessity than an emotional injection. There is fear written on their faces. *Tornado* is a powerful painting, a timeless masterpiece, which is as real today as it was in 1929.

In *Tornado,* Curry records the scene before the disaster. The onset of the storm itself would prevent its own expression, but Curry reveals the effects of the tornado in several sketches and a painting titled *After the Tornado.*

Another famous painting by Curry is *The Line Storm,* a work which focuses on two significant lightning strikes splitting the ominous clouds that threaten the entire landscape. Farmhands perched high upon the haywagon fear the potential danger as the horses gallop swiftly for safety. Curry reverses the significance of humans from that seen in *Tornado,* and the subordination of the farmhands to the atmospheric conditions actually propels their apparent insignificance into a position of importance. Appropriately employed are the two lightning streaks, which suggest an enclosure of the wagon and its load of hay. The painting also lends itself to a panoramic view of the rural landscape.

Another theme which Curry made famous was the prairie fire caused by lightning. In his painting titled *The Prairie Fire,* Curry compromises between the two extremes evident in *Tornado* and *Line Storm,* revealing the roleplayers on the middle ground. Horses rear in defiance of the flames as farmhands desparately attempt to contain the blaze. The composition relies on two horizontal planes, the land and sky, both of which are broken by the horses and farmhands.

Another natural disaster recorded by Curry in magnificent style is the flood, the aftermath of torrential rains. One of Curry's most powerful paintings is the

John Steuart Curry. *The Mississippi* (1935). Tempera on canvas, 47½ × 36 in. Courtesy of the Saint Louis Art Museum. Museum purchase, 7:1937.

masterpiece titled *The Mississippi*. This elegant portrayal of a family pleading for divine assistance is charged with emotional realism. One must empathize with the sheer terror pictured in the faces and bodies of the flood victims. Although the viewer remains a spectator, the victims' pleas beckon the viewer to share in the tragic experience. The eerie and pathetic imagery of the circumstances is dramatized and intensified by the sharp contrast of the luminous colors. Most effective is the father's plea to the lightened skies above which seems to form a huge cloudlike halo. Although unlike the halo representing the Christian saints in Renaissance paintings, the break in the darkness symbolizes divine intervention.

The calculated horizontal plane of the floating house and the vertically outstretched arms of the pleading father together form a cruciform, appropriately included in a prayer of beseechment.

Another popular painting by Curry, *Sanctuary*, echoes the flood story with the dilemma of animals seeking a single patch of land rising up from the flood waters. The overlapping of animal flesh cowering onto a comparatively wee hunk of land before flood waters threaten to devour the creatures is a remarkable bit of compositional unity. Again, the viewer is near enough to the scene to be a participant.

In his *Storm Over Lake Otsego*, Curry unites man and animal in an effort to

Top: John Steuart Curry. *Sanctuary* (1935). Oil on board, 30½ × 24½ in. Courtesy of the Pennsylvania Academy of the Fine Arts. Collections Fund Purchase, 1954.1. *Bottom:* John Steuart Curry. *Storm Over Lake Otsego* (1929). Oil on canvas, 50 × 40 in. Courtesy of the Museum of Fine Arts, Boston. Gift of Mr. and Mrs. Donald C. Starr, 55.369.

withstand the rage of the oncoming storm. Curry recorded the anticipation of storms, the before and after, and mastered the emotional effects upon people in the wake of such events.

One can sense the oncoming storm in the darkened skies, the moving clouds, the bending trees and the windswept bodies of man and animal. The process of the storm is more difficult to record than the storm itself or its aftereffects. It is usually the anticipation of an event that seems more terrifying than the actual disaster, and Curry masterfully exhibits terror on canvas within a given and limited framework.

There is a brutal force reflected in his work. But this violence is offset by tenderness and compassion as reflected in his paintings *Mississippi* and *Sanctuary*. *Storm Over Lake Otsego* is an action painting, not in the technical sense but in a literal sense. The attempt of the man to calm the fear of his team of horses is a physical activity, and to halt the action for transfer onto a canvas surface while retaining the excitement of a moving episode is indeed a sign of a master's touch.

The theme of the flood takes a curious turn in artist Mervin Jules's painting titled *The Flood*. Human life is snuffed out as flood waters, murky and eerie in color, engulf the remnants of the earth's surface. A dead tree branch breaks the rushing water in a symbolic reach for survival, a blue bucket swirls in an endless journey while an unidentified family home is swallowed up and the waters leave no image of land. Water and sky form the horizon line. An anticipation of the world's end seems an inevitable interpretation, and to cement the hopeless tragedy, death appears in the form of a skeleton shrouded in a fiery red cape riding a floating log.

Jules divides his weird image into two strong horizontal planes intersected only by the ghostly figure. He is careful to inject details to ensure a comparative unity between the objective positioning of certain details and the surrounding environment. Such a detail is the tip of the surviving branch piercing the stormy sky, thus halting the strong visual movement to the left of the canvas.

Jules's palette choice hints at Surrealism. Aside from the ghoulish creature riding the waves of death, the cloak of red identifies with Satan. Compositionally, Jules positions the moving Satan and the surviving tree branch in competition for attention. Both objects serve as focal points while the swirling bucket and the deluged home act subordinately. Unlike Curry's flood scenes, *The Flood* presents no invitation to the viewer to participate.

Simple in technique but dramatic in its appeal is Millard Sheets's watercolor titled *Storm Over Tahiti*. The simple composition presents three horizontal planes, and although carefully conceived, seems an instinctively executed work. A massive black stormcloud looms heavy over a narrow stretch of land and a choppy ocean. No humans are involved; no ships are seen at sea. The viewer actually becomes the sole witness to a breaking storm. There is no single focal point except the painting itself, 70 percent of which the storm cloud consumes.

The anticipation of the storm, rather than the storm itself (which has yet to occur) is what excites the viewer. *Storm Over Tahiti* is a subjective painting because the subject matter is a single stimulus enlarged to utilize the entire working surface.

Potential danger is an ideal stimulus for artistic expression, though disaster is not necessarily the result. In the case of

Marsden Hartley. *Storm Clouds, Maine* (1906–07). Oil on canvas, 24 $^{15}/_{16}$ × 30$^1/_8$ in. Courtesy of Walker Art Center, Minneapolis. Gift of the T. B. Walker Foundation, Hudson D. Walker Collection, 1954.

Storm Clouds, Maine by Marsden Hartley, the menacing clouds amassing over the vast acreage of forestland are a beautiful natural sight. The composition is split into two equal halves of sky and land, each forming an unorthodox shape and echoing its presence in awesome formation. The dark, gloomy clouds correspond to an equally awesome shadow on the landscape below. Hartley's handling of vast emptiness with effective texturing transforms a visually monotonous natural scene into one of textural beauty.

Simplicity becomes complexity. One

views the scene as a spectator and admires the grandeur of a master's brush. Although no humans are pictured, the emotional scene, the potential danger of flood, fire and devastation, holds the viewer in suspense. *Storm Clouds, Maine* is a masterful exploitation of a common but threatening natural occurrence.

Instead of showing the damage caused by a natural disaster, Ben Shahn calls attention to the tragedy via a newspaper. In *Dust*, Shahn's rendition of the dust storms of the thirties which ravaged the Midwest and Southwest and bankrupt farmers nationwide, a lonely farmer despairs and ponders the future. Pain is reflected in the victim's eyes as news of the tragedy hits the headlines while a young family member peers through the farmhouse window at the victimized tenant.

Not only does the viewer feel anguish over the farmer's dilemma, but the child, whose future is bleak, to say the least, must share in the tragedy. The subjectively composed painting thrusts the victim's agony directly into the viewer's attention. The major focal point rests in the distance between the farmer's face and the newspaper draped over his leg.

An unusual visual dialog exists between viewer and subject matter. The eyes of the viewer make contact with those of the farmer, drawing the viewer into the picture as a participant. *Dust* shows but a single farmer among thousands affected and thereby becomes a subjective recording of the devastating event. Shahn prefers to reveal the effects of the storm upon people rather than paint the disaster itself.

The artist Bror Julius Olsson Nordfeldt has painted several natural disasters. In *The Flood*, the flood waters have swallowed up an island of trees and grassland. The distant horizon exhibits a skyline of buildings seemingly unaffected by the raging waters. *The Flood* is an emotional painting, with brushstrokes laden with heavy pigment as the roiling waters whirl split tree branches.

The composition is split into three horizontal planes, each stroked with emotional jabs of the brush. The upper plane consists of threatening clouds that continue to cause the dynamic waters below to thrust an ugly discharge of murk and refuse onto the scene. The lower plane is a ferocious contest of survival between water and rocks. The solidity of the rock formation is an anchor to the composition and ensures a compositional base. The bold, heavy application of paint and the limited palette are compatible and make for a unified composition.

Destruction of nature takes several forms. In Nordfeldt's *Path of Fire*, burned remains of gigantic redwoods are stark, almost machine-like reminders of a great forest of life. The destruction has left naked a string of useless charred stumps and a barren landscape that will be lifeless for years to come. Carefully conceiving this work but allowing freedom for innovation, Nordfeldt modified his original notion with intuitive responses. The result is a moving exhibition of a stationary subject in which both process and product are present. *Path of Fire* is both real and Surreal, both objective and subjective. Each burned tree is part of a dead population of trees that constitutes a subject in and of itself.

In both of Nordfeldt's paintings, the influences of Hartley and Marin are evident. In spite of such similarities, Nordfeldt's own touch is indisputable in the remarkable technique of making a painting "move" on a stationary surface. In *The Flood*, although the solidly structured rocks anchored in the earth's surface

B. J. O. Nordfeldt. *The Flood* (1948–49). Oil on canvas, 52 × 40 in. In the collection of the Corcoran Gallery of Art. Museum purchase, W. A. Clark Fund Prize, 49.20.

thwart the rushing waters of the flood, the ravaging waters continue in an endless force to bash the rocks, and in so doing create an active event. Likewise, in *Path of Fire,* smoke seems to fill the air. One can smell the burnt and smoldering underbrush and tree branches. It is this emotionalizing during the process of painting that sets apart the works of Nordfeldt. His are instinctive responses to emotional events executed in a truly Expressionistic fashion.

Winslow Homer's seascapes included several storm scenes of shipwrecks and natural destruction. His painting titled *Hurricane, Bahamas* portrays a disaster in action. Strong winds move ferocious clouds rapidly through the haunting sky as rooftops await a battering. Homer brands

the palm trees as the trigger for the anticipation of devastation. His focus on the sky with only a small portion of the painting devoted to the island itself demands an enthusiastic brushstroke and limited palette.

The effects of the storm are left to the viewer's imagination. Homer rustles the trees and loosens a few rooftops, but the strength of the storm has yet to occur. It is this unknown factor that causes consternation. The composition tempts one to follow the direction of the wind even though the artist has positioned the housetops to slow down the visual process.

Another Homer masterpiece, *The Wrecked Schooner,* also avoids the human element. Survivors remain unidentified and lost to the sea. Or have they been

rescued? Homer gives no clues. Instead, one is faced with the loss of life created by the rampaging sea. Homer has laid the boat to rest, mast torn from its rigging. Sharp, rugged rock formations occupy the lower region of the painting, breaking the raging waters. Both sky and water remain stormy as the fury continues to pound the wrecked schooner.

The Wrecked Schooner is a subjective piece, contemplative in the sense that an eerie feeling of uncertainty prevails. Yet it is action after the fact; that is, even after the storm damage, the wreck of the schooner and possible loss of life, the storm continues. There is yet no peace, only continuous turmoil, as if to crush any hope for the lost seafarers. Homer was an action painter who generally showed both cause and effect in a single painting. He believed in recording the event itself, and when the event had elapsed, the after-effects became equally important.

According to several critics, Homer's painting *The Gulfstream* is one of the great masterpieces of all time. The painting is divided into three horizontal planes, each anchored as a highly activated phase of a single dramatic event. A ferocious shark dominates the lower foreground while the upper plane holds the eye of a tropical hurricane. In the central plane is found a physically handsome man whose rugged anatomy seems destined to withstand the oncoming peril. A previous storm has already destroyed his boat.

It is this anticipation of peril that has excited viewers for several decades. Each of three horizontal environments accommodates independent activities: the upper plane, the perilous path of the typhoon; the lower plane, the shark; the central plane, the shipwrecked seafarer's anticipation of his own fate. Homer has conceded that speculation about the painting's meaning is not unwarranted. It is this unanswered dilemma of uncertainty that creates a tumultuous inquiry. But in spite of the waiting that occupies the marooned sailor, Homer initiates an emotional drama through his brushwork and sustains that perilous setting with varied tones of a single color.

The consumption of canvas by a single color is unheard of among realistic contemporary artists. The blue skies and water are disrupted in color only by the sienna deck of the battered boat and the streak of crimson lining the bottom edge of the boat. This same red color could symbolize the anticipated danger dwelling in the shark-infested waters.

Homer does suggest a rescue of the shipwrecked sailor as the viewer is granted a partially visible sailing ship in the distance. Whether or not a rescue is to occur remains a mystery for the viewer to resolve. *The Gulf Stream* is a remarkable portrayal of a remarkable subject.

Leaning toward the ridiculous but with a Surrealistic imagery is Roger Brown's painting titled *Sudden Avalanche*. Extreme caricature enables the artist to soften the drama and cruel tragedy of the scene. Boulders of an unidentified origin and material bombard a metropolis, trapping frantic scores of people in hotels and areas of entertainment.

Safety is guaranteed only momentarily for those sheltered behind solid walls of concrete. Even buildings are not invincible to the avalanche's power as their eventual coverage will smother life.

The world, according to Brown, may be at its end. Those humans unfortunate enough to be in the path of the avalanche are swallowed up by unknown forces. The cartoon-like characters of this painting, part of Brown's Disaster Series of 1972, are

Top: Winslow Homer. *The Wrecked Schooner* (ca. 1910). Watercolor and charcoal, 21½ × 15 in. Courtesy of the Saint Louis Art Museum. Museum purchase, 25.1938. *Bottom:* Winslow Homer. *The Gulfstream* (1889). Watercolor, 50.9 × 28.9 cm. (20 × 13⅜ in.). Courtesy of the Art Institute of Chicago, Mr. and Mrs. Martin A. Ryerson Collection, 1933.1241. Photograph ©1990 the Art Institute of Chicago. All rights reserved.

Roger Brown. *Sudden Avalanche* (1972). Oil on canvas, 48 × 72 in. Courtesy of the artist and the Phyllis Kind Gallery, Chicago.

Roger Brown. *Twister* (1972). Oil on canvas, 60½ × 48⅜ in. Courtesy of the artist and the Phyllis Kind Gallery, Chicago.

brutal in their message but sweetened with a pastel-like brush and slick, evenly applied paint.

Ablaze and Ajar, another of the series, reveals the tragedy of an earthquake. Buildings split and shatter, creating monumental fires as humans flee from one disaster only to be caught up in a worse tragedy.

A more common reality is the tornado, which Brown depicts in *Twister.* Although destruction and tragedy are inevitable, Brown's painting is concerned with the anticipation of tragedy. Drama mounts as the twister proceeds from the background to the foreground, having already uprooted trees within the specta-

tors' view. Brown has recorded a natural disaster about to occur, yet again he softens the dramatic effect with Surrealistic, dreamlike images. Lollipop trees waver joyously in the foreground almost as if dancing to a tune.

Objects and figures are shadows of reality. One awaits a tragedy which may never occur. There is a lilting sequence of events which lessens the oncoming disaster. Brown's twister is an exaggerated recording of an event in reverse emotional deliberation. Humans seem to witness the event rather than be made victims.

Flood Refugees by artist Jon Corbino is a supreme example of the Renaissance influence, especially that of Peter Paul

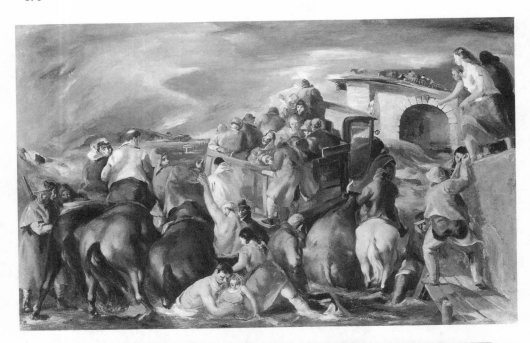

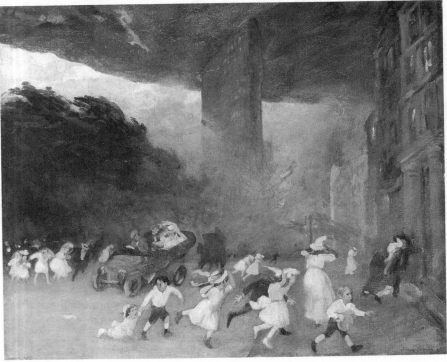

Top: Jon Corbino. *Flood Refugees* (1938). Oil on canvas, 64 × 40 in. Courtesy of the Metropolitan Museum of Art, Arthur H. Hearn Fund, 1950 (50.93). *Bottom:* John Sloan. *Dust Storm, Fifth Avenue* (1906). Oil on canvas, 27 × 22 in. Courtesy of the Metropolitan Museum of Art, George A. Hearn Fund, 1921 (21.41.2).

Rubens. Muscular flesh, both animal and human, crowds the canvas as refugees flee for freedom even though freedom seems hopeless as all exits are blocked. Corbino's anatomical mastery is witnessed in the numerous bodily gestures. The flood waters of this natural disaster are subordinate to the hardships and struggles of the people and their animal companions.

The tumultuous storm skies suggest an eternal tragedy, a flood scene which has destroyed all exits to safety. Corbino records the action at the highest level of its emotional pitch. There is a flurry of bodily action, an abundance of human activity which focuses the effects of the storm and floods upon the human condition. Corbino does not suggest hope for the refugees; his concern is with recording the action.

Within *Flood Refugees* there are several individual compositions which if isolated and enlarged would constitute major paintings. In the distance, remote and obscure, are the tips of telephone poles that illustrate the perilous venture of the refugees on their impossible path to freedom.

Dust Storm, Fifth Avenue by John Sloan is a dramatic, action-packed painting that also depicts human beings scampering for safety. It is not a matter of life or death, but the storm is nonetheless a scary experience, especially for the young children.

Sloan brings the ferocious storm into a city setting. The darkened sky, wind-blown trees and swirling dirt fog the skyscrapers, and people are stopped in their tracks as they attempt to shield themselves against the strong winds and choking dust.

Sloan has painted the fury of the storm and its physical effects on the city's residents. Automobiles are at a standstill, and people on foot race to shelter. The entire scene is blanketed with dust clouds that obliterate the identities of buildings and distant vehicles. Aside from the coloring, it is similar to a dense fog. Children scurry toward shelter on their own as mothers attempt to save their fancy bonnets from the brutal winds.

Compositionally, *Dust Storm, Fifth Avenue* is objectively conceived but subjectively rendered. The viewer must share his or her vision with the several discernibly human images in the painting. However, those several individuals form a team and thus are observed as a single unit suiting the cause of subjectivity. The buildings remain remote due to the clouds of dust which block them from view.

Finally, the book *Nature's Forms/Nature's Forces: The Art of Alexandre Hogue* deals specifically with the destructive forces of nature as seen in Hogue's series of drought paintings. Although Hogue has blamed such disasters on the ignorance and greed of man, the emotional results are caused by divine providence. No artist has devoted a career to a single theme as proficiently and as arduously as Alexandre Hogue, who has transformed such drastic and dramatic events as dust storms, drought and death into beautiful paintings. Not only is Hogue convincing in his portrayal of the Western dilemma, but the stillness and finality is devastating—yet there exists a glimmer of hope. Hope does not reign in symbolic splendor but rather in the color and the technical mastery of its application.

Dust Bowl, with its barbed wire fences, looks more like a battlefield than farmland. Hogue's stylized row of endless sand dunes is interrupted by wheel ruts and foot tracks leading nowhere. This hauntingly expressive painting of early evening focuses on broken fences and the trails into the unknown. There are significant

Alexandre Hogue. *Dust Bowl* (1933). Oil on canvas, 33 × 24 in. Courtesy of the National Museum of American Art, Smithsonian Institution. Gift of International Business Machines Corporation, 1969.123.

diagonal and vertical agents to counteract the strong horizontal windswept planes. A farm homestead with its typical windmill is posed in the darkened distance. Even the cloud formation resembles an enlarged, inverted sand dune. There is a finality about *Dust Bowl,* the result of man's greed to exploit the earth beyond its limits. The drought itself is not man's doing, only the preconditions.

Drought Survivors, in spite of its title and its subject matter, reflects a beauty similar to that seen in other works of Hogue's erosion series. Of all of his erosion and dust storm paintings, none includes the human factor. Hogue's death symbol is the cattle whose food has disappeared from sight due to the wind-driven sand.

Again, it is Hogue's masterful technique that creates at times a beauty unwanted because of the message itself. One is fascinated by the sheer emphasis of detail, the shimmering glow of death itself and the stylized fashion of the destruction. There is a completeness which overshadows the excitement of the event and a finality that ends anticipation. In spite of the natural devastation, there is a cleanliness, a sort of immaculate appearance.

Hogue and John Steuart Curry stand out as the artists of natural catastrophes. Each has individual preferences; one is concerned with the anticipation of the event, another with the action of the event, whereas still other artists are concerned with the effect of the event. Few

paint the event itself because of the difficulty and danger of observing it close-up. Contemplating the event in retrospect enables the artist to exploit the event in terms of emotional needs.

Painting nature in the midst of seasonal change is an eternal invitation to express beauty. The manner in which the artist handles it determines the emotional mood as well as its degree of beauty. The effects that seasonal change have upon humanity is a determining factor in the artist's choice of stimuli. Charles Burchfield has distilled the sloppiest nature scenes into paintings of stilled beauty and quiet splendor. Instead of nature's forces being disruptive or antagonistic, they can bring about scenes of beauty. Natural disasters are identified only if people are affected either directly or indirectly. Rainstorms as isolated events are not disasters, but if the rains cause floods, then a disaster results. A spring rain can be a godsend, an answer to a prayer; an oversupply, however, can be tragic.

Other artists have used the theme of natural disasters. Those discussed here are selected to offer different images and treatments of those events.

Bibliography

Baur, John. *Philip Evergood*. New York: Harry N. Abrams, 1971.

————. *Revolution and Tradition in Modern American Art*. Cambridge: Harvard University Press, 1951.

DeLong, Lea Rossen. *Nature's Forms/Nature's Forces: The Art of Alexandre Hogue*. Tulsa: Philbrook Art Center, 1984.

Eliot, Alexander. *Three Hundred Years of American Painting*. New York: Time-Life, 1957.

Feldman, Edmund. *Varieties of Visual Experience*. Englewood Cliffs, N.J.: Prentice-Hall, 1981.

Genauer, Emily. *Best of Art*. Garden City, N.Y.: Doubleday, 1948.

Gerdts, William. *American Impressionism*. New York: Abbeville, 1984.

Johnson, Ellen. *American Artists on Art*. New York: Harper & Row, 1983.

Larkin, Oliver. *Art and Life in America*. New York: Holt, Rinehart & Winston, 1949.

Mellquist, J. *The Emergence of an American Art*. New York: Charles Scribner's Sons, 1942.

Motherwell, Robert. *Modern Artists in America*. New York: Wittenburg, 1952.

Pousette-Dart, Nathaniel. *American Painting Today*. New York: Hastings House, 1956.

Schapira, Meyer. *America in Crisis*. New York: Alfred Knopf, 1952.

Schmeckebier, John. *John Steuart Curry's Pageant of America*. New York: American Artists Group, 1943.

Seitz, William. *Abstract Expressionist Painting in America*. Princeton: Princeton University Press, 1955.

Shahn, Bernada. *Ben Shahn*. New York: Harry N. Abrams, 1970.

Soby, James. *Ben Shahn*. New York: George Braziller, 1968.

Sweeney, James. *Plastic Redirections in 20th Century Painting*. Chicago: University of Chicago Press, 1934.

Sylvester, David. *Modern Art: From Fauvism to Abstract Expressionism*. New York: Franklin Watts, 1965.

Young, Mahonri. *The Eight*. New York: Watson-Guptill, 1973.

WARS AND AFTERMATH

War as a subject matter has fascinated the American painter for decades. Brutality appeals to the artist's psychology, but more appealing are moments of joy following the tragic events of combat. Then there are the glorious days of victory and the romantic nostalgia that haunts the soldier long after the combat has ended.

Magazines such as *Life, Time* and *Look* have at times commissioned artists to render the ravages of war for millions of readers. The thousands of paintings of World War II are seldom shown to the public by those galleries, museums and collectors fortunate enough to have acquired paintings of this theme.

The purpose of this chapter is to record a few artists who portray war and its effects upon society. A painting that does so is Edward Dancig's *V-J Day: Crowds Cheering at Times Square* (see color insert, G), which records a tumultuous response to the American victory over the Japanese forces. Though a painting of a mass of humanity gathered to celebrate a common cause might be expected to lean toward a subjective execution, Dancig's

deliberate portrayal of individually detailed human images maintains a highly objective appearance. The viewer takes in the crowd not as a single unit but rather as hundreds of individual personalities to be discovered. In addition, Dancig purposely attires each male celebrant in shirt and tie and scatters throughout the crowd "V" victory signs to form a pattern of balance. To diversify the composition even further, the American flag and newspapers spread the news of an Allied victory.

The composition is split in two, the lower segment being devoted to the festive crowd and the upper section to the habitat in which the mob is located. Dancig purposely extends the crowd to the canvas edges, suggesting a multitude beyond the scope of one's vision.

The artist's interpretation of an event frequently differs from that of the viewer. In Virginia Berresford's painting titled *Final Edition* (see color insert, F), the title refers both to the newspaper reporting an event and to the finality of the event. The endless rows of white crosses designate the final resting place of American soldiers.

The groundskeeper reads the final edition of the day's news while standing guard. The symbolic link between the deceased and the newspaper is uncertain. It may suggest the death of a newspaper just as the cemetery defines the finality of life. One may assume, however, that *Final Edition* refers to the end of the war.

One may find no connection between the crosses and the guard, but their placement intensifies the space between them. The geometric design of the landscape is unique in its contrast to the figure of the guard. The slightly primitive rendition of the landscape incorporating a realistic figure appears contradictory, but frequently blends of techniques strengthen a painting rather than weaken it.

Remove the guard and the cemetery becomes the sole focal point. No mystery, no anticipation survives in the face of such definite finality. Without the guard's presence death would not only be final, but the painting itself would lose its luster and end the anticipation of excitement.

There is a fascination in Berresford's title that hails the military cemetery as hallowed ground. A certain patriotism prevails that the guard realizes even as he considers the news of the day.

The viewer is drawn to the guard who oversees the cemetery grounds. His presence removes the subjectivity of the painting evolving from the team of crosses which serves as a single aspect of nature rather than individual crosses to be observed as representing isolated members of the armed forces.

The action of a war grants the artist a versatile stimulus for various approaches and schools of thought, as do the effects upon individuals, families, communities and entire nations for decades to come.

Artist Joseph Hirsch records the human suffering of a sole survivor in his 1943 painting titled *Air Raid*. The Expressionistic technique reveals a bandaged head wound victim, his mouth partially opened and his eyes gazing heavenward as they reflect the horrors of war. Hirsch's subjective portrayal is intensified by the muted background. Aside from its medical purpose, the head bandage serves as a compositional device in corralling the viewer's attention to the significant gaze of the victim. The rugged facial surface reveals the scars of war, which leave an indelible mark upon the survivor. *Air Raid* is both highly subjective and instinctive, as nervous brushstrokes identify flesh wounds and the muscular tone of a well disciplined soldier of war.

Although the victim is special in his personality, he more generally represents the typical American soldier under the most devastating circumstances. The portrayal may well be drawn from personal observation, since the war was a significant stimulus for the artists of the early forties.

Dated the same year as Hirsch's *Air Raid* is George Grosz's *The Ambassador of Good Will*. The meticulous rendering of color and detail, although beautiful in its mastery of application, is grotesque in its visualization of ghastly victims of war as they parade from a fiery and rat-infested environment to greet the abominable ambassador. Signs of Nazi barbarism are explicit: almost hidden amid the rubble of destruction are four figures hanging from the remains of destroyed buildings.

Another Grosz painting develops this grotesque dramatization further. Titled *A Piece of My World,* it has been called by the artist a "hell picture" because there is no end to the hopeless journey. It is a painting of destruction, a picture of ghosts and images without identification, a recording of victims of a worthless cause.

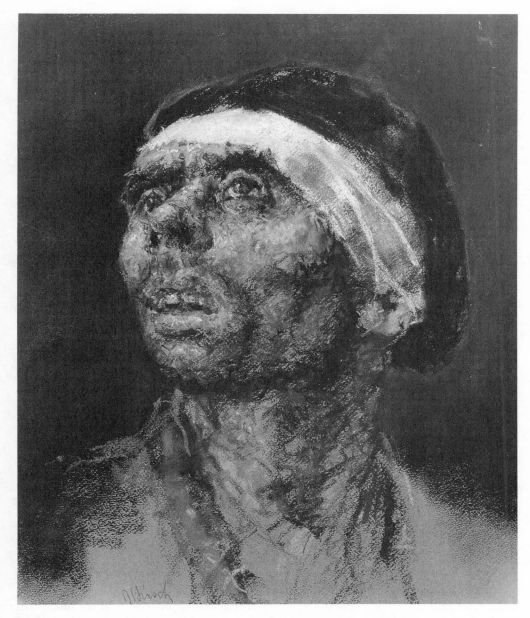

Joseph Hirsch. *Air Raid* (1943). Pastel, 16¼ × 20 in. Courtesy of the Metropolitan Museum of Art. Gift of Pennsylvania W.P.A., 1943 (43.46.9).

Fear spells defeat, so the victimized soldiers march on in blind loyalty to an empty vision of authority. Amid burning rubble and rat-infested habitats the blind follow the blind farther into certain agony and torturous fates. The trudging soldiers are the remnants of the past, a past that was once glorious Germany. The Germany that Hitler created caused Grosz to emigrate to America, and *A Piece of My World* is part of the Germany he left behind.

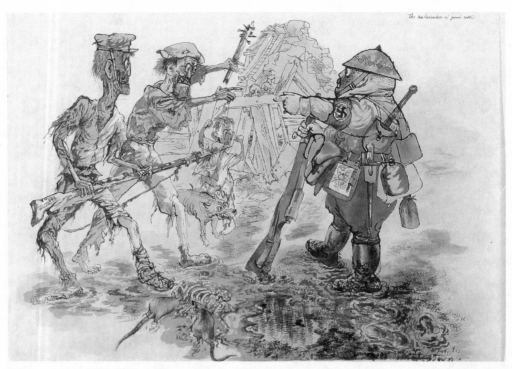

George Grosz. *The Ambassador of Good Will* (1943). Ink and watercolor on paper, 24 × 18 in. Courtesy of the Metropolitan Museum of Art. Gift of Mrs. Priscilla A. B. Henderson, 1950 (50.113.1).

A Piece of My World reminds one of the delicate but grotesque paintings of Ivan Albright. The evil and ugly details are so exquisitely achieved that they hinge on beauty. Grosz positions his marching victims in the blazing fires of hell, from which there is no return to the real world. The contours of the marching figures coincide with the fiery environment but are defined to meet compositional needs. In turn, subjectivity results.

The unity of positive and negative space is such that negativism is totally obliterated. Visual perspective is recognized through the placement of the grotesque figures which seem to emerge from an environment already making claims on its victims. Grosz's soldiers appear as victims and are so enmeshed in the environment that human figures are

difficult to separate from their habitat.

A different approach from Grosz's is that used by John Steuart Curry, whose joyous *Parade to War* portrays the enthusiasm of a parade and the patriotic fervor aroused by the circumstances, resulting in a seemingly glorious occasion. Hidden behind the excitement and anticipation, however, is a fear of the future, an apprehension of the unknown, as the soldiers march to a disciplined cadence.

A lighthearted atmosphere is created by chains of confetti sprawling among the marching soldiers as mothers, lovers and brothers keep company with their heroes, but the usual exuberance is overshadowed by a central couple of a young girl and her accompanying soldier, who is soon to die.

George Grosz. *A Piece of My World* (1935–36). Oil, 24 × 32 in. Collection of the Newark Museum. Purchase, 1944, Sophronia Anderson Bequest.

Curry makes the eeriness of this image more obvious in a painting of the same year titled *The Return of Private Davis*. The viewer is led into the picture by the deceased soldier's coffin, seemingly verifying Curry's prediction in *Parade to War*.

The entire focus is on the preacher presiding over the gravesite proceedings. All heads are bowed in prayer except for the soldiers, whose heads remain uptight and set in a disciplined unity.

The painting is divided into four hori-

zontal planes: the mourners, the procession of cars lined up in order of significance, the distant landscape and the sky. The compositional device joining the four planes is the American flag to the left of the painting.

As mentioned earlier, a war offers a diversity of subject matter. A case in point in Jack Levine's satirical painting titled *Welcome Home,* an attack upon the artist's commanding officer and the Army in general. An entire group of military bigwigs is effortlessly and convincingly portrayed so that individual figures, although separately situated, constitute together a singular unit and in so doing reveal the artist's subjective approach. Each character plays a significant role in the scheme of things.

Each personality enhances the appearance of another, and Levine uses the group of homecomers in a sardonic criticism of the wartime Army caste system. *Welcome Home* is a compact picture, a portrayal of a grouping of pseudosocialites whose claim to fame is pomposity and greed built on the efforts of the common enlisted man. The sin of greed is replaced with the evils of gluttony.

As mentioned earlier, World War II permanently affected those artists who saw action in the service of their country. Some turned to religious subject matter; others, including Edward Melcarth, exposed in a single painting the horrors of war. War, death and destruction are readily available as stimuli for the artist whose emotions are aroused by the futility of mass murder.

In Melcarth's *God Must Have Loved Them,* a delicate calculation of placement is essential to a symbolic yet realistic imagery. Victims of war have never been more graphic than those depicted in Melcarth's interpretation of the evils of ag-

gression. A cruciform anchors the composition and acts as a focal instrument, a crucifixion of eleven foes.

Although twelve victims were initially conceived for the painting, the unknown factor, the rope without a victim, fulfills a compositional need as well as a symbolic one. Melcarth decided against using a child as the twelfth victim in order to lessen the emotional impact on the audience. The figure to the right of the vacant noose is the mother of the orphaned child.

Working with a somewhat different motive from those already discussed is a portrayal by Stefan Hirsch. His painting titled *Nuremberg* relates his elation over the destruction of that place by the American Air Force during World War II. His childhood memories of hatred for his birthplace were diminished by the bombing of this Nazi stronghold.

Compositionally, *Nuremberg* depicts a bombing in action, but it reflects intensity in remission. It is a dynamic tug-of-war between action and anticipation. The destruction is vicious, but the worst is yet to come.

The church structures alone seem permanent, for to destroy the church would be to favor the Nazi philosophy. The spiraling steeples seem to reach to heavenly heights. The strong explosive diagonals of the skies are counterbalanced by the angled cathedral structures which lean slightly toward the right.

More sophisticated than others thus far discussed is Yasuo Kuniyoshi's treatment of the war's aftermath. *She Walks Among the Ruins* deals with the universal problems of war and aggression, the events of destruction and death and the ensuing agony of loneliness. This is a subjective work with hints of objectivity appearing

in subordinate aspects of the work. The victim, a typical Kuniyoshi figure, walks amid the ruins of the war's destruction as a bleak sky adds to the barrenness of the environment.

There is a self-determination in the facial expression and bodily gestures of the subject, a willpower to proceed into the unknown future. There is no predestination, only a strong will to live, a belief in the future with whatever joy or agony it may bring.

She Walks Among the Ruins is a delicate, sophisticated rendering of an ambitious subject matter. Grief and loneliness are lessened by the enlargement and placement of the subject in a manner that rejects vast barren expanses of landscape. In a sense, it is a pleasant painting suggesting a positive future for the woman who must walk among the ruins.

Artist Ben Shahn painted a series of works picturing the destruction and reconstruction of the European landscape after World War II. Several titles reveal the agony of lost loved ones. In *Italian Landscape I* women contemplate their loneliness and despair amid the rubble of war destruction. A young mother with a child witnesses a coffin being carried from the ruins, the wooden box containing the body of her husband. Shahn's appropriate use of vast areas of emptiness adds agonizing drama to the scene.

A similar scene transpires in his *Italian Landscape II,* in which a young mother searches the ruins of rock piles.

Shahn's *Cherubs and Children* seems to have a misleading name until one discovers the emotional relationship between the sleeping orphans and the cherub statuettes. The children left homeless by the war lie upon the grass, their motionless bodies huddled in the open air. The cherubs appear as guardian angels hovering over the innocent, vulnerable children. Shahn's daring introduction of a partial marble wall projecting inwardly acts as a windbreak for the young orphans.

The compositional strength of the painting is augmented by Shahn's unique style of activating vast, seemingly empty areas with textural nuances of color. This same characteristic prevails throughout the background.

Evident in much of his work is the combination of linear forms and solid three-dimensional shapes. The overlapping and interpenetration of shapes, colors and textures creates in a sense an unfinished symphony. *Cherubs and Children* is a complex composition of ideas and concepts which achieves a balance between the emotional and intellectual forces operating within the creative process.

The painting is planned in detail, but Shahn seems to allow spontaneous thoughts to emerge. The linear construction positioned in the upper portion of the painting is a possible afterthought that adds a meaningful image to the entire concept. It also adds to the depth of the painting and diversifies the environment. The subjectivity of *Cherubs and Children* is witnessed in the sleeping orphans, and surrounding objects seem to act as a cradle of protection.

In his remarkable *Reconstruction,* Shahn pictures Italian children playing joyfully among the ruins, seemingly undisturbed by the rubble about them. While the children enjoy their magical playground, an American soldier distributes American goodies to their outstretched hands.

Shahn's fondness for stone masonry is evident in the manipulation of gigantic slabs of marble which serve as an obstacle course for the children. Brick arches and

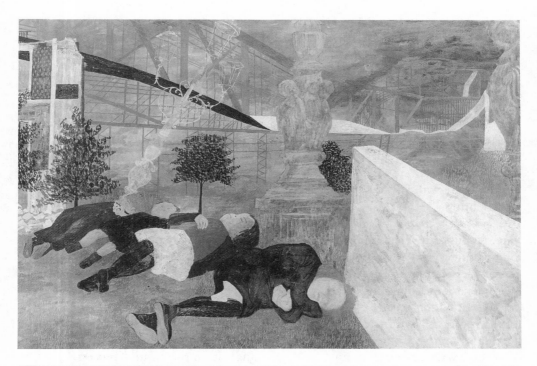

Top: Ben Shahn. *Cherubs and Children* (1944). Tempera on composition board, 22⅞ × 15 in. Collection of the Whitney Museum of American Art, New York. Purchase, 45.17. *Bottom:* Ben Shahn. *Reconstruction* (1945). Tempera on composition board, 39 × 26 in. Collection of the Whitney Museum of American Art, New York. Purchase, 46.4.

pillars add to the stability of the scene of destruction. The human presence is totally compatible with the architectural ruins. Bare feet, glazed starry eyes and distorted bodies indicate an emotional aftermath of a war-ravaged nation. However, Shahn has tempered the scene with timid brushstrokes. In sharp contrast to the delicately painted orphans are the solid, immovable masonry structures.

Shahn's inclusion of figures within the open gaps of destroyed buildings aids in the compositional structure. The artist's obsession with textural qualities is again evident in the intricately detailed brickwork of the pillars anchored to the background and in his unusual treatment of the translucent marble surfaces. This profound concern for structural materials spills over to the human portrayals so that all ingredients of the environment benefit.

Reconstruction has not yet begun, despite the title's suggestion to the contrary. Perhaps the marble slabs are preparatory materials rather than the ruins of bombardment. At any rate, more important are the innocent antics of the young children amid the environment of uncertainty and insecurity.

Cherubs and Children displays the homeless, helpless children orphaned by the war. They sleep wherever and whenever their tired bodies find a resting place.

The Red Stairway also reveals the aggressive nature of the war's destructive forces. Finally, Shahn's masterful painting titled *Liberation* exhibits three orphaned children swinging freely on a resurrected Maypole in a war-torn village of ruins and destruction.

Shahn's paintings are dramatic recordings of actual European scenes, but his deliberate distortions enable the viewer to envision the great depths of agony and despair that prevail.

Mitchell Siporin, known for his paintings of sad farewells and moments of loneliness, executes a masterpiece of despair in his foreboding depiction of war refugees titled *Night Piece*. Siporin exploits inner emotions under the most dramatic and agonizing circumstances. In a profoundly subjective revelation, three refugees are pictured staring aimlessly and dejectedly into the unknown.

The displaced or dispossessed person is the subject matter. The three overlapping figures seem filled with a fear of the future, everpresent and hauntingly real. Although individually conceived and executed, they form a single unit and are thus viewed in highly subjective terms.

Night Piece is a dramatic appeal to society for compassion as the refugees look to the viewer outside the picture plane. The clouds serve a dual purpose, accomplishing their usual mission of breaking up the sweep of the sky and acting as a structural barrier sheltering the refugees from further attack.

Peppino Mangravite's *Celebration* is not a reflection of victory but one of spite. Memories of war linger, but life goes on. According to Mangravite, the loss of a loved one to military service is a personal loss and should not affect the whole of society. In *Celebration,* a table is laden with food and drink while music is furnished by a clarinetist. Lovers make love, others drink toasts, and one figure stands aloft a cliff overlooking the ocean shore.

A peace dove nestles atop a pillar partially destroyed by the ravages of war. The entire gala affair is set amid ruins. Remotely positioned, but nonetheless significant, are the endless rows of white crosses symbolizing the American soldiers dead from the war. A naked tree anchored to the left of the celebrants symbolizes a remission of life, a temporary death

which one day will spring into new growth.

Atop the distant mountains are linear structures resembling huge crosses, symbolic of the most humble and unselfish death of all. Mangravite's *Celebration* is a joyous painting of thanksgiving by those who remain to live in recognition that the war's victims did not die in vain.

Philip Evergood's sardonic expression of the Nazi defeat at the hands of the allied Russians is a grotesque caricature. Evergood's purpose for this ugly satire was to express in pictorial form the futility of selfish and greedy aggression. Evergood believed in making known to the layperson the evils of man to encourage the creation of remedies that might eradicate such injustices.

In his famous painting *Orderly Retreat,* Evergood reveals endless rows of German soldiers, already dead, marching into infinity. Evergood's satirical climate is heightened by a tuba player who sets a musical cadence for the marching dead. A family of survivors witnesses the parade as the dead direct the dead. The futility of war has never been more directly and strongly communicated.

Evergood continued his attack upon the warmongers whose greedy appetites accounted for innumerable deaths of American servicemen. Because of his work portraying the evils of war, Evergood was accused of un–American sentiments in recording the war events. In his painting titled *The Quarantined Citadel,* Evergood takes issue with the warmongers by depositing them on a single island and engaging them in a make-believe conquest with toy soldiers.

Perhaps more astonishing is *Renunciation,* a devastating exposure of atomic warfare. The atomic bomb finalizes the destructive forces of war and places the

monkey superior to man. According to *Renunciation,* war lessens the intelligence of man to the level of the ape. Although brutal in his measage, Evergood levels his attack not at society en masse, but at those individuals who would profit from the tragedies of others.

As part of the Year of Peril series by artist Thomas Hart Benton, the crucified Christ becomes the symbol of human destruction initiated by the warmongers of Japan, Germany and Italy. It is not enough that the big three thrust a spear into the side of humanity represented by the divine figure of Christ; their brutal tactics shatter all hope and reveal the inhumanity of war.

It was during the early 1940s that war turned many artists to religious themes. Benton was one such artist, choosing not to express the evils of war but rather to present a solution to warfare in the person of Christ. Benton correlates religion and war within a single painting.

Maxim Kopf used the Madonna and child theme as the subject matter in depicting a war-torn European environment in *The Star.* The painting pictures a mother and child as victims of the German invasion of Czechoslovakia. Like many artists, Kopf saw the war in Europe as a call for religion, and the mother and child theme becomes a symbol of eternal life in the midst of war's desolation. Inhumanity has been an enduring motivation for the American artist, and when coupled with religious fervor it forms a legitimate and often ideal subject for artistic expression.

A painting called *Requiem,* by David Fredenthal, is a distillation of all the torturous agony and despair of war. The artist uses a single portrait of a grieving mother to encapsulate the war's anguish. His personal experience of witnessing a

peasant woman in a crude cart became the stimulus for a religious experience. In the painting the woman becomes a universal symbol of the total suffering wrought by war.

Guerrilla warfare resembles the creation of art in at least one respect: both are exercises, however rebellious, of total freedom. The guerrilla fighter may be seen as protecting the freedom of the future, and the artist utilizes that freedom in the creation of his art. In Joseph Hirsch's simply titled *Guerrillas,* guerrilla fighters assist a young mother in protecting the new life nestled in her arms. Adding to the bleak future of the new generation is the cold, wintry climate and fearful circumstances. Undoubtedly, Hirsch has posed his characters. Nonetheless, the tenderness reflected in the bodily gestures and facial expressions of the subjects results in a compelling drama of love and compassion.

A formal placement of figures forms a perfect rectangular composition pierced with linear interruptions to add interest. The bayonet held by the guerrilla to the left is balanced by the round of ammunition settled in the snowy foreground. The effect is perhaps a bit contrived, but the scene calls for a quiet moment of reflection and a compassionate and tender reaction to the scene.

Hirsch's anatomical mastery shows clearly in the well defined hands of the mother gently cradling her child, as well as the hands of the guerrillas. The composition is further enhanced by the compatible overlapping of the figures, which are perfectly positioned to create an ideal figure unit consisting of a composition objectively conceived but emotionally executed.

War brides are commonplace during warfare. The fear of loss compels young lovers to wed under pressing circumstances.

Artist Louis Bosa captures such a moment and expresses the event in *War Bride.* The painting presents a pleasant diversion from the brutality of war and its consequences. *War Bride* pictures a lovely country landscape, a farm homestead anchored in a stillness interrupted only by the elation of the newlywed couple. The country church viewed in the distant background becomes the compositional link between the scene of the event and the couple's getaway.

Several artists became war correspondents, photographers and artists during World War II. One such artist, Edward Reep, sketched and painted the action, misery, loneliness, frustration, despair and death each day on the battlefield. His paintings and beliefs spread beyond the war itself and into the aftermath. A case in point is his painting of the Berlin Wall, which he titled *Idiot's Garden.*

Reep has called the Berlin Wall a testimonial to man's idiocy as well as an exercise in futility and waste. *Idiot's Garden* is the result of the defeat of Germany — the split into East and West. The semi–Abstract, geometrically composed image is a solid barricade of steel and barbed wire set into concrete and to endure for eternity.

A second painting displays three orphans standing in a doorway patiently awaiting food scraps tossed into garbage cans. Titled *Garbage Collectors,* it depicts a highly realistic triangular composition of three orphans as pathetic, dramatic characters. They appear trained in their roles of living on the edge of starvation. Cigarette butts picked off the ground find their way into the orphans' mouths. In a sense, the painting is a pleasant portrayal of three scamps who spur the viewer to laughter. It has charm and reveals few signs of the ravages of war.

Umberto Romano. *Fallen Hero* (1943). Oil on canvas, 48 × 36 in. Courtesy of the estate of the artist.

A third painting, *Dead Soldier,* illustrates in direct terms the brutality of battle and the futility of war. The dead soldier sprawled upon the scattered ruins of the battlefield is exquisitely rendered and evokes a sense of remoteness and infinity. The horizon disappears as the earth's surface blends into the sky. The expertly chiseled hands of the dead warrior grip the sands of desolation in a desperate reach to the viewer.

Reep could have pictured the deceased from other angles, but to expose the facial expression of death to the viewer is more dramatic. The soldier's rifle stuck into the ground serves a dual purpose, realistically aiding the graves registration unit in locating the body and artistically uniting the horizontal planes of land and sky into a total composition.

The Dugout shows a foxhole which acts as a compositional shell. Reep had a knack for locating himself so that the actual scene before his eyes became the final composition. The battlefield was a strong motivation for Reep. *The Dugout* reflects a momentary rest for caged-in soldiers before the next bombardment or attack. There is little change in visual perspective and no significant physical distortion, yet a natural subjectivity colors Reep's painting. It has to do with the artist's intimate desire to connect himself with the purpose of victory. Reep became an integral part of the action he witnessed, maintaining no detachment from his comrades.

Umberto Romano. *Cries in the Night* (1945). Oil on canvas, 36 × 48 in. Courtesy of the estate of the artist.

Reep not only recorded the action but assumed the role of the victim inasmuch as death was close at hand several times.

It was not action on the battlefield that raised Paul Cadmus to the heights of American painting, but rather the words of the secretary of Navy, who called his painting titled *The Fleet's In* an unwarranted insult to the United States Navy. Even though *The Fleet's In* was painted during peacetime, the riotous scene is typical of the armed forces on leave

Thomas Hart Benton. *Negro Soldier* **(1942). Oil and tempera, 60 × 48 in. Courtesy of the State Historical Society of Missouri.**

whether in peacetime or wartime. The only disapproval that greets the high-spirited sailors is expressed by an elderly woman whose scowl says it all. Her disapprobation is ignored by the fun-loving sailors and their partners.

Shore Leave, another shocker for the Navy, reveals Cadmus's masterful drawing of the human anatomy. The scene is of a sailor's paradise, resembling an enlarged segment of a Brueghel landscape with dozens of individual and group activities in action. A similar work, *Sailors and Floozies,* illustrates a trio of couples who engage in drunken love-making. Their erotic behavior is typical of the Cadmus tradition. The floozy lusting over the drunken sailor sports a necklace that

holds a miniature crucifix, adding a sardonic twist to the sensual activity.

Cadmus's irony is as fascinating as it is controversial, yet he tells it like it is. Society may object to his critical analyses of certain issues, but frequently his message is irrefutable. *War Memorial* is a case in point, presenting a remarkable, devastating satire on the war effort. A dead veteran in the posture of a Michelangelo Pieta has a wound in his chest resembling that of the pierced side of Christ. Partially shielded in the background are the words "They shall have died in vain."

The victim's lower torso is wrapped in the American flag while anguished women mourn his departure, but greed,

jocularity and a total lack of concern for the dead characterize the remaining audience that occupies the right sector of the canvas. Splitting the painting in half would reveal two separate paintings totally opposite each other in both composition and subject matter.

Wars furnish a fertile ground for artistic expression. Aside from the action itself, its lasting effects upon the human condition are always relevant and always able to evoke emotional responses to the memory of the tragedies which never seem to end. Wars are temporary, but memories live forever.

Cases in point are two devastating works by Umberto Romano titled *Fallen Hero* and *Cries in the Night*. The powerful brushstrokes present hope in spite of the anguish they portray. The ability to express such power upon a limited work-ing surface is indeed the mark of a master. The paintings are disciplined and articulate, and they reveal a power directed through channels of urgent communication.

Readiness for war is dramatically illustrated by Thomas Hart Benton's *Negro Soldier*. The strong Benton style paints a fierce image of American tradition and devotion to democracy.

The art world is fortunate that World War II motivated giant corporations to commission outstanding American artists to portray the war and its effects upon the American populace. Such artists as Aaron Bohrod, Abraham Rattner, Edna Reindel, Gladys Rockmore Davis, Charles Sheeler and Bernard Perlin brought war scenes vividly to life for the readers of *Life, Time* and *Fortune* magazines, for example, creating a lasting legacy.

Bibliography

Alsdorf, James. *The Art Institute of Chicago: 100 Masterpieces*. Chicago: Rand McNally, 1954.

Avenarius, Ferdinand. *Artists on War*. New York: Garland, 1972.

Barr, Alfred. *What Is Modern Painting*. New York: The Museum of Modern Art, 1956.

Baur, John. *New Art in America*. New York: Frederick Praeger, 1957.

————. *Philip Evergood*. New York: Harry N. Abrams, 1971.

————. *Philip Evergood*. New York: The Whitney Museum of American Art, 1960.

Bear, Donald. *Contemporary American Paintings*. New York: Duell, Sloan & Pierce, 1945.

Bruckner, D. J. *Art Against War: Four Centuries of Anti-War Art*. New York: Abbeville, 1984.

Davidson, Abraham. *Early American Modernist Paintings*. New York: Harper & Row, 1981.

Dyer, Gwynne. *War*. New York: Crown, 1985.

Gerdts, William. *The Wayward Muse*. Buffalo: Albright-Knox Art Gallery, 1987.

Hall, Robert. *100 American Paintings of the 20th Century*. New York: Metropolitan Museum of Art, 1950.

Hilman, Bankhage and Leroy Baldridge. *I Was There with the Yanks in France*. New York: Garland, 1972.

Livingston, Jane and Frances Frolin. *The Indelible Image: Photographs of War*. New York: Harry N. Abrams, 1985.

Neumeyer, Sarah. *Enjoying Modern Art*. New York: New American Library, 1957.

Schmeckebier, Laurence. *John Steuart Curry's Pageant of America*. New York: American Artists Group, 1943.

Taylor, Kendall. *Philip Evergood*. New York and Cranbury, N.J.: Bucknell University Press, 1987.

Werner, Alfred. *Max Weber*. New York: Harry N. Abrams, 1975.

Wilmerding, John. *The Genius of American Painting*. New York: Morrow, 1973.

Young, Mahonri. *American Realists*. New York: Watson-Guptill, 1977.

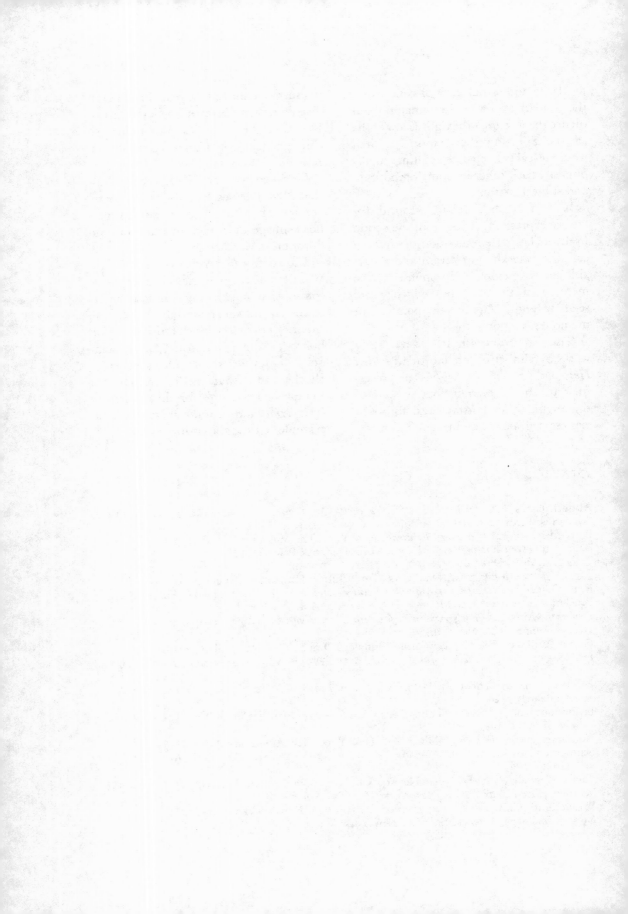

SOCIAL PROTEST
AND INJUSTICE

Social protest and injustice take several forms and stem from varied sources. Protest is a form of democratic freedom which all Americans possess under the law. American citizens have the right to nonviolent protest against what they consider unjust action on the part of society, and protest is an ideal stimulus for the artist to exploit. The artist presents the protest of others, and frequently the artist actually instigates protests.

A early protest by women is illustrated by Ben Shahn in *W.C.T.U. Parade,* one of a series of murals for the Central Park Casino. Shahn not only portrays the protest, but confronts the viewer head-on. Although meager in number in relation to today's standard of thousands of participants, this nonetheless impressive women's march halts in front of a local saloon.

Sober-faced spinsters challenge the tavern owner as they present their case. The leader of this motley crew of ten antagonizers splits the canvas while holding the staff of a banner which reads "Women's

Christian Temperance Union — for God, for home, for native land."

The unusual composition features a series of background diagonals, and with the introduction of a horizontal plane in a group of protesters overlapping the geometrically shaped environment, Shahn creates a compatible composition. The strong diagonals formed by sidewalks are counterbalanced by the acute angle of the protester's banner. Perhaps the most dominant factor in *W.C.T.U. Parade* is the typical Shahn facial expressions. The directly applied contour lines are true statements of the emotions of the protesters. There is an intense hidden desire to respond to whatever rebuttal may occur.

The artist has had the freedom to protest illegal and unjust verdicts, and in fact is at times obligated to expose in artistic media the results of unjust judgments. The international attention granted to the trial of Sacco and Vanzetti and their eventual execution had a profound impact on Shahn. His series of paintings that followed the trial was a form of protest.

Demonstration in Paris illustrates a group who claimed the two anarchists were innocent. They protested the verdict and mourned the sentencing of Sacco and Vanzetti. Shahn executed murals acknowledging the poor, the disadvantaged, the poorly treated laborers. The economic conditions of the Great Depression sparked a flood of protests and a rise in the activity of organized labor, including sometimes brutal clashes with police and management.

Philip Evergood's *American Tragedy* is an excellent portrayal of a deadly union protest. Evergood's bloody scene is heightened by the artist's sensitivity toward the tragic results of a peaceful assembly.

Artist William Gropper became a political commentator in exposing governmental inproprieties and injustices. Because of his satirical artistic work, he was ranked as the foremost critic of governmental procedure. In his painting titled *The Opposition,* Congress is portrayed in a mood of indifference. Playing the leading role is an physically exaggerated hulk who is blasting federal patronage of the arts. Half the senators have already left the chamber and the rest are either asleep or concerned with other matters.

During the Depression mine disasters became a major social concern of America and a significant subject matter for the artist, as well as eventually a cause of strikes. Coal mines were perilous chambers prone to cave-ins and explosions, and widows became more numerous each year. Miners finally went on strike for safer working conditions. Ben Shahn's sympathetic view of the miners' woes compelled him to paint *Miners' Wives,* which pictures a mother cradling her child while awaiting the news of a mine cave-in (see Chapter One).

Another famous work, titled *Mine Disaster,* was painted by Philip Evergood. It pictures a crew of miners with gear in hand, guided through darkness by lights attached to their helmets as they prepare for the downward plunge into the black caverns. A protesting mother and her several children attempt to block their descent into the earth.

The composition, already set with human figures, is enhanced by the flares of light emanating from the miners' caps onto the faces of the mine's occupants. The presence of the young children eliminates any hint of satire; instead one finds a compassionate plea for the miners' safety.

Slavery was a major tragedy until the nineteenth century, and racism continues to promote significant injustices in American society. In a major work titled *Mob Victim,* Lois Mailou Jones projects a powerful message to the American people. The artistic protest enables the viewer to engage in a personal act of soul searching and to react and perhaps spread the message. If no other benefit results, at least the artistic conscience is released of guilt and the artist can proceed to other areas of social injustice.

As mentioned earlier, social injustice is not only a theme to be portrayed in a painting, but it may provoke seemingly unrelated images to be used in protest. In the case of Umberto Romano's *Ecce Homo,* the artist expresses his personal protest through the image of a crucified Christ. His is an agonized expression of profound compassion for the homeless, starving, oppressed peoples of the world, and Christ becomes the symbol of that oppression. Thus, it is Romano's protest of man's inhumanity to man that is portrayed rather than a religious experience.

Edward Melcarth protested the war and revealed as his social foe the governmental

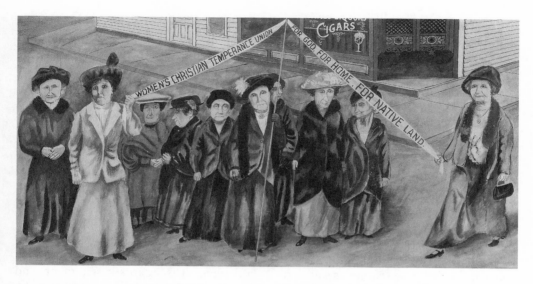

Ben Shahn. *W.C.T.U. Parade* (1933–34). Gouache on masonite. Courtesy of the Museum of the City of New York, by permanent loan from the Whitney Museum of American Art.

system. His painting *For God Must Have Loved Them,* discussed in Chapter Nine, becomes a devastating protest against the war whose professed purpose is freedom.

In *Jittering the Feelings,* Matta Echurren protests the atomic age and the threats it holds for future generations. George Grosz in his *A Piece of My World* (see Chapter Nine) protests against the Nazi regime of Adolf Hitler. American artists, especially those of the 1940s, have protested the war or any brutal conflict sanctioned by the U.S. government. Protest is not the theme of their paintings, but the cause of the paintings. Leon Golub's *Napalm* is another example. Golub is conscious of the mortal destiny that overshadows the human condition. The specter of war haunts him.

The Strike by Robert Koehler illustrates the result of unresponsive labor management. As industrialization increased, labor and management relationships grew more tense. Workers' bargaining power lessened as companies grew richer, and labor strikes increasingly be-

came a necessity. *The Strike* depicts a pre-riot assembly, a situation of unrest in which laborers challenge management. Although Koehler illustrates the strike in action, he gives no indication of conflict. A single worker challenging the injustices of his job becomes the focal point of the painting. To the far left Koehler suggests the far-reaching effects of a possible outbreak of violence by depicting a fearful young mother and her children.

A strike scene that does result in tragedy is pictured in Peter Hopkins's *Riot at Union Square*. Police battle civilian protesters led by the Communist party in a demonstration against unemployment. Management's hired goons inflict injury upon the peacefully assembled union workers.

In the Great Depression unemployment was common, contributing to an atmosphere of fear and uncertainty of the future. Although strikes were not unusual, they were not the answer to the unemployment problem. Too often they only led to tragedy and despair.

The Evils of the Abuse of Drugs, a painting by Ricardo Gonzalez, is a terrifying display of the effects of drugs used for purposes other than the cure of illnesses. The huge painting (six by ten feet) shows the cause, the process and the horrifying results. This painting is not a societal protest but rather an artist's personal protest that makes known to society the ugliness of drug abuse in the hope of securing some reduction of the unsavory practice. The artist's miniature mural protests that drug abuse spreads because of society's inability to deal with such tragedies.

Religious paintings forever serve personal and social protests, not as solutions but rather as acknowledgments of the evils of wrongdoings. The assassinations of Martin Luther King and the Kennedy brothers resulted in tragic aftermaths. Violence occurred as emotional reactions prevailed. Mourning was so profound that protest seemed inappropriate and futile.

The American artist has paralleled the Crucifixion of Christ with the deaths of King and the Kennedys. Robert Indiana illustrates rows of crosses in *Crucifixion* (1967) suggesting that the King assassination was one whose torturous agony was not calculatingly inflicted but rather finalized with a bullet's swiftness. Artistic protests were silent and inevitably personal in focus.

In Edna Andrade's depiction of the crucified Christ, she explains that the painting represents the assassination of President Kennedy. Her verbal statement confirms a purpose that is not apparent in the painting. One can conclude that the theme of social protest and injustice is approached in various ways and not always identified.

Eve Whitaker uses a contemporary theme of a nonviolent protest to lodge her own protest in a quiet artistic manner.

Her *No Hay Otra Manera de Protestar* translates into "no other manner of protest." Whitaker's protest is against the brutal murders of Catholic missionary priests who were called to serve the poor and deprived peoples of war-ravaged Guatemala.

Whitaker's portrayal, although objective in its compositional design, reflects a subjective concern. Mourning figures dot the landscape in protest and in reflection of the love and friendship of the Central American peoples toward those named to the priesthood. Whitaker's painting is more than a recording of a brutal historical event; it is an artistic statement, and one that will remain poignant for decades to come.

Although a profound sadness permeates the total environment of Gammon's *With Our Regrets,* an equal amount of gladness shows in the richness of color and the elegant attire of the celebrants.

A church funeral service according to Christian doctrine should reflect the joy of the Resurrection; death is sad only to the extent that one's own heart is dampened by the physical loss of a loved one. Gammon depicts rejoicing in the burial of one's fellow being. *With Our Regrets* shows not a bleak, mourning, wailing ceremony, but rather a scene that promotes the Christian message that life is born anew.

As the deceased lies in an open casket decked with red roses, the minister prepares for the eulogy and the choir director and organist lead a musical score that echoes throughout the filled church.

As in *Freedom Now,* Gammon organizes his composition to suggest numbers of participants beyond the visibly present. *With Our Regrets,* however, is a work which one views strictly as a witness to the event. Even though the painting is totally

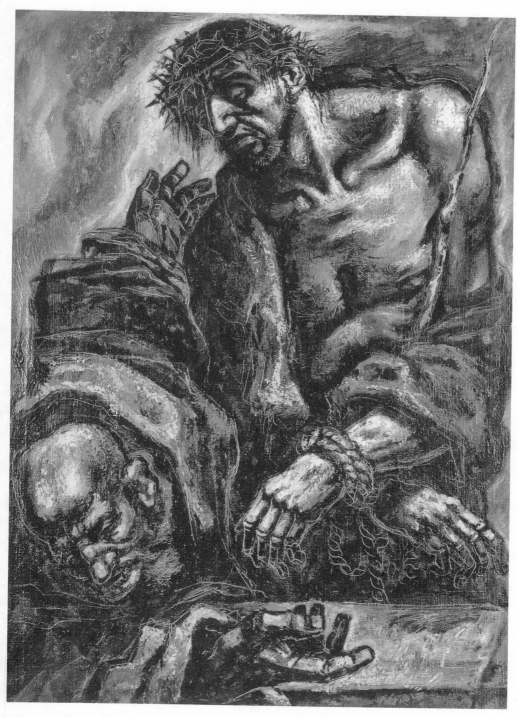

Umberto Romano. *Ecce Homo* (1947). Oil on canvas, 28½ × 40 in. Courtesy of the Pennsylvania Academy of the Fine Arts. Gift of Dr. and Mrs. Abraham J. Rosenfeld in honor of their son, Richard.

Peter Hopkins. *Riot at Union Square, March 6, 1930* (1947). Oil on canvas, 48 × 37 in. Collection of the Museum of the City of New York. Gift of the artist.

objective, there is a sense of intimacy which pushes the painting toward the subjective. Individuals when joined together for a common cause perform as a unit or team and thus create a sense of oneness. *With Our Regrets* creates such an effect.

A direct plea for a solution to the American starvation tragedy is illustrated in Ben Shahn's *Hunger,* the inclusion of which in a worldwide exhibition titled *Advancing American Art* raised eyebrows and angered politicians. Its direct message reflects a social injustice of starvation in the land of plenty. But its solitary figure suggests the whole of America suffers for the want of food.

The figure is simple and direct in its portrayal, the pleading hand enlarged as

it reaches toward the viewer. Highly subjective in its isolation and presence upon the canvas surface, the image of the begging waif is relentless in its plea, and captures the heart of the viewer. The viewer is forced to answer the call. There are no interruptions, no subordinate or secondary elements sharing the canvas with the pleading child. The viewer's eye contact with the shallow, emptied eyes and the seemingly distorted hand is never broken.

The muted background serves to strengthen Shahn's message of injustice while uniting its subject matter by virtue of incorporating color already present in the painting.

The same painting was reproduced as a poster titled *We Want Peace/Register/Vote,* by the Congress of Industrial

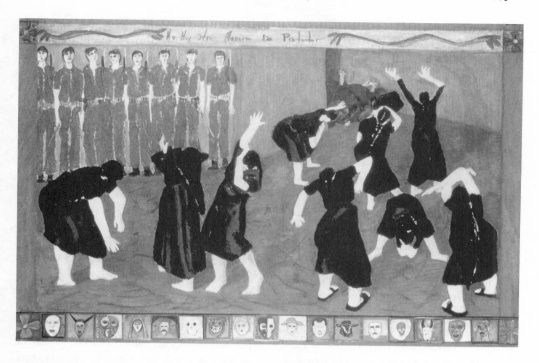

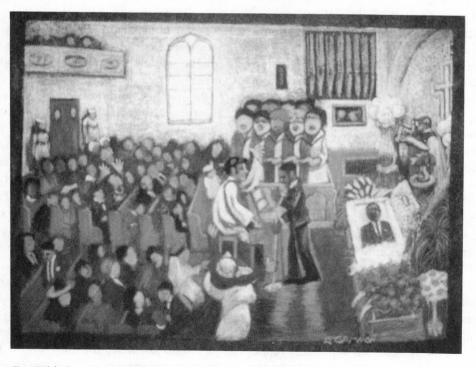

Top: Eve Whitaker. *No Hay Otra Manera de Protestar* (1989). Oil on canvas, 52 × 48 in. Courtesy of the artist. *Bottom:* Reginald Gammon. *With Our Regrets* (1987). Oil on canvas, 56 × 48 in. Courtesy of the artist.

Organization's political action committee after the painting was purchased by the State Department to the further anger of congressmen at the department's appropriations hearings in 1948.

Lee Blair's *Dissenting Factions* comments on a strike in the film industry. Strikes became a fertile subject matter for the artist during the Depression, and in this work strikers battle the police as tragedy emerges from the fray.

The American way of life is challenged as a striker climbs the flagpole to remove the flag from its staff. The scene occurred on a Hollywood lot, so the background is not one contrived for the composition. Completely opposite of Shahn's subjective rendering, Blair's highly objective protrayal forces viewers to develop their own emotional responses to the several and varied opponents of social injustice in the painting. Were one to isolate and enlarge one of the numerous compositions within the whole, a subjective appearance and reaction would likely result. Blair depicts social protest in the form of a worker's strike which is brought about by dehumanizing working conditions. The flagpole climber becomes the focal point as well as the disrupter of the strong horizontal structure of the foreground and its inhabitants.

Ralph Fasanella's *The American Tragedy* differs considerably from Philip Evergood's rendition. Its panoramic view incorporates the Kennedy assassination as well as protests, marches and sit-ins. Throughout the painting the struggle for civil rights prevails. In the upper right-hand corner the Freedom Marchers, accompanied by Martin Luther King Jr., march toward the Washington Monument. Other images include a burning station wagon and three civil rights workers chained to trees and about to be murdered.

Fasanella is deliberately blunt in his portrayal of the human atrocities occurring daily in America. Events such as the burning of churches and, more particularly, the Freedom Bus left the American scene forever scarred by bigotry. Fasanella covers a range of events from Ku Klux Klan activities to protests made violent by harassment from police to violence resulting from school.

Where Evergood illustrates his *American Tragedy* as a single event, Fasanella's identically titled painting encompasses a lifetime of relevant events as well as a philosophical statement. *The American Tragedy* is a true recording of happenings during the crucial period surrounding the John F. Kennedy assassination. The indifferent attitudes of the spectators are expressed as they actually occurred. Fasanella depicts a black protester being dragged to a police wagon while white patrons look on nonchalantly, knowing that to interfere would be suicide and choosing instead merely to stand by in amazement.

Reginald Gammon's *Freedom Now* presents a universal plea for racial freedom. The "now" refers to forever. By bringing the human figures to the forefront, Gammon creates the illusion of a mob scene. Thousands are suggested by the appropriate placement of a few. Furthermore, the intensity of the plea is created by the shouts of the crowd and directed to the vast audience outside the picture plane.

Freedom Now is not a spectator painting but more a participatory image that involves the viewer.

Compositionally, Gammon injects slogan signs to offset the intensity of the human element while simultaneously diversifying the character of the work. *Freedom Now* is a complex arrangement

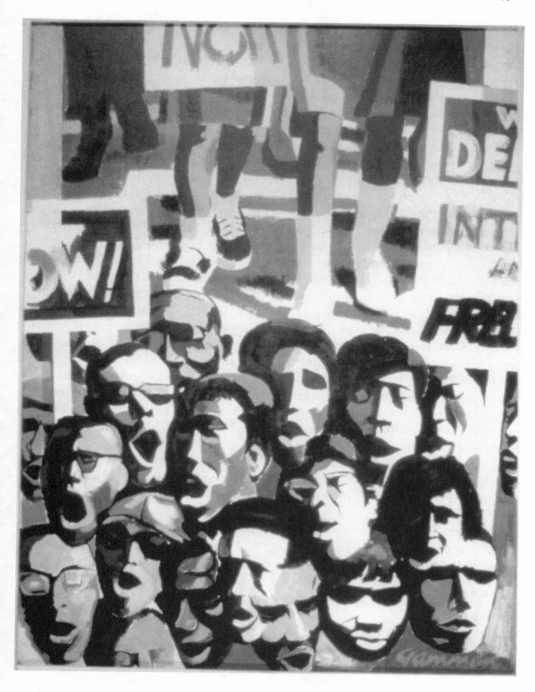

Reginald Gammon. *Freedom Now* (1977). Oil on canvas, 36 × 48 in. Courtesy of the artist.

of overlapping figures and rectangular shapes which combine to form a strong plea for the abolishment of racial discrimination.

Gammon tempers his explosive message with Naturalistic brushwork. He withholds the total message, allowing the viewer to interpret the unfinished message. One anticipates the event without the signs of protest by witnessing the scowls and sneers of the protesters and their upraised arms. The vertical dimensions of the painting add to the emotional impact that forces the observer to respond. This face-to-face confrontation makes for an immediacy and an urgency unattainable in a more objective approach.

Sons, Mothers and the Jury: Scottsboro, Alabama represents a nonviolent protest on the part of the artist. Gammon develops a lineup of relatives as indicated in the title. Photographic in its presentation, the painting extends beyond the lens of the camera with the inclusion of the wrongly convicted men. Gammon's composition involves three distinct horizontal planes, each aiding in the placement of human figures. The lower section is devoted to the female relatives, the middle segment to the male relations and the upper plane to the victims themselves. The artist has left the victims unseen in order to distinguish them from the lineup of males situated slightly lower in the composition.

Gammon manages to define each individual in a personal manner, each with a unique personality. Such a lineup of individuals presents a danger of monotony. Gammon's concern for individuality is projected in the different facial gestures, attire or posture of each personality. There is a concern for the cause for which Gammon has assembled his roleplayers.

His style is similar to that of Ben Shahn, whose various assemblages of personalities under differing circumstances are simple, direct and honest. Even those who know nothing of the Scottsboro incident will, upon observing Gammon's rendition, at least know of the grave injustices it enacted.

In Jack Levine's *The Trial,* it is difficult to distinguish between the innocent and guilty. Levine's style as applied to all figures is marked by an application of pigment in a bit of a blur as if the artist were unsure of his approach to his subjects. But he brings together all elements of the composition into a compatible whole.

The fusion of color becomes a melting process. The physical features of the subjects are globs of color seemingly smeared into place as if to suggest decay or some metamorphosis. There is a peculiar beauty in Levine's blend of color in spite of the theme being depicted, and there seems to exist in *The Trial,* as in all of Levine's works, a hint of irony or satire.

Individual personalities are identified and then forgotten. They are defined with accenting lines which vaguely separate the figures from their surroundings. The receding or advancing of forms relies upon its relative positioning on the canvas.

Levine relies upon the accenting line to instill and promote the anxiety, frustration and (in a sense) beauty of *The Trial.* Facial expressions and hand gestures generally convey the content underlying Levine's subjects and circumstances.

Artist Alice Neel claimed to have been a Communist when she painted *Nazis Murder Jews.* The underground Communist organization had great appeal for the working class during the Depression, and Neel's painting depicts a torchlight parade of Communists aggressively decrying the German Third Reich. Neel openly

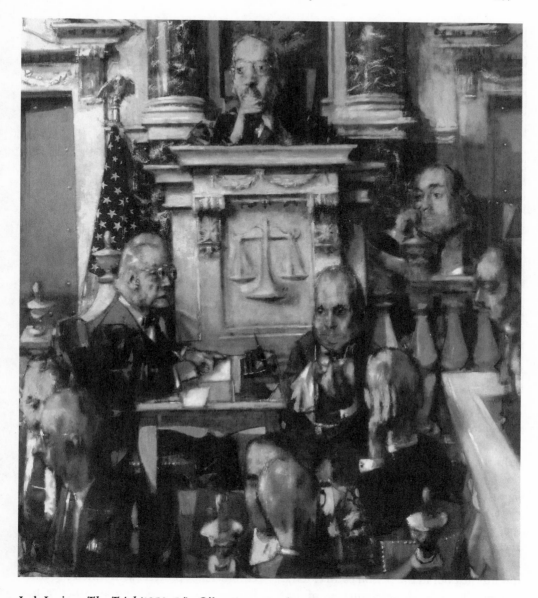

Jack Levine. *The Trial* (1953–54). Oil on canvas, 160 × 182.9 cm. (63 × 72 in.). Courtesy of the Art Institute of Chicago. Gift of Mr. and Mrs. Edwin E. Hokin and Goodman Fund, 1954.438.

proclaims the German government to be a pack of murderers. Throngs of marchers and onlookers are assembled to pronounce Neel's slogan. A sign carried by one marcher dominates the canvas and causes a focal point to exist in an awkward position. Were it lessened in its domi-nance but nevertheless significantly placed, the sign would still present its message strongly and the resulting painting would assume a masterful appearance.

Neel's painting titled *Investigation of Poverty* illustrates the ineffectiveness of government's ill-conceived attempts to

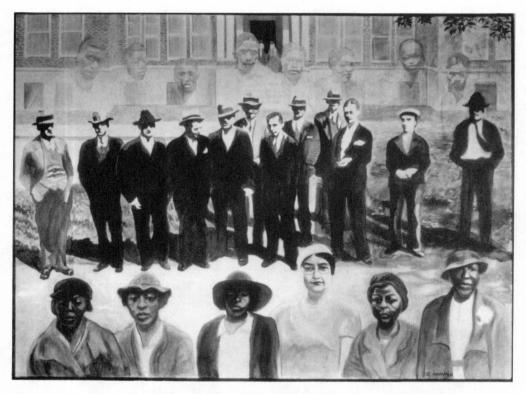

Reginald Gammon. *Sons, Mothers and Jury: Scottsboro, Alabama* (1979). Oil on canvas, 52 × 42 in. Courtesy of the artist.

help the poor. The Russell Sage Foundation, which is the subject matter of the painting, appears sympathetic toward the poor, and in actuality did aid in the eventual implementation of social security and welfare programs.

The composition's obvious sympathy toward the poor in the person of an elderly woman allows the viewer a full view of the entire proceedings. Figures overlap in the simple composition except for the focal figure, the elderly woman, who is viewed in her totality. Facial expressions domi-

nate the scene, and the background remains muted, reinforcing the drama of the scene.

Themes of social unrest and protest remain frequent stimuli for artistic expression. The artist sometimes assumes the role of protester; other times that of a chronicler of protests with which the artist is in sympathy. As long as America has social problems the artist will be there to record those problems in hopes of promoting a solution.

Bibliography

Barker, Virgil. *From Realism to Reality in Recent American Painting.* New York: Ayer, 1959.
Brown, Milton. *American Painting from the Armory Show to the Depression.* Princeton: Princeton University Press, 1970.

Caffin, Charles. *The Story of American Painting.* New York: Johnson, 1970.

Cathcart, Linda. *American Painting of the Seventies.* Buffalo: Buffalo Academy of Art, 1978.

Gerdts, William. *American Impressionism.* New York: Abbeville, 1984.

Godfrey, Anthony. *The New Image: Painting in the 1980s.* New York: Abbeville, 1986.

Goodrich, Lloyd. *Edward Hopper.* New York: Harry N. Abrams, 1962.

————. *Philip Evergood.* New York: Harry N. Abrams, 1963.

Guenther, Bruce. *States of War: European and American Paintings.* Seattle: Seattle Art Museum, 1985.

Kahan, Mitchell. *Roger Brown.* Montgomery: Montgomery Museum of Fine Arts, 1980.

Larkin, Oliver. *Art and Life in America.* New York: Holt, Rinehart & Winston, 1960.

Leepa, Allen. *Abraham Rattner.* New York: Harry N. Abrams, 1960.

Love, Richard, Walter Clark and Eliot Clark. *A Tradition in American Painting.* New York: Haase-Mumm, 1980.

McCoubrey, John. *American Tradition in Painting.* New York: Braziller, 1963.

Mandel, Patricia. *Selection VII: American Paintings from the Museum Collection.* Providence: Museum of Art, Rhode Island, 1977.

Martin, Alvin. *American Realism: 20th Century Drawings and Watercolors.* New York: Harry N. Abrams, 1986.

Romano, Umberto. *Great Men.* New York: Dial, 1980.

Smith, Bradley. *The USA: A History in Art.* New York: Thomas Crowell, 1975.

Soby, James. *Ben Shahn.* New York: Harry N. Abrams, 1968.

Young, Mahonri. *American Realists.* New York: Watson-Guptill, 1977.

THE STILL LIFE

The still life arrangement has been a popular theme in American painting for centuries. Because of its accessibility and the diversity of purposes to which it can be put, it is the start and finish of subject matter. The contents of the still life are wholly the determination of the artist. The impersonality of the still life allows it to be used, misused, abused and forsaken without consequence. The pieces of a composition may be repeatedly rearranged until they fully satisfy the temperament of the creator.

The phrase "still life" denotes a deadness, reality detached from life. The subject matter is a prop free to be exalted, humbled, prostituted, enslaved or revered. This versatility explains why popularity of the theme has never wavered. When all else is exhausted, the still life remains to be attacked, beloved or reinterpreted at any time to suit the intuitive urges of the artist. The still life frequently spawns more significant ideas. Titles discussed in this chapter have set artistic trends. Some of them are personal symbols or fantasies expressed by the ready means of engaging the still life mechanism.

A case in point is Philip Evergood's painting titled *Still Life with Fishermen*. Instead of the usual muted background, Evergood introduces a fantastic image. Fishermen toting oversized oars and draped in rain gear prance about the scene. In a form of interpenetration the outside is brought inward and the inside is pushed outward. The painting is an exquisite example of a childlike X-ray picture in which both the inside and outside activities are revealed simultaneously. The viewer is located indoors peering through a picture window which is blocked by an elaborate bouquet of richly painted flowers nestled in an ornate vase. Stone walls stretch across the canvas—or are they fish traps?

Negative space is attended to and thus relates additional clues to the artist's intent. Since the still life and fishermen share the title, the viewer is left to determine the relative significance of each component of the subject matter. Seemingly intuitive in application, color is preconceived and positioned according to an objective determination. Evergood is narrating a tale of fantasy.

Philip Evergood. *Still Life with Fishermen* (1963). Oil on canvas, 25 × 40 in. Courtesy of Kennedy Galleries, Inc., New York.

Evergood was considered a Realist, yet *Still Life with Fishermen* shows not only signs of unreality but obvious strains of Expressionism. Instinctive impulses definitely motivate much of Evergood's intellect and emotions in *Still Life with Fishermen,* and the painting is an excellent example of the motivational force underlying utilization of the still life concept.

To reflect the tremendous variety of ways in which the still life may be artistically interpreted, one must examine the incorporation of alien subject matter such as that witnessed in Abraham Rattner's *Farm Still Life.* The circular composition with its churning wheels and bent axles more resembles a war machine than a still life. Rattner's grotesque pieces of machinery gnash at each other while discovering new forms and shapes as color and line overlap and intermesh. The stark color contrasts energize the stilled images into a moving mechanism in a manner resembling the style of Marcel Duchamp's *Nude Descending a Staircase.*

The minimal negative space echoes the dramatic working of the farm machinery. Bold, dark contours define whirling wheels. The sparkling colors witnessed in Rattner's stained glass synogogue windows and in his deeply religious paintings dominate his still life too. The colors are strong and muscular and move by virtue of overlapping shapes. Artists generally record their ideas according to current techniques, and Rattner was no exception.

Farm Still Life exhibits in Rattner's typical manner the Oneness that became his trademark. Although deposited into a negative environment, Rattner's farm machinery occupies the total working surface leaving a mere remnant of negative space.

An unusual use of the still life concept is reflected in Paul Hartal's simply titled *Still Life.* Instinctive urges are revealed in the blotches of color, those attended and unattended. Additional instinctive applications of pigment result in a blend of objective and subjective techniques.

Still Life incorporates an objective style with subjective artistic impulses. Once the colors are recorded in finite positions, linear considerations are given to the background. An all-absorbing background is crisscrossed with rhythmic lines, activating an otherwise dull area.

A mysterious meandering of line extends the activity from the central focal point to the outer edges of the working surface, and to offset the demanding, dark linear composition opposing soft, light lines waver within the confines of the central object.

The mood of the painting suggests a detachment of reality from life. The unanchored elements of the still life tend to shift amid an atmospheric habitat. Although cemented in space, colors seem to move at will.

Hartal's *Still Life* is an exquisite exercise of the freedom engendered by the still life stimulus. Although the still life concept is ancient, fresh compositions and approaches to recording that content still make for exciting renderings.

Two paintings executed by Arshile Gorky within a two-year period reflect the diversity of the still life concept. Although both are titled *Still Life,* the 1927 version differs considerably from the 1929 adaptation.

The former relies on an instinctive, imaginative technique related to the Abstract Expressionist approach. Although the artist's mind successfully deposits images upon a working surface, the actual application of pigment is impeded by

emotional barriers. Nonetheless, the images are subjectively expressed although objectively conceived. In other words, the process of painting may produce a final image which differs from the initial intent.

There seems to be an urgent need to record the mental image before its disappearance. Once the image meets the canvas, it becomes vulnerable to change in order to meet the demands of the total composition. The contents of Gorky's 1927 work are recognizable—pitcher, oranges, pears, apples and a white cloth folded to the contours of the fruit. The composition is traditional in its format of three basic horizontal planes, the objects being nestled in the central plane. Negative space is identified with that area surrounding the focal objects.

The 1929 version differs in various ways. Negative space is nonexistent. During the process of composition, positive images create negative space simply because opposites occur whenever a positive statement is made. But in the continuation of the creative process, the positive and negative aspects become similar in the sense that all exert equal significance in the total composition.

Gorky's *Still Life* of 1929 has no horizontal or vertical planes and no environment or habitat. The original background disappears with the introduction of new positive aspects. The 1929 version differs also in the abstract content of the painting. Nonobjective shapes overlap in a flat pattern which tends to float in space although cemented in permanence. The usual interpenetration of inside and outside environments is lacking. These two paintings demonstrate vividly the versatility that has perpetuated the popularity of the still life.

Negative space is well used in Charles Sheeler's *Still Life with Teapot*. Although the title emphasizes it, the teapot is an insignificant presence in the composition. The major force in the painting is the tall, slender table which occupies much of the working surface. The surrounding negative space is adorned by the table's shadows and reflections, which are echoed in the distant wall.

The positioning of the table sets the stage to activate the environment. *Still Life with Teapot* is a typical Sheeler production, cool, articulate, immaculate, precise and sterile. Sheeler's style remains constant regardless of subject matter. He refuses an abstract pattern by avoiding the interpenetration of advancing and receding subject matter. It is this freedom of choice to exercise various options that characterizes the still life stimulus.

The placement of objects to form a unique still life composition relies upon the ingenuity of the artist. The removal or inclusion of a single object can alter the painting's psychological, emotional or intellectual effect on the audience. An overabundance of objects may obstruct the complete viewing of the painting.

The decision to add or omit an item determines the success or failure of the work. In the case of *Still Life with Bottle*, a painting by Preston Dickinson, several objects overlap in a pleasant arrangement of a personal character. Confusion can result if adjacent forms do not advance the total composition, but *Still Life with Bottle* is a perfectly composed set-up for a recording. It reflects the lifestyle of an individual who engages in the pleasures of drink and tobacco and the art of writing. The artists choose personal tools to present a life of fantasy or to record lifetime achievements through utilitarian symbols.

A fascinating approach to the still life

theme is Edwin Dickinson's *Composition with Still Life*. The artist employs objects and figures to form a mysterious blend of the human and the divine. A magical display of ornate vases, an iron gear shaft, a gold-plated door latch, dead human bodies and naked tree trunks combine to suggest a land of limbo.

Not only has Dickinson resurrected the still life theme in an exciting masterpiece, but the theme reeks with spiritual implications. The viewer is forced to respond with curiosity at first glance, then in an emotional manner, and finally in an intellectual search for the meanings of such seemingly incompatible partnerships.

The glowing, shimmering colors remind one of El Greco's religious paintings. There is an ascendency of spirit, and an immediate appreciation occurs as one studies the magical fusion of a limited palette which nonetheless emotionalizes one's vision.

The title, *Composition with Still Life*, seems to suggest that Dickinson's painting only secondarily includes still life images. The introduction of nude bodies is an unusual, if not daring, approach. But the delicacy of the style and the flow of color temper the display considerably.

Dickinson's still life is not a mere exercise in color, shape and line. It reaches far beyond the normal notion of a still life to touch the heart and soul of those who perceive its profound yet humble message.

Hans Hofmann was noted for interpenetrating color areas that flatten the picture plane. The most important result of this flattening process, which equalizes recessive and advancing areas, is to permit abstractionism to develop as an unifying force rather than fragmentizing the whole. At the same time, a tension between equally forceful opposing forces results in an intensified battleground.

It is in terms of this intensity that Hofmann's *Still Life, Yellow Table in Green* is best described and identified. As in many other paintings, an objectively conceived composition is executed in a partially intuitive manner. Various visual viewpoints are registered on a single working surface, again echoing early childhood concepts of a tactual-visual combination of sensations. There is a restlessness evident in *Still Life, Yellow Table in Green*.

Although versatility is a key to all successful art, the still life is particularly ripe for exploitation. The still life was conceived as a preliminary exercise, a forum for perfecting shapes and colors before attempting more serious paintings. And it was generally conceived as a horizontal working plane on which items were positioned in upright stances and maneuvered to form pleasant compositions.

During the late nineteenth century, however, such artists as Harnett and Goodwin opposed the horizontal theory by using the canvas as a frontal plane and applying objects vertically, thus eliminating visual perspective completely. One might suggest that they invented Pop art a century before its recognition. Instead of placing actual objects within the picture plane, these artists painted the items in place.

Theodore Roosevelt's Cabin Door, a painting by Richard Goodwin, is a remarkable display of minute detail and exquisite rendering. Its deliberate conception demands more than an intuitive response. Each painted object adds to the total composition; the removal of one item would diminish the unity of the composition. The rectangular shape of the vertical door compositionally influences the placement of surrounding objects.

Still life compositions tend to portray

Edwin Dickinson. *Composition with Still Life* (1933–37). Oil on canvas, 77¾ × 97 in. Collection of the Museum of Modern Art, New York. Gift of Mr. and Mrs. Ansley W. Sawyer.

individual personalities, and *Theodore Roosevelt's Cabin Door* is no exception. Roosevelt's noted hunting prowess is exhibited in Goodwin's remarkable interpretation, which features captured geese as the most prominent roleplayers. Centrally located, they stabilize the informal positioning of subjects within a formal composition. The door jamb provides equalizing boundaries. The successful composition avoids reliance on overlapping and instead depends upon the structural design of the door to act as habitat to the chosen mementos.

The linear aspects are echoed in shadow and reflection and reiterated in such items as the gun muzzle, boot laces, goose beaks and wrapping cord. Each seemingly insignificant item plays its role. Goodwin's painting becomes a scene from a historical biography, one which lives far beyond the death of its subject.

Satire enters the still life theme in Philip Evergood's *Still Life*, the impersonal atmosphere of which is enhanced by the intrusion of a gaudily overstuffed vase of flowers. The pride and vanity registered on the gluttonous faces of the two spouses are the complacent expressions of the rich, for whom the artist seems to have nothing but contempt.

The art of Ivan Albright has no competitors. Viewed as the art of decadence, Albright's fabulously intriguing and detailed portrayals of rotten flesh, rotten fruit and rotten life supersede similar works by other artists. Close and thoughtful examination is essential to a full and complete appreciation of his lushly painted *Wherefore Now Ariseth the Illusion of a Third Dimension*. The antique appearance of the objects developed by the master's adept hands is contrasted to a velvety environment. Lace doilies heighten the intensity of the scattered silverware.

The incongruity of perishability and the permanence of ancient utilitarian artifacts becomes a blend of artistic color. The brutal reality of life is reflected in the aging fruit, whose pores reek with decay. There are no major stimuli expressed in Albright's work. The viewer is invited to roam the canvas while halting frequently to delight in the lush colors and exquisite details. *Wherefore Now Ariseth the Illusion of a Third Dimension* is riddled with bulges and pits, marking Albright's techniques of depicting decay. An open cigarette case holds slender but voluptuous cigarettes, silvery gloves lie in sensuous display and silver and copper coins lie delicately upon the velvety background. Albright's top view exploits all angles of the displayed items, and his scratch-board style of detail contributes to a masterful rendition.

Time seems no longer precious, or perhaps it is too late to delight in life's pleasures. Old age becomes physically ugly, and in some cases evil. Youth is not a part of Albright's painting. *Wherefore Now Ariseth the Illusion of a Third Dimension* is beauty in its ugly state, yet its exquisite detail and lush coloring suggest a sign of hope for the future.

Exhibiting the same detailed analysis as Albright's aged images are the visually youthful subjects of Audrey Flack. One is reminded of the twin display of *The Picture of Dorian Gray* as executed by Marvin and Ivan Albright—the two extremes of life, youthful innocence and aged evil.

Flack's *Dutch Still Life* is a compact union of flowers, fruit and butterflies nestled onto a velvety background. A lustrous blue pitcher is foreshortened to allow for a graceful arrangement of the flowers and fruit at full maturity. Highly objective in concept and execution, the painting nonetheless utilizes an immediate frontal view that typifies a subjective expression. One is forced to acknowledge Flack's subjects and study the individual forms of each image. Known as a Photorealist, Flack indeed approaches a photographic image in this painting. One may question the validity of this mere duplication of nature, but it has long been established that features of natural objects when viewed in detail are transfigured. The images no longer appear natural but take on an abstract sense of visual perspective.

Although each image is dealt with

Ivan Le Lorraine Albright. *Wherefore Now Ariseth the Illusion of a Third Dimension* (1931). Oil on canvas, 91.4 × 50.8 cm. (36 × 20 in.). Courtesy of the Art Institute of Chicago. Gift of Ivan Albright, 1977.23. Photograph ©1990 the Art Institute of Chicago. All rights reserved.

individually, the union of all of the painting's parts elicits a response of visual exaltation. Flack's procedure of execution is subjective in concept, objective in process and subjective in its result. The end result is determined at the outset of the creative process.

The still life form has been used for preliminary works in several of Max Weber's excursions into different schools of thought. The loose action painting exhibited in *Still Life with Apples* is a peak performance for Weber. Visual perspective is ignored as objects float in space in an Abstract Expressionistic protrayal. Dots and blotches of color define contours and accentuate identities. Nuances of background colors extend an aggressiveness introduced by slashing brushstrokes and spontaneous color. The consistent display of intuitive urges through compelling and convincing pigment application is the beauty of Abstract Expressionism. A commonplace object assumes a magical

and permanent character in its potential for discovery.

Still Life with Apples is a rampage of color emotionally executed but intellectually conceived. It is this instinctive application of pigment in a seemingly careless manner that provokes a strong viewer response.

There is a suggestion of background divisions that are purposely obscured to avoid disrupting a quiet but vibrant transition of color. In spite of the immensity of the negative environment, slight interpenetrations of color sustain a visual unity. Dark contours of certain objects are reminiscent of Rouault, but Weber applies them discriminately. Each color blotch and each knife thrust is an intuitive act. This technique relies on impulse, but it is the intellect which controls the emotions.

There is a nervousness in each brushstroke, a sense of uncertainty, and what initially appears as disorganization is in

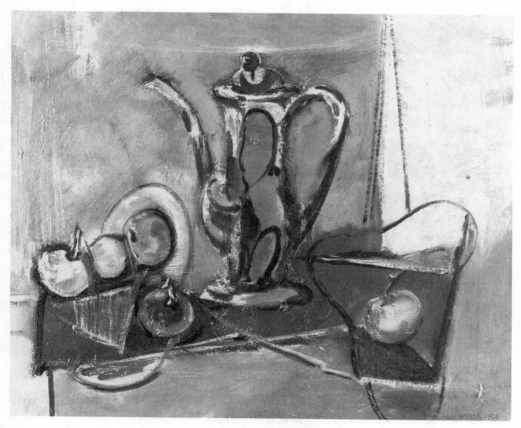

Max Weber. *Still Life with Apples* **(1950). Oil on canvas, 22 × 18 in. Courtesy of the Baltimore Museum of Art, Edward Joseph Gallagher III Memorial Collection, BMA 1952.29.**

reality a highly organized expression. Abstract Expressionism is a perfect union of emotional, physical and intellectual faculties.

Several studies preceded Stuart Davis's *Little Giant Still Life,* and the painting itself, with the word "champion" as its focal point, has been duplicated several times with slight adjustments. Davis, noted for his commercially stimulated flatly patterned abstracts, seldom veered from his customary style of expression. The manipulation of space and the various shapes of color are both simple in appearance and complex in design, creating optical illusions through receding and advancing colors, overlapping and inter-

penetration. A broad horizontal base is counteracted by vertical images of letters of the alphabet inserted into the central horizontal plane, setting the final stage of development into motion.

Since three-dimensional tension is essential to the color composition, a third adjustment is made in permitting diagonal geometric shapes to overlap both vertical and horizontal elements, thus unifying the whole. Davis is careful not to overplay the final adjustment; to do so would defeat the entire idea. The combination of line and shape is sometimes enhanced by deliberate textures.

Little Giant Still Life is not totally nonobjective. Davis's themes hint at com-

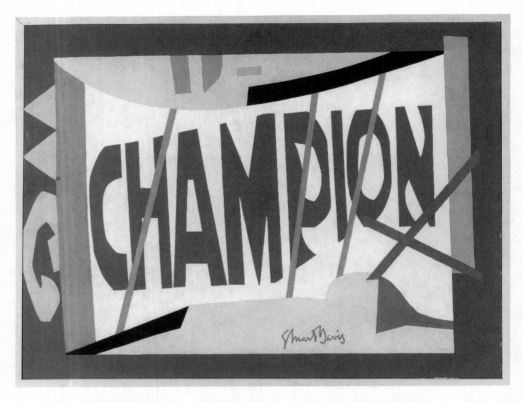

Stuart Davis. *Little Giant Still Life* (1950). Oil on canvas, 43 × 33 in. Courtesy of the Virginia Museum of Fine Arts, Richmond. The John Barton Payne Fund, 50.8.

mercialism, with remnants of reality appearing throughout (albeit in an abstract manner). Logic holds—not in a literal sense but in the language of color, space and shape.

Little Giant Still Life is set up by recollection. Images are then dispersed onto a limited working surface. The word "champion" assumes center stage, and from this initial stage of development various shapes of color are added. With each insertion, the balance of the composition is disrupted. Additional shapes of color create a continuous balancing act until the space is filled, the composition is balanced and vestiges of disruption and congestion are totally removed.

Little Giant Still Life is a satisfying display of color, shape, line and space

unified into an abstract design. Davis claims that indoctrination of an audience should not be essential to the understanding and appreciation of his work. In other words, *Little Giant Still Life* not only is intended for social consumption, by even the illiterate, but should be accepted and enjoyed as a work of art without study. His claim is that society is an automatic recipient of his work and that audience reaction determines the worth of his product. In a way Davis has indicated his purpose in choosing the still life concept as a stimulus for artistic production. Avoiding attempts to understand the elements in *Little Giant Still Life* opens the way for an enjoyable, exciting journey.

This discussion would not be complete if it failed to touch on Adolph Gottlieb's

William Michael Harnett. *For Sunday's Dinner* (1888). Oil on canvas, 21⅛ × 37⅛ in. Courtesy of the Art Institute of Chicago. Wilson L. Mead Fund, 1958.296. Photograph ©1990 the Art Institute of Chicago. All rights reserved.

Top: Adolph Gottlieb. *Unstill Life* (1952). Oil on canvas, 48 × 36 in. Collection of the Whitney Museum of American Art, New York. Gift of Mr. and Mrs. Alfred Jaretzki Jr., 56.25. *Bottom:* William Michael Harnett. *Just Dessert* (1891). Oil on canvas, 26¾ × 22¼ in. Courtesy of the Art Institute of Chicago. Friends of American Art, 1942.50. Photograph ©1990 the Art Institute of Chicago. All rights reserved.

painting titled *Unstill Life* (1952). The title seems to contradict the nature of the still life, but perhaps the title has nothing to do with the subject matter. Gottlieb depicts immovable contents in a manner that suggests movement. He applies paint intuitively to activate the objects into an illusion of movement. He produces this effect within strong barriers of stability. Within the ambitious contours of the still life arrangement, Gottlieb loosens the interior settings and creates an exciting pattern of abstract movements of color. Gottlieb, a member of the Abstract Expressionist school, relies somewhat upon the childhood concept of dual visual perception in *Unstill Life,* presenting a dual top and side view of a single image. The tabletop, the focal point of interest, is viewed from the top while chair legs, hidden under normal visual circumstances, spread outward. The painting re-creates the tactual experience of physically moving around an object.

Finally, one must return to the traditional, the springboard of all still life arrangements. William Michael Harnett, the master of the classical still life, presents an early American version titled *Just Dessert,* a calculated composition with little room for exploration. In a similar manner, Harnett hangs Sunday's dinner in view for all to see in his famous painting ironically titled *For Sunday's Dinner.*

Bibliography

Born, Wolfgang. *Still Life Painting in America.* New York: Hacker Books, 1973.

Cathcart, Linda. *American Still Life, 1945–1983.* New York: Harper & Row, 1983.

Davis, J. Ken and Ellye Bloom. *Painting Sharp Focus Still Lifes.* New York: Watson-Guptill, 1975.

Doherty, Stephen. *Dynamic Still Lifes in Watercolor.* New York: Watson-Guptill, 1983.

Frankenstein, Alfred. *After the Hunt: William Harnett and Other American Still Life Painters.* London and Los Angeles: University of California Press, 1975.

Gerdts, William and Russell Burke. *American Still Life Painting.* New York: Praeger, 1971.

Milman, Miriam. *The Illusions of Reality: Trompe l'Oeil Painting.* New York: Rizzoli International, 1983.

Sandler, Irving. *Alex Katz.* New York: Harry N. Abrams, 1979.

Stealingworth, Slim. *Tom Wesselmann.* New York: Abbeville, 1980.

Sterling, Charles. *Still Life Painting: From Antiquity to the 20th Century.* New York: Harper & Row, 1981.

Wilmerding, John. *American Art.* New York: Penguin, 1976.

Catalogs:

ACA Galleries, New York. "American Flower Painting." Text by Dennis Anderson, 1978.

The Corcoran Gallery of Art, Washington, D.C. "American Still Life Paintings from the Paul Magriel Collection." Essay by John Baur, 1957.

Joslyn Art Museum, Omaha, Nebraska. "The Chosen Object: European and American Still Life." Text by Ruth Cloudman, 1977.

Milwaukee Art Institute. "Still Life Painting Since 1470." Text by E. H. Dwight, 1956.

Museum of Art, Rhode Island School of Design. "Recent Still Life." Text by Daniel Robbins, 1966.

Philbrook Art Center, Tulsa, Oklahoma. "Painters of the Humble Truth: Masterpieces of the American Still Life." Text by William Gerdts, 1981.

University of Southern California, Los Angeles. *Reality and Deception.* Text by Alfred Frankenstein, 1974.

Wadsworth Atheneum, Hartford, Connecticut. "The Painters of Still Life." Text by Arthur Austin, 1938.

SELF-PORTRAITS

Perhaps more accessible to the artist than any other theme is the possibility of self-portraiture, a form often chosen for psychological or autobiographical purposes. The artist is free to distort either negatively or positively in order to create a portrait outside of himself or herself. Infrequently does the image on canvas resemble the sitter. Self-portraits often utilize a social setting; that is, the artist becomes merely an element of the painting, which is typically executed in a personal style and secretive palette. Physical characteristics are generally exaggerated in order to propel a message of greater importance than one's own ego.

The self-portrait may be an end in itself or simply a practice work done to enforce self-discipline before tackling notions of a greater or more personal belief. The convenient mirror approach seems a paradox: distortion seems evident, but the mirror image is a reflection of the real thing.

Techniques seldom change with a change of ideas. The fabulous style of an Ivan Albright retains its sinister realism and embellishment of detail whether the subject matter be a bowl of fruit, a jack-rabbit or the artist himself. This tendency applies to most artists. In the case of Albright, a lifetime was spent revealing in eerie atmospheres the passage of time. Youth was the past, never the present.

Albright painted several self-portraits, of which perhaps the one most directly connected with the passage of life was his 1968 *Self Portrait in Georgia*. Oddly enough, three distinct schools of thought surface in this work. Albright's usual wrinkly style is used for his face, but his upper torso is painted in lucid Expressionism. To cap his extraordinary masterpiece, Albright appoints a Pop image to invade his scene.

Self Portrait in Georgia is a morbid picture of a man nearing death. According to Albright life is never long enough or deep enough, and *Self Portrait in Georgia* is a confession of fantasies unrealized, of dreams shattered and of forgiveness received too late. Albright's painful revelation of self is not a self-portrait but a portrait of the life of mankind. Life is not merely within oneself; it is of the entire world.

Rusty spikes driven deep into the

weatherbeaten barn slats pierce the human soul as well. White disheveled hair, facial wrinkles resembling the furrows of a plowed field and eyes which reveal the human conflicts of several decades of searching seek not viewer compassion but rather a sanctuary from death.

The contrast of styles reflects transitions, the need to eloquently draw the deterioration of life yet recall the splashy brushstrokes of youth. There is a tension between the tautness and the looseness, the disciplined and the undisciplined, yet all blends into a unified composition. Self-portraits tend to localize a single personality, but Ivan Albright's *Self Portrait in Georgia* reaches beyond regionalism and lays bare the universal soul of man.

In Lyonel Feininger's portrayal of self, a strong, geometrically designed head image beckons the viewer. Encircled by a pillared structure, Feininger's sinister countenance provokes the viewer to further study. Feininger's *Self-Portrait* (see color insert, H) presents exaggerated features which strengthen the image. A rugged upper torso matches equally strong facial features. Geometric shapes glow from within as if the inner structure were designed after the pattern of the surface features.

The huge window frame barely encases the distorted head. Feininger's deliberate overlap of head and column is an attempt to unify the positive and negative areas. In a visual sense, the blue sky area surrounding the head is the negative space while the heavily structured pillars act as a middle ground, negative to the head structure but positive to the sky area. The strong diagonal contours of the columns are echoed in the physical contours of the artist's body.

The purpose of self-portraiture varies. Seemingly autobiographical in content, it also may serve to communicate a philosophy or lifestyle. Since the artist is free to create his own image, when reality falls short of personal desires fantasy may enter the scene. In Feininger's *Self-Portrait* the artist resembles his own characters, with emphasis placed upon the nervous linework and probing eyes.

Self-Portrait by Philip Evergood pictures the artist with brushes in both hands as if he is indeed in the process of painting himself. Female forms frolic in the background, introducing an element of personal fantasy. Although titled as a self-portrait, one may question the initial stimulus, and in so doing, question the validity of the title. Titles are deceiving and are sometimes deliberately misleading.

A free-flowing fluid figure alternately widens and constricts to prevent monotony in Clifford Still's *Self-Portrait*. The deformed, elongated figure is anchored within a rectangular shape which establishes a foothold for the angular linear structure and affords the positive image a contrasting negative environment. *Self-Portrait* is a highly personal painting and represents an unusual departure from Still's generally less linear work.

Edward Hopper executes his *(Self-Portrait)* in his usual lonely style, painting himself in a seemingly desolate environment. Large segments of the canvas are devoted to emptiness. A subtle blend of unidentifiable activities defines an environment to which Hopper and his characters logically belong.

There is an eloquence, a soothing quietude, a pensiveness that challenges the viewer. Prominent facial features are sharply defined in a puzzling glare that suggests either a subtle beckoning or a quizzical distrust. An aura of independence surrounds the artist. *(Self-Portrait)*

Ivan Le Lorraine Albright. *Self Portrait in Georgia* (1967–68). Oil on canvas, 16 × 20 in. Courtesy of the Butler Institute of American Art.

is envisioned as a segment of a broader environment. Its compositional subtleties include the vertical door which connects to the strong diagonals of the floor to create a right angle that relates directly to the angle formed by the artist's chin and cheek bone.

Loneliness is Hopper's trademark, and his own portrait answers a search for the unattainable by creating through artistic means a fantasy world in which nothing is unattainable.

One expects a self-portrait to picture a human being as its subject, but in the case

Edward Hopper. *(Self-Portrait)* (1925–30). Oil on canvas, 20¼ × 25⅛ in. Collection of the Whitney Museum of American Art, New York. Josephine N. Hopper Bequest, 70.1165.

of *Self-Portrait* by Charles Sheeler, a telephone is presented as the focal point of interest, with only a vague figure hidden in the background. Is the partial figure lurking in the shadows to be interpreted as the image of the artist? If so, why does the exquisitely fashioned image of the telephone command immediate attention?

There is a definite link between the secretive self-portrait and the telephone. Does the existence of one rely upon the other? The attachment between content and title, one can assume, is the constant

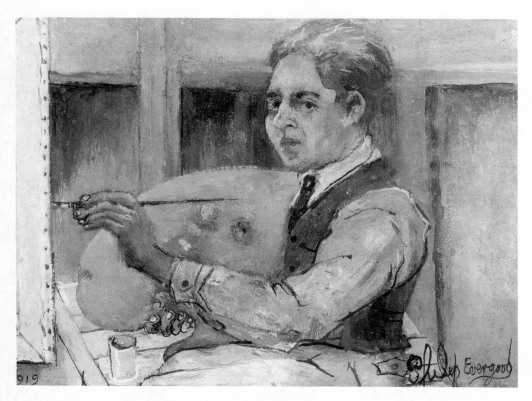

Philip Evergood. *Self-Portrait* (1919). Oil on fiberboard, 8½ × 6½ in. Courtesy of the Hirschhorn Museum and Sculpture Garden, Smithsonian Institution. Gift of Joseph H. Hirschhorn, 1966.

use of the telephone as a recorder of the human voice, the voice thus representing human emotions and intellect in the person of Charles Sheeler.

Self-Portrait is a typical Sheeler portrayal. As in most self-portraits, the central image stands alone within a muted background of horizontal and vertical planes. The telephone occupies a stabilizing position upon the lower horizontal plane. The upper plane contains the shadowy human torso that suggests a possible reason for the title. The secondary position of this image increases the imaginative link between the artist and his audience. Has the title preceded the work or followed it? Does it really matter?

The self-portraits executed by Raphael Soyer identify the artist with brush, easel and canvas—the tools of his career. In *Self-Portrait* (1927), a slightly diagonal image is balanced by the leftward-leaning torso of the sitter. Soyer looks like one of his own characters, a transient victimized by the social system that disregards the hungry and the homeless. The same despair is read in the artist's eyes as he stares into a world of disrepair.

Soyer's style is realistic but reflects a sense of urgency. The muted background strengthens the presence of Soyer's image and reinforces the artist's gentleness and concern for the human race. Soyer's is a mirror image of self, reflecting his resoluteness and methodical manner in his facial expression. His brushstrokes are loose and free but executed with absolute certainty.

Charles Sheeler. *Self-Portrait* (1923). Conté crayon, gouache and pencil on paper, 25¾ × 19¾ in. Collection of the Museum of Modern Art, New York. Gift of Abby Aldrich Rockefeller.

Although *Self-Portrait* is simply composed, light is deliberately cast upon the sitter's left side to move the balance to the extreme left of the canvas. Colors are applied directly, layer upon layer, never losing the freshness of appearance. *Self-Portrait* presents an atmosphere of life, an appeal to the audience. It is more than a portrait of an artist; it possesses a bit of bewilderment. Soyer paints himself in several of his creations, notably *Pedestrians* and *City Faces,* each of which is different from preceding or ensuing portrayals. He depicts himself as a common member of society, showing his concern for the downtrodden, the underdog, the underprivileged, and his search for elusive hope. Soyer never relinquished his love for immigrants, the unemployed, the displaced and the ever-present home-less transient, and this love is reflected in self-portraits throughout his life's work.

Milton Avery's *Self-Portrait* of 1930 addresses the subject matter of the academic school in a style like that of French master Henri Matisse. Utilizing a muted background, Avery's self-portrait exhibits a strong European influence in the decorative patterns that recall Matisse. Thick layers of pigment identify facial features. *Self-Portrait* becomes an experiment in paint, a means to an end—which, according to Avery, is the purpose of art.

There is a sense that the work is unfinished, suggesting continuous action. The idea that more is yet to come provokes anticipation and an emotional reaction to the unknown. Avery has dramatized a simple self-portrait into an exciting mystery.

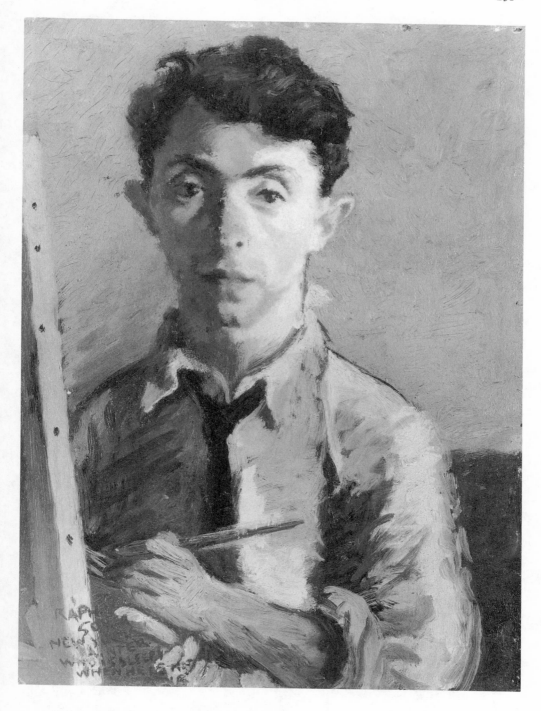

Raphael Soyer. *Self-Portrait* (1927). Oil on wood panel, 8¼ × 11⅛ in. Courtesy of the Phillips Collection, Washington, D.C.

Will Barnet. *Self-Portrait* (1966). Oil on canvas, 38 × 63 in. Courtesy of the Museum of Fine Arts, Boston. Anonymous gift, 68.143.

Frank Duveneck. *Self Portrait* (ca. 1877). Oil on canvas, 23 $^{11}/_{16}$ × 29 $^{5}/_{16}$ in. Courtesy of the Cincinnati Art Museum. Gift of the artist, 1915.122.

Brushstrokes stop short of completely identifying certain facial features, their intuitive application leaving the viewer to imagine the completeness of the image. Dots of color upon the painted surface add a further Matisse-like quality, and streaks of color further enhance the dec- orative pattern of the upper torso. Facial shadows are employed with dramatic cer- tainty, even to the point of facial dis- tortion. Avery's play on light and dark contrasts is dramatically exposed in *Self-Portrait,* which is indeed an experimental piece. Avery's experimentation in this

work helped to develop his well-known flat pattern style.

Each self-portrait represents an excursion into the unknown. This 1930 work has remnants of European influences while Avery's later works on this theme reflect personalized alterations in both palette and composition. Deliberate distortion became a major attribute of Avery's self-portraiture. Acceptance and exploitation of accidental discoveries enable images to develop from the real to the magical, and for Avery it was the self-portrait that frequently served as a sounding board for new techniques.

Although Avery's flat images tend to float in space, Will Barnet's flatly painted subjects are set rigidly in place. The set facial features, rigid stance and viselike hands establish equally set responses. *Self-Portrait,* executed in 1966, utilizes formal architectural shapes and a muted palette to express a firmness of style so rigidly carried out that any minute disruption would dissolve the effect of the entire work. Barnet successfully manipulates vast areas of subtle colors registered in the human framework into shapes of anticipated activity that coexist with restful areas. In so doing, he establishes adequate distance between the major points of attention.

Each hand holds an item of independent interest: a pair of paint brushes and a cat. The daring insertion of a dual rectangular shape in the image of a canvas to the extreme right of the painting is balanced by the equally strong shapes of the figure's attire.

There exists an intensity ready to burst within the painting. The austere glare, the iron grip of the hands, the threat that the unsuspecting feline will be suddenly crushed, and the obvious sterility of composition suggest a controlled intellectual phenomenon ready for an emotional response.

Negative and positive areas seem interchangeable as receding and advancing colors tend to ignore the principle of visual perspective. Barnet's portrayals are contour drawings of purposeful distortion enhanced by subtle and gentle color.

The late nineteenth century was an era of soft shadows and sharp contrasts and a strong focus on the facial features of the model. In a self-portrait by Frank Duveneck, one is drawn to the singularity of subject matter. Outside stimuli are ommitted, leaving the background free of objects and figures, so that full attention must be devoted to the subject.

The head receives central focus as if spotlighted on stage. The lower torso is eliminated by a gradual diminishment and with the total focus on the face of the model, *Self-Portrait* assumes a subjective appearance. The absence of interruptions makes the painting seem to have flowed naturally rather than to have been a deliberate or experimental work.

Painted during the same decade as Duveneck's self-portrait is James Whistler's 1871 *Arrangement in Gray: Portrait of the Painter.* The pose incorporates an artist's attire: smock, paint brushes and French tam. The smock even shows paint smudges and smears to identify the painting as a biographical record.

Brushes held vertically in hand, the artist glints at the viewer. The large, dark tam encircling his head is balanced by a similarly dark area in the background. A devoted composer of detail, Whistler hinges the two background areas into a single environment with the extension of the two paint brushes gripped in the right hand. Even the slant of the brushes coincides with the dip of the figure's head.

Marsden Hartley's *Self-Portrait* is a

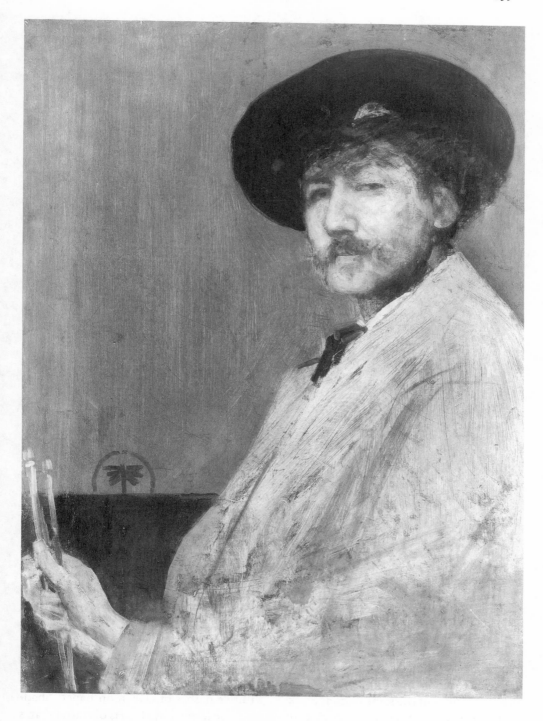

James Abbott Whistler. *Arrangement in Gray: Portrait of the Painter* (1872). Oil on canvas, 21 × 29½ in. Courtesy of the Detroit Institute of Arts. Bequest of Henry Glover Stevens in memory of Ellen P. Stevens and Mary M. Stevens.

Fairfield Porter. *Self-Portrait* (1968). Oil on canvas, 45⅜ × 59 in. Courtesy of the Dayton Art Institute. Museum purchase.

drawing of gesture lines creating movement and action not unlike that of his other paintings of the same period. Stark, penetrating eyes immediately capture the viewer's attention. The elongated head shape, highly suggestive with little precise linear definition, consists largely of numerous congested areas created by intuitive dashes of crayon on paper. Shadows are formed by clusters of crayon marks that overlap and interpenetrate to form an ultimately recognizable personality.

Edwin Dickinson. *Self Portrait* (1949). Oil on canvas, 36 × 48 in. Courtesy of the National Academy of Design, New York City.

Vast areas of emptiness become seas of excitement with undulating strokes of the crayon. Negative space becomes positive as shadows take form from numerous converging marks of the crayon.

Self Portrait by Edwin Dickinson, a 1949 rendition, is a rare profile view of modified geometric shapes. The unusual background of subtle rectangular shapes conveys no particular meaning but serves the central subject compositionally.

Psychologically, the masculine structure of the head form coincides with the structural strength of the artist's environment. The painting typifies Dickinson's fluid rendering of pigment. The head, sur-

rounded by an equally darkened rectangular shape, beckons the viewer's immediate attention and sets the stage for further action into the environment. Although painted on a practically square working surface, the work takes on a vertical appearance due to opposing directional forces.

Fairfield Porter has executed several self-portraits during his outstanding career under varying circumstances, at different locations, and during different moods. His 1968 version places him in his studio. His posture, simple and direct, might please a hurried cameraman's need for a photo, but for Porter it is the environment surrounding him that defines the autobiographical painting.

In *Self-Portrait* (1968), the artist stands erect with his right hand placed on a wooden chair and his eyes riveted on the viewer. In the background are the tools of his trade—sketches tacked to the back wall, a mirror, a large canvas in progress and the usual artistic essentials. A ceiling skylight allows ample sunlight.

Porter, paradoxically perhaps, appears posed for the event, clad in shirt and tie. In spite of the orderly display of objects calculated to suit each corner and nook, there is a quietness that prevails, and one wonders if the environment might change after the snap of the camera.

As mentioned from the outset, the self-portrait is a sounding board for exploitation and experimentation incorporating biographical tidbits. It is an ideal lead-in to more serious works.

Bibliography

Baur, John. *Philip Evergood*. New York: Harry N. Abrams, 1971.
Blake, Wendon. *The Portrait and Figure Painting Book*. New York: Watson-Guptill, 1979.
Chase, William Merritt. *William Merritt Chase*. Akron: Akron Art Museum, 1982.
Finck, Furman. *Complete Guide to Portrait Painting*. New York: Watson-Guptill, 1979.
Friedman, Martin. *Charles Sheeler*. New York: Watson-Guptill, 1975.
Gasser, Manuel. *Self-Portraits*. New York: Appleton-Century, 1961.
Goodrich, Lloyd. *Edward Hopper*. New York: Harry N. Abrams, 1971.
———. *Edwin Dickinson*. New York: Whitney Museum of Art, 1965.
———. *Raphael Soyer*. New York: Harry N. Abrams, 1972.
———. *Reginald Marsh*. New York: Harry N. Abrams, 1972.
Gutman, Walter. *Raphael Soyer*. New York: Shorewood, 1965.
Hyman, Trina. *Self-Portrait*. New York: A-W Publishers, 1978.
Kaintz, Luise and Olive Riley. *Understanding Art: Portraits, Personalities and Ideas*. New York: Harry N. Abrams, 1968.
Lerner, Sharon. *Self-Portrait in Art*. New York: Lerner, 1965.
Longstreet, Stephen. *Self-Portraits of Great Artists*. New York: Borden, 1962.
Ray, Man. *Self-Portrait*. New York: McGraw-Hill, 1979.
Romano, Umberto. *Great Men*. New York: Dial, 1980.
Sanden, John. *Painting the Head in Oil*. New York: Watson-Guptill, 1976.
Walker, John. *Self-Portrait with Donors: Confessions of an Art Collector*. Boston: Atlantic Monthly Press, 1974.
Werner, Alfred. *Max Weber*. New York: Harry N. Abrams, 1975.

MUSIC

As a fine art, music has qualities similar to those of painting in the nature of rhythm, composition, technique and color. The musical process itself is seldom a motivating force for artistic expression; instead it is the musicians who are the stimuli. One of the finest exponents of the exploitation of music for artistic purposes has been Max Weber.

Weber's several emotional paintings sing with praise his Jewish heritage. For example, his painting simply titled *Music* reflects the sheer joy of family interaction among several generations. Musical tones are transmitted visually through Weber's exhilarating color scheme. The rich palette also enlivens the movements of the participants.

Foreground figures and background environment are deliberately fused, but visual perspective remains evident. Weber's music has rhythmic qualities that can be seen in the agitated figures, which are defined less by line than by the action itself. Although cradled in the arms of the mother, a child moves about in unison with the others. The lute player strums his instrument with gusto, and there is a ner-

vous tension even among the stationary figures.

Nods to Expressionism are apparent. Subjects are presented through color alone, without definition of form. Areas suggesting form engulf the canvas, and the illusion of movement is created by linear gestures that both overlap and interpenetrate the established bodies of color.

An earlier Weber musical painting, *The Two Musicians,* reveals the French Abstract influence. The Gris, Braque and Picasso styles are obvious in this tightly knit composition. Bodies are deliberately truncated to meet compositional needs. Instead of the fusion of objects evidenced in Weber's paintings of the 1940s, this work is marked by shapes that overlap and interpenetrate. Decorative areas are appropriately positioned in contrast to flatly painted shapes.

The complex design defies literal translation, and a lack of emotion is due to the absence of the movement that is evident in Weber's later works. Movement in *The Two Musicians* is created by positioning darks and lights in accordance with eye contact.

Max Weber. *The Two Musicians* (1917). Oil on canvas, 30⅛ × 40⅛ in. Collection of the Museum of Modern Art, New York. Acquired through the Richard D. Brixey Bequest.

The dual composition allows for immediate overlap, and the images of the musicians and their instruments present a complexity of positive aspects. The background incorporates the colors of the positive aspects, thus avoiding a separation of visual perspective. The entire composition rests on a frontal plane. Musical symbols lie within the surroundings as a compositional technique.

Weber's two players contrast with a full orchestra in Philip Evergood's *Music*.

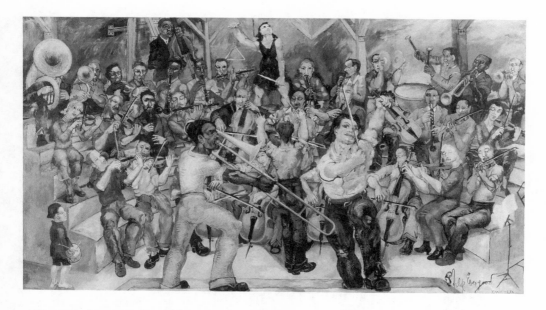

Philip Evergood. *Music* (1933–59). Oil on canvas, 112 × 72 in. Courtesy of the Chrysler Museum, Norfolk. Gift of Walter P. Chrysler Jr. in memory of Jack Forker Chrysler.

Evergood jams his musicians (38, plus the conductor and a miniature admirer) into a small area, and the congestion of human anatomy alone creates an arena of confusion. The very complexity of design, however, creates a pleasant union of all parts of the painting. There is no rhythmic pattern of sound, only a conglomeration of human flesh competing for individual honors. The intense overlapping of figures constitutes its own concert.

There is humor as well as music. A musclebound character in the rear waits patiently to ting his triangle while the swinging fiddler leading the fray accentuates his anatomy.

Amid the musical celebration is a young lad standing aloof with his toy drum awaiting a signal to participate. The ignored tyke is positioned to meet an obvious compositional need as well as to lend a bit of satire to the scene.

Music was painted over a 26-year period. Initiated during the Great De-

pression when such concerts were free and viewed by thousands, it was completed long after World War II.

Each of the individual players tells a tale by virtue of Evergood's psychological analysis of the human condition. In a sense Evergood has miraculously combined several individual compositions into a single unit of entertainment.

From the 38-piece Evergood orchestra to the 4-piece band of Ben Shahn is a leisurely transition. *Four Piece Orchestra* is a bit of nostalgia, featuring musicians who appear outdoors in their work clothes.

Rather than ignore individual performances as in Evergood's *Music,* the viewer is beckoned to appreciate the attitudes and love of music shared by the three offbeat musicians who play in an obscure wooded area for only the winds to hear. The violinist, cellist and guitarist (who doubles on the harmonica) are seated on what appears to be a wooden bench. Each musician displays an intense concentration

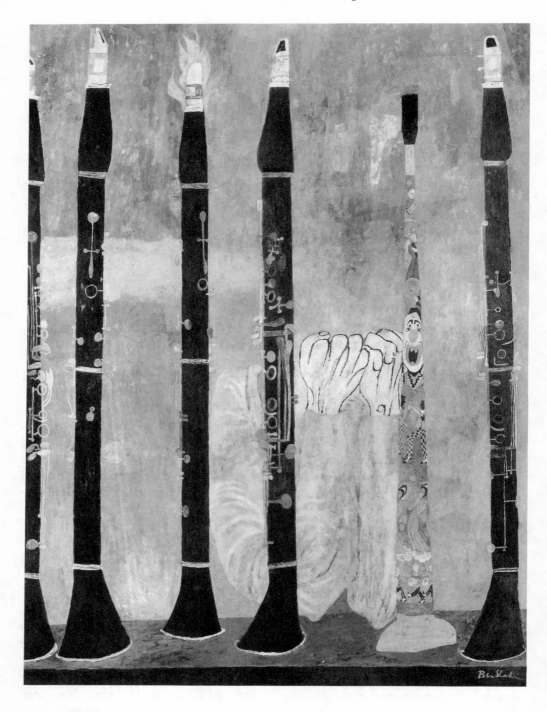

Ben Shahn. *Composition with Clarinets and Tin Horn* (1951). Tempera on panel, 36 × 48 in. Courtesy of the Detroit Institute of Arts. Founders Society Purchase, Friends of Modern Art Fund.

and devotion. Shahn's love of music appears in several painted images; *Four Piece Orchestra* is a rare expression of the depth of that love.

The unconscious plays a significant role in the creative process, and interpretations that appear obvious to an outside observer may surprise the creator. Blotches of color placed on canvas during the creative process may or may not have meaning to the artist. An accidental application of pigment allowed to remain merely to serve a compositional need may unduly concern the spectator.

To apply literal meaning to Shahn's *Composition with Clarinets and Tin Horn* may be to erroneously attack an image which qualitatively merits honor regardless of the interferences of reality. The red flame surrounding a single clarinet mouthpiece seems to demand a literal translation, but perhaps it is not intended to carry a specific meaning.

One might question the headless musician, which is merely a simple solution to a compositional need. Rather than congest the central area of the composition with the completed figure, which by its inclusion would disrupt the unity of the painting, Shahn allows the headless human in defiance of a literal viewing. The red flame may well recall an ancient religious symbol or a totally alien concept. The vertical composition of five clarinets and one tin horn is held together only by the red bands of color in the base and center of the painting.

Shahn often omitted certain expected features of a painting, like the musician's head. Musicians are completely erased from his unusual portrayal titled *Still Music.* Empty chairs and music stands overlap and intermingle in a complex linear composition. Their disarray creates a certain chaotic order. Stands are tilted,

chairs are disarranged and contrasts of darks and lights saturate the scene. *Still Music* might have been titled *After the Concert* or *Intermission,* but instead the viewer is left to his own inner musings, invited to imagine intimate delights or personal favorites. Color, line, shape and space created the music, which is not heard but seen. The musical arrangement is the color harmony of the canvas.

Musical Theme (Oriental Symphony) by Marsden Hartley is the product of painting music or the equivalent of sound in color. It is a strictly abstract assemblage of shapes which tend to explode within limited confines. Each abstract shape is surrounded by thick, dark outlines which waver in intensity depending on adjacent areas. Colors are toned and blended to decrease the intensity. Consequently, contrasts are indefinite and uncertain.

There is an overall structure of shape and color which defines the entire composition, and within the whole are disjointed musical symbols. Sound is related to color, and a melody stems from the diversity of rhythmic patterns of line and shape. Shapes are generally open-ended, allowing "sound" to carry throughout the composition. There is a definite Kandinsky influence.

Intuitive responses are recorded throughout the painting. There are nervous touches of color, blotches and smears which blend into a unified composition. The abstract nature of music is well suited to an abstract painting of color. Intuitive spotting of color relates to a method of modern jazz: "play as one feels" becomes "paint as one feels." Hartley injects a mystical quality in *Musical Theme* by diluting color. Lines became calligraphic, joining the basically Cubist structure. Symbolic eight-pointed stars float throughout the painting as well as various

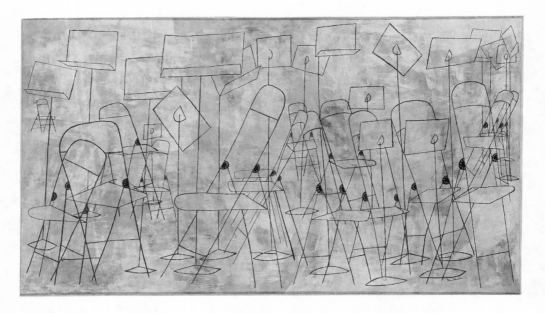

Ben Shahn. *Still Music* (1948). Casein on fabric mounted on plywood, 83½ × 48 in. Courtesy of the Phillips Collection, Washington, D.C.

Christian and Oriental mystical symbols such as crosses and a Buddha in a lotus position.

Although the work is intuitively expressed, objectivity exists in the preplan. Instinctive responses occur after the general layout has been established, but intent is not meaningful at any stage in a literal sense.

Not unlike the musical theory of Hartley's intuitive responses to the spiritual is Jim Forsberg's intuitive musical painting *Nocturne.* Thick layers of pigment spread across the canvas like cement troweled on, and textural qualities emerge from the overlay of color. Contrasts are formed by the rich edges of pigment adjacent to each other as they break space into dramatic shapes. The sweeping knife strokes play upon each other in a provocative display of color nuances.

In total disregard for visual perspective, recessive and advancing tiers of color perform a three-dimensional struggle on a

two-dimensional plane. The painting is as abstract as its title. One meditates upon its color, its technique and its mood. There are no objects to interfere, no aspects of sharing, but rather a total giving of self. *Nocturne* is a retreat, an escape from turmoil, chaos and confusion to a scene of order. Because of its singularity of purpose, its strength sustains lengthy periods of spiritual meditation.

The satire of Jack Levine is not as evident in his musical paintings as in his later works such as *Welcome Home.* World War II left him with a contemptuous attitude toward the upper strata of society. In *String Quartet,* there is a snobbish aura of complacency registered in the postures of the quartet. One marvels at the complex juxtaposition of shapes and color.

The four musical portraits attract the viewer's attention immediately as a circular composition is formed. After noting the facial gestures, one is turned toward

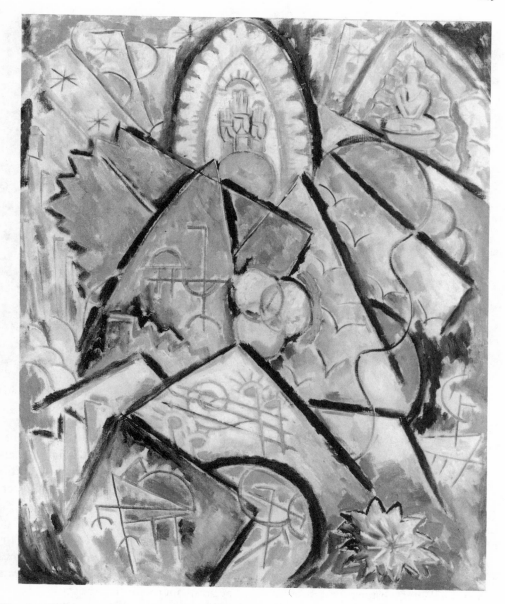

Marsden Hartley. *Musical Theme (Oriental Symphony)* (1912–13). Oil on canvas, 31¼ × 39⅜ in. Courtesy of Rose Art Museum, Brandeis University, Waltham, Mass. Gift of Samuel Lustgarten.

the instruments and the hands which control the ensuing sounds. Thus one sees in *String Quartet* a series of four compositions, each picturing an instrumentalist with tension focused upon the distance separating the head and hands.

Although activity is visually present, added excitement is created by the anticipation of action. The current movement of sound is eliminated to allow intervals of sound and silence. The setting is consumed by the string quartet itself, presenting in a sense a subjective expression which forces the viewer to acknowledge

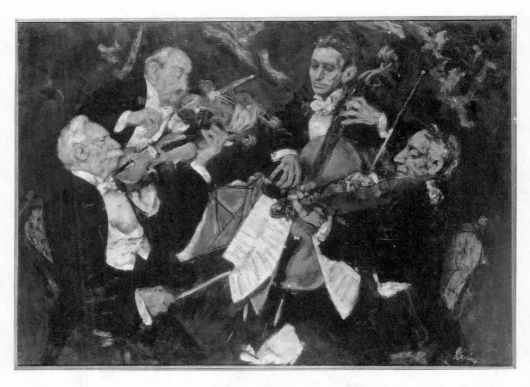

Jack Levine. *String Quartette* (1934–37). Tempera and oil on composition board, 67½ × 47½ in. Courtesy of the Metropolitan Museum of Art. Arthur H. Hearn Fund, 1942 (42.156).

only the four players. Levine adds sufficient suggestive aspects to avoid a separation of foreground and background.

A semi-abstract version of the music scene is presented by Philip Guston in his haunting *Performers,* a work reminiscent of such earlier psychological works as his intriguing *If This Not Be I. Performers* is a middle ground between his early Realism and his later Abstract Expressionism. It distorts figures to suit both physical and psychological needs, resulting in a visually satisfying composition.

The four performers are not readily accessible to the viewer. Their elongated figures, half hidden amid tribal symbols and geometric shapes, plead for assistance through their music.

Exaggerated heads with overactive eyes enliven the spirit of *Performers.* The com-

plex overlapping creates a sense of oneness. The overlapping of figures, although compositionally beneficial, supports a complex methodology. Guston packs his figures onto a limited working surface, making for a high percentage of positive action. He leaves no room for negative reaction, so *Performers* becomes a positive message. The musical players perform not for musical satisfaction but as a compositional challenge. Guston has conceived and executed on a limited working surface a message of worth and satisfaction.

Negro Jazz Band, an exciting musical display executed by Jan Matulka in black and white, is an intricate design of overlapping musicians and their instruments, Tuba, drums, trombones, saxophones, trumpet, guitar and several musical symbols

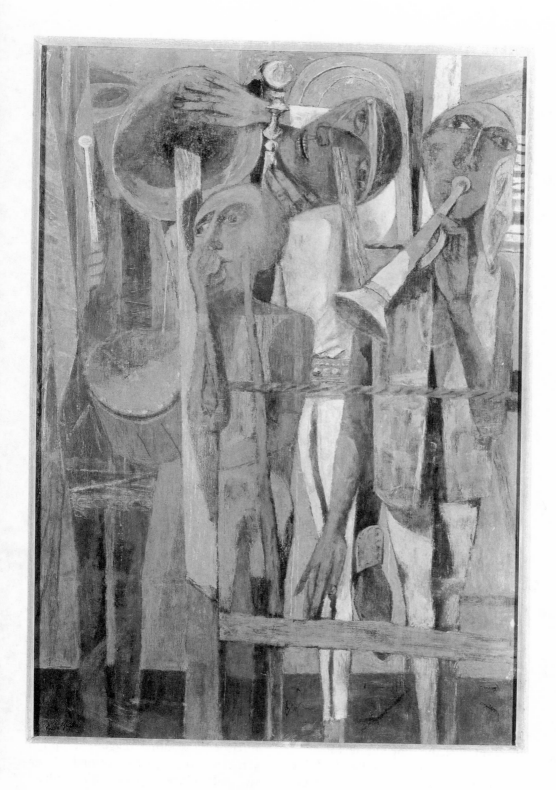

Philip Guston. *Performers* (1947). Oil on canvas, 32⅜ × 48½ in. Courtesy of the Metropolitan Museum of Art. Arthur Hoppock Hearn Fund, 1950 (50.32).

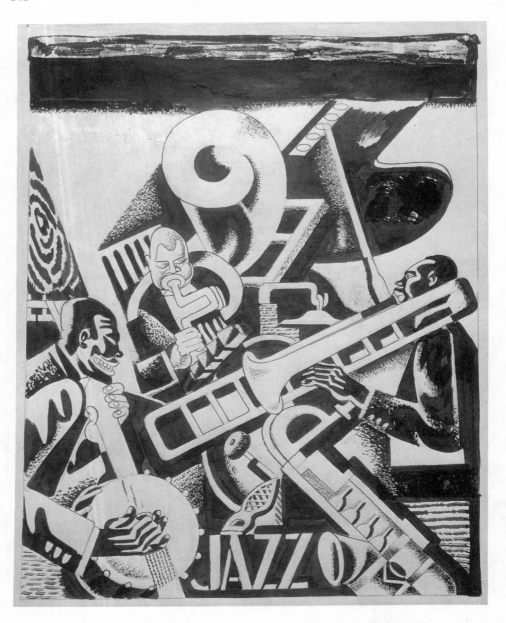

Jan Matulka. *Negro Jazz Band* **(1972). Black ink heightened with white over pencil, 19⅛ × 25 in. Courtesy of the Saint Louis Art Museum. Purchase: Friends of the Saint Louis Art Museum funds.**

join with the three performers in a combination of shape, line and texture.

Tightly knit *Negro Jazz Band* exhibits exuberance in spite of its compactness. The sharp contrast of equally distributed dark and light enables a consistent unity to evolve. Movement is suggested by the interspersal slanting diagonals, upright verticals and lengthy horizontals. Negative and positive shapes combine with apparent positivism prevailing as optical illusion enters the scene.

John Covert. *Brass Band* (1919). Oil and string on composition board 24 × 26 in. Courtesy of the Yale University Art Gallery, Société Anonyme Collection.

What appears as negative is actually positive, with shadows acting as negative. Hands of the musicians incorporate darks and lights and are executed solely for the purpose of meeting compositional needs. *Negro Jazz Band* is an adventure in space, jammed with geometric shapes which to a literal viewing are readily recognized and which perform not only a musical service but an artistic purpose. The tension of these activated shapes bolsters the unity of the composition.

Brass Band, painted in 1919 by John Covert, presents a large image of a single instrument rather than a total band. Influenced by Marcel Duchamp, Covert conveys the notion of the resounding blast of a chorus of brass instruments. One is reminded not only of an accordion but of the sound of a trombone quartet.

Arthur G. Dove. *Chinese Music* (1923). Oil on canvas, 18⅛ × 21⅝ in. Courtesy of the Philadelphia Museum of Art, the Alfred Stieglitz Collection.

The choice of a brass band suggests a Pop approach, and the style of the composition suggests the school of optical illusion. Furthermore, the style is reminiscent of the Cubist school: visual perspective becomes an interweaving of abstract shapes, and the optical illusion created by the juxtaposition of brass bands creates tension. Color advances and recedes in an exchange of negative and positive shapes. Recession is created by the closing in of brass bands, advancement

by the spreading of those same brass bands farther apart. Color also creates shadows and reflections in those areas set into the background.

Chinese Music, a 1923 painting by Arthur Dove, stems from musical inspiration of an unknown origin. It is a typical example of a musical theme translated into a painted expression. Various shapes are chained in a series of varying movements. The purposeful lack of human forms enables a combination of abstract forms to communicate the abstract melodic movements. Five distinct series of shapes dominate the canvas, and each series typifies a rhythmic pattern. Instead of sounds emanating from musical instruments, colors overlap to form a visual tension between foreground and background.

The modulation of each color is softened by the gradation of dark and light, avoiding the logical three-dimensional form. Vertical structures resembling skyscrapers rise sharply before being severed by sweeping circular cutting movements which not only alter a rather placid portrayal but introduce a vibrant change of tone. Interpenetration, the obvious form of abstract unity, is avoided as each geometric shape is tucked behind another.

Rehearsal II, a 1942 painting by Dan Lutz, reflects the spiritual fluidity which dominated his work of the forties. Beautifully orchestrated musicians are totally given over to the conductor's leadership. The relaxed, fluid atmosphere of *Rehearsal II* leaves the occupants unidentified. Facial features are blurred, or in some cases indistinguishable, creating a union of musicians rather than individuated personalities.

Individual forms, though conceived separately, blend in color to form a team. Colors forming anatomical shapes are defined with carefully positioned contours. Although the entire painting is activated by the presence of the various musicians, spatial anticipation occurs in the area between the conductor and his orchestra. One senses that similar activated space occurs between each musician and the leader.

Lutz is careful to blend together certain figures while clearly isolating others, thus avoiding monotony. The orchestra conductor is the focal point at which the viewer enters the painting. The musicians assume a devotional attitude toward their leader, and their dedication transfers itself at least partially to the viewer. Classified as a magical Realist, Lutz intrudes upon the inner dynamic of the rehearsal. Just as Lutz is devoted to his art, the conductor is devoted to his orchestra.

Bibliography

Baur, John. *Philip Evergood.* New York: Harry N. Abrams, 1971.

Brown, Milton. *American Painting from the Armory Show to the Depression.* Princeton, N.J.: Princeton University Press, 1955.

Celender, Donald. *Musical Instruments in Art.* New York: Lerner, 1966.

Driskell, David. *Two Centuries of Black American Art.* New York: Alfred Knopf, 1976.

Goldwater, Robert. *Artists on Art.* New York: Pantheon, 1945.

Goodrich, Lloyd. *Reginald Marsh.* New York: Harry N. Abrams, 1972.

Kinsky, George. *History of Music in Pictures.* New York: Scholarly Press, 1934.

Kootz, Samuel. *New Frontiers in American Painting.* New York: Hastings House, 1943.

Lang, Paul and Otto Bettmann. *Pictorial History of Music.* New York: Norton, 1960.

Langley, Patrick. *The Intimate Connection Between Music and Art*. New York: American Classical Press, 1980.

Leepa, Allen. *Abraham Rattner*. New York: Harry N. Abrams, 1963.

Lewis, Samella. *Art: African-American*. New York: Harcourt Brace Jovanovich, 1978.

McCarter, William and Rita Gilbert. *Living with Art*. New York: Alfred Knopf, 1985.

Maxon, John. *The Art Institute of Chicago Collection*. Chicago and New York: Harry N. Abrams, 1970.

Motherwell, Robert. *Modern Artists in America*. New York: Wittenberg, 1952.

Piper, David. *Random House Library of Painting and Sculpture*. New York: Random House, 1981.

Sandler, Irving. *The Triumph of American Painting*. New York: Praeger, 1970.

Shahn, Bernada. *Ben Shahn*. New York: Harry N. Abrams, 1970.

Soby, James. *Ben Shahn*. New York: George Braziller, 1968.

Young, Mahonri. *The Eight*. New York: Watson-Guptill, 1973.

• INDEX •